D1548521

The Triumph of the Cross

The Triumph
of the Cross

*The Passion of Christ in Theology
and the Arts, from the Renaissance
to the Counter-Reformation*

RICHARD VILADESAU

OXFORD
UNIVERSITY PRESS

2008

156891987

OXFORD
UNIVERSITY PRESS

Oxford University Press, Inc., publishes works that further
Oxford University's objective of excellence
in research, scholarship, and education.

Oxford New York
Auckland Cape Town Dar es Salaam Hong Kong Karachi
Kuala Lumpur Madrid Melbourne Mexico City Nairobi
New Delhi Shanghai Taipei Toronto

With offices in
Argentina Austria Brazil Chile Czech Republic France Greece
Guatemala Hungary Italy Japan Poland Portugal Singapore
South Korea Switzerland Thailand Turkey Ukraine Vietnam

Copyright © 2008 by Oxford University Press, Inc.

Published by Oxford University Press, Inc.
198 Madison Avenue, New York, New York 10016

www.oup.com

Library of Congress Cataloging-in-Publication Data
Viladesau, Richard.
The triumph of the Cross : the Passion of Christ in theology and the arts from
the Renaissance to the counter-Reformation / Richard Viladesau.
p. cm.
Includes index.
ISBN 978-0-19-533566-8
1. Crosses. 2. Crosses in art. 3. Christian art and symbolism. 4. Jesus Christ—Passion.
I. Title.
BV160.V56 2007
246'.5580903—dc22 2007029396

9 8 7 6 5 4 3 2 1

Printed in the United States of America
on acid-free paper

To Matthew and Katie

Contents

Abbreviations

Monographs and Primary Source Collections

DS = Denzinger-Schönmetzer, *Enchiridion Symbolorum,*
definitionum et declarationum de rebus fidei et morum.
(Freiburg im Breisgau: Herder, 1976).

LW = *Luther's Works: The American Edition.* Edited by
Jaroslav Pelikan and Helmut Lehmann. 55 volumes
(St. Louis: Concordia Publishing House and Philadelphia:
Fortress Press, 1955–86).

MGG = *Die Musik in Geschichte und Gegenwart: allgemeine*
Enzyklopadie der Musik. Edited by Ludwig
Finscher (Bärenreiter, 1994–).

PG = *Patrologia Graeca.* Edited by Jacque-Paul Migne (Paris:
Garnier, 1842–1905).

PL = *Patrologia Latina.* Edited by Jacque-Paul Migne
(Chadwyck-Healey, 1996).

ST = Thomas Aquinas, *Summa Theologiae.*

WA = Martin Luther, *D. Martin Luthers Werke: krittische*
Gesammtausgabe (Akademische Drück-und Versagssanstalt,
1964).

Books of the Bible

Old Testament

Gen.	Genesis
Ex.	Exodus
Num.	Numbers
Deut.	Deuteronomy
Est.	Esther
Ps(s).	Psalm(s)
Is.	Isaiah
Jer.	Jeremiah
Mic.	Micah

Apocrypha

Jdt.	Judith

New Testament

Matt.	Gospel of Matthew
Mk.	Gospel of Mark
Lk.	Gospel of Luke
Jn.	Gospel of John
Acts	Acts of the Apostles
Rom.	Romans
1 Cor.	First Letter to the Corinthians
Gal.	Galatians
Eph.	Ephesians
Phil.	Philippians
Col.	Colossians
1 Tim.	First Letter to Timothy
1 Pet.	First Letter of Peter
Heb.	Hebrews
1 Jn.	First Letter of John
Apoc.	The Apocalypse (aka Revelation of John)

General

art.	article
ch.	chapter
dist.	Distinction
dists.	distinctions
fol(s).	folio
q.	question
r.	recto
v.	verso

Illustrations

The Triumph of the Cross

Introduction

This book serves as a sequel to my earlier study *The Beauty of the Cross*. That volume examines the passion of Christ as presented in theology and the arts from the beginnings of the church to the late Middle Ages.[1] The present volume takes up the same theme in the period of the Renaissance and Reformation. At the same time, it may also be read independently, as a self-standing study of Christian approaches to the theme of the cross in a period particularly eventful for both theology and art. For those who read it without having read the previous volume, I will here repeat certain points concerning the intent and method of my project as a whole.

Contemporary scientific studies confirm the philosophical position that human thought takes place in many forms besides the verbal/conceptual.[2] Even within linguistic modes of thinking, imagination and feeling seem to play a much stronger and more integral role than was once conceived in purely rationalist epistemology.[3]

Recent scholarship increasingly has turned to art and music as being ways not only of communicating, but also of thinking. Their relationship with verbal/conceptual thought is complex. At one extreme, they may exist as completely independent "languages" and forms of cognition, conveying a message that is untranslatable into words. At the other extreme, they may serve the communication of verbally expressed concepts, as simple bearers of words or of symbols that refer to words. Or they may take on roles that are

variously and more ambiguously related to words and concepts. Art and music may be an alternate way of expressing ideas that can also be expressed verbally—a quasi-translation into another language. They may illustrate ideas, extending the reach of the latter into the realm of affect and desire. And in both these cases they may—purposely or unconsciously—add to ideas or words other meanings that have an ambiguous relationship with their purely conceptual content.[4]

This complex interrelationship between theology and the arts provides the reason for my study. This book continues an experiment in presenting theological history by using art as both an independent religious/theological "text" and as a means of understanding the cultural context of a historical period's academic theology. The sacred art of a historical period gives access to a realm of symbolic expression that is both a source of the faith tradition and a reflection on its verbal theological tradition. The church's dogmatic theology most frequently shapes this realm of sacred art; but often sacred art goes beyond dogmatic theology, and is sometimes even in tension with it.[5] Hence in each period of the history of church, we may speak of its theology existing in both conceptual/ theoretical and aesthetic "mediations." My purpose is to correlate these two types theological engagement. Normally, studies of theological themes give prominence to written sources and academic thought—perhaps necessarily and rightly so. But people, even academics, actually live their religion largely on "aesthetic" grounds. Therefore, one may wonder about the "real" relation between conceptual, dogmatic theology and artistically felt and seen theology. Certainly, people have died and have killed for dogmas; but to what extent was it the dogmas themselves that really mattered, and to what extent were the dogmas simply the—perhaps poorly understood—verbal symbol for a whole complex of feelings and attitudes? When the Basque soldier Eneko de Loyola, not yet transformed into St. Ignatius, was tempted to plunge his sword into the heart of a man who denied the virginity of Mary, how much was he motivated by systematic theological convictions, and how much by the maternal images of the Blessed Virgin that he was familiar with from childhood? This is not, of course, to in any way detract from the importance of the intellectual, particularly in theology. But it is to suggest that intellect may be exercised, expressed, and influenced in many ways, including the nonverbal/nonconceptual.

In this series of studies, I examine the interplay between these two theological mediations in a central object of Christian faith: the passion and death of Jesus, that is, the entire series of events summarized symbolically by "the cross." The first part of each chapter, following an aesthetic/theological introduction, will summarize the high points of the conceptual "theology of the cross" for major thinkers. The second part will examine whether, to what

extent, and how the artistic portrayals of the cross in the same period relate to its conceptual theology. The primary topic, then, is the place of the cross in salvation, as seen in theology and art. Clearly, this topic intersects with many other issues. Theologically, it involves the doctrines of sin, justification, redemption, and ultimately the entire economy of salvation. Similarly, the topic raises questions about aesthetics, including the place of art in society and the way it communicates, as well as its relation to conceptual thought.

As many studies of theological aesthetics have shown, religious art and theological concept, like art and concept in general, are partially parallel and partially incommensurable symbolic forms. They sometimes directly "translate" each other; they sometimes respond to common influences, and sometimes show mutual influence; they sometimes develop independently; and sometimes have different concerns altogether. The relationship is complex, both historically and theoretically.

Religious art (and indeed, religion itself) has nearly always served goals other than being a medium for a message or serving devotion. Sacred art may be used instrumentally, to convey a specific religious message. But it may at the same time have other purposes that occasionally overshadow its instrumental function. It may strive for beauty, or it may be decorative, or it may embody an implicit message about art itself. Furthermore, religious art and the variations in its styles depend on factors other than content. The arts have their separate lives, in which patrons, consumers, locations, talent (or the lack of it), tradition, materials, techniques, etc., all play an important role, quite apart from the message that religious art at least ostensibly serves.

This is particularly true of the period covered by this volume, a period that marked the beginnings of what Hans Belting has called "the age of art,"[6] which is at the same time the beginning of the end for the age of sacred art. In this respect, the Renaissance marked the start of the modern period, when the arts in Christian Europe began for the first time to be widely practiced and appreciated for their own sake, when artists became self-conscious, attending to aesthetic issues and proclaiming their individual "genius," when secular patronage began to outstrip the religious, and when nonreligious subjects became increasingly prominent in the high arts.

To deal with this subject adequately and in detail would require many volumes and broad interdisciplinary collaboration. My purpose within this overall project is modest. I hope to offer a small contribution by comparing various "paradigms" of soteriology with each other and with various styles of artistic presentation of the cross. In doing so, I will refer to classic presentations in both conceptual and aesthetic theology that may be taken as representative of certain large paradigms of thought.

I use the notion of "paradigms" in the sense that the term has been adapted to theology from its original use in Thomas Kuhn's celebrated thesis on scientific revolutions.[7] Hans Küng, for example, defines a paradigm as "an entire constellation of beliefs, values, techniques, and so on shared by members of a given community."[8] A paradigm in this sense designates fundamental ways of thinking that are common within an era, despite differences of theory on particular subjects. In theology such paradigms are illustrated by the forms of thought, dominant questions, methods of procedure, common influences, and major positions of particular periods or movements: the New Testament era; the Patristic period; the Scholastic synthesis; or the Reformation and Counter-Reformation, which are the paradigms of Christian thinking examined in this book. This period in fact provides a "paradigmatic" example of the meaning of paradigms of thought; for Reformation Protestants and Counter-Reformation Catholics formulated opinions that were seen to be irreconcilable within the context of their time. But these classical points of controversy today are largely seen as misunderstandings or as limitations of historical context (see for example the 1997 Lutheran-Catholic *Joint Declaration on the Doctrine of Justification*).[9] On the other hand, both sides in the controversies shared assumptions, about the historicity of the Scriptures, inspiration, the reality of "original sin," and so forth that later generations would find problematic, at the least.

Naturally, there is an inevitable and irreducible difference between a "paradigm" or thought context conceived in the abstract and the actual thought of any particular individual or the general reception of thought in a community. Nevertheless, we may recognize there are large patterns of similar theoretical, technical, and cultural-linguistic formation. They form the intellectual and spiritual "environment" of an age, which, like the physical environment, can be more or less constant for a time, and can change from era to era.

The same may be said of styles in the arts. As Arnold Hauser says, "style has no existence other than in the various degrees of approximation towards its realization ... Style is always a figment, an image, an ideal type."[10] Nevertheless, Hauser insists, stylistic concepts are essential, because without them we could not associate different works with each other nor contrast them with the works of other periods. "Refusal to seek for what is common to the various trends and personalities, whether of the Baroque or of Mannerism, would leave one with a vague nominalism which made the concept of an artistic style impossible and put out of court the writing of art history in any real sense of the term."[11] In using terms like "paradigms" and "styles," then, we are speaking of an intelligibility based on common features and presuppositions, always realized more in some works and some thinkers than in others, but reflecting

generally accepted presuppositions, attitudes, and ideas of a particular way of thinking or representing.

In difference to scientific paradigms, paradigms in theology, like styles in the arts, often overlap; they sometimes coexist with each other within the same period; and frequently older paradigms of thought endure even after new paradigms have developed. This is eminently true for the theological paradigms of the Reformation and Counter-Reformation. Protestant and Catholic thought, respectively, have been shaped for several hundred years by these two paradigms. Indeed, they are still powerful today, even after having been radically challenged by the Enlightenment and the scientific revolution. They can still be found, sometimes existing alongside more recently developed theological models and sometimes hidden as partial components within them.

In this book's methodology, the idea of paradigms is complemented by that of "classics" of theology and of art. The term "classic" is used here in two senses. A "classic" is on the one hand a ("paradigmatic") representative of a particular period's thought-forms or artistic style. On the other hand, there are also "classics" in a deeper sense: works that speak beyond their own period, embody an approach to reality that is relevant to other ages, and continue to be studied and appreciated after their own time. Such classics are works that, in David Tracy's words, "involve a claim to truth as the event of a disclosure-concealment of the whole of reality *by the power of the whole*—as, in some sense, a radical and finally gracious mystery."[12] These are works or, in my treatment, ways of thinking and imagining that have proven themselves to have a lasting power to challenge people to encounter the truth they disclose.

It is the nature of such classics to speak beyond their original context, to some extent, by engaging their readers or hearers or viewers with a reality that they can encounter in a different cultural context. Yet these classics are also bound to their own times. As Hauser remarks, "though every artist in certain respects is a special case, nevertheless he inevitably bears the stamp of his age . . . even the most unique phenomenon has its historical place, and is more or less closely connected with other contemporary historical phenomena."[13] Encountering the great classics as representatives of their times gives one aspect of their meaning, and (by comparison) aids us in seeing those others that transcend the original context. In this way, the great classics above all allow us to see how the work refers to reality or truth.

Following an insight of Frank Burch Brown, I have expanded the notion of a "classic" to apply not only to specific works, but also to "styles."[14] I use this word in a way that does not entirely coincide with the art-historical sense, although it overlaps with it. My interest is in the larger ways of thinking,

feeling, and representing that individual works represent. Hence not every theological text that I will refer to is itself a great work; it is the schools of thinking or way of imagining that they represent that are Christian classics. Likewise in the field of art, I will begin each chapter with the consideration of a particular artwork that is in some way illustrative of its period, and will attempt to correlate theological ideas to the works of particular artists, among them some of the greats. But I will also refer to general styles as classic exemplifications of a way of thinking.

To summarize, in this study I will appeal to certain religious, theological, and artistic classics to exemplify major ways of thinking about and communicating the meaning of Christ's passion. My purpose is not to write a history of theology or of art; either of these is far beyond my competence. My interest here is in the theological ideas themselves, and the correspondences and differences between their varied mediations. Individual theological and artistic works appear here as "illustrations" of large movements and ideas. Obviously, such an undertaking carries a grave danger of oversimplification—which is exacerbated if the work's purpose is taken to be something other than what I intend. Even an examination of general paradigms should involve a good deal of historical contextualization. Much more could and should be said about the social/economic/political/psychological location of both the arts and the theology of the periods I am considering than I am able to undertake here. Hence this work makes no pretense at giving a complete picture from either a historical or an aesthetic point of view. On the contrary, its theological interest cries out for more detailed study of the historical and aesthetic issues that it touches on.

My ultimate purpose falls more within the realm of foundational and systematic theology than that of art history or historical theology. These brief historical surveys are intended as preliminary to an eventual engagement with what seems to me a crucial epistemological question for fundamental theology: the relation of thought to image. However fascinating the historical data are in themselves, here they are used primarily as an exercise in the method of correlation, as background to formulating a contemporary systematic theology of the cross. And the theology of the cross is in a sense a test-case for the use of such correlations, as well as for the use of notions like paradigms, classics, and styles, as means of coming to understanding and making contemporary theological judgments.

This volume, ambitious as it is in scope, covers a much narrower time period than its predecessor. This is first of all because of the peculiar relevance of the Renaissance and Reformation periods to the theme of theological aesthetics. Ecclesiastical Gothic and Romanesque were in a sense not merely artistic styles, but also styles of theology and preaching in art. That is, aesthetic

content and form were largely (although certainly not exclusively) dictated by theological criteria and needs. The Renaissance represents a more or less explicit declaration of independence of the arts and the artist. Sacred genres of course still remain important, and ways of treating them to some extent reflect theological style (Cranach) and/or the religious conversion of the artist (Michelangelo). But art styles begin to belong more and more to artistic creators. They are less expressive of theology, and more expressive of the individual artist and of the period. At the same time, as we shall see, the churches attempted to preserve sacred art from the more radical effects of this revolution, and to recreate specifically religious or sacred styles in the arts.

A second reason for the comparatively extensive treatment given to this period is the centrality of the cross in its theology, and hence also in its sacred art. Obviously, the passion of Christ has been of primary importance in every age of the church. But the Reformation controversies over the means of justification, the significance of Christ's sacrifice, the mode of its presence in the eucharist, and so forth, make the theologies of this era particularly paradigmatic as theologies of the cross.

Each of the following chapters will examine the theology of the cross in both its conceptual and aesthetic mediations. Each chapter begins with a representation of the crucifix that in some way exemplifies the focus of the chapter. There follows an examination of themes from representative theological writings on soteriology and a consideration of parallel artistic developments. I have attempted to correlate theological paradigms of soteriology with artistic classics and/or styles that were more or less contemporaneous with or (in some cases) that were consciously derived from the theological ideas. The history of religious art, of course, does not always neatly correspond with the history of theological ideas. And artistic styles do not coincide neatly with theological paradigms, even in the realm of sacred art. But, as has been noted, in this period there are certain unusually definite correlations between theology and the arts, on the one hand because of the crisis precipitated by the radically increased secularity of art and, on the other hand, because of the church's explicit raising of the question of the purpose of sacred images.

I have tried to make the text accessible to general readers, presupposing very little. It is my hope that it may be read by educated lay people, artists who wonder about theology, students of theology who have little knowledge of the arts. This direction toward a nonscholarly audience may cause some frustration to academic specialists, who may have justifiable reservations about the generalizations and simplifications that an overview like this entails. It is for their benefit that I have included fairly extensive footnotes containing scholarly material that might be excessive for interests of the general reader. These notes

in effect present the reader with the possibility of reading a significantly more technical volume than the body of the text itself.

The volume also contains a comparatively small number of illustrations. These will allow us to look closely at several classical works that are representative of larger movements in art. Other visual artworks referred to in the text unfortunately cannot be reproduced here. Fortunately, a vast virtual museum of art is available today to anyone with access to a computer. In the notes I refer the reader to various Web sites where the major works referred to in the text may be viewed.[15]

I

The Cross in Early Renaissance Theology and Art

Introduction: Fra Angelico's *St. Dominic in Adoration before the Crucifix*

In the year 1436 the Observant Dominicans in Tuscany finally obtained a long-desired goal: a convent for the friars within the city of Florence. The Observants, an officially recognized minority within the Order of Preachers, wished to return to a stricter observance of the Rule of their founder, St. Dominic, particularly in the matter of poverty. Since 1406 they had occupied a convent in Fiesole, a suburb in the hills overlooking Florence. The Dominicans were already a major force in the religious and cultural life of that city. Indeed, along with the Camaldolese monks of Santa Maria degli Angeli, they were the primary center of Florentine intellectual activity.[1]
But up to this point the order was represented in the city only by the "conventual" or nonreformed friars, who possessed the major church of Santa Maria Novella. Now, empowered by a bull of Pope Eugenius IV and with the support of the Medici family, the Observant Dominicans were permitted to take over a former convent of the Silvestrine monks.

The move was difficult as well as significant. The old convent was in a state of serious disrepair. The Medici family promised financial support and engaged the architect Michelozzo; but work on the new convent of San Marco was not begun until 1437.

The completion of the project involved not only rebuilding, but also decoration with frescoes—major works in the chapel and refectory, and a large fresco for meditation in each of the monks' cells. The painting was placed in the hands of a member of the Observant community of Fiesole who was also the Order's preeminent artist: Fra Giovanni Pietro di Mugello, known to posterity as Fra Angelico or "Beato" Angelico—"blessed" Angelico—a longstanding popular title that was made official by his beatification in 1984.

By the time he was moved to San Marco to supervise the fresco painting, Fra Angelico was an established and well-known artist.[2] Like most artists of the period, he had a workshop employing a number of assistants, who were often responsible to varying degrees for the actual execution of the projects.[3] The extent to which we can see Fra Angelico's own hand in the San Marco frescoes is a matter of much discussion among art historians. But there is general agreement that Angelico himself was primarily responsible for the paintings in the public areas of the convent: the chapel, the refectory, and the cloister. We

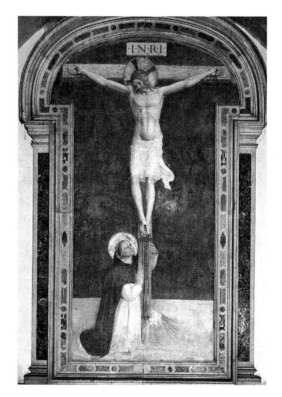

FIGURE 1.1. Fra Angelico, *St. Dominic in Adoration before the Crucifix*, ca. 1440–1445. Convent of San Marco (Museo di S. Marco), Florence. Credit: Nimatallah / Art Resource, New York.

may then assume that Fra Angelico himself designed and painted the striking image of St. Dominic in adoration before the crucified Christ that is found in the cloister of San Marco, near the door of the convent—a "first severe admonition to recollection and to Dominican religious teaching"[4] for those who enter.

As in the cell frescoes, the fresco's content is reduced to bare essentials. The upper two-thirds are dominated by the figure of Christ on the cross. The cross itself is in the shape of a "T," with a narrow piece of wood inserted at the top bearing a wooden plaque with the abbreviated inscription "I.N.R.I." in well-formed Roman letters. The cross and the plaque are painted naturalistically; the grain of the wood is clearly visible. The plaque is of a different color and grain, and is visibly thinner than the cross. The bottom edges of the crossbeam and of the plaque are visible, indicating that they are seen from below.

The body of Christ is realistically represented. Unlike the slender and more ethereal "Gothic" Christ seen in some of the cell frescoes, as well as in Angelico's early works, this corpus is more "classical." It is muscular and well-proportioned, and is represented as having volume, being solid and weighty. (Art historians see here the influence of Masaccio's painting.) The legs splayed at the knees and tautly stretched arms give the impression that the body is sagging, and that the torso is tilted from the waist toward the viewer. The hands are nailed through the palms. Blood flows from the wounds, and large drops fall from the cross. The feet are held to a *suppedaneum* or foot-rest by a single nail, and streams of blood flow down to the bottom of the cross and onto the small hill on which it is mounted. The wound from the centurion's spear is visible in the chest. The body is clothed in a white loincloth that is tucked in on one side while the loose end billows away to the right. The head of Christ is tilted forward and to the left side and bears a circular crown of thorns. The face is peaceful, with eyes closed or lowered; there is a slight smile on the lips. The long golden hair falls in orderly waves. If the body of Christ is portrayed in a classical renaissance manner, the head still retains features of the *beau Christ* ("beautiful Christ") of the Gothic era. Behind the head is a golden halo with a red cross. The halo is portrayed as though it were a solid object, covering the juncture of the crossbeams with the upright beam of the cross.

At the feet of Christ, on the left of the picture, is the kneeling St. Dominic. His left arm extends around the back of the cross, the hand grasping the farther side just below the footrest, while his right hand is placed flat on the front. His face is tilted upward, to look at the face of Christ. His brows and narrowed eyes and compressed lips portray concentration and sorrow. Behind his head is a golden halo. Dominic wears the habit of his order. The black cloak is rendered in a deep blue, with lighter highlights. The saint's figure is portrayed as slightly below the viewer's line of vision. The background of the painting is a pure

azure. The earth below is represented as flat, bare ground in light tones of grey-brown. The horizon is at the level of Dominic's waist. From the ground rises a small mound representing the hill of Calvary. The cross is inserted into its flat top. Onto it rivulets of blood flow from the base of the cross. The shadows on the figures and the cross are consistent with a source of light shining diagonally from above and to the right.

What are we intended to see in this painting?

If we are Christians, on one level we understand quite spontaneously what Angelico is communicating to us. Similar paintings are probably familiar to most Christians, and indeed to most Westerners. But if we place ourselves for a moment outside that familiarity and try to explain—as we might, for example, to a non-Westerner seeing such a painting for the first time—we realize that our ability to understand the painting is based on presuppositions and habits that we bring to it. What we see visually is clear: St. Dominic at the foot of the crucified Jesus. But what does this mean to portray? Are we meant to "see" St. Dominic actually present at an event that had occurred centuries before his birth? What is the meaning of the crucifix itself, placed in physical space but without any historical or narrative context? What exactly is this a picture of?

We might think of the painting in different ways. Is it a portrayal of the crucifixion of Christ, to which St. Dominic has been mystically transported? This idea, strange to the modern mentality, was not at all unthinkable to the medieval mind. Christ on the cross was thought to have a foreknowledge and consciousness of all those for whom he was dying. In this sense, we were all "present" to Christ at the crucifixion Does Dominic in the picture represent something that was in Christ's mind as he hung on the cross?

Or, on the other hand, is this a representation of something going on rather in the mind of St. Dominic? Is Angelico portraying Dominic imagining the passion? Again, we know that medieval preachers and spiritual writers encouraged such practices.

Or is this a portrayal of the passion of Christ as a timeless spiritual event, to which Dominic and the artist and we are all "contemporary"? The doctrine of the eucharist as a sacrifice was understood to mean that the one sacrifice of Christ was made really present each time it was memorialized at the altar, and became the sacrifice of those who worshipped. Should we see the painting in a sacramental context?

Or does the fresco somehow include all these things?

Such questions themselves could be misleading, if they start from the presumption that the purpose of the picture is to represent what some thing or some event looked like. The naturalism of the forms in Angelico's painting might reinforce this presumption. Yet other elements clearly militate against it.

Most obvious, of course, is the presence of the supernatural gold halos, and, on the other hand, the lack of any natural setting—the abstraction of the dramatic scene from any historical context. Even the blue of the background—a precious color made of lapis lazuli, nearly as expensive as gold—is not the color we see in the sky; it evokes rather the "heavens." The spear wound indicates that Jesus on the cross is already dead; yet he seems to smile gently down at Dominic. His well-groomed hair and beard seem to belie the suffering indicated by the wounds. Christ's loincloth billows to the right—giving a visual balance to the figure of Dominic on the left—but nothing else in the painting is moved by wind. The hill of Calvary is painted as though it were a miniature mountain.

The perspective and the spatial relationships of the figures are plausible, particularly if we look at each section of the painting separately. But is there any point in physical space where a viewer of the scene could actually see it exactly this way, so that one would view, for example, both the expanse of the flat top of the miniature "hill" and the underside of the crossbeam? The ambiguity of the spatial perspective is seen especially in the placement of Dominic's body in relation to the cross. Our visual logic tells us that he is located in front of the cross and in front of the small hill that the cross is placed on. This is clear if we look at where the figure is kneeling on the ground. Yet the position of his hands, especially the right hand, which appears to be in the middle of his chest, would seem to place him rather to the side of the cross, or even behind it. Dominic is kneeling upright and straight. But in order to be in front of cross, and yet embrace it, would he not have to be inclined considerably away from the viewer? In short, if we look at parts of the painting individually, they are convincing and "realistic." If we look at the whole, the inconsistencies of detail in positioning are not immediately noticeable; again, the figures are convincing. But when we being to analyze the fresco spatially, problems arise. The scene is visually plausible; but is it visually possible?

This question arises when we examine the picture from the point of view of naturalistic perspective. But if we have any acquaintance with Western religious art, we know implicitly as soon as we look at the painting that Angelico's use of naturalism is within a context that is not naturalistic. The purpose of the painting is primarily iconic. It does not portray what one would see if one were at the scene; it does not even portray a real physical scene. Rather, it is intended to present a spiritual message, conveyed with the immediacy and emotional power of a physical encounter. The reality portrayed is the interaction between Dominic and Jesus. Angelico has produced a painted sermon and a painted prayer. The fresco is an evocation of presence, both of Christ and of Dominic.[5] It exhorts the viewer to achieve the same kind of relation that takes place between them, by means of recollection and meditation.

In technique, Angelico's painting belongs to the early Renaissance; but its theology and spirituality are still within the mental world of the middle ages. Angelico is far advanced beyond Giotto in the naturalism of his figures and perspective. But the way in which he uses the image to mediate spiritual reality is not essentially different. We can therefore see in Angelico a certain tension, between a naturalistic style of representation—the accurate depiction of physical appearances—and an "iconic" style, whose purpose is to communicate not appearances, but ideas. The former attempts to mediate a visual experience; the latter mediates a non-empirical experience of divine presence. We shall see that this tension—or, from another point of view, this coexistence of different styles and "paradigms"—is relevant not only to the art of the early Renaissance, but also, in a somewhat parallel way, to its thought, and in particular its theology.

Part 1—The Cross in Pre-Reformation Renaissance Theology

The Social Context: End of the Middle Ages

Intellectuals of the fourteenth century evidenced awareness of the novelty of their age in the language they used to speak of new tendencies in art (*ars moderna*), music (*ars nova*), literature (*dolce stil nuovo*), philosophy (*via moderna*), spirituality (*devotio moderna*), and even the newly arrived classes in society (*homines novi, gente nuova*). But from a twenty-first century perspective, all of this was a prelude to even more significant changes that were to come. The following century saw events and movements that radically altered European society, thought, and culture. The mention of only a few should remind us of their scope and influence: the beginnings of the Renaissance, including the rise of humanism (the Platonic Academy founded in Florence, 1440), with the recovery of classical models of art and literature and the discovery of new techniques in the arts; the rule of the Medici in Florence (beginning 1450); the introduction of movable print and then the printing press (Gutenberg's Bible, 1453), facilitating the diffusion of ideas and information; the fall of Constantinople to the Turks (1453) and emigration of Greek scholars and artists to the West; the end of the Hundred Years' War (1453), whose battles presaged the eclipse of the mounted knight's military superiority; the institution of the Spanish Inquisition (1481), taking the investigation of orthodoxy in Spain and its possessions out of the hands of the Pope and placing it in the power of the monarchs; Columbus's voyages to the Western hemisphere (1492) and Vasco da Gama's circumnavigation of Africa (1498), opening a sea route to the Orient—both initiating an enormous expansion of trade, colonization, and missionary activity.

It was an ambiguous period for the institutional church. The fifteenth century began with the Great Western Schism still raging; it ended with the infamous Roderigo Borgia (Alexander VI) on the papal throne. In 1415, the reformer Jan Hus was burned at the stake; a little more than a century later, the Protestant Reformation had begun. In the intervening period, both the secular and the spiritual authority of the Roman church were under constant attack. The medieval model of Christendom, centered theoretically on Pope and Emperor, was confronted with the rise of nation-states and of independent cities, with the increasing power of princes, and with the growing economic influence of the bourgeoisie. The credibility of the church was challenged from two sides. On one side, the classical pagan fonts of the renaissance and the growing mercantile economy fostered independence and secularity in life and thought. On the other side, the rebirth of Christian sources inspired reform movements that criticized empty speculation in theology, the lack of Christian values in society, and—most of all—immorality in church leaders and structures. None of the elements of tension in the church were new; the roots of renaissance and reform can be found already in medieval thinking. But their cumulative effect was increasing to a critical point at which radical changes would emerge.

Renaissance, Reform, and Retrieval

Not surprisingly, the early Renaissance was a period of ferment and tension in thought as well as in social life. However, the direction of Renaissance thinking was not entirely toward novelty. The period from about 1400 to the Protestant Reformation was also in many ways a time of retrieval and synthesis of the past. The words "renaissance" and "reform," which so largely describe the ideals of the period, imply as much: a re-birth, a re-formation.

For the early humanists, what was to be reborn was first of all the classical Latin language and the art of rhetoric, which had (in their view) been debased by the vulgarized speech and writing of the Middle Ages.[6] The recovery of classical texts included not only pagan authors, but also the Christian Scriptures and the Fathers of the Church. An idealized vision of the Christian past underlay many of the reforming movements. Similarly, the art of the early Renaissance, especially in its beginnings in Italy, was inspired above all by a recovery (or at least what was thought to be a recovery) of the aesthetic ideals of classical Roman and Greek civilization.

To a large extent then, the Renaissance was an attempt to return to more ancient traditions, in reaction against the still vigorous inheritance of the more recent past, which was seen as a period of decadence. Of course, the Middle Ages also had many conscious connections to antiquity. What was new in the

Renaissance spirit was a different attitude toward the classical heritage. As Erwin Panofsky puts it, the Middle Ages saw "an unsurmountable gap... between the Christian present and the pagan past," while the Italian Renaissance for the first time "reintegrated classical form with classical subject matter and there reinstated the emotional qualities of classical art."[7]

The proponents of the rebirth of classical cultural ideas defined their ideal over against scholastic language and thought, against the structures of the medieval church and society, and against the long-prevailing aesthetic forms for which Italian classicists now invented the deprecatory term "Gothic."[8] At the same time, the early Renaissance built upon movements and ideas already present in late medieval thought, which now found conditions for maturing and flourishing. The shift to new paradigms of thought and new styles of art was neither immediate nor complete; especially in religion and theology, there was a strong movement to retrieve and preserve and sometimes to advance and build upon the scholastic and spiritual heritage of the Middle Ages.

We shall see this tendency strongly present in the classic works that I have chosen to exemplify the late medieval theology of the passion in its theoretical and aesthetic forms; emphasizing more the former than the latter, for in Renaissance religious art conservatism of message is offset by novelty of technique. In this chapter, we will find relatively little new in the content of the theology of the passion. The period's burning questions (literally, in the case of "heretics" like Jan Hus and Savonarola) were ecclesiological, social, moral, and disciplinary. This is not to say that our subject, the passion of Christ, was neglected. On the contrary, it was a primary theme in doctrine, preaching, spirituality, and art. For many, the cross seems to have been the very center of Christianity. But the theology of the passion, its meaning and message, was generally taken as established. In doctrine and preaching, we find repetition and synthesis of classical Patristic and medieval theology. At the same time, we find an intellectual and aesthetic context (nominalism in theology, naturalism in the visual arts) that sets the stage for the more radical rethinking that would come about in the Reformation, both in expressing of what the Reformers would reject and in anticipating what they would affirm.

Theoretical Mediation

THE INHERITANCE OF SCHOLASTICISM AND LATE MEDIEVAL PIETY

The theology of the cross in the period immediately preceding the Reformation shows strong affinities with the scholasticism of the previous centuries. There

was a continuation and renewal of Thomism, particularly in the Dominican order. (Through the initiative of Juan de Torquemada, uncle of the notorious inquisitor, the works of St. Thomas were among the earliest books to be published though use of the newly invented printing press.) At the same time, the Franciscan tradition deriving from Bonaventure and Scotus remained strong. The "nominalism" of William of Ockham was arguably the philosophical tradition that had the most potent influence on the theology of the period. Scholarship also returned to Patristic sources, especially Augustine. In addition to the tradition of the theological "schools," therefore, we also find a certain degree of eclecticism.

The perceived disorders and corruption in the church and society made moral life an especially important theme, especially in preaching. Virtually all Christian theology has held that salvation includes a component of human response to God's saving acts in Christ. This aspect of soteriology was particularly strong in the late Middle Ages. In the period leading up to the Reformation, we find a continuation of this medieval emphasis on the cross as an example of virtue and a call to conversion. This is combined with the use of meditation on the passion to inculcate of a highly affective relationship with the suffering, crucified Lord.

A PREACHED THEOLOGY OF THE CROSS: VINCENT FERRER

An example of how the medieval theology of the cross was extended into preaching can be seen in the work of the famous Dominican missionary and preacher Vincent Ferrer (1350–1419). Most of the earlier part of his life was spent in academic and ecclesiastical/political circles. He taught both philosophy and theology, and was subsequently confessor to the queen of Aragon and then to the Avignon Pope Benedict XIII (Pedro de Luna), whom he had earlier served when the latter was papal legate to León. It was only in 1399 that Vincent (or Vicent in his native Valencian dialect) began the missionary work for which he is most famed. For the next twenty years, he worked as an itinerant preacher throughout Western Europe. An eloquent speaker, he centered his message on conversion and penance in preparation for the coming judgment. The Apocalypse was a favorite theme; like many others of his time, Vincent seems to have interpreted the perceived decay of morality in society and the church as a sign of an imminent apocalyptic crisis. He himself led a life of extreme austerity. Followed about by a vast throng of penitents, Vincent was credited with numerous healings and with the conversion of thousands of Jews and Muslims in Spain. (We may today wonder whether these conversions, which so impressed

Vicent's contemporaries, may have had other motivations besides the saint's eloquence; the state imposed severe penalties on those who persisted in their non-Christian beliefs.)

In one of his transcribed sermons, for All Saints Day, Ferrer gives an excellent example of the adaptation of the scholastic theology of redemption to practical moral preaching.[9] It is common teaching in theology, Ferrer says, that Christ could have redeemed and saved humanity in innumerable ways. Yet he chose the cross in order to save and redeem people who would respond with belief and obedience to him. St. Thomas gives seven reasons for this choice of the cross, the preacher notes. But Vincent chooses to expound on only one: it is reasonable that the act of satisfaction should fit the sin that was committed:[10]

> How did that offense against God come about that caused the total loss of the human race and all the evils that make us exiles in this vale of tears? Was it not by the theft of a certain apple [!], against God's express command? Indeed it was. Therefore the restitution, repair, or correction of the fault had to be made by the restoration of fruit to the tree. Thus Christ the redeemer of all is our fruit—as the Virgin is told, "blessed is the fruit of your womb"—and he chose the tree of the cross in order to restore a fruit of infinite value to the tree.[11]

Moreover, Vincent adds, ancient Greek history says that the wood of the cross was taken from the wood of Adam's tree. (This legend is not found among St. Thomas's reasons for the suitability of the cross, but it was prominent in medieval thought, and would be the subject of a famous fifteenth-century fresco series in Arezzo by Piero della Francesca.)

In the greater part of the sermon, Vincent then enumerates other ways in which Christ might have died, and explains the "moral" reasons why he did not choose them, drawing lessons for his hearers. St. Thomas very briefly poses and answers the question whether other means of death would have been more suitable for Christ; but Vincent's treatment is much more expansive. In some ways, it is reminiscent of the arguments of the early church writer Athanasius, who discusses in detail why the cross was more "appropriate" than any other means of death for Christ. However, Vincent provides for his hearers his own explanations, which depend on rather strained allegories and are particularly suited to his moral message.

Other modes of death for Christ would have been inappropriate. For example, why did Christ not allow himself to be killed as an infant by the sword of Herod's soldiers? The "literal" reason is that already given: because the act of satisfaction must correspond to the offense of stealing from a tree. But the "moral" reason is symbolic: the sword corresponds to the sword of Peter,

whose meaning is excommunication—cutting off from the church. Christ avoided this form of death to teach us to flee excommunication by Peter's successor. Why did he not permit himself to be thrown from the city hill by his scandalized countrymen? To teach us not to die by falling from the mount of pride.[12] Why did Christ not choose death by stoning? Because stone represents avarice. The avaricious person is hard and cold as stone: hard because he has no softness to debtors; cold because he lacks the fire of charity. Why not die by poison? Vincent notes that since Christ lived in poverty, and ate whatever he was given, this form of death at the hands of his enemies could easily have been arranged—and indeed, the attempt seems prophesied by Jeremiah (chapter 11). But there was a moral reason for Christ's choosing not to die this way: to teach us to avoid the poison of sensuality, which seems sweet, but is actually deadly.[13]

It was in order to instruct us symbolically or "morally" that Christ chose to die on the cross. "The other forms of death that Christ fled from signify the evil death that we must flee, and his death on the cross signifies the good death that we must choose. Each element in Christ's death has a moral lesson for us. The inexpressible pain of Christ on the cross signifies the contrition that we must have for our sins, bowing our heads in confession...." The piercing of his right hand signifies giving alms, while the piercing of the left symbolizes making restitution for usury and theft. Our feet are what hold us up or sustain us in traveling. Hence Christ's two nailed feet signify the food that sustains us: the right signifies spiritual communion, and the left physical food. The right is nailed by devotion, the left by abstinence. The opening of Christ's side with a lance teaches us to open our hearts to forgive injuries.[14]

Ferrer's sermon, with its strong moralizing use of the theology of the cross, might remind us of those medieval portrayals of the crucifixion in which Christ is nailed to the cross by personifications of the virtues. The cross is both the result of Jesus' own virtue and the prime example to us of virtue and love.

THE *VIA MODERNA* IN LATE SCHOLASTICISM: GABRIEL BIEL

One of the most influential thinkers of the fifteenth century was theologian and preacher Gabriel Biel (ca. 1414?–1495), sometimes described as "the last of the scholastics."[15] Biel's theology had a great impact on both the Reformation and the Counter-Reformation. In his Scholasticism, in many ways he epitomized the theology that Luther would reject.[16] But in his nominalism, he embodied many of the presuppositions of Luther's thinking. He was a member of the Brethren of the Common Life, a community that embodied the spirituality of the *devotio moderna*. (The most famous work of the movement, the *Imitation of*

Christ by Thomas à Kempis, a member of the Brethren, was published between 1414 and 1425, about the presumed time of Biel's birth. Luther in his early life studied at a school run by the Brethren.)

Biel is somewhat eclectic in his choice of authorities. He frequently cites Thomas Aquinas in his sermons, while he generally favors Scotist positions in his academic works. But the overriding factor in Biel's thinking is his adherence to the *via moderna* (the "modern method") of the Franciscan William of Ockham, a philosophical school often called "nominalism."

Without going into a detailed treatment of the issues involved in Ockham's philosophy, we may summarize a few general characteristics of Ockhamism or nominalism as a school of thought. The followers of Ockham strongly emphasized the limits of human reason when applied to anything beyond the empirical world. This did not mean religious agnosticism, however. The Ockhamists appealed to faith and to God's positive revelation as sure sources of knowledge. They showed a preference for affective piety based on the Scriptures and on religious experience, rather than on reasoning.

Perhaps most significant for theology was the Ockhamist penchant toward voluntarism, in contrast to the "intellectualism" of Aquinas. In this context, "voluntarism" refers to the conviction that the intelligibility or order in the actual world is not an ultimate metaphysical reality, but is dependent on the "will" of God; that is, on God's free choice of what the order of the universe should be.[17] Absolutely speaking, God can do anything whatsoever, as long as it does not imply self-contradiction. This is God's *potentia absoluta* (absolute power). But in fact, God has decided to operate in the world in a particular way. This concretizing is called God's *potentia ordinata* (ordered or conditioned power).

A consequence of Ockhamist voluntarism is that theology cannot seek for necessary reasons. It can only point to the "congruence" or "suitability" of what God has actually done and revealed. (As we shall see, this point is important in the consideration of the classical question of why Christ died on the cross.) Since Ockhamism denies any necessary ontological structure in God's dealing with the world, revelation is understood primarily as the conveying of factual information about God's concrete will and ordering of things. Since positive revelation is the only source of such knowledge, this implies a certain "positivism" in faith: "faith by necessity must become a reliance on some form of authority, ecclesiastical, biblical or otherwise."[18] Correspondingly, Christ is understood above all as revealer or teacher, a preacher in his deeds as well as his words (*predicator in factis et verbis*).[19]

Another consequence is an emphasis on fulfilling the conditions that God has actually set for salvation. Absolutely speaking, God could accept and justify a person who was without love, without grace, and without merit. But in the

actual world, all of these are required for salvation, because God has so willed it. Absolutely speaking, God's mercy is infinite and unconditioned. But in the actual world, God has freely decided to reward good human acts, performed within a state of grace, with eternal life (that is, to accept them as "meritorious") and to reject those who lack this merit. Hence, one cannot be saved without God's grace, which is essentially a matter of God's acceptance; neither can one be saved only by grace (sola gratia), without personal merit.[20] Since a person can never know whether he or she is in a "state of grace" and has fulfilled the requirements of God's concrete will, there is a strong motivation for constant striving (including recourse to the sacrament of penance). At the same time, there is also cause for anxiety. Indeed, for Biel the tension between love and fear of God is necessary: our lack of security is itself a sign of our being on the right way to God.[21]

A final significant feature of Ockhamism is the conviction that human beings are able, by their natural powers, to make the first steps toward salvation through good actions that God then rewards with grace. This idea is expressed in the axiom *facienti quod in se est Deus non denegat gratiam*: "God does not withhold grace from one who does what one is able to do." The Ockhamists held that human reason and freedom were not eradicated by the Fall. Hence, even in the state of "nature" we are able to do good, and even to love God above all things. God responds to such good natural acts with the infusion of grace as a "suitable" reward. Then one does one's best *with* the aid of grace, and God rewards this collaboration with eternal life, as its just due.[22] The Ockhamists did not think that this position was Pelagian (i.e., a denial of the priority of grace), since the entire order of salvation, including God's decision to reward good natural acts with grace, is in no way necessary, but is the consequence of God's free choice.

In consequence of these positions, as Heiko Oberman observes, we find in Biel an "extraordinary emphasis" on humanity's part in achieving salvation.[23] This emphasis is evident in Biel's treatment of the meaning of the cross.

BIEL'S THEOLOGY OF THE CROSS. We find a concise summary of Biel's theology of redemption in his commentary on the *Sentences* of Peter Lombard. Biel generally follows the teachings of Scotus, but not uncritically. He cites other thinkers as well, and sometimes prefers them. He uses the Anselmian language of "satisfaction" and "payment" for humanity's sin. With this he incorporates the scholastic notion of Christ's "merit." He is also clear in affirming the "elevating" aspect of redemption.

First, God's initiative is clearly stated: it is the entire Trinity that is the "redeemer" of humanity, "because the entire Trinity accepted the price paid,

that is the satisfying passion, because of which it forgave sin, not demanding its penalty (*non imputando ad poenam*), and conferred grace, ordaining [humanity] to glory, and thus restored humanity to liberty." In a secondary sense, it is Christ who is redeemer, in his human nature, which suffered and paid the price, "since he made satisfaction by suffering."[24]

Biel's Ockhamist context is seen most clearly in his discussion of the question of whether the passion was necessary as the means to our salvation. The solution to this question, Biel says, is given by St. Anselm in his "*Cur Deus Homo.*" He summarizes Anselm's argument in four steps:

(1) God destined humanity for beatitude; it is necessary for God to "repair" fallen humanity, lest God's work be frustrated.

(2) Humanity could not be redeemed without satisfaction for the sin of the fall, because that sin "stole" God's honor, and made humanity a debtor. Humanity remains in guilt until satisfaction is given. If God's mercy forgave sin without satisfaction, sin would be unpunished; and this would be unfitting (*indecens*) and disordered (*inordinatum*). The only way of restoring order without satisfaction would be punishment of sin.

(3) Satisfaction could only be accomplished by a human who is God (*hominem Deum*). Satisfaction must restore something of more value than the whole of creation, since humanity should not have sinned even for all creation.[25] This "something" could be nothing other than God. But, on the other hand, none owed the debt except humanity. Thus it is necessary that satisfaction be made by one who is both God and human—God incarnate (*Deus homo*).

(4) It was right that satisfaction be made through suffering and death, since one who has sinned through pleasure (*suavitas*) should make satisfaction through pain (*asperitas*). Hence the sacrifice of Christ's most holy life through death, which he freely underwent for the Father's glory, most sufficiently satisfied for the sins of all.

We may prescind for the moment from the question of the accuracy of Biel's understanding and exposition of Anselm's argument and its context. It is his thorough critique of it that most reveals his Ockhamist way of thinking. Although Biel praises Anselm, he rejects the fundamental purpose of his project, namely to show that the incarnation and the cross were necessary. (This purpose, we recall, flows from Anselm's apologetic intent: he wishes to reply to the objection that an incarnation of God is unreasonable, and that for God to demand the suffering of an innocent person on behalf of others is unjust and cruel. These criticisms can be met, Anselm thinks, only if it can be shown that both incarnation and cross are somehow necessary.)[26]

Biel accepts Anselm's arguments as being both devout and clear (*apparentes*). However, they prove nothing unless from the outset one presupposes

that God wills the concrete order of the world. Anselm's reasoning deduces a certain necessity of what happened, but not the necessity of its happening. That is, these events necessarily follow if, and only if, God wishes and ordains this to be the means of salvation. "God pre-ordained that humanity should be redeemed this way; therefore this is the way humanity was redeemed." But Anselm's arguments do not prove the necessity of either redemption itself, or of the means of redemption. Only something whose opposite is contradictory is strictly necessary; and this is not true of God's redeeming humanity.

First, it was not necessary that humanity be redeemed at all, just as it was not necessary for humanity to be created. The argument that God's work should not be frustrated does not hold, according to Biel. After all, one could say that God ordains every individual rational creature to beatitude; and if it does not attain that end, one could say that God's will is frustrated. But this is true only of God's "antecedent" will, according to which God wills the creature's salvation, and gives it the means of salvation. However, God also knows beforehand that some creatures will not accept these means and will not be saved. And God's concrete or "consequent" will, God's actual will of choice (beneplacitum), chooses and creates exactly this situation of free acceptance or rejection. Hence God's actual will is not frustrated if individuals are not saved; neither would it be frustrated if God chose that no humans at all be redeemed.

Furthermore, God could forgive humanity simply by the nonimputation of sin. Sin does not remove anything real from God, nor is the divine honor in itself lessened. There is in fact nothing to be restored to God. Therefore it is not right to say that the sinner remains guilty until satisfaction is made; rather, the sinner is guilty until God remits the satisfaction due. And if God remitted sins without satisfaction being made, there would be no disorder in universe. There would be "disorder" only if something occurred against God's concrete will of choice (voluntas Dei beneplaciti), for only the will of God determines what "order" or "right" is. So nothing can be disordered, just as nothing can exist, against God's concrete will. The sinner is ordained to punishment because it pleased God to order the world this way. But God could establish a different world order.

Moreover, even if penal satisfaction were demanded by God's will, there would be no need for the incarnation; nor is it true that satisfaction could be made only by the debtor. Biel points out that Christ, although human, was sinless. Therefore he was not in debt to God because of sin. So even in Anselm's schema, Biel argues, payment is not made by the debtor. Moreover, God could have accepted reparation on humanity's behalf from an angel, or from some pure human being. Nor does Biel accept Anselm's objection that such a being would then be worshipped as divine by other humans; the redeemer would

simply be God's agent, like the saints and the Virgin Mary in the actual order of salvation.

This means that in the realm of pure possibilities (de possibili) a human being could make satisfaction to God for him or herself, if that person were first given God's unmerited grace.[27] Biel points out (as Abelard had before him) that this is in fact the case with Christ's humanity, which received the grace of the incarnation without prior merit, either of its own or acquired by another.

Furthermore, it is not true that God's justice could only be satisfied by the offering of something more valuable than all creation. Humanity would merely have to offer something more pleasing to God than sin was displeasing (as Aquinas had said): namely, the love of God for God's self. If it so pleased God, such an act of love could be accepted as "satisfaction." Yet such a love for God would not be something greater than all creation. The human love of Christ for God, which in fact did merit our salvation, was not greater than all creation, since it was itself a creature and was the act of a creature, namely the humanity of Christ.

Nor was infinite suffering needed as punishment for sin. The delight (suavitas) of sin was finite, and could therefore be balanced by finite punishment. (Biel therefore does not accept—indeed, does not even consider—Anselm's principle that the offensiveness of sin is measured by the greatness of the one sinned against, in this case the infinite God.) Adam preferred his own will to God's commandment; a sufficient satisfaction, in the realm of possibility, would be found simply in the mortification of human will by its subjection to God's will.

Hence it is clear, Biel says, that the reasoning of St. Anselm holds only insofar as God has from all eternity willed that the fall of humanity should be repaired in this particular way. But this decision of God's was not necessary; it was merely contingent. It depends on the free will of God, which can do whatever it wishes.

Thus the redemption of humanity was not necessary, nor was the particular means of redemption. However, Biel holds that the actual means of redemption chosen by God, that is, the passion of God's Son, was the most fitting (congruentissimus) of all means by which humanity could be redeemed. This is "proved" from the fact that this means was foreseen and preordained by the infinite wisdom of the Trinity, out of superabundant love for humanity. Biel quotes Eph. 2 in support of this ("God . . . because of the superabundant love with which God loved us . . . gave us life in Christ . . ."). God therefore chose that means which would be best and most fitting for humanity. Biel refers the reader to the reasons given by other theologians like Aquinas, Bonaventure, Alexander of Hales, et al.

Biel then considers how Christ did in fact redeem us through his passion and death. He follows the teaching of Scotus: for our sake Christ freely offered his soul in sacrifice, to the honor of the Father, for the sake of justice. The Father accepted this sacrifice as satisfaction for the sins of all. Biel continues with Scotus's exposition of the concrete earthly circumstances and human motives for Christ's death. There must be such human reasons, for the divine plan works in and through human freedom. Christ saw the evil behavior of "the Jews,"—in particular, their distortion of God's law. He knew that the truth must be spoken to them, even at the cost of his life, and "he preferred death to silence." And in fact, by speaking to them of their sinfulness, he incurred their mortal hatred and finally underwent death. "For our sake Christ freely willed his acceptance of death for the sake of justice and obedience to the Father, so that the Trinity might accept his obedience, suffering, and voluntary death in satisfaction for the sins of all who believe in him and obey God's law, and thus the Trinity might be honored and praised by humanity both on earth and perpetually in beatitude."[28] And therefore God was more pleased with Christ's good action and his sacrifice than God was displeased by the evil of all humanity. (This last sentence reflects Aquinas's notion of "satisfaction.")

Although this means of redemption was not the only one possible, it was the most fitting, and the one that makes us most obliged to God. Of course, even if God had chosen for us to be redeemed by a pure creature, our obligation of gratitude would be to God above all, since redemption consists above all in the *acceptance* of a work as meritorious for the salvation of all; and this acceptance can only come from God. However, we are all the more bound to God in the actual order of salvation, in which the incarnate God performs the work of satisfaction itself. Moreover, even presupposing the incarnation, Christ could have redeemed us by another way. But God chose this penal mode of redemption for our sake, because it would better inspire us to produce the fruits of redemption.

God's love for us is shown most clearly not only in that the Father in no way spares the Son, but also in that the Son most strongly draws us to the love of himself. The manifestation of the divine love is the most significant point for Biel. For without a responding love on our part, the act of redemption would not benefit us at all. But nothing could more effectively lead us to this love than our being loved first.[29] Agreeing with Peter Lombard that Christ merited salvation for us through suffering and death in order to be "an example of virtue and the cause of glory,"[30] Biel most strongly emphasizes that the passion is the most effective way to evoke a response of love in us.

This point is also made forcefully in Biel's commentary on the Canon of the Mass. Christ could have saved us without dying, but he loves us more by

accepting our wounds. Biel quotes Gregory the Great (*Moralia,* section 108): "The Mediator between God and humanity could have rescued us even without dying; but he wished to come to the aid of humanity by dying, because he would have loved us less unless he also accepted our wounds." He also gives a quote that he attributes to St. Bernard: "A single drop of the most precious blood of Christ would have sufficed for the redemption of the whole world, but an abundance was given, so that the power of the lover should be manifest in the overflowing of his goodness to us."

"And this manifestation of the divine love," Biel continues, "was truly necessary for us, so that by it we should be inflamed with love for God. For the Lord decreed that no one should attain beatitude except by clinging in love to Christ our redeemer . . . No other means could so effectively entice and enflame our will to the love of God than the manifestation of such great prior love from God, undebited to any merit on our part."[31] The "necessity" of the cross, then, stems not from anything inherent in God's nature or justice, but from our need to be converted to love of Christ. But for Biel this need itself is the result of God's eternal decree, rather than something that is intrinsic to the nature of salvation (as it was for St. Thomas).

It is notable that Biel continually speaks of satisfaction for the sins of *all* humans, not merely for the "original" sin stemming from Adam. And most significant is the stress he places on the need for a human response to redemption. Interestingly, Biel insists that even in the actual order of salvation, by his obedient love for the Father Christ merited from the instant of his conception—and throughout his life—the same thing he merited by the passion. Indeed, Biel places a great deal of emphasis on Christ's life, especially the institution of the sacraments and the giving of the new law.

However, Biel also says that the passion was the "principal" reason for the conferral of grace,[32] and he frequently speaks as though the passion alone was the cause of salvation. There seem to be several possible reasons for this. First, the incarnation took place for the sake of the passion. Significantly, Biel rejects the "supralapsarian" (*supra* = before; *lapsus* = fall) position of Scotus, which gives priority to the incarnation in God's "plan." (Scotus's position holds that even before the fall of humanity God intended the incarnation, and permitted the fall precisely in light of this intention. Biel can see no basis for this position, and thinks moreover that it takes away the reason for the passion.)[33] In becoming human, the Son already wills the passion preordained by the Trinity. And Biel sees Christ's entire life as being associated with his suffering, from the confinement in the narrowness of the womb, through childhood poverty, to adult labors, persecution, temptations, hunger, etc.[34] Finally, Biel

teaches that the cross merits *the same thing* that was merited by the incarnation and by Christ's entire life.

We might be inclined to think that this last point makes the passion superfluous, since salvation was "already" merited. But Biel's purpose is the opposite: namely, to stress the unique importance of the passion as a motive for the love of God. He points out that the same thing can be merited on different grounds. Hence even though what the passion merits was also merited by Christ's entire life of obedience, his suffering and death give a new reason for that merit. Moreover, time does not enter into the matter; there is no before and after the meriting, since acceptance of anything as meritorious is a free and eternal decree of God.[35]

Most importantly, for Biel the suffering of the passion was needed not merely to satisfy "superabundantly" for sin, but also to give us an example to imitate, and to effectively evoke our response to God's mercy. Our responsive love for God is stimulated through the psychological impact of this dramatic manifestation of God's prior love for us. This is the crucial point for Biel: for without this response, and the merit we gain by it, we would not actually be saved.[36] "Unless our merit is joined to it, [Christ's merit] will be insufficient, indeed, will be nothing [for us]."[37] In this sense, one could say that we, having received God's grace, must then "merit" the same salvation "already" won for us by Christ.[38]

Biel's emphasis on human collaboration is seen also in his treatment of Mary. He takes a maximal view of Mary's place in salvation, stating that it is "probable" that after her initial reception of grace, God accepted her good acts as meriting the incarnation itself.[39] Mary is also the prime example of the success of what the cross was intended to accomplish, namely to excite us to the love of God. Her "compassion" with Christ as she stood at the foot of the cross "cooperated" with the act of redemption, making her the not only the mother of the redeemer, but the mother of redemption itself (*redemptionis mater*), as Christ is father of redemption.[40] She is the "minister" and "dispenser" of the fruits of Christ's sacrifice.[41] Although Biel's Mariology is by no means the most extreme of his era, we can clearly see in it the late medieval tendency to see Christ as the just judge, and Mary as our intercessor with him, the "mediatrix to the mediator," as Biel himself puts it.[42]

A PREACHED AND APPLIED THEOLOGY OF THE CROSS:
GIROLAMO SAVONAROLA

A similar emphasis on the passion as the means of inspiring us to a saving love of God, but in a more strictly Thomistic context, is found in the theology and preaching of the Dominican reformer Fra Girolamo Savonarola.

Born in 1452, Savonarola studied the works of Aquinas and Aristotle at Ferrara, joining the Order of Preachers in 1475. Favored by the Medici family, he was brought to Florence, and in 1482 was assigned to the same convent of San Marco that had been decorated some forty years earlier by Fra Angelico. Scandalized by the state of society and especially by the corruption of the church, he soon began preaching the need for reform. Starting in 1492, his preaching took an apocalyptic turn. He subsequently proclaimed that the invasion of Italy by the French King Charles VIII (1494) was the cleansing judgment of God that he had prophesied. With the expulsion of his former patrons the Medici, Savonarola became Florence's effective leader, and set up a "Christian and religious Republic." Under his influence, public morality was strictly enforced: sodomy was made a capital crime, taverns were shut, gambling was prohibited.

In 1497 on the Tuesday before Ash Wednesday, the traditional day of pre-Lenten "carnival" celebrations, Savonarola and his followers orchestrated the event for which he is probably most remembered: the "Bonfire of Vanities" (rogo delle vanità). The event was repeated on the same occasion the next year. It should be noted that this kind of penitential spectacle was not Savonarola's invention, although he is so often associated with it. The two great Franciscan preachers of the early fifteenth century, Bernard of Siena and John of Capistrano, regularly ended their preaching tours (the first in Italy, the second in Germany) by inviting the people to throw their "vain" articles into a great fire. A Bonfire of Vanities was in fact "the concluding act of the theatrically dramatized popular missions of the Franciscan wandering preachers."[43]

Savonarola's bonfires, however, had the added force of being associated with his quasi-theocratic government in Florence. The flames in the Piazza della Signoria consumed piles of pagan books, mirrors, finery, and worldly pictures. There is a legend—perhaps apocryphal—that the painter Botticelli (Alessandro Filipepi), convinced by Savonarola's preaching, threw in some of his own paintings.[44]

We should note that Savonarola's spirituality was not necessarily at odds with the thought of the neo-Platonic philosophers who strongly influenced the ideals of the Florentine Renaissance. Indeed, the two most influential "humanist" figures, Marsilio Ficino (1433–1499) and his student Giovanni Pico della Mirandola (1463–1494) were both influenced by Savonarola and were on good terms with him. (He delivered the oration at Pico's funeral.) Although they aspired to a rebirth of the classics, placed humanity at the center of the universe, preached the importance of love and beauty, and often used ancient mythology in an allegorical sense, their humanism by no means implied a return to paganism. On the contrary, they explicitly took Christ as the supreme

example of humanity, and they were essentially pious in religion and frequently ascetical in outlook. They severely castigate lower forms of love (*l'amore volgare*)[45] and corporeal attachments. Pico della Mirandola's writings contain strong statements about the need for self-denial and appropriation of the cross[46] that are reminiscent of Savonarola's preaching.

Not surprisingly, however, Savonarola's puritanical policies did alienate a large portion of the populace, while his calls for reform in the church and his political positions incurred the enmity of the Pope, the worldly Alexander VI (Roderigo Borgia). A revolt in Florence in 1497 placed Savonarola in prison, where he wrote several meditations on the psalms. He was excommunicated by the pope in the same year, and hanged and burned in 1498.

Savonarola considered that the center of his preaching was nothing other than Christ crucified.[47] In several of his writings he expounds his theology and spirituality of the cross. Although his purpose is preaching and meditation, rather than academic study, his considerations are highly theological. Savonarola based his writings—exclusively, according to his own testimony—on the Scriptures and the Fathers and Doctors of the Church. He depends theologically especially on St. Thomas Aquinas, whom he calls, "my venerable and most beloved master."[48] The significance of Savonarola's understanding of redemption, therefore, is not any novelty of theoretical content, but rather its emphases and moral conclusions. Above all, Savonarola the apocalyptic preacher and moral reformer stresses the need for Christians to act in such a way as to appropriate for themselves the salvation won for them by Christ. Hence he concentrates on the need to respond to Christ's love by taking up the cross in one's life.

In a short apologetic work entitled *On the Truth of the Christian Faith Concerning the Glorious Triumph of the Cross of Christ*, Savonarola expounds his understanding of the theology of the cross in the context of an attempt to explain its "reasonability."[49]

He begins by inviting the reader to imagine a triumphal processional chariot with four wheels, representing the four parts of the world. (The comparison of the cross to a trophy at a Roman triumph predates the Middle Ages; but Savonarola's description of the chariot and procession is particularly reminiscent of early Renaissance pictures. Botticelli, who later illustrated Savonarola's work, was just at this period working on drawings for the *Divine Comedy* in which he shows chariots for the triumph of the Church and for Beatrice. But there is no need to speculate about whether the monk saw these particular drawings. He could easily have seen one of the many similar paintings or tapestries inspired by Petrarch's "Triumph of Love.") On the chariot rides Christ, crowned with thorns and wounded all over. Above is a three-sided light, representing the Trinity. At Christ's left is the cross and all

the other instruments of the passion; on his right, the Scriptures of the Old and New Testaments. At his feet are the chalice and host of the eucharist, as well as other vessels of oil and chrism and other signs of the sacraments of the church. A step below Christ is Mary, surrounded by gold and silver jeweled vessels, full of ashes and bones. Before the chariot march the Apostles, prophets, and preachers; all around it are the martyrs. The enemies of the cross of Christ lie prostrate.

This image represents the fact that the passion and cross of Christ are the first cause of all grace and salvation. Savonarola draws a parallel to the Aristotelian schema of causality. For the "philosophers," he says, the ineffable God, the Unmoved Mover, first moves the *primum mobile*, the outermost sphere of the cosmos, which in turn is the cause of the motion of the lower spheres. Similarly, for the Christian the passion and cross of Christ are the first created cause of grace and salvation: they in turn cause the sacraments, which are the proximate means.[50]

In explaining how the passion of Christ operates our redemption, Savonarola adopts the idea of "satisfaction" for original sin. Although this schema was adumbrated by Augustine and classically stated by St. Anselm, Savonarola's treatment is most highly influenced by scholastic theology, especially that of St. Thomas. (He explicitly notes that he prefers the "reasons" for the manner of our redemption given by St. Thomas in the third part of the *Summa* to those given by Augustine in his book on the Trinity.)[51]

Like most Western theology, Savonarola considers the cross first of all in the Augustinian-inspired context of reparation of the sin of humanity's first parents. This sin is "not unreasonably" communicated to all humans; not as personal guilt, but as a lack of the original justice with which humanity was created. Because of this, our lower faculties are not properly subjected to reason. The communication of Adam's sin to us, that is, to our "nature," is reasonable because humanity is a single body, of which he is the head and we the members.

It is notable that Savonarola holds that this privation of original justice in us would not be called "sin" if it were not for its connection with the "bad will" of Adam, because there can be no sin where there is not a disordered will. Were it not for this connection, Savonarola opines that humanity would be born in a "purely natural" state (*in puri naturali*), and would be able to attain a "proportionate" and purely natural beatitude. Indeed, Savonarola holds that such a state of natural beatitude ("limbo") is the fate of those who die in the state of original sin (i.e., without baptism), but without personal sin.[52]

Moreover, God's grace was operative in the world from the beginning, providing remedies for original sin: first, faith and sacrifices; then circumci-

sion; finally baptism. Through these remedies humans were sanctified and made capable (*habili*) of supernatural beatitude.[53] One might object: then why were the Patriarchs of the Old Testament kept in limbo until the coming of Christ? They died in grace, purged of original sin; why did they not enter into glory at death? Savonarola answers that original sin affects all human nature; since it was this sin that closed the door of Paradise, it was necessary that satisfaction be made for it before the door be opened, even for those who died in grace.[54] For Savonarola it is not repugnant to reason that original sin should have an infinite number of subjects, since he holds (contrary to Biel) that the sin was in some sense (*quodam[m]odo*) infinite. Thus no creature could make satisfaction for all of human nature: "for every creature is finite, and scarcely can make satisfaction for itself for all the benefits it has received from God."[55]

But if God is good and loving, should not God in benevolence accept whatever humanity can offer in satisfaction, even if it is inadequate? Could not God simply freely forgive the debt? Savonarola replies that if no other remedy were possible, then God in infinite goodness would accept even humanity's inadequate satisfaction. But another means is possible, through which God can redeem humanity while at the same time preserving the divine justice, which leaves no fault unpunished. And God chose this way, not only in order to satisfy for sin, but also to show God's great mercy by bringing human nature to a new stage of perfection. No creature could make satisfaction for original sin, but only God, who was not a debtor to sin. Yet humanity must make satisfaction. Therefore "the most merciful and wise and powerful God finds a marvelous way: that is, that God should become human, so that satisfaction is made by one who can and who must make it." Thus we see the suitability (*convenientia*) of the incarnation.

Savonarola wishes to stress above all that the motivation for both the incarnation and the cross is the love of God. But the moral message is two-sided: humanity must respond to this love, or face God's punishment. God entered entirely into human nature "to embrace it and totally draw it to [God's] love. And God's mercy appeared even more clearly to the world, when [God] willed to be crucified for love of us. And no less appeared God's justice, in desiring to be satisfied completely for original sin. And from this, sinners, if they wish to repent, can have sure hope in God's mercy. But if they do not repent, they must tremble before such justice."[56]

But Christ came not only to make satisfaction on behalf of human nature; he also came to give an example of life and of justice. For that reason it was suitable that he chose a most bitter and disgraceful death: to give humans an example of faithfulness to truth and justice in face of any disgrace or martyr-

dom. And above all he chose this death on the cross to give to those who love him a most wonderful illumination and joy—"which only those who experience them can know"—at this demonstration of his love.[57] Our reaction to this proof of love must be a corresponding love of God and neighbor.[58]

It follows, as Savonarola says in a number of contexts, that meditation on the cross is crucial for the spiritual life of the Christian; it should be our spiritual food, night and day.[59] Moreover, we should take great joy in contemplating Christ crucified. Following Aquinas's Aristotelian theory of knowledge, Savonarola states that here on earth we know the invisible through the visible, and all our knowledge is mediated by sensible images. But "there one can find no visible thing more conducive to the knowledge and love of invisible and divine things than the contemplation of Christ crucified... because there is nothing else that more demonstrates the goodness of God and God's inestimable love (carità) toward us."[60] Being loved brings delight; therefore meditation on the cross, which shows such great love, is delightful above all else.

In 1492 Savonarola published "The Passion of Our Lord," along with the small work "The Love of Jesus Christ," to aid Christians in such meditation. Most of what Savonarola writes is a repetition of the standard content of the genre, punctuated with his own comments and exhortations. Christ's passion was without parallel because all his senses were affected, external and internal. He suffered especially from his consciousness of the sins of humanity, "which dishonored his Father and led to the perdition of an infinite number of souls."[61] (Note the notion of an offense against God's "honor," an important element in Anselm's "satisfaction" schema.) He was saddened by the malice of the leaders, and compassionate for the ignorance of the common people. (Here Savonarola follows Aquinas, who assigns blame for the passion to the leaders rather than to the Jewish people as a whole. Nevertheless, a certain degree of anti-Semitism seems to form part of Savonarola's context. For example, although the gospels attribute the crowning with thorns, beating, and scourging to the Roman soldiers of the praetorium, Savonarola says that "the cruel Jews ... crowned him [Jesus] with a cruel crown," and he exclaims, in words that could easily be taken by his contemporaries to apply beyond the event of the crucifixion: "O impious Jews, O cruel synagogue, will you never have enough of wounding my sweet spouse?")[62]

Christ's physical suffering was all the greater because of his human perfection. Savonarola sees this in terms of his being "noble" and "delicate" and (perhaps his most frequently used adjective) "sweet" (dolce). "The sweet and good Jesus was of noble constitution, tender and delicate and very sensitive ... therefore even the smallest wound was painful to him."[63] His hands were

"beautiful" and "delicate," and Savonarola wonders at the condescension of their washing the feet of the fishermen disciples.[64]

But it is typical of the tenor of Savonarola's approach that he stresses above all Christ's emotional suffering, which also stemmed from the "nobility" and sensitivity of his character. Thus he was especially sensitive to the shame of being stripped nude before all the people. Savonarola makes repeated references to Christ's love for his followers, especially for Mary: "Above all these afflictions, what caused him most sorrow was the pity and compassion he felt for those devout women who followed him with great sadness; and beyond all other pains he was interiorly afflicted by the tears and the sighs and the great suffering (*passione*) of his sweet Mother, whom he loved most tenderly."[65]

It is to the emotions of the reader also that Savonarola appeals. The suffering of Christ was a purposeful sign of his love; and we should respond in kind. "Now think of what great suffering he bore, amidst so many wounds, for love of you." Jesus wished to suffer as much as possible, in order to show his love all the more and thus inspire our love in return: "Jesus opened up his entire sensibility to suffering, and did not wish it to be lessened at all . . . on the contrary, he voluntarily increased it, because, having taken on this passion by his own will, he also willed to suffer it grievously in order to satisfy God most abundantly for the sake of humankind . . . O inestimable love! Jesus could make satisfaction with a single drop of his blood, but in order to show his great love and to incite his creature to love him, he wished to undergo a most bitter passion . . . in order to move your hard heart to love him."[66]

Savonarola rhetorically asks Jesus, "Why do you not demonstrate your power?" and imagines the answer: "Because I desire your salvation more than my life. You, soul, are the one who has wounded me. You, soul, are the one who scourged me. You are the one who has wounded me all over."[67] In light of such love, Savonarola asks himself (and, indirectly, the reader): "Why, then, do you not burn with love for him? Why do you not suffer every tribulation [with him]? Why are you so cold? . . . O my hard heart, why do you not break? My eyes, why do you not weep? Why do you not become two fountains of tears? . . . Weep over him, weep out of compassion, weep out of pity."[68] "O pitiless spouse, made of iron; o cruel one, why do you not bear this passion always in your memory . . . it is your hardness that makes him suffer, your hardness causes his death."[69]

In line with the tradition of imaginative prayer, Savonarola considers himself present at the event of the passion, and able to participate in it. Examples are found in his breviary, annotated with comments to himself and with notes for preaching. At a passage recounting Christ's mounting the cross, he writes to himself: "Go then, soul, to console him."[70] And in his published contemplation on the passion: "Run, soul, run quickly and wash the holy body with your tears,

wash those cruel wounds, embrace him and carry him, for he can no longer hold himself up because of his great pain."[71] "O hard heart, become compassionate (*pietoso*); weep, sigh, lament greatly and sighing embrace your suffering Jesus."[72] He addresses the executioners: "O pitiless dogs, are you not moved by the compassion (*pietà*) of that holy face?"[73]

He frequently speaks to Jesus directly: "Who would not be moved to compassion? Who would not be moved to love You? Who would not wish to die for love of You?"[74] "I beg you, Jesus, give me that cross, let me carry it." "Your Father leaves you in such straits in order to free my soul from eternal damnation. Your Father has no mercy on you now, in order to lead the sinner back to salvation."[75] "O sweet Jesus, why do I not die with you today?... Who will grant me to be crucified with you?"[76] "Wounded by love of you, make me weep every hour."[77] "What arrow, what bow tightly drawn, what sword, ever so sharp, could ever twist and penetrate a solid diamond? But you, Jesus, have broken the stones, you have pierced the pure diamonds. You, Jesus, have warmed the ice, you have broken our hard hearts. You, Jesus, have entered into our cold minds. You have made us all in love with your infinite love, so much that I would wish to die for love of you."[78]

Such sentiments, typical of Savonarola's spirituality of the cross, are also found repeatedly in his poetry and hymns. A single example may suffice: his poem "Praise to the Crucified":[79]

Laude al crocifisso
Iesú, sommo conforto,
 Tu se' tutto il mio amore,
 Il mio beato porto
 E santo redentore.
 O gran bontà,
 Dolce pietà,
 Felice quel che teco unito sta!

Iesú, fammi morire
 Del tuo amor vivace;
 Iesú, fammi languire
 Con te, Signor verace.
 O gran bontà, ec.

O Croce, fammi loco
 E le mie membra prendi,
 Che del suo santo foco

Praise to the Crucifix
Jesus, greatest comfort
 You are my only love
 My blessed harbor
 And holy redeemer.
 O great goodness,
 Sweet compassion,
 Happy the one united with you!

Jesus, make me die
 From your living love;
 Jesus, make me languish
 With you, true Lord.
 O great goodness, etc.

O Cross, make place for me
 And take my limbs,
 So that my heart and soul

Il cor e l'alma accendi.	May burn with his holy flame.
O gran bontà, ec.	O great goodness, etc.

Infiamma il mio cor tanto,	Inflame my heart so greatly
Del tuo amor divino,	With your divine love,
Si ch'arda dentro tanto	That it burns within so much
Che paia un serafino.	That it seems a Seraph angel.
O gran bontà, ec.	O great goodness, etc.

La Croce e 'l Crocifisso	May the Cross and the Crucified
Sia nel mio cor scolpito,	Be inscribed in my heart,
Et io sia sempre affisso	And may I always be fixed
In gloria ove egli è ito.	On glory, where he has gone.
O gran bontà, ec.	O great goodness, etc.

Savonarola exercises his imagination and emotions above all in his treatment of the sufferings of Mary at the cross. She serves as a model for the sentiments the Christian should feel on viewing the passion: "The sorrowing Virgin heard every blow [of the hammers nailing Christ to the cross], and weeping profusely, said: 'O cruel minister, why do you not nail the mother along with her sweet son? Why, my son, sweet Jesus, am I not crucified with you? Why are my hands not placed on top of yours?'"[80] "Weep, weep my soul, along with the mother of your Redeemer. Bear her company at the cross . . . Look at the son, look at the mother, and consider whether you have ever seen such a cruel spectacle."[81]

Mary is not only a model, but also an object of compassionate devotion, along with Christ: "O sweetest Virgin and Mother Mary, who could express your great sorrow? . . . O Mary, you were spiritually pierced by those nails. . . ."[82] Like Jesus, Mary must suffer to the utmost. Just as for our sake the Father does not have mercy on Jesus,[83] so neither do Jesus and Mary spare each other: "The Son does not comfort the mother in such calamity, nor the mother the son. Jesus is the bitterness of Mary, and Mary the pain of Jesus. O cruel, O pitiless, O hard look of one upon the other, because together they cause each other sorrow where they should console each other."[84] Savonarola imagines Mary addressing Jesus on the cross:

O my Son, you pray for your enemies, and you give a happy reply
to a thief, and to me, your mother, you do not speak; you do not reply
to me; to me, you give no consolation. Perhaps your enemies and
a thief are in your mind in such sorrow, and not your so beloved
Mary. O my soul, what sorrow do you think there was in the heart

of Mary, when she saw her son praying for those dogs, and give such hope to the thief, and not say a word to her?. . . Perhaps, while looking at her with pity, in his heart he said: "O my mother, your sorrow and your tears afflict me more than my wounds."[85]

And Savonarola addresses Mary as he addresses Jesus: "I, I am the reason for the passion of your son, and yours . . . O beautiful virgin, I pray you, grant me part of your bitter sorrow. . . ."[86]

Several elements of Savonarola's treatments of the passion are worthy of note. Except for the fact of suffering, the humanity of Jesus seems entirely eclipsed by his divinity. Savonarola not only takes for granted Christ's consciousness of his divine identity, but also projects a consciousness of it onto others. He imagines Peter at the Last Supper refusing to have his feet washed, saying to Jesus: "Lord, you are God, you are the Creator of the world, you are the eternal Word, you are the splendor of paradise, you are the glory of the angels, you are the image of the Father's substance, you are the font of all wisdom on high—do you wish to wash my feet, I who am a mortal man . . .?"[87]

For Savonarola, Christ also fully aware of his sacrificial mission and conscious of all those for whom he suffers. He not only voluntarily undertakes his passion, but is entirely in control throughout. Thus, with the freedom of imagination that was practiced and recommended by medieval spiritual writers, the monk introduces elements that are not in the gospel accounts, but that follow from his Christology. He writes, speaking of the moment of Christ's arrival at Calvary:

> I think, my soul, that he asked for time to pray, and it was granted to him, because the ministers of Satan could do nothing except what he allowed them. So he turned to his beloved Father, saying: . . . You commanded me to suffer this passion for love of human nature, and I have been obedient to you, and again here I present to you the sacrifice of my body. Receive it, my Father, in an odor of sweetness for the salvation of the world. After such and similar words, I think he extended himself on the cross.[88]

Contrary to accounts that have Jesus forcefully thrown onto the cross and wrenched into position, Savonarola imagines him placing himself in readiness for the crucifixion. This is his voluntary act for the sake of winning souls. When Jesus cries out, "I thirst," Savonarola explains, "he did not so much experience physical thirst as a thirst for souls."[89] The passion of Jesus is undertaken in satisfaction for original sin; but *our* sins are the primary cause of his suffering.

Moreover, it is not only our sins that afflict Jesus, but our lack of response to the passion itself, for its prime purpose is precisely to excite love in us.

Insofar as that purpose is achieved, the cross becomes a symbol of triumph. But it is a triumph *of* the cross, not *over* the cross. The victory of Christ consists in his drawing us to similar self-mortification. Savonarola designed and published an image of the cross, "for quick and easy understanding" of its meaning, and encouraged devout people to carry the cross either in their hands or on their bodies, as well as in their hearts.

In these images the emphasis is not on the theology of redemption, which is presumed, but rather on the "ascetical theology" of the cross, that is, the way in which Christians must act to appropriate the salvation won by Christ. Savonarola accompanies the images with an itinerary of psalms and prayers to be said while contemplating the cross, and gives a brief explanation of the meaning of his images:

> Because the foundation of Christian life is faith, which, when formed
> by charity, purges the intellect from error and the affects from
> self-love, at the foot of the face of the cross we have placed *faith*, and
> above it *purity*.
>
> And since the *Virgin Mary* was of greater purity than all the other
> saints, we have placed her as representative of the entire Church,
> to signify that we must strive to grow continually in purity of heart,
> like the Saints, members of the Church, and above all like the
> Virgin Mary, in order to come to the perfection of love.
>
> And because our Savior in the midst of the Church is in the
> midst of our hearts, and awakens and perfects this love, we have
> placed his *Name* in the midst of the name of the Virgin Mary, and *love*
> at the summit of the cross.
>
> And because we must walk rightly in good times and in bad—
> that is, in good times must be humble, and in bad times be enduring
> (*pazienti*), we have placed on the arms of the cross: humility and
> endurance (*pazienza*). And we have placed *humility* on the left and
> *endurance* on the right, so that you understand that when you have
> worldly success, then you should retreat in your soul to the left
> of Christ and his Saints: that is, think about the sufferings they
> bore in this life and humbly desire to suffer their adversities than to
> experience the prosperity of this world. And when adversity strikes
> you, go to his right: that is, to the contemplation of eternal things
> promised to those who endure.

The Standard of the Cross

Hail, holy Cross
hail, glory of the
world

Love

O adorable Cross
I shall make you alive
in myself

Humility

JESUS

Purity

Mary
Virgin and Mother
of God

Purity

Faith

Our true hope,
bringing true joys,
Sign of salvation
savior from dangers,
living wood
bearing the life of all.

Redeemed by you,
sweet adornment of the world,
we shall always praise you
and sing to you,
having been enslaved by a
tree,
by you we are set free.

FIGURE 1.2. Girolamo Savonarola, *The Standard of the Cross*. Obverse.

The Standard of the Cross
(reverse)

To God the Father

be glory

in the Cross of the Son

Death

Behold the Cross

of the Lord

Flee, evil ones

Indignities

JESUS

Wounds

Human
and
Divine

May equal praise be

given to the Holy Spirit

May the exaltation of

the cross bring joy to the

angels on high and

honor to the world

Poverty

The Lion of the tribe of Judah

has conquered,

the root of David,

to open the Book

and loosen its seven seals

Hope

FIGURE 1.3. Girolamo Savonarola, *The Standard of the Cross*. Reverse.

Next turn to the other side of the Cross, and you will find at the bottom written: *hope*. Because you must hope above all to be saved when you suffer evil while doing good: that is, *poverty* against material goods; *indignities* against fame; *wounds* against bodily comforts; and finally *death* against the present life. Christ suffered all these things along with all his members; therefore in the middle of these four adversities is Christ, with the Virgin, signified by his name JESUS. She, as I have said, represents the Church and all the Saints who by the power and merits of Christ have overcome all tribulations, and through which they have entered eternal life.[90]

As we have seen, Savonarola holds that the primary reason for the cross as the means of salvation is that it shows both God's mercy and justice: it is on the one hand an invitation to reply with love to the inestimable love of Christ, and on the other a warning of the consequences of failing to do so. Savonarola points out that Jesus himself says that anyone who does not obey his words will be condemned (John 12:48), and that anyone who does not love him will not keep his words (John 14:24). Savonarola takes these verses as the premises of a syllogism, and concludes that anyone who does not love Jesus will be damned.[91]

The love of Jesus, for Savonarola, is not merely the remedy to original and personal sin. As we have seen, Savonarola envisions the possibility of humans living in a state of "pure nature." But salvation in Christ is not merely such a restoration of our "nature" to a guiltless state. Savonarola teaches that the life of charity, entered through grace, is an elevation of humanity to a new level of being. Following St. Thomas closely, he understands this new state as a capacity to know God directly and intimately: ultimately, the ability to have and enjoy the "vision" of God. Since God is infinite, and the creature finite, no creature could be proportionate to the vision of the light of God's being, unless God elevated the creature by some other supernatural light; and that elevating light is grace, from which love necessarily follows.[92]

Savonarola is therefore clear in teaching the necessity of grace, because life in Christ is in fact above our "natural" capacities. At the same time, he strongly stresses the personal moral and ascetical effort that the individual must make, especially through prayer and works of piety. It is certainly exaggerated to say that Savonarola wanted to make all Florence into a convent, as his opponents charged. In his writings and preaching, he is explicitly conscious of his audiences' different states of life. Nevertheless, it is clear that Savonarola the monk considers that for the individual, religious life is the more perfect response to God's love; and even his idea of lay spirituality presupposes a certain rejection

of the world. If someone wants, with the help of God, to "acquire" (*aquistare*) the love of Jesus, he should first raise his affects totally from earthly things.[93] But for perfect love, this is not enough. One must also, if possible, leave behind all things of the world and "poor and naked, follow Jesus Christ."[94] One should flee human society, "because the spouse of our souls is shy, and does not wish to embrace the bride—that is, our soul—in the presence of others."[95]

The doctrine of grace teaches that the goal of our lives has been elevated to something beyond our natural happiness. From this follows the need to get rid not only of sin, but also to withdraw from of all the "vanities" of the world that might distract us from our true goal, and to accept suffering, as Christ did, with obedient patience (*patientia*). Similarly, because they are the concrete means of grace, the church and its sacraments and its ministers must be pure. Hence Savonarola's vehemence in denouncing the corruptions in the church and the clergy and the strength of his calls for reform. The same need for purification applies to Christian society, which should reflect Christian values and embody, and indeed enforce, Christian morality.

SALIENT CHARACTERISTICS OF PRE-REFORMATION SCHOLASTICISM

As we have seen, the period immediately preceding the Reformation saw the coexistence of theology that continued the "old way" (*via antiqua*)—primarily the tradition of Aquinas, Bonaventure, and Scotus—and that followed the "modern way" (*via moderna*) of Ockhamism. We can note certain theoretical differences in the theology of redemption that flows from each. One example is found in their respective receptions of the "satisfaction" theory classically expressed by St. Anselm.

Anselm could speak of the debt created by Adam's sin as being owed by all humanity because, like Augustine and "Platonic" theology in general, he presumed some kind of metaphysical unity of "human nature." Since God's word takes on that human nature in the incarnation, Christ can legitimately pay the debt, even though he is personally sinless and is not liable to the inheritance of original sin.[96] Savonarola, in accord with the "old way," accepts this unity of "nature." Biel denies it; for the Ockhamist, only individuals really exist, not "natures."

In his critique of Anselm's theory, Biel contends that the sin of humanity took nothing from God, and that therefore there was nothing that needed to be restored. Anselm agrees that God can lose nothing. Although he speaks of Adam's sin as "taking" God's honor, he explains that this is only a manner of speaking of the offense. In fact, God's honor and God's beatitude cannot be affected. Nevertheless, for Anselm there is something to be "restored," namely,

the proper human relationship to our Creator. The "satisfaction" of God's honor and justice is not for God's sake, but for humanity's. The crucial point of difference between Anselm and Biel is that the former holds that our relationship to God could not be changed without a radical change *in us*. (St. Thomas would expand this idea into the notion of grace as an "entitative habit.") For the Ockhamist, this is not the case. God could theoretically "remit sin" simply by an act of forgiveness—an amnesty, so to speak—without operating any intrinsic change in the sinner, but merely taking away the punishment for sin.

Anselm of course also considers the possibility of forgiveness without satisfaction. But he rejects it, because such a solution would be contrary to God's justice. Without satisfaction, something would be lacking to the beauty and order of the world. God is not held to any extrinsic standard of conduct, but God must be true to God's nature.

This is also the crucial point of difference between the Ockhamists and the earlier scholastics, especially the Thomists. By placing salvation within the context of the theoretical concept of "grace," the latter have already moved away from a notion of strict necessity of a "payment" to God. God could, and does, remit sin by the infusion of grace. But the crucial issue recurs: is this grace a new way of being, a change in us, or is it simply the fact of being accepted by God in a new way? Does the life of supernatural charity make our being more "like" the very being of God or does it simply mean that we obey the rules, including the supreme rule of charity, that God has set for this world?

Behind such issues of course is a more fundamental epistemological question. In knowing ourselves and our world, can we know something about God? For the Thomists, our ideas of justice, goodness, beauty, love, etc., correspond to what God *is*. For the Ockhamist, they correspond to a free decision on God's part about the laws of this created world. What is at issue, then, is the question: to what extent is creation a reflection of or participation in God's being? When we speak of being, goodness, beauty, etc., are we speaking of attributes of God's nature that are shared by God's creation, especially by humanity as God's "image and likeness," or are we speaking merely of qualities and acts that God has willed to be the rules of this world? Behind this question, in turn, is the more basic one about the validity and extension of general concepts themselves.

Nevertheless, in the end the difference between the two theologies with regard to Christ's passion is less than might seem to follow from their philosophical divergences. Despite some fundamental differences on the reliability of human reason and on its relationship to faith, theologians of the *via moderna* and the *via antiqua* were united in their conviction that the inspired Scriptures provide us with a sure source of knowledge about God and our relation to God in

the actual world. Both emphasize that the most important reason for the cross is to inspire us to love and meritorious action. For Biel, conversion to the love of God is in fact central, although, ironically, it is only so because of a decree of God that wills it to be so. Biel, as we have seen, denies any *necessary* connection between us and the "debt" of Adam, between the humanity of Christ and that debt, between Christ's merit and us, or between grace and eternal life. Nevertheless, he affirms all these links on the basis of God's concrete will. Precisely because this means of salvation is not necessary, the adoption of the cross as the means of salvation is all the more a sign of God's love. Savonarola, although he accepts the idea of a unity of humanity with Adam, thinks that the loving God would damn no one simply on the basis of original sin alone. Hence it is logical that the passion of Christ be understood primarily in terms of reparation for *our* sins. Moreover, concretely salvation means grace, which is not merely forgiveness of sin, but the creation in us of a supernatural way of being. If no one is saved without active and super-natural love of God above all things, it is logical that the passion be understood above all as the example of that love. Hence it is the moral and affective meaning of the cross that is primary.

Although their theoretical reasons differ, both ways of thinking stress above all the need for human collaboration in salvation. Both Biel and Savonarola emphasize the need for humans to collaborate with Christ's salvific act: to merit for themselves what Christ merited for us, by means of total love of Christ. Although they hold clearly that God's love for us is prior, they also hold that it is in some way possible and necessary to "acquire" a responsive love for God. Both stress the institution of the sacraments of the church as the concrete means of salvation, and especially emphasize the sacrament of penance as a means for overcoming sin and living the life of following Christ. Both encourage an affective stance toward the crucified as the means of attaining a psychological state of gratitude and love. Both give an important place to Mary as the prime example to us of sharing in Christ's passion by the virtue of willingness to suffer (*patientia*).

Part 2—The Aesthetic Mediation: The Cross in the Arts of the Early Renaissance

The Rebirth of Art

It is obvious that in speaking of the art of the early Renaissance, we are necessarily generalizing and at the same time speaking selectively. The Renaissance, beginning in Italy, progressed differently and at a different pace in the various parts of Europe. Even within Italy, as Arnold Hauser says, "the artistic

culture of the Quattrocento is already so complicated, and so many different hereditary and educational levels of society participate in it, that it is impossible to form any completely uniform and universally valid conception of its nature."[97]

Moreover, as we have already pointed out in our introduction, the shift between paradigms of thought is neither complete nor universal. We often find hybrid forms of, inconsistencies in, and the coexistence of different paradigms at once. The same is true of styles in art. "In an economically so differentiated and culturally complex society as that of the Renaissance, a stylistic tendency does not disappear from one day to the next.... Different classes of society and different artists dependent on these classes, different generations of art-consumers and art-producers, young and old, harbingers and stragglers, live side by side in every more highly developed culture...."[98] Hence there can be no absolutely strict demarcation between the early Renaissance and the late Middle Ages. Fra Angelico, for example, exemplifies elements of both Gothic and Renaissance styles in painting. Yet there are certain characteristics in his art that can be seen, in historical perspective, as signaling a different way of viewing and portraying the world.

If we look at the treatises on art and specifically on painting that appeared in the fifteenth century, we find an acute awareness that something revolutionary was happening in art. The very existence of such documents is telling: artists suddenly emerge not only as persons of culture, but as philosophers of art who discourse on its nature and especially on its new ideals and methods.

Certainly, there had been a few artistic "superstars" prior to the Renaissance: the sculptor Gislebertus, the painter Cimabue, and above all Giotto. But in general artists were considered simply skilled craftsmen plying a trade like the others in the guild they belonged to (which might be that of masons, goldsmiths, painters, or even apothecaries). Indeed, it is possible that the young painter Guido di Pietro, our Fra Angelico, joined the reformed Observant branch of the Dominicans precisely so that he could remain a painter and also be ordained a priest. This was not possible among the conventual Dominicans; they still considered painting a manual labor, and entrusted it to the non-ordained brothers (*conversi*) of the order.

Now, however, artists begin to assert and to receive both personal recognition and stature in society. Leonardo da Vinci claims for painting the status of a "science" (*scientia*), and calls the painter a natural philosopher (or, as we would say, a scientist). The painter's "science," for him, is by no means a mere knowledge of mechanics, but is the practice of a "liberal" or spiritual art (*contra* the university curriculum of the Middle Ages, which considered music a liberal art, but painting a "servile" activity).[99] According to Leonardo, painters are in

fact superior to poets and musicians, who had long enjoyed high cultural status.[100] Erasmus of Rotterdam, the paradigm of humanists, also proposed that painting be regarded as a liberal art. Albrecht Dürer says that the aspiring painter should read and write well, and know Latin.[101] Leon Battista Alberti goes farther: he recommends that the painter, in order to accomplish his task, should be well-schooled in literature (dotto in buone lettere), and should be knowledgeable not only in geometry, but in all the liberal arts.[102] The young Michelangelo, as though to exemplify the ideal, frequented the Platonic philosophical circles at the Medici court, and throughout his life produced very competent poetry in addition to his sculptures and paintings. Obviously, Leonardo and Michelangelo were exceptional, and the claims of Alberti or Leonardo for the artist are ideals that may contain a certain amount of wishful thinking; in any case they reflect the special situation of artists in Italy. Many fifteenth-century artists remained simply trained craftsmen within the structure of the guilds. But a new status for the artist and for art were in the making.

The humanist artists of the period ascribe the new status of art to the discovery (or, according to some, the recovery) of techniques, to the "genius" of the new generation of artists, and, perhaps most importantly, to a renaissance of classical ideals. The last involved at least two aspects: artists first received ideas and inspiration from the recovery of ancient literature about art, then eventually began to imitate recently recovered classical art works themselves. In sculpture, in particular, one can easily see a genuine rebirth of classical form, going beyond the naturalism that had already begun to take hold in the late Gothic period. But Renaissance painting also profited from technical discoveries—the conscious application of geometry to problems of perspective, for example, and the perfection of the technique of oil painting—that made this form of Quattrocento art something new. In both sculpture and painting, however, perhaps the most significant re-birth was that of the classical idea of art as the imitation of nature.

THE NEW AESTHETIC CONTEXT: NATURALISM

Renaissance artists sometimes seem to presume that the imitation of nature is the obvious goal of pictorial art, and that their predecessors were simply not knowledgeable or talented enough to accomplish it.[103] At other times, they seem aware that the imitation of nature is in fact a new ideal for art—or rather, a renewal of an ancient ideal, one that was lost in what they considered the darkness of the "Gothic" (i.e., barbaric) and "Greek" (Byzantine) periods.[104]

In any case, we find in the treatises on painting many statements about the importance of following nature. Significantly, what Quattrocento painters mean by the word "nature" is the empirical world and its principles of organization. This represents the beginnings of a shift from the abstract scholastic concept of "nature" as opposed to "grace" or the "supernatural," as the word is used in theological considerations about "human nature," for example. At the same time, as we shall see, in the Renaissance aesthetic context, "nature" is still a normative concept designating an ideal, not merely phenomena as they are observed. The notion of "nature" in the modern empirical sense ("nature" as the entire nontechnological empirical world) derives from an abbreviation of the classical phrase *rerum natura*, "the nature of things." This could of course simply mean "the way things are." But in the Renaissance use of the term *"natura"* there is still implied the presupposition that things have a "nature" in the sense of an intrinsic essence or "form" in the philosophical sense, an intelligibility or meaning that is more than their mere appearance.[105] As Erwin Panofsky remarks, "The Renaissance...established and unanimously accepted what seem to be the most obvious, and actually is the most problematic dogma of aesthetic theory: the dogma that the work of art is the direct and faithful representation of a natural object."[106] This conviction was in turn based on two problematic assumptions: 1) a concept of "nature" based on an epistemological "realism" about what the eye sees; and 2) a conviction that graphic art can portray it with objective and "scientific" accuracy.

Ghiberti says that he strove to imitate nature and to investigate the way nature functions in art.[107] Alberti takes it as axiomatic that painting attempts to represent what is seen. A picture, according to him, is a "window through which we look out into a section of the visible world,"[108] and he recommends that the painter should "follow nature" in order to correctly present what we see.[109] Leonardo writes that painting is the sole imitator of all the visible works of nature. Visible things are the children of nature, and painting, which renders them, is nature's grandchild, and is thus a relative of God.[110] The use of the technique of linear perspective is especially emphasized as a newly discovered (or perhaps rediscovered) means of portraying nature as it appears.[111]

This is not to say, however, that painting was considered simply a mechanical reproduction of things. On the contrary, there is a particular emphasis on the need for *ingenio*, talent or genius, in the artist. (Indeed, it is from the Renaissance that we can date the beginnings of the modern cult of the artist as a separate and special kind of person.)[112] The imitation of nature for Renaissance artists by no means implies a simply factual realism. It means rather finding in "nature" the principles of beauty and proportion, as well as the principles of human vision. Moreover, the painter represents not merely things, but

also ideas and states of mind. As Leonardo says, "The good painter has two principal things to paint: the human person and the forms that the mind conceives (*il concetto della mente sua*).[113]

Alberti writes concerning the portrayal of the human body—the epitome of nature's work— that the painter "should not only render each part accurately, but should add beauty, since in painting beauty is both pleasing and required."[114] The ancient painter Demetrius, he warns, failed to achieve the highest praise precisely because he was more concerned with making things look as they appeared (*di fare cose assimigliate al naturale*) than with making them beautiful.[115]

According to Alberti, the artist must seek from nature the principles of grace and beauty, must seek out the "form" of things, and must exercise skill in composition both to produce a pleasing effect and to convey meaning.[116] In this sense, most painters of the early Renaissance, although using naturalistic forms and perspective, are still painting things as known by the mind or as seen individually, rather than reproducing the *Gestalt* of the act of vision itself. Each thing has clear, sharp boundaries, and each can equally be an object for the viewer's eye; it is composition rather than visual quality that draws our attention to the main focus of the picture. (In the course of the fifteenth century, especially under the influence of Jan van Eyck and Leonardo, Renaissance painters would increasingly account for the effect of distance by the use of *sfumatura* ["smokiness," a lack of distinctness in outline] and by diminution of the intensity of color. But even then there is still no "peripheral" vision. Each single object in the painting is looked at directly.)

What is "natural" for early Renaissance art theory is not merely what we receive in our subjective optical impressions, but objects in their proper proportions.[117] That the painter is meant to portray "the thing itself" rather than merely our perception of it is implied by Alberti's statement that the artist should construct bodies "from within:" "just as in clothing a person, one first draws the nude, then puts clothing on it, likewise in depicting the nude, we first place its bones and muscles, then we cover them with flesh in such a way that it is not difficult to discern where each muscle lies under it."[118] Hence "nature" is still in some sense an objective and normative notion.

The influential Florentine philosopher Marsilio Ficino gives a more explicitly neo-Platonic philosophical explanation of the artist's task. Things in the world are images of the forms or ideas in the divine mind; the artist, in providing images of natural things, is not merely recording sensible experiences, but is expressing his own soul's capacity to grasp the intelligible reflections of God in things. Thus art, on a created level, reflects the creative workings of the divine mind.[119]

Michelangelo in particular was influenced by such ideas. He understands the *concetto* or "idea" of the work of art in terms of Platonic "form," mediated to matter by the artist's mind. He writes in one of his poems:

Non ha l'ottimo artista alcun concetto	The best artist has no Idea
c'un marmo solo in sé non circonscriva	That a marble block within itself does not contain
col suo superchio, e solo a quello arriva	With its surface, and to it arrives only
la man che ubbidisce all'intelletto.	The hand that obeys the intellect.[120]

Art is no mere mechanical operation, no mere operation of the "hand." Only by following the artist's intellect, the image of God, can artistic skill, the "hand," expose in matter the "idea" or "form" that corresponds to a beauty that reflects and leads to God.

THE NEW AESTHETIC CONTEXT: SECULARITY

Throughout the Middle Ages, the primary patron of the arts was the church. The Renaissance began a significant shift. The increased wealth and power of secular rulers, cities, and merchants provided another clientele for both religious art and, more importantly, for art that was used for decoration and for enjoyment. The creation of art for its own sake, that is, for the sake of beauty and pleasure, conformed with the pre-Christian classical views of art that were becoming influential, and was compatible as well with the Christian philosophical view of the high scholastics. It also contributed to the new status and prestige of the artist. Hence we see in the fifteenth century, in addition to sacred art, an abundance of art with nonreligious themes. In painting, there was a great development of portraiture, a means of celebrating the wealth and position of the patron. In the north in particular, artists devoted a good deal of attention to careful detailed renderings of plants and animals. (Dürer's meticulous and lifelike drawing of a hare is perhaps the most well-known example.) In both painting and sculpture, mythological scenes and figures, based on ancient models or on their ideals, became common.

The representation of pagan myth can be seen as playing an intermediary role in the process of the secularization of art. For centuries Christian artists had used the now harmless pagan gods and heroes in allegorical and symbolic ways, especially in connection with astrology. (The visitor to the Borgia apartments in the Vatican, painted between 1492 and 1494, might be surprised to find in its decorative paintings not only subjects from the Old and New Tes-

tament and the lives of the saints, but also the myth of Isis and Osiris, along with other allegorical representations, including the pope himself sitting under the figure of Apollo the sun god.) The great change from the medieval artistic representation of the mythological figures is that now classical form is added to the classical subject matter.[121] In this respect, there was perhaps a thin line between the representation of moral lessons in allegorical mythological form and the representation of classical subjects for their own aesthetic value. In particular, the pagan myths provided ample opportunity for the portrayal of the nude figure, which, of course, could be explained in a Christian Platonic context as the microcosm of the beauty of the world and as the image of God. On the other hand, the renaissance of classical form and subjects could also be taken to express quite a different standard of beauty, what Panofsky calls the classical "animalistic conception of human nature," in which "beauty was the poise and strength of a perfect animal."[122] At least in the minds of some, the tension between the pagan and the Christian world could not and should not be overcome.

CONFORMITY AND TENSION WITH THE GOALS OF SACRED ART

How did the new forms of art fare when confronted with religious values? How far could they serve the purposed of sacred art? How were the classicism and the new secularity in art to be evaluated from a religious perspective?

The standard theological explanation of the purposes of images had changed little since the Middle Ages. A sermon by the Dominican Fra Michele da Carcano, given in 1492, expands on the three reasons for the use of images that were expressed by William Durand in the thirteenth century:[123]

> *First*, on account of the ignorance of simple people, so that those who are not able to read the scriptures can yet learn by seeing the sacraments of our salvation and faith in pictures.... *Second*, images were introduced on account of our emotional sluggishness; so that men who are not aroused to devotion when they hear about the histories of the Saints may at least be moved when they see them, as if actually present, in pictures. For our feelings are aroused by things seen more than by things heard. *Third*, they were introduced on account of our unreliable memories ... Images were introduced because many people cannot retain in their memories what they hear, but they do remember if they see images.[124]

Religious images were to narrate a message, arouse feelings of devotion, and help one to retain the story or message in one's memory. Saint Antoninus

(Antonino Pierozzi), Fra Angelico's prior, who later became bishop of Florence, writes in his *Summa Moralis* that images should be used to make the eyes into "the gate of Jerusalem, through which Jesus enters."[125] Images were considered an extension of the mental imagining that was an integral part of the method of mental prayer. A typical example is found in a fifteenth-century handbook called the *Zardino de Oration* (*Garden of Prayer*). It speaks specifically of need to represent the Passion internally in one's mental prayer:

> The better to impress the story of the Passion on your mind, and to memorize each action of it more easily, it is helpful and necessary to fix the places and people in your mind: a city, for example, which will be the city of Jerusalem—taking for this purpose a city that is well known to you... And then too, you must shape in your mind some people, people well known to you, to represent for you the people involved in the Passion—the person of Jesus Himself, of the Virgin, Saint Peter, Saint John the Evangelist, Saint Mary Magdalene, Anne [Annas], Caiaphas, Pilate, Judas and the others, every one of whom you will fashion in your mind.[126]

If a goal of sacred art is to excite the imagination and emotions by concrete vision of a scene, it could be argued that naturalistic representation is an advantage. Alberti comments that "a narrative will move the mind (*l'animo*) when the persons painted there show their own state of mind. This is from nature, which above all is attracted to what is similar to itself, so that we weep with those who weep, and laugh with those who laugh, and mourn with those who mourn. But these movements of the mind are known through the movements of the body."[127] It follows that art which more accurately portrays the bodily features that show emotion will all the more move the beholder.

It is probably in line with such ideas that Dürer expresses the pious thought that painting is a "godly" art, "employed for holy edification," as well as being "rich in joys in itself."[128] But the last phrase reminds us that art is also an end in itself. In the Italian Renaissance view (although not in Dürer's) it should always seek to be beautiful and pleasing. Even religious art need not simply serve sacred purposes, but can also have other goals. Ghiberti, discussing his famous doors for the Baptistry of Florence cathedral, says that he was given permission to execute them as he saw fit, "in whatever way I believed would result in the greatest perfection, the most ornamentation, and the greatest richness... I strove to imitate nature as closely as I could, and with all the perspective I could produce, [to have] excellent compositions rich with many figures."[129]

Yet "secular" values like richness of design, beauty, ornamentation, etc., even in sacred art, need not detract from its religious value. *A fortiori* there is no

need for the condemnation of art when it turns to the pursuit of nature or of beauty or of skill outside the religious sphere. As Alain Besançon points out, the secularization of the arts was in continuity with classical scholastic theology.[130] Thomas and Bonaventure had implicitly proclaimed beauty to be a transcendental, that is, an attribute of all being whatsoever. In their various ways, all things are icons, reflecting—at different levels, of course, and to different degrees—the beauty and goodness of God. Renaissance neo-Platonism reinforced such ideas. Moreover, St. Thomas saw art not merely as edifying, but also as a means of enjoyment, a legitimate form of recreation and play.[131]

In theory, then, neither the new naturalism nor the increase of secularity in the arts need necessarily have been opposed to the Christian spirit. Obviously there were many who took this positive view, including ecclesiastical patrons of the arts. But there were others who thought that these tendencies posed a danger. Saint Antoninus, the friend of Fra Angelico who became bishop of Florence, speaks of three faults of painters: to ignore heretical implications in their paintings; to use apocryphal subjects; and "to paint curiosities into the stories of the Saints and in churches, things that do not serve to arouse devotion but laughter and vain thoughts—monkeys, and dogs chasing hares and so on, or gratuitously elaborate costumes—this I think unnecessary and vain."[132]

Savonarola, living in the same cradle of the Italian Renaissance, was acutely sensitive on the issue of "vanity." He explicitly wished to extend his reformation to art. He wanted to do away with "worldly" paintings altogether, as being luxuries and distracting "vanities." In sacred art, he espoused a style in which it was the sacred subject matter, and not the art itself, that was the focus of attention. We have noted already the tension between the different goals of sacred art. Citing an extreme instance, Arnold Hauser mentions "the episode reported from the Renaissance of a believer refusing to kiss a crucifix handed to him on his deathbed because it was ugly and asking for a more beautiful one."[133]

This story, if not entirely apocryphal, surely points to an unusual case. But it underscores a genuine problem for sacred art. The service of beauty in art may conflict with the religious value of self-sacrifice, that is, with precisely what is symbolized by the cross.

Savonarola's solution to this problem was a rejection of precisely the aesthetic values that inspired artists like Alberti, and a return to a simpler style. He complained of Madonnas painted like courtesans and of "vanities" in the churches.[134] He disapproved of the paganism and sensuality of mythological painting, despite the pretense of allegory. As we shall see, concerns like those of Antoninus and Savonarola about the conflict of sacred subject matter and the new aesthetics come into play even in the portrayal of the passion of Christ.

The Crucifixion in Renaissance Sculpture and Painting

Before considering the specifics and the varieties in the sculpting and paint-ing of the crucifix in the pre-Reformation period, we should make a few general remarks about the Renaissance stress on Christ's suffering and death.[135]

In continuity with the spirituality of the previous century, sacred art in general shows an increasing emphasis on Christ's sufferings and attempts to evoke pity and compassion. A number of new artistic themes become common: for example, the dead Christ on the lap of Mary (the *pietà*), Christ awaiting death, etc. Several reasons may be cited for such developments. The poetry of the fifteenth century (François Villon, for example) witnesses to a general preoccupation with death. The plague that had ravaged Europe in the previous century still broke out sporadically; as we have seen, the movement of flagel-lants was still active, and we can see the "*Danse Macabre*" painted in several churches and cemeteries. The apocalypticism we have seen in Vincent Ferrer and Savonarola was another manifestation of this phenomenon.

Another reason for the preoccupation with Christ's suffering was the more widespread diffusion of devotional literature, especially after the invention of the printing press. In addition to sermons, two important works of the four-teenth century were widely read in the fifteenth: the *Meditations* of Pseudo-Bonaventure, and the spiritual exercises of Tauler, both of which stress com-passion with the suffering Jesus. Similarly, the fourteenth-century revelations of St. Brigid of Sweden, which contain vivid descriptions of Christ's passion, were often cited by mystics of the fifteenth. From the early Middle Ages, certain prophetic texts, especially from Isaiah 53 ("he had no comeliness in him; he was the most despised of men; he was as a leper," etc.) were taken as literal descriptions of the passion of Jesus. With the printing of bibles, these were increasingly taken as the point of departure for meditations and sermons. Above all, the mystery plays influenced the portrayal of the crucifixion in art. The artist was inclined to present Christ's death with the same realism that people were used to seeing in theatrical presentations, and the new techniques in art provided the means for doing so.

Many early Renaissance crucifixes exemplify the preoccupation with the suffering and ugliness of Christ's death. At the same time, there was also a contrary current in the art of the passion, especially in Italy: the influence of classicism and the renewal of Platonic spirituality. This is particularly visible in certain sculpted crucifixes of the early Italian Renaissance, to which we shall now turn our attention.

The Sculpted Crucifix

The fifteenth century *Tractatus pro devotis simplicibus* (Tract for Simple Pious People) expresses the fear that even the nudity of the crucified Christ as portrayed in art might be the occasion of lascivious thoughts.[136] An anecdote recounted by Giorgio Vasari in his *Lives of the Painters* may help us understand the basis for such a concern.

The story concerns two of the greatest artists of the early fifteenth century and creators of the Renaissance style: Donatello (Donato di Nicolo; 1386–1466), whose bronze *David* was probably the first free-standing nude statue since antiquity, and Filippo Brunelleschi (1377–1446), who is credited with the formulation of the rules of linear perspective and who designed the dome of the Florence cathedral.

Vasari recounts that Donatello, having finished a crucifix for the church of Santa Croce, invited his friend Brunelleschi to see it and asked his opinion.

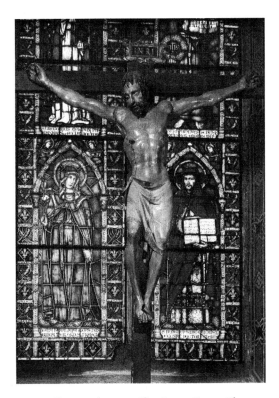

FIGURE I.4. Donatello, wooden crucifix, Santa Croce, Florence.
Credit: Scala / Art Resource, New York.

Brunelleschi at first just smiled. But on being pressed, he expressed a negative judgment. It seemed to him that Donatello had put a peasant (*un contadino*) on the cross, and not the body of Christ, "which was most delicate in its members and adorned with a noble appearance (*d'aspetto gentile ornato*)." The irritated Donatello replied with the challenge, "take some wood and try it yourself." Brunelleschi produced a crucifix of the same dimensions, the one now in the church of Santa Maria Novella in Florence.

According to Vasari, Donatello was so impressed with this work that he conceded that Brunelleschi indeed could produce Christs, and himself only peasants.[137]

Whatever judgment we may make of the relative worth of the two crucifixes, it is significant that both artists accepted Brunelleschi's premise about how the crucified Christ should be portrayed: he should be supremely beautiful. This reveals something important about early Renaissance religious art, and especially about the portrayal of Christ.

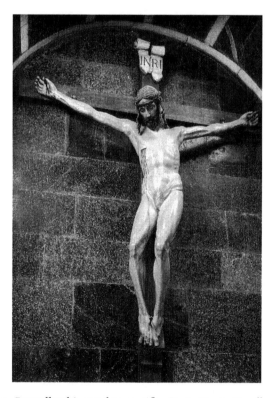

FIGURE 1.5. Brunelleschi, wooden crucifix, Santa Maria Novella, Florence. Photo: George Tatge, 1998. Credit: Alinari / Art Resource, New York.

Michael Baxandall notes that religious artists generally drew on a set and conventionalized repertoire of gestures to convey meaning. Similarly, the physiognomy of individual figures in religious art was usually conventionalized and undistinguished. Baxandall speaks specifically of painting; but the same observations apply to sculpture as well. "Painters specially popular in pious circles, like Perugino, painted people who are general, unparticularized, interchangeable types. They provided a base—firmly concrete and very evocative in its patterns of people—on which the pious beholder could impose his personal detail, more particular but less structured than what the painter offered."[138] As we have seen, a long-standing tradition, reinforced by revered figures like St. Francis and St. Bonaventure, encouraged people to provide their own imaginative concretizations of the figures involved in biblical stories, using the features of people they knew personally.

But the great exception to this was the representation of Christ. Although, as we have seen, the *Zardino de Oration* recommends that a person meditating should imagine a familiar person to represent biblical figures, including Christ, in the arts "the figure of Christ was less open to the personal imagination than others because the fifteenth century was still lucky enough to think it had an eye-witness account of his appearance."[139] Already in the Middle Ages there was a strong tradition concerning the physical features of Christ, based on the transmission of supposed eye-witness reports and even of miraculously produced pictures. The traditional account was reinforced by the translation into Latin in the thirteenth or fourteenth century of a Greek manuscript containing a description of Christ's features supposedly given in a letter by a governor of Judea before the time of Pontius Pilate:[140]

A man of average of moderate height, and very distinguished. He has an impressive appearance, so that those who look on him love and fear him. His hair is the colour of a ripe hazel-nut. It falls straight almost to the level of his ears; from there down it curls thickly and is rather more luxuriant, and this hangs down to his shoulders. In front his hair is parted into two, with the parting in the centre in the Nazarene manner. His forehead is wide, smooth and serene, and his face is without wrinkles or any marks. It is graced by a slightly reddish tinge, a faint colour. His nose and mouth are faultless. His beard is thick and like a young man's first beard, of the same colour as his hair; it is not particularly long and is parted in the middle. His aspect is simple and mature. His eyes are brilliant, mobile, clear, splendid. He is terrible when he reprehends, quiet and kindly when he admonishes. He is quick in his movements but always keeps

his dignity. No one ever saw him laugh, but he has been seen to weep. He is broad in the chest and upstanding; his hands and arms are fine. In speech he is serious, sparing and modest. He is the most beautiful among the children of men.[141]

The details of this description obviously agree with (and probably derive from) written traditions handed on by Nicephorus, John of Damascus, and the Athos "Book of Painters," as well as representations like the Abgar icon (a representation supposedly miraculously created during his lifetime by Christ himself), the crucifixion image called the *Volto Santo*, supposedly begun by Nicodemus and finished by an angel, and the Shroud of Turin. The importance of the Greek manuscript text for the Renaissance lies in its rediscovery by the fifteenth-century humanists, who cast it in its present form.

Whether individual artists like Donatello or Brunelleschi knew this text itself, they were clearly formed in the tradition that inspired it. They take for granted that Christ was "the most beautiful among the children of men." His beauty was the effect of the incarnation: the overflowing of grace into Christ's physique as the sign of the spirit. This notion was reinforced by neo-Platonic thought, which saw physical beauty as an image of the soul and an impetus toward intellectual beauty, which is in turn an image of the divine.[142]

A wooden painted crucifix attributed to the young Michelangelo[143] exemplifies the beautifying of the passion perhaps even better than the works of Donatello and Brunelleschi or his own later *Pietà* (1498–9). Dated 1492—the artist would then have been seventeen years old—the crucifix is said to have been made as a gift in gratitude to the prior of the convent of Santo Spirito in Florence. Unlike the Herculean figures of Michelangelo's later representations of the crucifixion, which either hang weightily or twist in superhuman struggle, this Christ seems suspended gracefully on the cross. The head is bowed in counterpoise to the bent legs. Although the legs are plied at the knee, the arms extend from the body at only a slightly upward angle. There is no apparent effort to show the pull of the body's weight; the figure shows no strain or tension (again, compare Michelangelo's later treatments of the subject). The torso is slender but with well defined muscularity. The legs, by contrast, are softly rounded and slight in comparison. The waist is thin. The forehead bears marks of the crown of thorns, and blood drips from the wound in the side, showing that Christ is already dead. The face and hair are rendered according to the standard iconography. The eyes are closed, the expression peaceful and calm. The figure is completely nude, as the pagan gods were portrayed in antiquity. There is no halo or other sign of divinity but the grace of the figure itself.

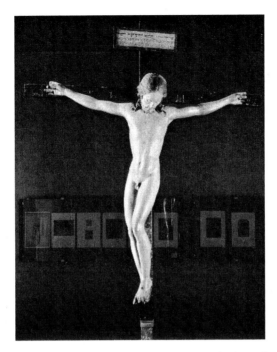

FIGURE 1.6. Michelangelo Buonarotti, wooden crucifix from the Convent of Spirito Santo, Florence, ca. 1492–1493. (The superscription in Hebrew, Greek, and Latin [the latter two mirrored] is original, while the support cross is of later date.) Casa Buonarroti, Florence. Credit: Scala / Art Resource, New York.

It was generally assumed, and is stated by theoreticians like Alberti, that one's physique was a sign of one's temperament, and the body a sign of the soul. But this crucifix, if it is indeed a work of Michelangelo, may signify something that goes beyond such generally accepted ideas. It would not be difficult to see here a conscious expression of the Christian neo-Platonism of the humanists Marsilio Ficino and Giovanni Pico della Mirandola, whose thought Michelangelo encountered at the Medici court. For them, the beauty of the human body is an expression of the beauty of the soul, and an intimation of the beauty that proceeds from and leads to God.[144] Humanity is the center of creation, formed by God precisely to appreciate and marvel at its beauty;[145] and Christ is the head of humanity. Whoever its sculptor, and however conscious or implicit its message, this crucifix portrays not merely redemption, but the beauty of redemption. It invites the viewer beyond the suffering of the cross to its ultimate purpose, which has been consummated: the entry of humanity into the sphere of the divine.

Michelangelo's poems again provide a key to understanding the art:

Gli occhi mie vaghi delle cose belle	My eyes, entranced by beautiful things,
e l'alma insieme della suo salute	With my soul, entranced by its salvation,
non hanno altra virtute	Have no other means to ascend to
c'ascenda al ciel, che mirar tutte quelle.	heaven, than viewing all these [beauties]
Dalle più alte stelle	From the farthest stars
discende uno splendore	Descends a splendor
che 'l desir tira a quelle,	That draws our desire to them—
e qui si chiama amore.	A splendor known as love.
Né altro ha il gentil core	And the noble heart has nothing else
che l'innamori e arda, e che 'l consigli,	To enamor it and counsel it
c'un volto che negli occhi lor somigli.	Than a face whose eyes are like those stars.[146]

The beauty of a beloved face, or in this case, a figure, reflects and reveals the divinely created light, the light from the stars, which in medieval cosmology are the visible lights of the celestial spheres that move in musical harmony, guided by spiritual intellects, to express their love for God. This light, received by our intellect and senses, inspires the love that entrances both the eyes and the soul, leading them to the goal of our love, our ultimate desire, God. The crucified Christ is the ultimate physical symbol of that active spiritual beauty, the love of God, that moves the universe and captures our sense as well as our hearts.

THE CRUCIFIXION IN PAINTING

COMMON FEATURES OF THE PAINTED CRUCIFIX OF THE EARLY RENAIS-
SANCE. Turning from sculpture to painting, we find again two sometimes con-
flicting tendencies in the portrayal of the passion: concentration on Christ's suffering and beautification of the body. Before turning to specific examples of these, we will note a number of features enumerated by Paul Thoby in his survey of the common features of fifteenth-century paintings of the crucifixion.

The cross of Christ is frequently portrayed in this period as being high and thin. The inscription above the head ("Jesus of Nazareth, King of the Jews") is almost always present in the Latin abbreviation INRI (although there are ex-

ceptions, including some—Michelangelo's early sculpture, for example—that have the full text in Hebrew, Greek, and Latin). The *suppedaneum* or footrest, common in medieval crucifixes, nearly disappears in the Renaissance; but Fra Angelico, Brunelleschi, Donatello in his first crucifix, and Andrea della Robbia keep it. Christ's body is generally straight and elongated, especially in the first half of the fifteenth century; in the second half, there is a tendency to soften such elongation. (The medieval legend that the holes made in the cross to receive the nails had been placed too far apart, so that Christ had to be stretched out to be nailed, was contained in the *Livre de la Passion*, a narrative poem about the crucifixion composed in the fourteenth century, but most widely diffused in the fifteenth. This legend is possibly responsible for the elongated and stretched figures of Christ that are common in paintings of the period.)

The arms of Christ are generally raised above the horizontal, except in Florentine painting. The crown of thorns is usually present on the head, which is generally inclined forward and to the figure's right. The face is almost always that of the dead Christ, although sometimes he is just on the point of expiring (again, there are exceptions; for example, Fouquet paints Christ alive and triumphant on the cross in the *Hours of Etienne Chevalier*). The expression on the face is one of sadness, which tends to be attenuated in the second half of the century. The influence of ancient nudes on the Florentine Renaissance led to naturalism in anatomy, which was copied elsewhere in Europe (but in painted wooden crosses, the traditional Byzantine portrayal of the thorax and abdomen frequently remained). The *perizonium* or loin cloth is generally short, except in Italy, where the long cloth of the previous century is retained. In the second half of the century, falling draped cloth recurs; the ends frequently appear to be blowing as though in a (supernatural) wind, especially in Germany. Sometimes the *perizonium* is reduced to a band rolled around the body. Some artists, influenced by classical models, do away with it altogether (the *Heures de Rohan*, Michelangelo, Brunelleschi in Santa Maria Novella—although when displayed later this figure was covered with a cloth around the waist). There is generally a great deal of blood, sometimes flowing down the length of the cross and onto the ground. The symbolic sun and moon of medieval representations disappear, and are replaced by a more naturalistic sky. Some painters fill the scene with many figures (as Alberti advised, for the sake of interest), allowing portrayals of secondary themes like the curing of the blind centurion Longinus by Christ's blood (a story again found in the *Livre de la Passion*).[147]

NATURALISM IN PAINTING AND IN SCULPTURE. It is characteristic of the early Renaissance that—in "high" art, at least—both the "beautiful" and the suffering Christ on the cross is portrayed in an increasingly naturalistic man-

ner. We should note, however, that there is an important difference between the naturalism of painting and that of sculpture. Naturalism, particularly in dealing with the human body, showed itself already in sculpture long before the Renaissance recovery of classical form. Both in free-standing statues and in sculpted reliefs of Gothic cathedrals, like Orvieto or Bourges, we see a naturalism that is striking when we compare these artworks to contemporaneous religious paintings. Perhaps a tendency toward naturalism emerged early in sculpture because figures are represented (to a greater or lesser extent, depending on the genre) in the round, and are sometimes life-sized.

On the other hand, it is an intrinsic feature of most free-standing religious sculpture that the figures are taken out of their historical visual context, and placed in the physical context of a place of worship or devotion: a church façade, a shrine, an altar, or another chosen location. Normally, the sculpted or carved crucifix that serves the Christian's devotion is not visually located on Calvary. Instead, the crucifix is standing on an altar in a church, hanging on a wall over one's bed, or perhaps placed in a roadside shrine that is surrounded by fields. It is immediately a crucifix, a sacramental object, rather than a portrayal of a scene. (There were in fact sculpted "Calvaries" with groups of figures; but even these occur in an artificially defined worship space. The sculpted relief presents the opportunity for the representation of background, like a painting. But Gothic reliefs, like Gothic painting, generally restricted such background—if present at all—to minimal evocations of the scene. Compare Ghiberti's reliefs on the bronze north doors of the Florence Baptistry [1401–1424] to the reliefs by the same artist on the east doors [1425–1452]. The former, while they have naturalistic figures, are like Gothic paintings with minimal and conventional iconic settings. The latter, as Ghiberti himself notes, show the same innovations in naturalism and perspective that we find in Renaissance painting.)

Ironically, then, three-dimensional sculpture is in a certain sense less naturalistic than painting. Precisely by being made into a three-dimensional object, the sculpture is made an artifact in the viewer's world, affected by its position and size, and especially by the play of light and shadow on it. The painter, on the other hand, creates the entire visual field. A naturalistic painting invites the viewer into the world of the figures within it. Leonardo remarks on this, and notes it as a sign of the superiority of the painter over the sculptor. Because he must create a coherent visual world, the painter must use the mind more than the sculptor, who works primarily with the "hand."

> Painting is more a mental activity than sculpture, and involves more
> art, since sculpture is nothing other than what it appears, that is,
> a three-dimensional body surrounded by air and affected by light and

shadow as other natural bodies are. The [sculptured] artwork has two authors, nature and the human artist; but nature has by far the greater part . . . but the painter's light and darkness are with the greatest mental care generated by the painter himself, and he must himself provide the same quantity and quality and proportions [to the painting] that nature, without any human talent (*ingegno*) provides for sculpture . . . and nature provides such artifacts (i.e., statues) with the necessary diminutions of size that produce perspective, without thought on the part of the sculptor; but this science (of perspective) the painter has to acquire for himself by his talent (*ingegno*).[148]

(Interestingly, Leonardo says that when he uses perspective in a relief, as Ghiberti for example does, the sculptor makes himself a painter, that is, he is using the technique proper to painting.)

However, as we have already seen, the kind of naturalism that Leonardo takes for granted as the goal of painting is not necessarily primary to the goal of the sacred picture. If we return now to the work of Fra Angelico, with whom we began this chapter, we will see purposefully different degrees of naturalism used to portray the passion.

CLASSICS OF THE RENAISSANCE CRUCIFIXION GENRE IN PAINTING. As we have noted, by the time of the San Marco commission Fra Angelico was a mature and well-known artist. Hence, as was usual at the time, he had a full workshop, with perhaps four or five assistants who collaborated to various degrees in the preparation stages and even in the painting itself. It is difficult to discern definitely what belongs more or less exclusively to the master, and what was executed by his disciples, following his plans.

Among the frescos for the monks' cells are a number of passion scenes, of which the greater part are representations of the crucifixion with either Saint Dominic or Saint Peter Martyr as well as figures from the gospel passion accounts (Mary, Mary Magdalene, John, etc.) and sometimes other saints. Some of the crucifixions, now usually ascribed to Angelico's assistants, have a somewhat archaic look. (See especially the thin, beardless Christ of cell 29.)[149] "Late Gothic prototypes underlie most of the depictions of the Crucifixion, defined by a slender, ethereal Christ far removed from the solid, all-too-human type painted by Angelico in the Cloister."[150] A few—perhaps the figure of Christ in crucifixion scenes in cells 23 and 25—are more reminiscent of the Cloister portrayal that we discussed in our introduction, and are likely to be largely by Angelico himself. But what unites all of these representation is that the scene is reduced to the bare essentials needed to communicate the

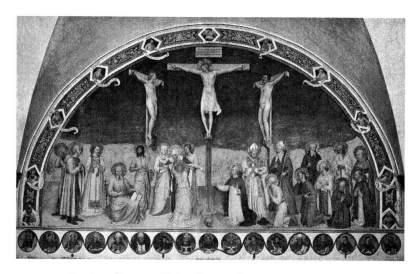

FIGURE 1.7. Fra Angelico, crucifixion fresco, Chapter House, San Marco, Florence,
1441–1442. Museo di S. Marco, Florence. Credit: Scala / Art Resource, New York.

meditative context. Although there is naturalism in the figures, there is not the
slightest "illusionism:" no attempt to reconstruct a visual scene as it might have
looked. The physical surroundings are either not represented at all (so that the
cross stands against a bare background) or they are indicated by minimal
conventional representations of bare mountains, which do not so much portray
a scene as they frame the cross between them.

The fresco of the crucifixion in the Chapter House of San Marco is much
larger in scale and more finished in its portrayal of figures than the meditative
representations in the dormitory cells. Here Angelico is thought to have been
directly involved in the entire painting.[151] Although the theme of presence at
the passion is the same, this painting has more of the nature of a proclamation
and a commemoration, as befits a more public space, and its messages are
multiple and complex. In addition to four figures who belong to the historical
scene (Mary, John the Evangelist, and two women, of whom one is no doubt
Mary Magdalene), many saints are present, exhibiting a variety of postures and
gestures (as Alberti recommends). Most look at the crucified, but some address
the viewer (St. Mark looks at us and points to his gospel, in which we will find
the same passion story; John the Baptist looks outward and points with his
finger in his typical iconographic gesture to say "This is the lamb of God"); some
turn away in sorrow. St. Augustine looks at a book; St. Benedict looks away from
the cross toward St. Anthony the Abbot. The faces of the figures, of different
ages, are wonderfully expressive and uniformly attractive. Their contemplation
of the cross and sharing of Christ's sorrow is beatific and beautifying.

The portrayal of Christ is reminiscent of the figure of Christ in the Cloister fresco of Dominic adoring the crucified. It stands starkly revealed in the upper half of the picture, high above the saints below, framed by the crosses of the two thieves. The background was once the blue of lapis lazuli; it has now been lost. At the top of the painted semicircular decorative band that surrounds the scene is the traditional symbol of the pelican, which was thought to feed its young with its own blood—a reminder of the eucharist as the means of participating in the salvation won by the cross. The band is punctuated with figures of Old Testament prophets holding scrolls bearing writings relevant to the passion. At the bottom they are joined by witnesses from the gentile world, a Sybil and Dionysius the Areopagite. Below is another band, containing a "family tree" of the Dominican order, with "portraits" of its most important members, joined by a vine or sinuous root. The message is a communal extension of the idea in the cell frescos. The contemplation of Christ, which begins as an interior exercise, becomes a motivation for the church's mission to communicate the salvific message to others. The fresco also evokes the specifically Dominican understanding of that mission, calling to mind the order's motto *contemplata aliis tradere*, communicate to others what you have contemplated.

Shortly before the time when the San Marco frescos were being painted (1438–1443), Fra Angelico produced a major panel painting for the sacristy of

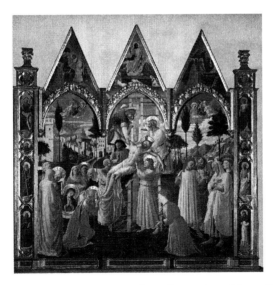

FIGURE I.8. Fra Angelico, *Deposition*, from the sacristy of Santa Trinità, Florence, ca. 1430. Museo di S. Marco, Florence. Credit: Erich Lessing / Art Resource, New York.

the church of Santa Trinità in Florence (1430–32).[152] It is revealing to compare this work, which portrays the deposition of Christ from the cross, to the crucifixions in San Marco. Although it is slightly earlier, it is in the panel painting, destined for occasional viewers rather than for cloistered contemplation, that we see clear evidence of Angelico's mastery of the new Renaissance style exemplified by Ghiberti and introduced in painting by Masaccio (Tommasso di Ser Giovanni di Mone, 1401–1428). In the San Marco frescos we can see a naturalistic modeling of figures, attention to facial expression, and consciousness of the effects of light and shade in producing the appearance of dimensionality. In the Santa Trinità panel we can see in addition the construction of credible perspectival visual space (with a city—Cortona standing in for Jerusalem?—in the background), closely observed landscape, complex and varied composition, accurate foreshortening, minute detail (the grain of the wood on the cross; the nails in the ladder), and richness of color. In comparison, the style of the San Marco frescos seems stark and medieval.

Yet there is a commonality among these examples of Angelico's different styles. His adoption of Renaissance naturalism is selective, even in his paintings intended for a general audience. Apart from the presence of obviously supernatural elements like angels and halos, there are stylistic elements that indicate the iconic nature of the paintings. For example, it is notable that in the *Deposition*, as in the San Marco frescos, although there is molding of figures by light and shade, there are no cast shadows. (The *Deposition's* dark ground punctuated with flowers is reminiscent of the flowery lawn in the *Paradise* section of Angelico's *Last Judgment*.) The visual world of the painting is spatially credible, but it is still the space of sacred narrative, not of ordinary experience.

The Christ of the deposition, as of the crucifixions, is the contemplated and adored savior. The type is universally that of the "beautiful Christ," whether the body is portrayed in more Gothic or more classical form. The saving blood that stains the cross is emphasized. The triumph of Christ is implied by the golden halo with a red cross that adorns his head in all the paintings (in the *Deposition*, the halo also contains the now barely visible words *corona glorie* [*sic*], the crown of glory). But above all it is the beauty and repose of the figure that remind the viewer of Christ's divinity, and proclaim that the cross is not the end of his story, but only the means to that end.

The participants in the scenes are of two kinds. Some were present physically at the event. Of these, the most important are those whose suffering along with Christ we are to imitate: the Virgin Mary, Mary Magdalene, John, Nicodemus, etc. (In the deposition painting, but not in the San Marco frescos, there are also persons present who are simply part of the historical action.) Others are

spiritually present to the event (the saints), contemplating and reacting to it. Their purpose is to give us an example of compassionate meditation on the passion.

The latter make their meaning to us clear by engaging in the language of gestures recommended to artists by writers such as Alberti and Leonardo[153] to indicate their reactions and inspire us to feel the same emotions. These postures and gestures are for the most part easy to interpret; their use would also be familiar to any fifteenth century viewer from theatrical performances, which normally included on stage a mute commentator who guided the audience by his gestures (Alberti recommends that the painter use similar figures to indicate what is happening or draw the viewer's attention.)

Some of Angelico's saints face the viewer and gesture with an extended hand, palm facing outward (a common gesture, but possibly imitated by Renaissance artists from ancient Roman reliefs), saying, "Behold!" The same hand-extended gesture may also be one of greeting: "Hail!" (Alberti notes that the same gesture can mean different things, according to context.) Hands clasped together on the breast, with fingers interlaced, indicate pity, sorrow— the saint, looking at Christ's suffering, is taking it into him- or herself. Thought or meditation is indicated by the resting of the head on the hands or fingers. Hands held together straight are the medieval (and modern) gesture of prayer. Covering the eyes indicates extreme sorrow, weeping. Both hands raised near the body is a sign of acclamation and adoration, or of speaking about a holy subject (it reflects the posture of the priest at mass.) Some of the scholarly saints hold books, their works that proclaim and explain the message about Christ that they and we see in the painting. In the fresco of the mocking of Christ, where disembodied symbols of the persecutors' actions take the place of figures, the seated Saint Dominic looks neither at the scene nor at the viewer, but meditates on a book—presumably the gospels—that gives him in words the same message that the picture communicates to those who view it.[154]

Like religious art in general, Angelico's representations of the passion demand that the viewer bring a great deal of prior knowledge to them in order to appreciate and interiorize their meaning. They presume a knowledge of the gospel message: the cross will end in Christ's victory over death in resurrection. The very fact that the cross can be portrayed in a beautified manner, that it can even assume the aesthetic function of decoration, as in the "Deposition" painting, assumes that the cross is the means to glory. Beauty itself is a theological statement. One may approach the paintings with different theologies of salvation; they do not tell us whether the cross is a necessary means, as Anselm thought, or a freely chosen one, as the Ockhamists taught. But they tell us of our existential relation to that means. They call us to meditate on and partici-

pate in the passion like the saints portrayed. The expressive faces and gestures of Mary and the saints, addressed either to Christ or to us, are meant to move us to the same emotions. They bear the message that we, like them, must be personally and affectively attached to the savior. Like them, we are to join ourselves to Christ's death. But the motivation of this com-passion, suffering with Christ, is the hope of sharing in the victory. This can only take place, as we have seen emphatically proclaimed in the theology of the fifteenth century, through our active appropriation of what Christ has done for us. By the presentation of compassion with Christ as an ideal, they implicitly present not merely the fact of salvation, but the imperative for collaboration. As Luther would correctly intuit, they could easily be taken to imply a theology of "works."

Angelico's paintings of the crucifixion are in some ways conservative in style and technique. (It is interesting that Vasari qualifies Angelico's painting as "devout." We may perhaps take this as an implicit comparison with other painters, who even in rendering religious subjects are more interested in purely aesthetic values.) Angelico's crucifixions are nevertheless representative of the religious spirit of many portrayals of the passion in the early Italian Renaissance. Paintings of the crucifixion by Pinturicchio, Bellini, Mantegna, and later Raffaello show considerable development in naturalistic treatment of perspective and modeling, and especially in the variety of imaginative backgrounds. (At the same time, of course, we can still find crucifixion scenes painted in the old "iconic" way, on a gilt backdrop.)[155] But theologically speaking, the treatment of the crucified is within the same *genre*. Like the sculptures of Donatello and Brunelleschi or the young Michelangelo, they use the beauty of Christ, often expressed in a new imitation of the classical nude, as the expression of his divinity and of the ultimate meaning of the cross.

It has frequently been remarked that during the Middle Ages the portrayal of the crucified shifted from the *Christus Victor* model (Christ the victor over sin and death) to that of the *Christus Patiens* (the suffering Christ), and that this change represented a new emphasis on the humanity of Christ. (We have examined this process at length in *The Beauty of the Cross*.) The spirituality of the passion was increasingly centered on compassion with Christ and with Mary. This is the function of the grieving figures at the crucifixion scene: they are examples for the viewer's devotion. At the same time, the "humanistic" crucifix of suffering is by no means forgetful of who it is that is suffering, and for what purpose. The divinity and triumph of Christ are indicated directly by references to glory (gold halos, gilded or lapis lazuli backgrounds) and to salvation (a cross within the halo, angels gathering the salvific blood, which is also the sign of the eucharistic new covenant, and the presence of worship-

pers). They are also indicated, more indirectly, but perhaps even more effectively, by the beauty of the form itself. The early Italian Renaissance crucifix, by emphasizing bodily beauty and finding naturalistic and appealing means to portray it, accomplishes a new synthesis of the *Christus Patiens* and *Christus Victor* models, while remaining within the narrative context of suffering and death and the spiritual context of compassionate response.

If we look now to the Northern Renaissance of the same pre-Reformation period, we find examples of a different tendency, one more akin to late medieval painting in its stress on Christ's human suffering, but at the same time frequently more advanced in its naturalism and less tied to classical models.

Probably about a decade before Fra Angelico began his work in San Marco, his contemporary the Flemish painter Jan van Eyck (1390?–1441) produced a remarkable *Crucifixion* (1420) as one panel of a triptych meant for private devotion (the central panel has been lost; the remaining accompanying panel portrays the Last Judgment). The painting is narrative and naturalistic in a historical manner. It does not portray meditation on the crucifixion, but makes the viewer as it were an eye-witness of the event. The rendering of the visual

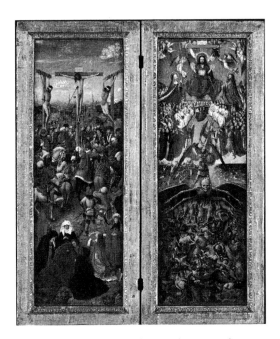

FIGURE 1.9. Jan van Eyck, *The Crucifixion; The Last Judgment*, ca. 1430. The Metropolitan Museum of Art, New York, N.Y. Credit: Image copyright © The Metropolitan Museum of Art / Art Resource, New York.

field is a *tour de force* of perspective. It is divided into three sections. At the bottom or foreground of the picture is a group consisting of the holy women with Mary, who is crumpled in a blue cloak in the arms of John. The middle section is occupied by soldiers and onlookers at the crucifixion, dressed in colorful garb in a mixture of vaguely Oriental and northern European styles. Several, closest to the foreground, are on horseback. Eyck accurately portrays a mob, showing minute details of facial expression. Some jeer at Christ, others laugh, others engage in dialogue with each other, some look indifferent or bored, a couple seem to look up at Jesus with astonishment or awe. At the left side a soldier on horseback pierces Christ's side with a long lance.

By making the crosses extraordinarily high, Eyck is able to isolate Christ and the two thieves in the top third of the picture. Christ is framed by the slanting crossbars of the thieves' crosses and by the figures of the thieves themselves. They hang limply from ropes, their heads at the level of Christ's chest. The legs are not bent from the body's weight, but straight. There is no *suppedaneum*. Christ's thin body is taut, as though he were pressing upward and stretching out his arms. (The posture is reminiscent not only of the triumphant figures of pre-Gothic crucifixes, but also of the medieval passion accounts in which Christ, while being nailed to the cross, is stretched out, like the string on a harp, so that the nails can be placed in the pre-positioned holes.) The face is haggard, the eyes closed and the mouth open. The head is still crowned with thorns, and the hair hangs limp and disheveled over the shoulders. Jesus is nude except for a diaphanous veil (Mary's, according to legend), which allows us to see vaguely his pubic hair. The cross has a "T" shape, with the sign written in three languages mounted on top.

Behind the crosses extends a mostly empty foreshortened landscape, with a few minute figures, leading to a walled city in the middle distance. Behind the city we see a river flowing and ranges of mountains, progressively lighter in tone to create the illusion of remoteness. Above is a clouded blue sky, whose light tones effectively set off the more intense coloration of Jesus' body, drawing attention to it. The composition of the picture as a whole also focuses our attention first on the crucified body of Jesus, and secondarily on the foreground group around Mary.

This painting goes a step beyond the perspectival naturalism of Fra Angelico and other early Italian painters of the crucifixion. In technique, it profits from Eyck's innovative methods in the use of oils, which give the painting's figures luminosity and also permit a shading that creates deep perspective.[156] The extraordinary and finely rendered detail is reminiscent of the best manuscript illumination (which seems to have been Eyck's first artistic calling). In

portraying people Eyck gives a remarkable variety of facial expressions, some of which are far from beautiful or classical.

However, Eyck's naturalism consists in more than technical advances. He attempts to present not merely the theological idea of the crucifixion, but rather a reconstruction of what it might have looked like. Hence there is nothing supernatural in the painting: no halos, no angels, no golden backdrop. Obviously, there are historical anachronisms. The costumes and the city are products of the painter's imagination. Again, the careful composition of the painting, and especially the posture of the crucified, direct the eye in such a way as to point to its religious meaning. But it is naturalistic in the sense that it convincingly portrays a physical situation, and there is nothing in it that could not be seen by a human eye.

At the same time, the religious meaning of this naturalistically portrayed human drama is clear to the Christian viewer. The focus is on the sacrificial suffering of Christ as the means of redemption. The frame, which is original, contains quotations from the book of Isaiah about the "suffering servant" of God that were taken to prophecy Christ's redemptive death: "he was brought as a lamb to the slaughter;" "his grave was made among the wicked;" "he bore the sins of many" (Is. 53: 7, 9, 11).

The companion picture of the Last Judgment is crucial to understanding the crucifixion panel. The theological meaning of the historical event of the crucifixion is made clear in the future event of Christ's universal triumph. In this panel, individual figures are still treated naturalistically, in a portrait-like fashion. But the bodies are of different sizes, according to importance, as in medieval painting. In this panel there is no single unified perspective, but a juxtaposition of independent scenes, each with its visual logic. At the top, the same cross and the same instruments of the passion that we see in the cru-cifixion panel are now portrayed in triumph, held aloft by angels. A halo, altogether absent from the crucifixion scene, now surrounds not only the head, but also each of the wounds of Christ seated as judge. The saints are ranged around and below Christ, while at the bottom of the picture his enemies are thrust into the darkness of hell. The cross is both a sign of victory and a warning.

Numerous other crucifixion scenes from the Flemish Renaissance are similar to Eyck's in their use of naturalism to emphasize Christ's human suf-fering. However, not all carry historical realism to the same extent. In Rogier van der Weyden's crucifixions of 1440 (?) and 1445 Christ's face shows the ravages of suffering; but his body is elegantly displayed, and "supernatural" elements, equally naturalistically portrayed (angels and a billowing, untied

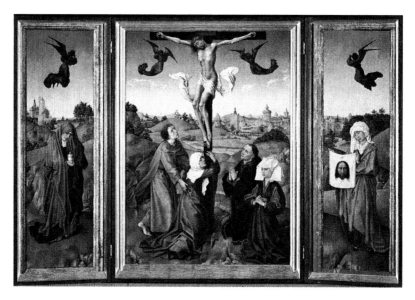

FIGURE 1.10. Rogier van der Weyden, *Altar of the Crucifixion*, ca. 1440. Kunsthistorisches Museum, Vienna. Credit: Erich Lessing / Art Resource, New York.

cloth that modestly covers the genital area) serve to interpret the event. In the 1440 painting, there are patrons present in postures of prayer; but their faces are far from showing the emotions of Angelico's contemplators of the passion. They are essentially portraits inserted into a conventional sacred context. Similarly, the lovely countryside seems more decorative than theologically significant. The same might be said of the miniature-like background of a crucifixion from about 1490 by the "Master of '*Virgo inter Virgines.*'" But here the dead body of Christ—again totally nude, but with the genitals covered by a supernaturally billowing cloth—hangs realistically limply, listing to one side, although, as in Eyck's painting, the legs are unbent and the body is classically well-formed, so that the overall impression is graceful. In contrast, the face and unkempt hair bear the remembrance of suffering.

An extreme version of the type of the suffering Christ is found in the well-known paintings of Mathis Neithardt, known as Grünewald (b. ca. 1460–1480, d. 1528).[157] Although Grünewald's earliest known works date from a half-century after Fra Angelico's death, in some ways they even more strongly represent the endurance of Gothic style in the early Renaissance.

Grünewald produced several similar versions of the crucifixion, the most famous is probably the one that forms part of the Isenheim altarpiece.[158]

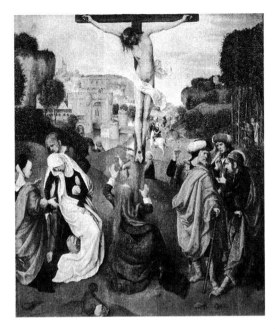

FIGURE I.II. Master of the Virgo inter Virgines, *Crucifixion*. Uffizi, Florence. Credit: Scala / Art Resource, New York.

In each the painter brings to stark realization the alternative late medieval tradition of portraying the crucifixion not with beauty but with almost grotesque ugliness. As the prophet Isaiah writes, "there was no beauty in him to make us look at him, nor appearance that would attract us to him" (Is. 53:2–3). In three of the renderings, probably painted some time between 1501 and 1512,[159] only figures mentioned in the gospel accounts appear. In one version we see Mary, John, and two women at the base of the cross. Standing a bit behind and to the right is a figure in full sixteenth century armor who gestures upward toward the cross. Near his mouth are written the words of the centurion, *vere filius Dei erat iste*, "truly this was the son of God" (Matt. 27:54). In a second version, Mary, John, and Mary Magdalene are present; and in a third, only Mary and John.

 In his most ambitious treatment of the subject, on the large panels that form the central part of the Isenheim altarpiece in its closed state,[160] Grünewald continues the medieval symbolic tradition. At the left, the swooning Mary is held by John the evangelist, while a grieving Mary Magdalene kneels at the foot of the cross. On the right, anachronistically, is the figure of John the

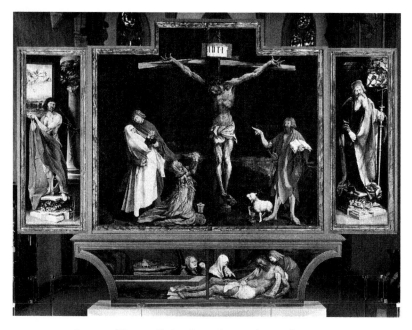

FIGURE I.12. Grünewald, *Crucifixion* from the *Isenheim Altarpiece*. Musée d'Unter-
linden, Colmar, France. Credit: Scala / Art Resource, New York.

Baptist, who holds a book in his left hand and with his right points to Jesus on
the cross. Next to his head are the written words, *Illum oportet crescere me autem
minui*, "he must increase, while I must decrease" (Jn. 3:30). At the foot of John
is a small lamb that carries a thin cross and spills its blood into a gold chalice.

Dominating the whole scene is the figure of Christ, which is very similar in
all the Grünewald versions of the theme. We notice immediately that the size of
Christ's body is disproportionate to the other figures. The body is enormous,
massive and muscular. The sufferings that it has undergone are not merely
emphasized, but intensified. It is contorted, especially the hands and feet, and
hangs heavily with taut muscles. The heels of the feet do not reach to the
suppedaneum or footrest to which they are nailed, giving the impression that the
body was stretched onto the cross (as is described in some medieval literature).
Blood drips from Christ's side and feet. The head, which droops forward and to
the viewer's left, bears a crown of enormous thorns. If we look closely, we see
that not only head, but the entire body is pierced by thorns, some of them still
sticking out in various places. We also see marks of the scourging. The lips are
whitened, as though parched with thirst. The eyes are closed, and the wound in
his side indicates that Christ is dead. The wood of the cross, especially the
crossbar, is so clearly and so meticulously rendered as to have an almost *trompe*

l'oeil quality, as is the sign above Jesus' head with the letters "I N R I" in Gothic script.

Grünewald's painting presents us with a combination of Northern Renaissance, naturalism, medieval symbolism, and religious expressionism. The figures and clothing are rendered naturalistically; but the arm of the disciple John embracing Mary is much too long for the body. The strident colors (the red and white of the robes of John and Mary on one side, the red cloak of the Baptist with his white book and the white lamb on the other) form a striking frame for the dull color of Christ's dead body. The three faces on the left bear expressions of extreme grief; but the Baptist is entirely stolid as he matter-of-factly points to the crucified. The shadows cast by the figures are consistent with a single source of bright light. But what is its source? The background of the painting is a dimly lit, barren landscape, and the sky is black with the darkness that accompanied the crucifixion. The receding hills behind the figures suggest a large landscape, effectively creating depth of space, but without detail. Some elements in the painting are clearly iconic. Mary Magdalene is near the vessel of oil that is her identifying symbol, and that anticipates Christ's burial; John the Baptist bears a book, like the prophets and evangelists in medieval paintings.

The presence of John the Baptist in the painting removes it from the genre of historical narrative, since he was already dead at the time of the crucifixion. He is speaking not in the gospel context, to his disciples, but rather in the present, to the viewer. Although at a first glance the painting seems to present a single spatially coherent scene, when we look more closely we find discrepancies. Like the figure of St. Dominic in Fra Angelico's cloister painting, Grünewald's Baptist is located ambiguously. The position of his feet puts him well in front of the cross; yet he can be pointing to Christ only if he is standing next to it (which is in fact what we assume if we look at the upper part of the body).

Like Fra Angelico, Grünewald has created a "painted sermon." Jesus is the "Lamb of God who takes away the sins of the world" (the words of the Baptist in John's gospel, Jn. 1:29) and who establishes the new covenant in his blood; the covenant celebrated in the eucharist at the altar below the painting. The blood that pours from the lamb's breast flows in a stream exactly parallel to the blood flowing at the bottom of the cross. (We should also recall that the altar was frequently thought of as the symbolic tomb of Christ; hence the relevance of the scene pictured in the predella immediately above the altar, below the crucifixion.) The figure of the lamb is a symbolic key to the interpretation of the tormented figure on the cross, which bears no sign of divinity. With its head raised in counterpoint to the bowed head of Jesus on the cross, it signifies not only sacrifice, but also triumph. Christ's merciful love for humanity makes him

the Passover lamb of the cross and the eucharist; the Father's response to his obedient love makes him also the victorious lamb of the Apocalypse, bearing the cross as a trophy. He is thus a sign of hope for those who look on this image in the hospital context of the Isenheim altar. Not merely hope for physical healing, which is represented by the saints commemorated there, but hope for eternal life rising out of suffering and death.

OTHER PASSION THEMES IN ART

Although the crucifix is the predominant image of Christ's passion, the extreme preoccupation of late medieval spirituality with the sufferings and death of Jesus is expressed also in the portrayal of other moments during the passion, both within narrative series and as individual events. Among the frequently represented scenes are nearly all the major dramatic moments of the story: the mocking of Christ, the scourging, the showing by Pilate (*Ecce Homo*), the way to Calvary, the nailing to the cross, the descent from the cross, Mary's reception of Christ's dead body, and the burial. The reception of the dead body of Jesus from the cross inspired an entire genre of art, the "lamentation;" one variant of which, the *pietà*, became a primary subject of devotional art.

In addition to individual scenes abstracted from the passion narrative, the late Middle Ages saw the development of several devotional motifs that are not historically located, but that portray rather the theological *idea* of Christ's suffering and death for humanity. The *imago pietatis* or "Man of Sorrows" is a diversified genre that shows the suffering or dead Christ outside any specific narrative context: usually crowned with thorns, sometimes displaying his wounds, sometimes dead, sometimes alive.[161] Frequently Christ's torso is shown from waist up, as though rising out of a sepulcher.[162] Sometimes he is supported by angels or by Mary. Representations of the "Mass of St. Gregory" (a miraculous appearance of Christ at the altar while St. Gregory celebrates the eucharist) often use a similar figure. The *arma Christi* icon shows the instruments of Christ's humiliation and torture, generally without his figure. Sometimes these different types of image overlap and combine.

We shall look first at how several examples of how such images, widely used in the Renaissance, were affected by the new naturalism in art. Then we shall turn to a brief consideration of the *pietà*, which was probably the most well-known and important medium of devotion to the sufferings of both Christ and of Mary outside the crucifixion scene itself.

PORTRAITS OF THE SUFFERING CHRIST. As we have already seen, there are several legends about portraits of Jesus' face made during his lifetime. The

Mandylion was supposedly a likeness miraculously produced and sent by Jesus to Abgar, King of Edessa (or, alternatively, a portrait painted by the latter's emissary); the *Sudarium* (or *Sudarion*) was an image impressed on a cloth presented to Jesus on the way to the cross (the "veil of Veronica," whose legendary name derives from "true image"); the "shroud of Turin" is a supposedly miraculous image of Christ impressed upon his burial shroud—according to recent studies, actually a medieval painting, probably originating in Byzantium. (These were images whose legends were widely known. In addition, the second-century Church Father Irenaeus tells us that the Gnostics claimed to have a portrait of Jesus done at the order of Pontius Pilate.)[163] It was probably the inspiration of one or more of these, combined with the late medieval fascination with the passion, that led to the production in the early Renaissance of a number of portrait-like representations of the suffering or dead Christ. As we have seen, realistic portraiture became a major element of fourteenth century art. Its application to Christ marked the emergence of a new phase in devotional imagery.

A remarkable example is the painting of *Christ Crowned with Thorns* by Fra Angelico.[164] It is similar in form to other paintings of the Holy Face that were widespread, especially in northern Europe, since the early fourteenth century.[165] Art historians presume that Angelico was inspired by Flemish models, in particular by the realistic image of Christ as *Rex Regum* ("King of Kings") by Jan van Eyck (1438). But Angelico combines Eyck's triumphal style of portrait with the theme of the suffering Christ of the "Veronica" types of representation.[166]

Like Eyck's painting, and unlike paintings of the Sudarium or "Veronica's veil," Angelico presents the viewer not with a painted image of a prior image impressed on cloth, but with a direct representation of Christ as a living person. Moreover, this is clearly the triumphant Christ. On the gold band around the neck of his gown, Angelico completes Eyck's inscription *Rex Regum* with abbreviations for the words that follow in the text, *Dominus Dominantium* ("Lord of Lords," Apoc. 19:16). In the upper part of the gold halo, in the spaces between the red cross, appears the Greek abbreviation IHS XPS, "Jesus Christ." The writing on the lower part of the halo, which is portrayed as a gold plate behind Christ's head, is interrupted by the head itself. But we can see on one side the letters "SA" and on the other "M" followed by the conventional sign that letters have been omitted. Presumably the educated viewer is intended to read the words *Salvator Mundi* ("Savior of the World"), which would fit in the space if the lettering were continued behind Christ's head.

Nevertheless, despite his regal robe and divine attributes, Christ is portrayed at the height of his suffering. His head is crowned with enormous thorns, and blood drips down his face. Most strikingly, his eyes are red, filled

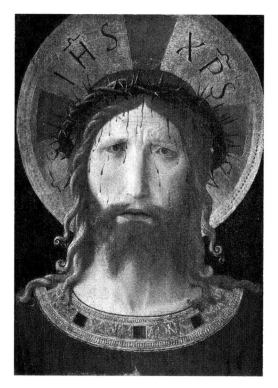

FIGURE 1.13. Fra Angelico, *Christ Crowned with Thorns*, ca. 1435. S. Maria del Soccorso, Livorno. Credit: Alinari / Art Resource, New York.

with blood. This detail may derive from the widely read *Revelations of St. Bridget of Sweden* (1304–1373), in which the Virgin describes this aspect of Christ's suffering. The crown "pricked so hard that both my son's eyes were filled with the blood that flowed down, and the ears were stopped up and his beard was thick with blood."[167] Bridget's description may well have inspired the Dominican archbishop of Florence and friend of Angelico, Saint Antoninus (1389–1459), in writing his *Opera a ben vivere*, a tract of devotional advice addressed to a pious lady: "you should meditate a little every day on the passion of our Lord Jesus Christ...kneel down before a Crucifix and with the eyes of the mind, more than with those of the body, consider his face. Beginning first with the crown of thorns, pressed into his head, down to his skull; next the eyes, full of tears and of blood; the mouth, frothing and full of bile and of blood; the beard, similarly full of spit and of blood and of bile...."[168]

But Angelico does not show Christ's suffering as deforming. On the contrary, he presents the head with an idealized beauty, dignity, and majesty. Christ's light-colored hair and beard are elegantly curled. His skin is smooth

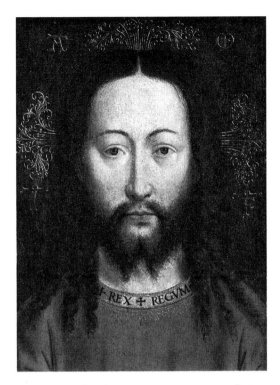

FIGURE 1.14. Jan van Eyck, *Christ as Rex Regum* (King of Kings). Copy after a lost painting. Photo: Jörg P. Anders. Gemaeldegalerie, Staatliche Museen zu Berlin, Berlin. Credit: Bildarchiv Preussischer Kulturbesitz / Art Resource, New York.

and unblemished, although blood flows from the wounds made by the thorns. He looks directly at the viewer, his brow furrowed perhaps more with sorrow than with pain. His open lips and eyes make a mute appeal to us. It is the glorified eternal Lord, the savior of the world, who endures this supreme suffering. Is the suffering itself therefore glorified and eternalized?

The paintings of Antonello da Messina (ca. 1430–1479), who is credited with having popularized oil painting in Italy, demonstrate several approaches to a naturalistic portrait-like representation of the suffering Christ. In a small devotional panel (from the 1460s?) the head of Christ is portrayed with his traditional Gothic features, rendered with extreme precision and a feeling of depth. The presence of the crown of thorns and of a thin rope around the neck indicate the *Ecce Homo* genre. But there is no indication of physical suffering. The face is young and handsome, the hair is neatly waved. The eyes of Christ are downcast, and the expression may be taken for one of sadness or of

thoughtfulness. The head is surrounded by a halo, the background is gold, and the whole is surrounded by a painted simulation of a decorative architectural framework.

Two other paintings of the theme, probably from the same decade, show even more similarity to the Renaissance portrait genre. Antonello has apparently imitated the style of Flemish portrait painting, adapted to the sacred subject. Half-length figures of Christ usually occur in Flemish art in pairs, showing the triumphant and the suffering Jesus.[169] The latter, treated alone, gave rise to the development of the *Ecce Homo* type by about mid-century.[170] In Antonello's versions, Christ's head and nude torso appear behind a parapet, with a black background. In each, the face is individual and expressive. The eyes of Christ look under furrowed brows appealingly to the viewer.

The hair in these paintings falls loosely on the shoulders, and there are barely-noticeable traces of blood (in one case on the chest, in the other on the head under the crown). There is no halo or sign of divinity; but the viewer is reminded of the iconic nature of the paintings by the initials "INRI" on the parapet in one painting and a small *trompe l'oeil cartellino* (a paper, painted to give the illusion of being attached to the painting, and containing the artist's signature) in the other. Antonello retains the conventional view of Christ's beauty, especially in the rendering of the torso, which is classical in form. At the same time, he appeals to the viewer's emotions by portraying faces of real types one might meet, with easily recognizable features of sorrow and psychological pain, directly addressing the viewer. (Compare Antonello's paintings of the dead Christ in the arms of an angel, and Christ at the column, in which Jesus' gaze is focused on the heavens.)

Hans Memling (1430?–1494) also provides a striking example of the combination of naturalism with a devotional message in his portrait-like *Man of Sorrows* of about 1480.[171] Christ bears a thick crown of thorns, and blood runs down his forehead. He is living and suffering, but he is clothed, and shows the wounds of the crucifixion in his hands. Thus the picture is removed from any historical moment in the passion, and transferred to the realm of eternity. Like a "portrait," it intends to memorialize the subject's essential features, rather than show a moment in his life. The face shows sorrow, and tears run down the cheeks. Yet the expression is gentle, and the lips seem to bear a slight smile. The eyes gaze thoughtfully off to the side. The wounded right hand is raised as though in blessing, while the left significantly points a finger directly at the viewer.

Another type of representation that takes the suffering Christ out of historical context and places him in the eternal realm is the "Seat of Mercy." The earliest examples date from the twelfth century, but the genre became more

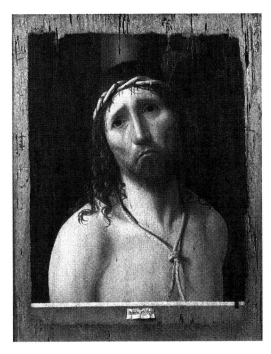

FIGURE 1.15. Antonello da Messina, *Ecce Homo*. Museo Civico, Piacenza. Credit: Scala / Art Resource, New York.

widespread in the fourteenth, as the suffering of Christ became increasingly the center of devotion. The image shows the Trinity with the Second Person represented as the crucified Jesus, sometimes on the cross, sometimes dead in the arms of God the Father. The Spirit is generally portrayed as a dove floating above Christ's head.

Perhaps the most famous example of this type is also one of the ground-breaking works of the early Renaissance: the *Trinity* fresco by Masaccio (Tommasso da S. Giovanni di Mone, 1401–1428) in the Florentine church of Santa Maria Novella (painted 1425–28).[172] Masaccio shows God the Father, dressed in a red robe and blue toga (Christ's usual clothing), standing erect on a kind of high altar. He is portrayed as an old man with a long gray beard, but with a massiveness that suggests a powerful physique. His hands are placed under the cross bearing the dead Christ. His eyes look straight out from an impassive face. The spirit flies above Christ's head as a white dove. Although the Father seems to be holding up the cross, it is also implanted in the ground. What is in the Father's hands is not a crucifix, that is, a representation of the event, but rather is the event that took place on Calvary itself. Jesus is dead, head

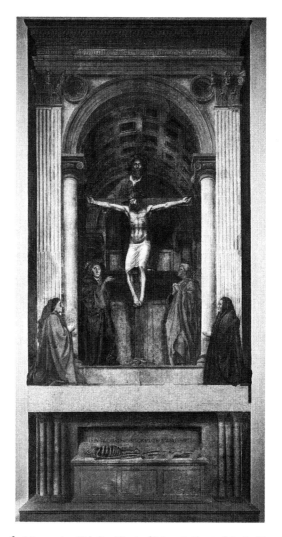

FIGURE 1.16. Masaccio, *Trinity (Seat of Mercy)*, Santa Maria Novella, Florence. ca. 1425. Credit: Alinari / Art Resource, New York.

bent forward with a peaceful expression on his face. His legs are bent as though the body sags from his weight. He is clothed only in a nearly transparent loincloth that slips down over his haunches. Mary, to the left, looks toward the viewer and gestures with her hand indicating Christ on the cross. John the evangelist by contrast looks at Jesus, and clasps his hands in commiseration. Behind their heads, all the sacred figures have golden halos; in perspective these haloes are portrayed as though they were solid plates resting on the figures heads. The whole scene is placed within a vast architectural framework

showing a vaulted ceiling, supported by pillars, all in deep perspective. Outside this imaginary chapel and a step lower two patrons, male and female are kneeling. They reverse the positions of Mary and John, and wear contemporary clothing in colors that create a symmetry with the other figures.

The fresco is famous for Masaccio's revolutionary use of atmospheric perspective. Not only does he create an illusion of space, but he models the figures as a sculptor would, in light and shadow, with consistent lighting, as though from a single source. In this way, the scene is placed in within this world, that is, within the visual rules of this world, even though the content of the painting is a theological idea about a supernatural and intrinsically invisible reality, namely, the Trinity as humanity's savior through redemption on the cross.

A later and more dramatic treatment of the theme is found in Lucas Cranach the Elder's *Trinity*[173] (early 1500s). We see an enormous figure of God the Father, robed in a golden cope and wearing a triple-crowned tiara, holding up the body of the dead Jesus, while the Spirit, in the form of a dove, perches on Christ's leg. The Father has a long grey beard. His eyes express deep sorrow, and his cheeks appear stained by tears. The body of Jesus is curled up, but his arms are held extended by the Father's hands, as though he were just being taken from the cross. His eyes are closed; he still wears the crown of thorns, and the gaping marks of the nails are visible in his hands and feet. Beyond the golden background that surrounds the Trinity, cherubs hold the instruments of the passion, while below Mary and John the evangelist look on.

This theology of redemption could be represented in other ways, and in fact sometimes was. For example, there are pictures showing a heavenly scene in which God the Father designates the Son as savior through the incarnation and cross, before the events take place,[174] and others showing the Father and Spirit with the resurrected Christ in glory.[175] It is surely significant that none of these attained the popularity of the portrayal of the suffering and death of Christ. In the common form of the Seat of Mercy, the Son's part in God's redemptive plan is represented not by the preexistent Word, nor by the triumphant figure of the resurrected Jesus, but by his dead body. If we approached such portrayals with a presupposition of empirical visual realism, we might find them theologically strange, since Christ's dead body—even if still "hypostatically united" to the "second person of the Trinity"—is by definition lacking in an essential component of his humanity, the "soul." But in an iconic sense, what is represented is not simply Jesus' dead human body, but rather that body in its connection with the entire narrative of redemption. Hence the representation of the dead crucified is a symbol for the person of Christ, the Son of God incarnate who died for us. Still, the choice of this particular form of representation seems to

underline certain messages. First, that the Son does the will of the Father, or, more precisely, of the Trinity (an important point, as we have seen, in fifteenth-century theology). Second, it implies that despite the resurrection and ascension, or, indeed, because of them, the eternal form of Christ remains his suffering obedience. For the spirituality of the late Middle Ages, this is how we primarily meet him, both in meditation and, above all, sacramentally in the eucharist.

THE LAMENTATION OF MARY AND THE PIETÀ. Devotion to Mary was of course widespread and intense throughout the Middle Ages. In the period immediately preceding the Protestant Reformation, such devotion became if anything more pronounced and explicit, both in spirituality and in theology. We have seen the emphasis given to Mary by Biel and Savonarola. Yet, strong as their Mariology was, they were less extreme in their devotion to Mary than some.

MARY'S PASSION IN THE CONTEXT OF MARIAN DEVOTION. The late Middle Ages saw an increased emphasis on Mary's sufferings as a sharing in the passion. A liturgical feast dedicated to the sorrows of Mary specifically during Christ's crucifixion and death, "Commemoratio angustiae et doloris B. Mariae Virginis," was instituted by a provincial synod at Cologne to expiate for the "sins" of the iconoclast Hussites. Its observance spread to much of northern Europe.

Such developments can only be fully appreciated in the context of the entire scope of this period's Marian devotion. A major sign of the extent of such devotion in this period is the success of the doctrine of the Immaculate Conception. This teaching was opposed by many in the tradition (Augustine, Bernard of Clairvaux, Thomas Aquinas, and Gregory of Rimini were all authorities cited against it), and it long remained a source of theological controversy. Nevertheless, during the course of the fifteenth century the notion that Mary must have been conceived without original sin was ever more widely accepted, not merely as a theological opinion, but as church doctrine.

This doctrine, of course, is not explicitly found in Scripture. Its basis is the principle (derived from Anselm of Canterbury) that one should ascribe to Mary every possible perfection that does not *contradict* Scripture or tradition. In line with this thinking, the Franciscan John Duns Scotus formulated the classical argument for the doctrine: *potuit, decuit, fecit*—God *could do* it; it *was fitting* to do it; therefore we must conclude that God *did* it. It was common teaching that Mary was liberated from sin by Christ's grace from the beginning of her life (although it was not universally assumed that human life begins at conception),[176] and hence was *born* without sin. But Scotus reasons that it is more

perfect for someone to be *preserved* from sin than to be *liberated* from it. It was possible for God to do this for Mary, in light of Christ's redemptive grace. It was fitting for God to do so, so that there would be a perfect instance of redemption, and it was furthermore fitting that this perfect instance should be the mother of the redeemer. Hence we are forced to conclude that God actually did preserve Mary from original sin from her conception, even though the Scriptures do not mention it.

By the second half of the fourteenth century, the Immaculate Conception was accepted almost universally by the Franciscan order. It was established by law that the doctrine had to be taught at the University of Paris. In 1439 it was officially declared a doctrine of the church by the Council of Basel. (However, there were doubts about this Council's validity; hence the doctrine continued to be rejected by some theologians, particularly among the Dominicans).[177] A feast of the Immaculate Conception, with indulgences for those who observed it by attending services, was instituted by Pope Sixtus IV (a Franciscan) in 1476.

One reason for the rejection of the doctrine by some theologians was the fear, explicitly expressed by Gregory of Rimini (died 1358), that the acceptance of an Immaculate Conception for Mary would inevitably lead to the doctrine of her bodily assumption to heaven. Since death is a result of original sin, one preserved from original sin should logically be preserved from death as well.[178] Hence Mary would have lived a life in every way parallel to Christ's. It would take only a small step farther to extend this parallel, as Biel for example did, to hold that she was "coredemptrix" along with Christ the redeemer, and, even more importantly, "mediatrix" of Christ's graces to us.

LAMENTATION AND PIETÀ IN ART. From very early on, it was customary to portray Mary and John the Evangelist at the foot of the cross, and frequently to include indications of Mary's dialogue with Jesus, in which he entrusts the disciple to her and her to the disciple (who is taken to signify the church). Pre-Gothic art generally emphasized Mary's dignity even in confronting the passion. With the Gothic period, the emphasis was increasingly placed rather on her uncontrollable sorrow, so that by the late Middle Ages we frequently see her collapsing with grief. As we have seen, spirituality frequently made her sorrows an example for what Christians should feel. However, by the late medieval period she was presented not only as a model for compassion for Christ, but also as an object of compassion herself.

This is especially evident in the development of devotion to the continuation of Mary's "passion" *after* the crucifixion. At this point, Christ's suffering has been ended by his death; theologically, he is already the triumphant victor who is breaking the gates of hell. But Mary continues to be the sorrowing

mother, lamenting over the dead body of her son. Mary's sorrow is presented pictorially in several popular narrative contexts: the deposition from the cross, a lamentation over the body at the foot of the cross, and the burial of Jesus (notably, the Scriptures record her presence at none of these). However, just as with the "Man of Sorrows" icon, the image of the suffering Mary with the dead body of Christ could also be abstracted, to varying degrees, from its concrete narrative context and placed in an eternal iconic setting immediately present to the viewer. The term *pietà* is frequently reserved for such non-situated images, although it is sometimes extended to narrative pictures at the foot of the cross or even at the tomb.[179]

The *pietà* as a genre developed in the fourteenth century, and became ever more widespread in the period up to the Reformation, both in painting and in free-standing sculpture. A few instances of various ways of treating the theme will indicate some of the effects of Renaissance naturalism, classicism, and decorative sense on this popular type of devotional art.

A 1441 painting by Rogier van der Weyden shows Christ in the arms of Mary at the foot of the cross, with John and Mary Magdalene. The carefully posed and realistically modeled figures show dignified grief. As Mary caresses

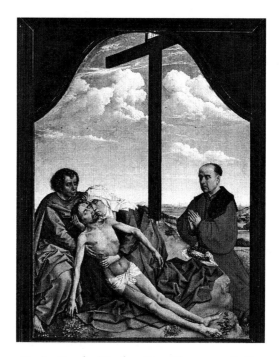

FIGURE 1.17. Rogier Van der Weyden, *Deposition*, ca. 1436. Museo del Prado, Madrid. Credit: Scala / Art Resource, New York.

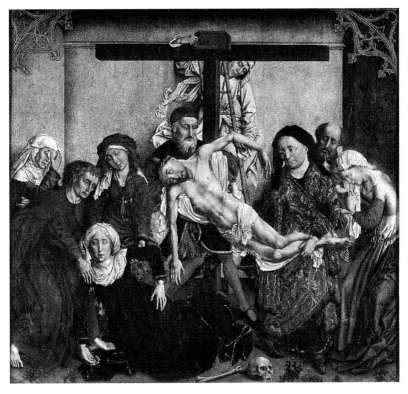

FIGURE 1.18. Rogier Van der Weyden, *Descent from the Cross*. St. Pierre, Louvain-Leuven, Belgium. Credit: Scala / Art Resource, New York.

the head of Christ, John places his hand on her head. The theological motif of salvation is made clear by the skull of Adam at the feet of Christ.[180] At the horizon the sky is lit as though with sunset colors; but the figures appear as though in a light coming from the side of the viewer. The same theme is repeated in van der Weyden's "Lamentation" (1460–80), also situated at the foot of the cross. Here, however, Mary kneels in praying posture next to the body of Christ, with John behind her. The body of Christ is thin, almost emaciated, but well formed and elegantly posed. It shows the marks of the crown of thorns and the wounds in hand, feet, and side, with blood flowing down from the last; but there are no signs of the scourging. Three saints on the right contemplate the scene. The other figures in this painting are more numerous, and most are dressed in elegant fifteenth-century costume. The faces are individual and realistic; the poses are conventionalized and somewhat contrived. The colors are vibrant and carefully balanced. The background shows a Flemish countryside in the far distance. The figure of Mary is physically and

compositionally the center of the picture, but her gaze and posture immediately bring the eye below to the recumbent body of Christ. The figures to the sides are portrayed in the same focus and light, so that each may be looked at as a kind of portrait. In van der Weyden's *Deposition* of 1436, the body of the fainting Mary is visually parallel to her son's body being lowered from the cross. The participants in the scene are richly and elegantly dressed, and strike poses that symbolize more than they portray emotions.

In the "Avignon *pietà*" (1460), by an unknown painter, the figures are taken out of the narrative context and placed in a vast bare landscape, with the towers of a city (presumably papal Avignon) in the far distance. In place of the sky is a gold backdrop, giving the entire scene a sacred and ultimately triumphal meaning. The halos of Mary, Mary Magdalene, and John, with their names inscribed, are raised on the same gold. Mary holds the dead body in her lap, her hands folded in prayer, her eyes cast downward. The body of Christ forms a graceful arch. The figure shows accurate anatomical knowledge, and is portrayed in classical style. The head bears signs of blood from the crown of thorns. It is surrounded by rays of light. The face has closed eyes and slightly open lips. The corpse bears the wound in the side, with a stream of blood proceeding from it toward the waist. Mary's face bears an expression of gentle sorrow; John's is tender and meditative. He looks down upon the head of Christ that his left hand gently raises, while the right approaches to touch it with affection. Mary Magdalene weeps into her gown. The robes of all the figures are of rich materials; Mary's are decorated with gold. The intricate folds in the cloth of the gowns are rendered with still-life-like precision. At the extreme left and on another visual plane ("in front" of the other figures) is a portrait of the donor, in prayer. His eyes are not turned toward the scene, but gaze off into space in contemplation, as though the painting represents what is in his mind.

Yet another level of abstraction from the narrative context takes place in sculptured representations. Probably the most celebrated of these is the *pietà* created by Michelangelo in his youth (1499). (He returned to the theme several times later in his life.[181]) This sculpture reflects the same classical and humanistic spirit as Michelangelo's early crucifix that we spoke of previously.

The *pietà* with the dead Christ on the knees of Mary was a favorite theme of late medieval French and German sculptors (and it is perhaps not coincidental that Michelangelo did this piece on a commission from a French cardinal).[182] But in the north, the scene was generally treated as one of extreme pathos, meant to evoke in the viewer compassion for Christ and his lamenting mother. Michelangelo has instead presented figures of great physical and moral beauty. Rather than evoking the viewer's compassion for Christ, it proclaims the divine

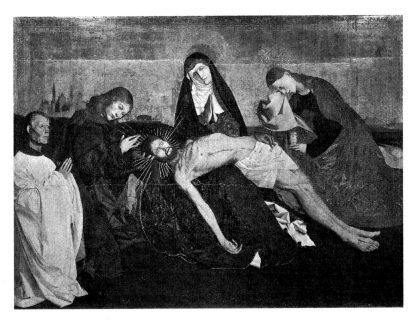

FIGURE I.19. Anonymous (Enguerrand Quarton?), *Avignon Pietà* (Pietà de Villeneuve d'Avignon). Musée du Louvre, Paris. Credit: Erich Lessing / Art Resource, New York.

compassion for humanity (another possible meaning of *pietà*), manifested in Christ's sacrificial love. Mary both witnesses to this love and participates in it. The perception of the beauty of such love is meant to move our hearts to respond in kind.

The figure of Christ represents his humanity as the sign of his divinity; the incarnate Word is the most beautiful of men. His body, even in death, exudes a sense of life. The veins of the hand, arm, and feet, for example, are prominent, whereas in a corpse they would go flat; the eyes seem gently closed; the small beard, moustache, and curled hair are all in elegant state. The brow is un-furrowed and unmarked by the crown of thorns. The lips seem to bear a gentle smile. In contrast to Northern *pietàs*, where the wounds of Christ are empha-sized, here they are virtually unnoticeable. Jesus lies across his mother's knees like a child peacefully asleep. The dead body still shows the life of the divine Son and Word, still united to the body, even though the human soul has departed.[183] (As we shall see, Michelangelo's friend Vittoria Colonna was very taken with the idea that the divine qualities that showed through in Christ during his life also left their traces, *vestigij*, after his death). Michelangelo might also have been acquainted with the legend that as a special favor to comfort

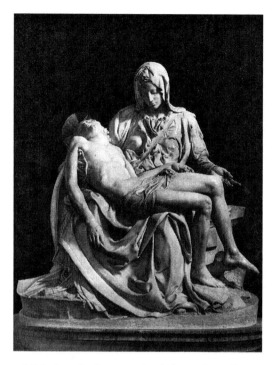

FIGURE 1.20. Michelangelo Buonarotti, *Pietà*, Basilica of St. Peter, Rome. Credit: Alinari / Art Resource, New York.

Mary, God momentarily restored to Christ's dead body all its glory and beauty. (Pietro da Lucca mentions this miracle early in the sixteenth century,[184] but it dates from the Middle Ages. We may presume that at least some of Michelangelo's contemporaries knew of it.) This explanation, however, is perhaps superfluous, given the symbolic cast of neo-Platonic thought and of Michelangelo's art. Although the artist has ostensibly portrayed a narrative moment, the message of the work transcends that moment. It presents above all a timeless icon of the meaning of the passion as a whole.[185] The grace and liveliness of the body signify both the reality of the incarnation and the anticipated life of the resurrection; the historical interval of Christ's death is merely a momentary transition.

The figure of Mary likewise serves as an icon. She is young (Michelangelo explained that this was a result of her virginity and purity) and beautiful. Her eyes are cast down; her face shows no anguish, but rather calm. Her lips even seem to bear a slight smile. One hand holds the upper body of Christ; the other is extended, palm upward, in an elegant stylized gesture that might be inter-

preted as one of lamentation, but equally as one of invitation to the viewer, or of prayer, or of offering, or, of course, all of these.

THE MEANING OF PORTRAYALS OF MARY'S PASSION. As we have seen, fifteenth century theology gave a foundation to an extraordinary degree of devotion to Mary. She was thought to play an active role in the work of redemption through acceptance of her role in the incarnation and especially through her innocent suffering along with her son in the passion. This collaboration could be understood in a way that preserves the uniqueness of Christ, as is clearly the case with Biel and other theologians. Mary is coredemptrix, but she does not operate in redemption on the same level of causality as her son. Mary is able to collaborate in salvation, as we are, because of Christ's grace; but in her case, that grace is operative from the very beginning, and the collaboration is complete. Moreover, Mary works by influence, not by power. Her role is *impetrare* (to intercede), not *imperare* (to command).[186] But, on the other hand, her intercession is infallible, and, most important, is necessary to our salvation; and her infallible intercession is possible by virtue of her willing and conscious collaboration in Christ's incarnation and suffering. Pictorial art, however, does not by itself make such theological distinctions; it is open to different interpretations according to what theology or lack of theology one brings to it, how sophisticated one is as a viewer, and how one chooses to use the art. What is clear is that representations of the suffering Mary, particularly in scenes after Christ's death, make Mary a primary and somewhat independent subject of contemplation, and present her sufferings as an object of devotion.

LITURGY, DRAMA, MUSIC

THE PASSION AND THE EUCHARIST. Gabriel Biel's *Canonis Misse Expositio* (Commentary on the Canon of the Mass) gives us a good idea of the connection made in pre-Reformation theology between the eucharist and the passion of Christ. In consonance with the moral cast of his theology, Biel here particularly stresses the need for the faithful to make Christ's sacrifice their own. We have seen that the cross is the "remedy" chosen by God for original sin. But Biel equally speaks of the eucharist—the concrete means of our participation in the sacrifice of Christ—as that remedy, and sees in it the same "congruence" that is ascribed to the cross, namely, that it corresponds to the sin of Adam. "Our first parents brought many miseries onto the whole of humanity through eating a forbidden apple. Hence it was fitting—indeed necessary—that the same human race be raised up from those miseries by the eating of another food, food

that is saving and fruitful."[187] Here the means of salvation is the sacramental food by which *we* bear fruit that restores the tree.

The eucharist, Biel teaches, is a sacrifice and an oblation; not in the sense that Christ suffers and dies again, but because it is the memorial and sign of Christ's one sacrifice, and because it is the cause of similar effects. The eucharist is both Christ's sacrifice (in sacramental sign) and our sacrifice, insofar as we cohere to Christ by our will and our love.[188] And, Biel stresses, our sacrifice is the *same* as Christ's unique and perfect sacrifice, once offered on the cross: not merely a memorial of it, but "the sacrifice itself and always itself."[189]

And this sacrifice of ours produces effects like those of the sacrifice on the cross. Biel lists four effects of the eucharist: First, it memorializes the passion. Second, it forgives sins. Third, it inflames us with love by being a memorial of the Lord's passion, in which God's love for us is above all shown. Fourth, it gives us the virtue of enduring the sufferings of life (*patientia*).[190]

Savonarola's spiritual writings also indicate a strong connection between the passion and the eucharist. In a short set of instructions for lay people on how to attend mass, he indicates what the pious person should be thinking of while the priest celebrates:

> When [the priest] says the Confession, contemplate human nature full of sins before the coming of Christ, because the whole world was full of idolatry and ignorance of God.
>
> When the mass begins, contemplate the desire of the holy Patriarchs for the coming of Christ...
>
> When he says the Gloria, contemplate Christ born in the stable.
>
> When he says the Epistle, contemplate John the Baptist who preaches.
>
> When he says the Gospel, contemplate the preaching of Christ that came after Saint John.
>
> When he says the Credo, contemplate the faith of the people who followed Christ.
>
> When he offers the chalice, contemplate Christ's willing acceptance of the passion, to which he offered himself.
>
> When he says the Preface, contemplate Christ when he entered Jerusalem on an ass.
>
> When he says the Secret prayer, contemplate the Mysteries of his Passion and how he was raised on the Cross.
>
> When he lowers Him [after the Elevation], contemplate his burial, up to the Our Father.

When he says "the peace of the Lord," contemplate His resurrection.

When he receives Communion, receive Him spiritually, praying God to give you the grace of the Sacrament as though you received communion.

When he returns with the book toward the right, contemplate the end of the world, when the Jews, from whom he departed to go to the Gentiles, will be converted.

When he gives the Benediction, contemplate the glory of the blessed, to whom Christ says: "Come, blessed of my Father."

And note that you must go to mass with this intention: first, you must recollect (*fare memoria*) the Passion of Christ; second, to offer with the priest that sacrifice for you and for yours and for all the faithful; third, to receive communion and to transform yourself into the divine love.[191]

It is notable that the monk presumes that the main purpose of the eucharist, at least for lay people, is meditation on the passion. Since most lay people (outside the educated classes) would not know Latin well, if at all, participation in the liturgy is based on use of the liturgical actions as the occasion for mental prayer. The reception of communion for the laity is presumed to be exceptional: the pious person is normally to "communicate" spiritually. In principle, Savonarola held that frequent sacramental communion was a good thing: the early Christians were able to face martyrdom, he claims (unhistorically), because they received communion daily, and he laments that Christians of his own time generally receive communion—and confession—only once a year.[192] But in response to an inquiry from a lady from Bologna, he writes that "frequent" communion, i.e., receiving the sacrament once a week, or once every two weeks, was generally dangerous for the laity, although it could also be very fruitful for those properly disposed. It is only appropriate for those who are willing to separate themselves from the world, he counsels, and each reception must be preceded by sacramental confession of sins.[193] Elsewhere he counsels that good Christians should receive communion at least four times a year: on the feasts of Easter, Pentecost, the Assumption of Mary, and Christmas.[194]

PASSION PLAYS. The medieval tradition of sacred drama reached a high point in the period immediately preceding the Reformation. It was not equally accepted everywhere; for example, while it flourished in Florence, it was forbidden in Venice.[195] In Paris, the *Confrèrie de la Passion* (Confraternity of the Passion), a

group of amateur actors from the merchant and artisan class, was given permission in 1402 to perform mystery plays. Their performances, which took place at the appropriate liturgical seasons, became highly popular. Passion plays expanded in length and complexity as the century proceeded. They frequently containing thousands of lines of verse, and demanded an enormous commitment from the performers. Many prosperous cities in Germany vied to produce elaborate and magnificent plays.[196]

The passion plays represented events from the entire history of salvation, but with emphasis, of course, on the drama of Christ's crucifixion, which was sometimes represented with a realism dangerous to the performers. By the fifteenth century, the plays had evolved from their simple paraliturgical origins to a more popular vernacular form that blended piety with entertainment. This development was connected with the growth in power and wealth of the cities where the plays were performed, usually in a public square.

Increasingly, noncanonical elements were added to the gospel drama. One frequent expansion was the introduction of a "Lament of the Virgin Mary" (*Lamentatio Beatae Virginis*) at the foot of the cross. There was also a play of Mary Magdalene (*Lamentatio Mariae Magdalenae*), which emphasized the need for redemption through Christ's sacrifice. Such expansions were generally reflections of popular piety. But in some cases comic and even obscene farces were introduced into the productions, leading to their prohibition by ecclesiastical authorities.

As we have mentioned, the dramatic gestures used in the plays are reflected in the art of the period. Likewise, the presence in paintings of figures who point to the scene, or indicate the proper reaction, reflect the drama's use of a choric personage, frequently an angel, who remained on the stage to introduce the action, instruct the audience, and comment on what was taking place.[197] As we have seen, Alberti recommends to painters the use of such a figure.

THE POETIC/MUSICAL PASSION. The passion narratives themselves may be considered a distinct form of literature within the New Testament. Over the course of time, their liturgical use, particularly during Holy Week, led to the development of a distinctive Christian artistic genre: the musical Passion, including musical settings of both the gospel texts and poetic expansions on them. The greatest flourishing of this genre began during the late Renaissance, and it reached its high point during the Baroque period, during which it produced major expressions of the Reformation and Counter-Reform paradigms of theology and piety. The period covered by this chapter, the early Renaissance,

provided the first known settings of the Passion in polyphonic music, an important step in the development of the "Passion" as a musical genre. Before considering some important examples from the period we are currently examining, it will be helpful to look briefly at the early development of the genre of the musical passion itself.

THE EARLY HISTORY OF PASSION MUSIC. The earliest history of the passion in music is somewhat unclear.[198] The custom of reading the passion accounts during Holy Week liturgies stems from early Christianity. It may have originated in imitation of the daily ceremonies held in Jerusalem. Augustine mentions that the passion "of him by whose blood our sins are taken away" is solemnly read and celebrated, "so that by [this] annual devotion our memory may be renewed more deeply."[199] The fifth-century pilgrim Egeria describes a ritual at which the bishop read "the account of the Lord's resurrection," which presumably included some portion of the passion narrative, for she writes that "at the beginning of the reading the whole assembly groans and laments at all the Lord underwent for us, and the way they weep would move even the hardest heart to tears."[200]

The accounts of Matthew and John, the longest and most detailed, have always had special prominence. According to ancient Roman tradition, the passion according to Matthew was read on Palm Sunday. In the pontificate of Leo I (440–461) the tradition was established of reading this gospel also on Wednesday of Holy Week, while the passion according to John was read on Good Friday. By the year 1000, the other passion accounts also took their place in a sequence that lasted for centuries: Matthew's passion on Palm Sunday, Mark's on Tuesday of Holy Week, Luke's on Wednesday, John's on Good Friday.[201]

It is uncertain when the passion narrative began being chanted or solemnly recited rather than simply read—if, indeed, a simple reading was ever the practice in a liturgical context. Probably by about the sixth century, the custom had arisen of a dramatic recitation of the Passion during the Office of Holy Week by three deacons, representing the *chronista* (narrator), *Christus*, and *Synagoga* (the Jewish leaders and the people).[202] Perhaps as early as the eighth century, a differentiation was introduced between the way of singing the different parts. The narrative was chanted on a fixed tone, but the words of Christ were sung in the tone usually used for the gospel, with inflections and cadences. By the high Middle Ages, special tones had been introduced for the singing of the Passion. By the twelfth century, the three parts were divided among the ministers. The priest celebrant took the part of Christ; the deacon,

the role of the Evangelist or *chronista*, and the subdeacon that of the *turba* or crowd and other persons in the story. By the thirteenth century, the voices were related in a way (ultimately based on Plato's musical theories) that became traditional. Christ sings in a deep register, to symbolize *gravitas* (solemnity) and majesty (a convention that has been preserved in many later settings); other characters and the crowd are sung in a very high register; the evangelist or narrator sings in a middle range.[203]

In accord with the new theology of "compassion," this period shows indications of an effort to portray emotion in the liturgical performance of the passion and the other readings associated with it. For example, the great Ordo of Siena cathedral (*Ordo offitiorum ecclesiae senensis*) of 1215 contains the instruction that the words from St. Paul "death on the cross" (*mortem autem crucis*) are to be sung "in a weeping voice" (*flebili voce*).[204] The late thirteenth-century *Rationale Divinorum Officium* (Order of Divine Services) by Johannes Durandus Mimatensis explicitly calls for reading the passion with "the sadness of compassion" (*tristitia compassionis*). The purpose, he specifies, is "to evoke devotion and at the same time sorrow in the souls of the hearers."[205] Durandus also directs a differentiation in the way the three roles are performed: the words of the evangelist and Jesus are to be sung sweetly, those of the crowd "of the most impious Jews" harshly and loudly.[206]

PASSION MUSIC IN THE EARLY RENAISSANCE. By the fourteenth century, the practice had developed of using a chorus, in unison, for the parts of the *turba*. The fifteenth century saw the introduction of two new ways of singing the Passion: the "responsorial" or "dramatic" Passion and the "motet" passion. The development of the new genre of the musical "Passion" was facilitated by the spread of the practice of using notes to indicate polyphonic music.[207] Presumably there was improvised polyphony before this; but the first polyphonic *turbae* written down in musical notation date from the second half of the fifteenth century.[208]

In the responsorial type Passion, the three chanters are retained, but some or all of the *turba* (crowd) sections (and sometimes the voices of individual characters) are set in polyphony, that is, several voices sing them in distinct musical lines in counterpoint to each other. This practice parallels and corresponds to the development of pictorial depictions of the passion and to passion plays of time. More and more people are portrayed as involved in the event, and there is an attempt to "imitate" it, in the sense of giving a pictorial explication of a gospel text.[209] The earliest known examples of this type are English, probably from about 1430–40. They include fragments of a responsorial St. Matthew Passion, and a three-voiced *exordium* (introduction), *turbae*, and soliloquies of

an anonymous *Passion According to St. Luke* (traditionally sung on Wednesday of Holy Week).[210] A *St. Matthew Passion* by Richard Davy (ca. 1490) is the first of this type to have a composer's name attached to it. In Italy, the genre begins in the 1480s, with responsorial pieces from Matthew's and John's passions, probably connected with passion plays.

The rise of many-voiced settings of the passion has an unfortunate connection with the persecution of Jews. The use of multiple voices in singing the *turbae* was a way of further dramatizing and emphasizing the guilt of the Jewish crowd. Significantly, one of the first texts to be set polyphonically was the crowd's cry, "Crucify him!" (*Crucifige eum!*) As we have seen, even during this period theologians followed Aquinas in placing responsibility on the leaders, and not the Jewish people as a whole. Nevertheless, such distinctions obviously were frequently lost on the level of popular preaching and piety. An early example of such polyphony is found in a manuscript of about 1450 from the parish church of Füssen. It has three-voiced settings of only of the Jewish *turbae*, and the manuscript speaks of them as "the horrible faithless Jews."[211]

A further development apparently occurred in Spain, where polyphony was used not only for the *turbae*, but also for the words of Jesus and the evangelist. This innovation was spread by visits of a Spanish choir to the Papal court in Rome in 1462 and again in 1506.[212]

The second new type was the performance of the entirety of the Passion as an extended motet. Each of the three traditional melodies was used as a *cantus firmus* or melodic line to which contrapuntal voices were added. The first known of this type was probably written by Antoine de Longaval (also known as Jean à la Venture), a Flemish musician at the French court, in about the year 1510. It uses a text, *Summa Passionis* ("Compilation of the Passion"), taken from all four gospels. (This music was formerly attributed to the more famous Jacobus Obrecht [or Hobrecht], 1450–1505.)

Passion music thus followed paths that parallel those of the passion as depicted in pictorial art. On the one hand, there is a tendency to dramatize and to evoke emotion. This is especially true of the "responsorial" passion, which is also called "dramatic" precisely because of the effect of the contrast of the polyphonic crowd sections with the narrative's plainchant. On the other hand, the use of polyphony, especially when sustained throughout the entire Passion, added a new dimension, in which the beauty and artistry of the music becomes an important element. Making the Passion into something beautiful to listen to not only makes the account dramatically involving, but also evokes the ultimate sacred context, which is God's conquest of evil and salvation of humanity. Beauty, especially in the context of the cross, is an implicit theodicy.

However, in music, as in art, the dramatization and the beautification of the Passion (present to different degrees, separately or together) are also symptomatic of the emergence of a new form of aesthetic consciousness, which is at this point, still in the service of the sacred, but having its own dynamic.

MARIAN PASSION DRAMA AND MUSIC. As we have already seen, the late Middle Ages saw the development of the "Lament of the Virgin" as a dramatic and musical genre. The short dialogue of Christ with Mary and the "beloved disciple" reported in the gospel of John inspired a mass sequence, the *Planctus Ante Nescia* ("Formerly I knew not lamentation"). This in turn seems to have been the direct or indirect inspiration for the various "Lament of Mary" dramas in which Mary, John, Jesus, and the bystanders all take part. Such lamentations were frequently part of a longer passion play; less frequently, they were independent pieces.

A good example of the genre is the *Bordesholmer Marienklage* (1476), a lament of the Virgin written by one Johannes Reborch, a monk of Jasenitz in Pomerania who later became provost at the Augustinian monastery at Bordesholm in Holstein in northern Germany.[213] The play alternates song and recitation in Latin and Middle Low German, with words set to melodies from both liturgical and nonliturgical sources. Like sacred pictures, the drama was intended to be a sermon in artistic form. Thus there are didactic sections and prayers. But the primary focus is the dramatic evocation of the sorrows of Mary, and the goal is to produce compassion with her. The author's Latin preface to the work clearly indicates its purpose:

> This is a deeply devotional lament of the Most Blessed Virgin Mary,
> with a very pitiful and religious preface. The Blessed Virgin leads this
> lament with four pious performers very devotedly on Good Friday
> before midday, in the church before the choir or on an elevated place,
> or, when the weather is fine, outside the church. This lament is not
> a sport and not a brief affair, but grieving, weeping, and religious
> compassion with the glorious Virgin Mary. When it is performed
> by good and pious people on Good Friday, it moves the people
> standing around, as an audience and as individuals, to pious weeping
> and to compassion in the same way as does a sermon on the suf-
> fering of the Lord Jesus Christ.[214]

Although Jesus himself plays little part in the drama, his sufferings are mentioned frequently. Among them is his consciousness of Mary's pain. "He suffered much heartache inside Himself when He heard His dear mother Mary weep and cry bitterly over Him."[215] It is Mary's suffering that is the

specific center of interest; but the cause of her pain, the passion of her son, is constantly in mind. The performer of the role of John says to the audience:

> Dear friends, you have heard what our good Lord Jesus has suffered.
> Now I want to tell you more things:
> The suffering of Holy Mary is what we want to begin with right here.
> May God let you live so long till you seek His grace,
> And help you today to weep for Holy Mary.
> Watch with fervour her painful grief today
> Which makes her suffer so much
> Because of the death of her dear child,
> By this means, you women, and also you men,
> Let her suffering sadden you.

The play incorporates several traditional songs—not only the *Crux Fidelis* ("Faithful Cross") and the *Stabat Mater*, which are specifically appropriate, but also the hymn *Ave Maris Stella* ("Hail, Star of the Sea") from the liturgy of feasts of the Virgin. The verses composed by Reborch reflect conventional themes. Mary is astonished at the appearance of her son: she asks John, "What is hanging before us on the tree? Is it a man or a worm? It squirms in the nails and fights the bitter throes of death. It must be in great bitter pain."[216] She wishes that she could bear the suffering in his place: "Woe, is that my dear gracious son? I wish that his sharp crown of thorns sat upon my head instead, and his many deep wounds would cover my body instead of his...."[217] Her pains are seen as the sword that Simeon had predicted would pierce her heart.

Anti-Semitism is present in the Bordesholm play, although not to such extremes as in some other such dramas; there is even some sympathy expressed for the "poor Jews" who have acted in blindness. Still, Mary condemns "the false Jews" (*valsche yodenkynt*)[218] for the death of her son. She wishes they would put her to death with him.

In accord with the apocryphal story, Mary covers Jesus' nakedness with her veil: "I wish to cover him again; he shall no longer stand naked. I will wrap my shawl around him, for I, poor mother Mary, will find myself another shawl."[219] She speaks to Jesus, asking for comfort from his "divine mouth." Jesus replies:

> "Woman, act according to my teaching.
> Do not wail and weep so sorely—
> Your great wailing and weeping
> Renews my bitter suffering."[220]

John comforts Mary with knowledge of the coming resurrection, and reminds her of the purpose of the passion, and of her part in it: "Humanity must have been lost were our good Lord not born of you ... He wanted to release humankind by his goodness from the power of evil ... he drove away our old guilt that came from our first parents ... from Eve and from Adam. ..."[221]

John, speaking to the Virgin, describes the effect that this performance is intended to have on the audience: "I am saddened, and everyone is saddened by your sadness. They all weep with you, they sigh. Here the eye turns red, the devoted people weep over the grief of Christ ... all those who are here weep over your great wailing and lamenting."[222] Significantly, in his last address to the audience, John underlines the place of Mary's suffering in their salvation: "Her holy suffering shall aid us all, so that we may come into eternal life." He commends the people "to God and to holy Mary."[223]

In the realm of "high" culture, among the many Marian hymns put into polyphony by Renaissance musicians we find a number of settings of the *Stabat Mater*. The method of contrapuntal writing did not favor a close connection between the meaning of words and the music. As with the polyphonic settings of the Passion, it is the joining of musical elegance and beauty to a prayer text whose subject is sorrow and shared suffering that reveals something of the religious aesthetics of the era.

Conclusions

Sacred art, as we have seen, both reflects theology and is reflected by it. But the aesthetic medium also has criteria of its own, and these affect the message. Because of the way visual art presents data, it is necessarily more concrete than conceptual thought, since the artist must necessarily choose specific spatio-temporal objects to portray, and must locate them in a visual field. But in interpretation, visual art is less specific. This becomes increasingly true as art attempts to reproduce empirical experience, rather than serving as a symbolic medium for conveying ideas. This is of course exactly one of the transitions in the meaning of art that took place in the Renaissance. To the extent that a picture presents empirical data, the message that its viewer receives depends on what "interpretative baggage" the viewer brings to it. Of course, Renaissance art, as we have seen, is far from attempting photographic realism. The artist is still conveying ideas and messages, and still attempts to portray or to evoke of a level of beauty that is seldom encountered in concrete everyday experience. But the conceptual element is necessarily more vague as the naturalistic and decorative elements become more important. Moreover, Renaissance art explicitly

appeals to the emotions; hence, as compared with medieval sacred art, it is more visual and visceral than conceptual.

Another tension that increasingly comes to the fore in Renaissance sacred art and music concerns the purposes of art. Medieval sacred art already had a decorative purpose, and consciously sought beauty of form. Savonarola's complaints about excessive artistry getting in the way of the message were not entirely new. Yet a number of factors in the Renaissance exacerbated the tension. We might mention a few: advances in technique; the use of pagan models and themes; the change in patronage from clerical to secular; the increasing presence of sacred art in private dwellings rather than churches, due to the wealth of princes and the bourgeoisie; the growing importance of purely secular art and music; a new empirical spirit of observation and depiction of nature. All of these factors led to the beginning of what Hans Belting has called "the era of art,"[224] that is, the modern situation in which the arts exist for their own sake, rather than simply as the conveyer of a religious message or as a medium of encounter with a supernatural presence.

One might ask what effect the new tendencies in painting and sculpture toward naturalism and toward independent aesthetic values had on the religious message in sacred art. From one point of view, one might say that there was generally no discernable effect on the message, at least as far as content. Renaissance preachers took moral lessons from events in the Scriptures; Renaissance religious art did the same.[225] We can recognize in the message of much Renaissance religious art the theological characteristics of the late Middle Ages, particularly of the *devotio moderna*: mistrust of intellect, and emphasis on emotion; stress on good works, including the feeling of compassion for the sufferings of Christ. The naturalistic portrayal of the events of the passion and of the grief of Mary, or the portrait-like representation of Christ, might more effectively evoke such a compassionate emotional response, leading to a corresponding response in the affects and will and ultimately in behavior. For many medieval thinkers, this was the very purpose of meditation on the passion. On the other hand, the humanistic and Platonic tendencies in some art might implicitly convey different messages: about the value of the world and the beauty and goodness of the human body; about ways of seeing, and the nature of representation itself; about society and its attitudes and values.

Another set of questions arises from the new uses of art and its new audience. Medieval art was often associated with sacred places.[226] It frequently celebrated or was connected with relics of saints and sites of pilgrimages; indeed, by the late Middle Ages, pictures themselves could be the object of pilgrimages. Pictures were sometimes thought not only to be a means of meditation or of entering into God's presence, but to be invested with some inherent

sacred power. (The English Carmelite Thomas Netter, writing about 1420 to defend the cult of the crucifix and other images, explicitly states that God gives them a certain power [virtus].[227]) Even up to the beginning of the sixteenth century, many people still retained a belief in the "living presence" of persons in cult images.[228] Paintings as well as relics were thought to be therapeutic. (A number of cures were attributed to Grünewald's portrayal of the crucifixion in the Isenheim hospital chapel.) Theologians might explain that the healing power of Christ works through devotion, and our devotion is excited and increased by paintings and sculptures. But many Renaissance thinkers, among them Erasmus, thought that the popular understanding was closer to pure superstition.

Did Renaissance naturalism in any way affect the sacred status or function of artworks? On the one hand, naturalism might tend to reinforce a tendency to an unreflective emotional response. On the other hand, a naturalistic representation has a less "numinous" quality; it is more narrative; sometimes it can be explicitly didactic; sometimes the religious message may be subordinate to admiration of the artistry or the beauty of the work. As we have seen, a new conscious reflection about the nature of art was developing. The notion of "representation" was already being highlighted, and the idea of the supernatural power of images was correspondingly limited.[229] In part, this was a response to the intellectual critique of images; a topic that we will return to in the next chapter, when we consider Reformation iconoclasm. However, it was also part of a cultural shift from the medieval idea of "compassionate spectatorship" to a new form of mediation: art. In this newly self-conscious art there was increased place for the *fantasia* of the artist.[230] Iconoclastic critics had long complained that pictures give us not a vision of reality, but only of the artist's imagination; ironically, the explicit recognition and appropriation of this fact is what would justify the existence of sacred art precisely as art.

2

The Protestant Reformation in the Church and the Arts

Introduction: Cranach's "Crucified Christ
with the Converted Centurion"

In the course of the years 1536–39, the painter Lukas Cranach com-
pleted several versions of a painting of the crucified Christ with the
converted centurion. Although there are variations in details, on
the whole they are similar in theme and style. We shall refer here to
the painting now in Yale University Art Gallery (1536?), using the
versions in the National Gallery in Washington (1532) and in the
Museo de Bellas Artes in Seville (1538) for comparison.

The body of Christ is conventionally portrayed, softly molded
in light and shadow. The chiaroscuro is significantly more pro-
nounced in the later version, and the musculature is slightly more
accentuated; but the contours of the body are the same. In each
painting we can see the influence of the classical nude. Christ wears
the crown of thorns on his head. He is alive, and looks toward
heaven. Above his head on the cross is a placard sheet with the initials
INRI, and above it, written in gold, appear the words Jesus is speak-
ing: *Vater in dein hendt befil ich mein gaist,* "Father, into your hands
I commend my spirit." In the earlier painting, Jesus' face bears an
expression that might be taken as ecstatic; in the later, the ashen color
and disorderly hair under the enormous crown of thorns evoke suf-
fering, but the uplifted eyes with concentrated gaze eloquently be-
speak Christ's address to the Father. The body is not contorted, but is

stretched tightly, as in Flemish crucifixions. The arms are raised only slightly above the horizontal. In the earlier version, there are no visible wounds except those in the nailed hands and feet, and no blood is seen to flow; in the Seville version, blood streams down Christ's arms, sides, legs, and feet, and his body appears wounded all over. Christ is girt with a white loincloth, whose long ends billow out in opposite directions.

The cross is in the shape of a "T," with the placard added on top of it. The wood of the cross is carefully and naturalistically painted to resemble a newly hewn tree. The two thieves crucified with Christ are portrayed with a high degree of naturalism. The "good thief" on Jesus' right has a classical muscular physique and a heroic stance. He looks intently at Jesus. The other thief is bulky (actually fat in the later version), with a scowling face, and he slumps on the cross, looking away from Christ.

At the foot of Christ's cross is the mounted centurion, portrayed in a suit of early sixteenth century armor with fluted surfaces ("Maximilian armor"). In the

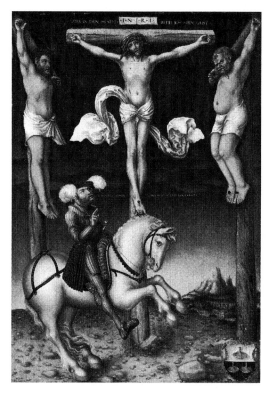

FIGURE 2.1. Lukas Cranach the Elder, *The Crucified Christ with the Converted Centurion*, 1538. Yale University Art Gallery, New Haven, Connecticut. Credit: Yale University Art Gallery / Art Resource, New York.

later painting the armor has gilded piping, like parade armor. The white horse on which the centurion sits assumes a statuesque but improbable pose, elegantly raises its front legs, but without appreciably rearing upward. The face of the centurion bears a similarity to portraits of the Elector of Saxony, Cranach's patron. He wears a plumed hat—broad brimmed in the earlier painting, narrow in the later. He looks upward toward Jesus, and points to him with his right hand. Near the centurion's head appear the words he is speaking, written in gold: *Warlich Diser mensch ist Gotes Sun gewest,* "Truly this man was God's son." A medieval tradition identified the centurion who confessed Christ with Longinus, the soldier who pierced his side. One legend told that Longinus was cured of blindness by the flow of blood that struck him at that moment. This legend is graphically portrayed in some Renaissance paintings, but not here. Yet its symbolic meaning is present. Longinus's coming to sight and confessing Christ was taken to signify conversion, and specifically the conversion of the gentiles.[1] In Cranach's painting, the centurion comes to spiritual sight, expressed in his profession of faith.

The crosses are set in a bare rocky landscape. In the later painting, in the distance as though seen from a height, there is a green plain with the towers of a city, and a white mountain on the horizon. The sky is covered with black clouds above, but is light at the horizon. The cast shadows indicate light shining on the figures from above and to Christ's right, but the source of this light, illuminating the figures against the blackness of the sky, is unexplained. Indeed, we seem to be seeing a sunset behind the figures, making the front lighting more dramatic, but also more unnatural.

In fact, these paintings manifest a curious combination of Renaissance naturalism with a symbolic style reminiscent of the Middle Ages in its disregard for visual realism. Most striking, of course, is the presence of the written word within the painting, clearly indicating its narrative purpose. But other elements also bespeak the painting's didactic rather than pictorial emphasis. The scene itself combines different moments in the gospel accounts. The words of Christ written above his head are spoken only in Luke's gospel, shortly before Jesus' death (Lk. 23:46), while the centurion's confession takes place after Jesus has died (Matt. 27:54; Mk. 15:39; Lk. 23:47). Hence the picture does not present a vision of a single moment in time, but instead indicates a story line with which the viewer is familiar. Such juxtapositions of noncontemporaneous events within a picture were common in medieval art. The modern viewer normally expects a "realistic" picture to represent what one could actually see at a particular moment. In fact, by the sixteenth century Renaissance painting, although still full of symbolism and sometimes anachronisms (in clothing, for example), had largely made this move from painting ideas or

narratives (what the mind knows about the subject) to painting natural objects that the eye sees, and in the way the eye sees them. This meant also the creation of the modern convention of temporal as well as visual naturalism. The narrative style of Cranach's painting therefore marks its specifically religious purpose and allies it to earlier art.

We have noted already the artificial light, with no apparent source, that dramatically illumines the figures. The figures themselves are naturalistic in form, but the body of Christ in particular is lacking in individuality and attention to detail. (For example, as Joseph Koerner points out, there is a contrast between these paintings' portrayal of Christ's nailed feet—which are simply generic representations of feet, unaffected in their contour by the nailing—and the distorted and deformed nailed feet of the crucified in earlier representations.)[2] The centurion's horse, although bulky, is unnaturally small for a warhorse carrying an armed rider. Its proportions are significantly more realistic in the later painting; but its pose and general contours still might remind one more of a wooden horse from a carousel than of a warrior's charger.

The spatial relations in the picture are also ambiguous. As we have seen, correct visual perspective was hailed by early Renaissance theorists as the hallmark of the age's discovery of "naturalism" in painting. But in these paintings, although the individual figures are in realistic perspective, their relation to each other violates perspectival logic. The centurion is placed well in front of the cross of Christ; yet he appears to be looking at him while gazing straight upward, without turning his head away from the viewer, as he would have to do in order to see Christ from this position. (In the early version, the broad brim of his hat would prevent him from seeing anything by simply gazing upward. This anomaly is eliminated in the later paintings by the use of a different style hat.) If we look at the bottom of the painting, we see from the placement of the crosses' feet that Christ's is the foremost of the three (this is much more evident in the Yale and Seville versions). Hence the thieves should be perceived as hanging behind Christ. Yet the relative size of the bodies makes us presume that the thieves are on the same visual plane as Christ, or perhaps even in front of him. Moreover, the portrayal of the story demands that the "good thief" be looking directly at Christ from the side, which is in fact what we "see" when we look at the figures alone, in abstraction from the bottom of the painting. In the later versions, the visual relation between the thief and Christ is achieved at the expense of an unnatural placement of the thief's body in relation to his cross. He seems to be located to the side of the cross, closer to the viewer, rather than on it.

And what are we to make of the billowing loincloth of Christ? Is there any natural circumstance in which it would appear this way? This device is

common in late fifteenth century paintings of the crucifixion, especially in Germany. It seems to have been inherited from Flemish painting, especially that of Rogier van der Weyden. As Leo Steinberg notes, compositionally it is ingenious: it provides a visual balance and a point of interest in the middle of the painting, the otherwise empty space between the three crosses.[3] This is especially true when, as here, the two ends of the cloth fly in opposite directions, forming with the body of Christ another visually dynamic cross shape in the middle of the picture. But how does this device fit in the narrative? Even if we ignore its enormous length, which fits neither with the notion of an under-garment nor with the legend of Mary's veil, the loincloth's complex billowing folds are enigmatic from a physical point of view. The floating cloth could be explained physically only if the cloth were raised unevenly by currents from below. But this looks like falling drapery, not like a cloth raised upward by an undercurrent or blown sideways by a wind. Indeed, the appearance of the loincloth suggests the many careful studies of falling drapery that were a com-mon exercise of Renaissance artists. It seems to be a decorative element, similar to the mantling of helmets in coats of arms, or to the fanciful convoluted floral decorations common in manuscripts and sculpture (see for example the dec-oration of the pulpit from which Luther speaks in Cranach's predella of the Wittenberg altarpiece), or to the convoluted scrolls for captions that occur in many woodcuts (see Dürer's 1495 etching of *The Conversion of St. Paul*).[4] Above all, the billowing loincloth is reminiscent of the unaccountably floating ribbons and cloths so favored by Italian Renaissance painters of mythological scenes (see Raffaello's *Mond Crucifixion* [1502/3], where the device has been applied both to the floating angels and, less extravagantly, to Christ).

In short, the billowing loincloth, although naturalistically portrayed, is clearly not naturalistic in context or meaning. And it would seem that in this context, it is not simply decorative, but is decoration with meaning. In the context of Christ on the cross, it is a visual fanfare, a flourish of trumpets. It is like the robes and banners of medieval angels that blow in no earthly wind, but float gracefully as though in a spiritual current created by their constant mo-tion in the heavenly spheres that are their true home (see the angel in Simone Martini's famous *Annunciation* of 1333)[5] or like the often gratuitously floating drapery that covers the genitals of nude mythological divinities (see Dürer's *Death of Orpheus* of 1494, among many examples).[6] Here, it serves as a banner that proclaims Christ's true identity, even on the cross.[7] (In a woodcut of 1547 by Cranach, the floating loincloth of the crucifix is visually continuous with the banner held by the symbolic Lamb of God atop the altar.) It affirms the truth of what Jesus and the centurion are saying: Jesus puts himself entirely in the hands of the Father in obedience, even unto death; in this and because of

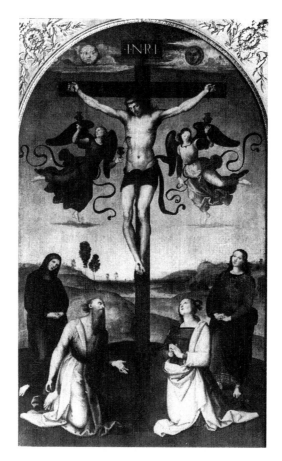

FIGURE 2.2. Raffaello, *Mond Crucifixion* (Crucifixion with the Virgin, Mary Magdalen, Sts. John and Jerome), ca. 1502–03. National Gallery, London. Credit: Foto Marburg/Art Resource, New York.

this, he is truly God's son. The supernaturally billowing loincloth identifies the subject of the painting as *Christus Victor*, the victorious Christ of Luther's theology of the cross.

Part 1—The Theoretical Mediation: Classical Reformation Theology of the Cross

Martin Luther

The cross of Christ is at the center of Luther's theology. "True theology and true knowledge of God is in the crucified Christ."[8] All genuine theology is "the

wisdom of the cross."[9] By such phrases Luther does not merely mean to indicate a theological content: rather, he is insisting that theology must be existential. As opposed to every kind of "natural" theology, Luther proposes a theology that begins with the suffering of Christ, which can only be known if we join ourselves to it. As Paul Althaus puts it, for Luther "we cannot look at the cross as an objective reality in Christ, without at the same time knowing ourselves as crucified with Christ."[10]

At the same time, Luther's theology of atonement and of the cross is complex and multifaceted, and is expressed in a mixture of imaginative and systematic language. Texts written at different times and in different circumstances show considerable difference in emphasis and sometimes in content. Rather than attempting a synthesis, I will refer to some of the major themes contained in various writings.[11]

In the *Larger Catechism* Luther gives a brief summary of the theology of redemption:

Now if someone asks: What do you believe according to the second article [of the creed], concerning Jesus Christ? Answer briefly: I believe that Jesus Christ, the true Son of God, has become my LORD. What does it mean "to become Lord"? It is this: that he has delivered (*erlöst*) me from Sin, from the devil, and from all evil. For formerly I had no Lord or King, but was imprisoned by the devil's power, condemned to death, bound by sin and blindness.

For when we were created by God the Father and had received from God every kind of good, the devil came and brought us into disobedience, sin, death, and every evil, so that we lay under God's anger and disfavor, and were condemned to eternal damnation, as we merited and deserved. There was no counsel, help, or comfort, until this only begotten and eternal Son of God, out of undeserved goodness, took pity on our misery and wretchedness and came from heaven to aid us. So now those tyrants and jailers are all expelled, and in their place has come Jesus Christ, the Lord of life, righteousness, and every goodness and blessedness, and has freed us poor lost humans from the jaws of hell, has won us, has made us free, and has brought us back into the favor and grace of the Father, and has taken us for his own possession under his shelter and protection, so that he may rule us by his righteousness, wisdom, power, life, and blessedness.

Let this be the summary of this article: that the little word "LORD" quite simply means as much as Redeemer (*Erlöser*), that is, the

one who brought us from the devil to God, from death to life, from
sin to righteousness, and who thus preserves us. The parts of the
article that follow do nothing else than clarify and expound this
redemption, saying how and by what means it happened . . . namely,
that Christ became man, by the Holy Spirit and the Virgin, was
conceived and born without any sin, so that he might be Lord over
sin; that for this purpose he suffered, died, and was buried; that
he made satisfaction [*genug täte*] for me and paid [*bezahlte*] what
I owed, not with silver or gold, but with his own precious blood. And
all this, so that he might be my LORD, for he did not do any of
this for himself, nor did he have need of it. Afterward he rose again,
he swallowed up and devoured death. And finally he arose to heaven
and assumed rule at the Father's right hand, so that the devil and
all powers must be subject to him and lie at his feet, until finally
at the last day he separates and sunders us from the evil world, the
devil, sin, etc.[12]

As we can see here, one line of Luther's thought takes "redemption" in its
literal sense: Christ pays the price for our sins and bears God's just condem-
nation. As he explains elsewhere:

Because an eternal, unchangeable sentence of condemnation has
passed upon sin—for God cannot and will not regard sin with favor,
but his wrath abides upon it eternally and irrevocably—redemption
was not possible without a ransom of such precious worth as to
atone for sin, to assume the guilt, pay the price of wrath and thus
abolish sin.

This no creature was able to do. There was no remedy except
for God's only Son to step into our distress and himself become
man, to take upon himself the load of awful and eternal wrath
and make his own body and blood a sacrifice for sin. And so he
did, out of the immeasurably great mercy and love towards us, giv-
ing himself up and bearing the sentence of unending wrath and
death.

So infinitely precious to God is this sacrifice and atonement
of his only begotten Son who is one with him in divinity and majesty,
that God is reconciled thereby and receives into grace and forgive-
ness of sins all who believe in this Son.[13]

Although Luther sometimes uses the term "satisfaction,"[14] and presumes,
like Anselm, that God's mercy cannot be extended unless God's justice also be

satisfied, nevertheless his notion of "redemption" is significantly different from Anselm's. It harkens back to an older idea: substitution (in Luther's German, *Stellvertretung*). "God's Son takes our place," or "stands for us" (*für uns steht*).[15] Of course, this general idea can encompass different meanings. In its wide sense it could include the Patristic and Anselmian schemas. In Luther's interpretation, Christ does not simply render to God's "honor" the moral equivalent of Adam's or of our sins' disgrace (as in Anselm), or accomplish something God loves more than God hates sin (as in Aquinas). Rather, Christ actually takes our place, in two ways: first, by fulfilling God's will expressed in the law, which we are unable to obey; and second, by suffering the pains that our sins deserved, because, by God's so willing it, he has actually "taken on" or "become" our sin. "Whatever sins I, you, and all of us have committed or may commit in the future, they are as much Christ's own as it he had committed them. In short, our sin must be Christ's own sin or we shall perish eternally."[16] This "wonderful exchange" (*mirabilis translaccio*) is the heart of redemption.

"Satisfaction" is here understood as substitution in punishment. It is not simply the restoration of God's "honor," but the accomplishment of God's justice. However, this justice is served by the punishment of a victim who is personally innocent, but replaces the guilty by taking on their guilt. The idea of substitution, as we have seen, has ancient roots. Athanasius, for example, spoke of Christ's undergoing the penalty of death in our place. What is striking in Luther's thought is the insistence on a literal interpretation of the Pauline notion of Christ's "becoming" sin, combined with an emphasis on the unspeakable suffering he bore in our stead. The emphasis on suffering is in strong continuity with the passion piety of the late Middle Ages, which concentrated above all on Christ's physical agony. The possibility of substitution is an element of the heritage of nominalism.[17]

Luther's anthropology provides the background for this view of redemption. In the fall, according to Luther, human nature itself becomes sinful. He denies that humanity's original holiness was supernatural. Hence the loss of that original state meant not merely the forfeit of a specially gifted condition, but the corruption of our nature itself—to the point that our will is virtually incapable of avoiding sin. Moreover, human concupiscence is seen not simply as the disordering of our desires and faculties, but as sin.[18] So corrupt is our condition that we would not even be aware of our plight unless God revealed it. It is Christ's death for us that reveals our sinfulness and God's wrath at it.[19]

But above all, Christ's death reveals God's love. Luther speaks of God's "anger" at sin and sinners. Because of God's holiness and justice, which are God's very self,[20] God cannot but respond to sin with enmity and anger. At the same time, Luther holds that God *in se* is love. We perceive an angry God

because of our sinful mode of being: "For one who sees [God] as wrathful, does not properly see [God], but only a curtain and a covering, indeed a dark cloud drawn before one's eyes...";[21] "in my terror I imagine for myself an angry God...an idol in my conscience. Yet this is not the real God, but a kind of cloud in my heart, which I think is an angry God."[22] Anger is in fact "alien" to God, and against God's nature. The anger of God is actually the product of the bad conscience of the sinner. Yet it is also real: "If you think that God is wrathful, [God] is so...Our ideas have the greatest effect. The way I think of God, that is how God is to me. If this idea of a wrathful God is false, nevertheless this wrath occurs, even though it is false."[23] Because of human wickedness, God's love takes up and uses such ideas as a divine instrument, although they are really the work of our minds and are incompatible with God's true nature.

God's true mind toward us is revealed by our justification through the cross. We are justified by God's acceptance of Christ's suffering in our stead, and by the imputation of Christ's justice to us, who accept it in faith. "God wills us to be saved not by our own, but by another's justice and wisdom, that do not come from us or are born in us, but that come from outside into us...."[24] "Hence I have rightly said that all our good is extrinsic to us: that is, Christ. All are only in us through faith and hope in him."[25] "[God] does not freely give grace in such a way as not to demand satisfaction, but rather gave Christ as the one who satisfies, so that God might freely give grace to those who have thus satisfied through another."[26]

The possibility of such a "marvelous exchange" being worked through faith seems to be grounded in a notion of God's absolute freedom: for God could, theoretically speaking, have willed otherwise.[27] Luther appears here to have absorbed some of the presuppositions of the nominalist Scholastic theology that he largely rejected.

Hence, for Luther, we are justified only by faith. Christ's work was objective, independent of us and our works; but it does not help us without our faith.[28] By faith, Christ's victory is actualized in the Christian. But this does not mean the rejection of good works. As Luther makes clear in his *Commentary on Galatians*, for example, sanctification follows from justification. A good tree bears good fruit, in God's spirit. "Faith looks entirely and completely toward Christ 'for us,' toward his justice 'outside us;' yet, it is at the same time the presence and power of Christ in us," the beginning of a new creation.[29] In his later writings, Luther even formulates his doctrine in terms of a double "justice" (*justitia* or *Gerechtigkeit*): perfect justification is imputed by God, but is not actual (*wirklich*) in us; imperfect justification is actual in us through our works, which are the fruit of the Spirit in us.[30]

But in any case, Luther wishes to emphasize that we do not achieve salvation "on our own." He therefore derides those who see in the passion of Christ simply an example of virtue for us to follow so that we can be saved by our own merits (the "Pelagian" opinion wrongly attributed to Abelard, which Luther ascribes also to the Scholastic theology he learned). Such a view deprives people of the true comfort (an important Lutheran notion) that comes with faith in salvation by Christ, apart from our merits. Indeed, it is counterproductive: "In this way they make Christ not only useless to us but also a judge and a tyrant who is angry because of our sins and who damns sinners...."[31] Influenced by Erasmus's translation of the New Testament's imperative, *metanoeite*, "repent" or "be converted," rather than the Vulgate's *agite poenitentiam*, "do penance," Luther affirmed that our salvation is in trust in Christ's merits, despite our sinfulness, rather than in the process of contrition expressed in confession, penance, and satisfaction for sins[32]—a process so emphasized, as we have seen, by theologians such as Savonarola and Biel.

At the same time, the passion of Christ *is* an example and a "sacrament" for us.[33] The death of Christ on the cross shows us sinners the judgment of God, through which we must also go, in spiritual death and suffering.[34] It is not enough merely to believe in the death and suffering of Christ: we must show it in our lives. Crucial to Luther is not only the cross of Christ, but also the cross of the Christian. We must imitate Christ's suffering and dying, and make his passion our own.[35] Moreover, it is not enough to suffer in imitation of Christ. Love must follow from faith.[36] In his important tract *The Freedom of a Christian* (1520), Luther explains at length that although justification occurs through faith alone, there is a need for the "good works" of love.[37] Where works and love do not follow, the gospel has not really taken hold.

This point follows from another aspect of Luther's theology of the cross. In addition to affirming the notions of satisfaction and substitution, Luther's theology also strongly emphasizes the cross as God's victory over the devil, sin, and death.[38] Indeed, in reality they are the same thing. Sin wishes to damn Christ, with all humanity, but meets his righteousness, his unconquerable obedience. Satan and sin have no right over him; they are defeated by him because he lives in full love of God. Hence sin is conquered.[39] The devil is the lord of this world, armed with power and cruel hate, as Luther proclaims in his famous hymn, "A Mighty Fortress is Our God." But God in Christ's humanity battles against the devil and defeats him, even using him toward God's own ends. It is Christ's humanity that engages in this battle; but without his divinity, he could not succeed.[40] Hence the divinity of Christ is crucial to Luther's soteriology. In expressing this conviction Luther also uses the ancient Patristic

idea of the "tricking" or deceit of the devil, with the humanity of Christ as a kind of "bait" to catch him:

> the devil's folly is that he sees not he has to do with the Son of God; he knows not that in the end it will be his bane . . . I often delight myself with that similitude in Job, of an angle-hook that fishermen cast into the water, putting on the hook a little worm; then comes the fish and snatches at the worm, and gets therewith the hook in his jaws, and the fisher pulls him out of the water. Even so has our Lord God dealt with the devil; God has cast into the world his only Son, as the angle, and upon the hook has put Christ's humanity, as the worm; then comes the devil and snaps at the (man) Christ, and devours him, and therewith he bites the iron hook, that is, the godhead of Christ, which chokes him, and all his power thereby is thrown to the ground. This is called *sapientia divina*, divine wisdom.[41]

Luther sometimes uses extravagant language to express the theme of Christ's victory. The devil is like a lion, who devoured Christ; but Christ has slain the lion and exited from his mouth by the resurrection.[42] Salvation is like a battle between two giants who could swallow up the world, that is, two deaths: death itself, and the death of Christ. "But Christ exclaims: I am the death of death, the hell of hell, a devil to the devil . . . I have won!"[43]

The wonder of God's salvific action is that devil is overcome by his own works. Luther uses a distinction that was made by the early medieval commentator Odo of Cluny, on the basis of a verse in the prophet Isaiah. In Is. 28:21, the prophet speaks of God's own work, and then calls it "a strange work." The Vulgate version translated the Hebrew word for "strange" with the Latin word *alienum*, which could also mean "foreign."[44] On this basis, Odo differentiates between God's own work (*opus ejus*) and the work of others (*opus alienum*).[45] Luther applies this distinction to the process of salvation. God's own work is justification; but God uses the work of others (*opus alienum = das fremde Werk Gottes*), including the crucifixion of Christ, which was the work of the devil and of evil people, to serve the divine purpose.[46] This applies also to us: God's own work toward us is love and the giving of life; but God uses the "alien work" of anger, penance, and punishments on us to prepare us for that love.[47] God even uses the devil's power to afflict us and punish sin.[48]

Luther's notion of exchange demands that Christ "become" sin and suffer its punishment. Hence, for our sake, Christ was actually damned and abandoned by God: in his passion and death, "his human nature was no different

from a person eternally damned to hell."[49] Christ dies the death of the sinner, and experiences God's anger at sin.[50] Here Luther's position borders on paradox, if indeed, one can speak of a single consistent "position" gleaned from his complex of writings. Christ as a human really was accursed, really was abandoned by God, really experienced God's anger and felt as the damned feel. Yet Christ in all this loved God totally, and it was because of the great love of this sacrifice that God raised him. And although he claims that Christ felt the pain of damnation, and interprets the "descent into hell" in these terms,[51] Luther (like Aquinas) also denies that Christ's "descent into hell" was actually to the hell of the damned.[52] And he quotes Saint Hilary's saying that Christ rejoiced with greatest joy to suffer the greatest pain. This also is a pattern for us: God makes us rejoice at the same time that we most greatly suffer.[53] For Christ's victory does not mean the end of the battle. The demonic powers, and the anger of God, are still present realities; they are overcome in Christ, and only in Christ. His triumph of his death and resurrection must become actual in the battle and the victory of his followers.[54]

Luther's scholarly collaborator the humanist Philip Melanchthon put Luther's scriptural theology into dogmatic form. His *Loci Communes Rerum Theologicarum seu Hypotyposes Theologicae*[55] of 1521 was the first textbook of Evangelical dogmatic theology. Luther so admired it that he worked on its translation into German. The context of the work, however, is somewhat polemical. Melanchthon consciously emphasizes the contrast between Reformed and Scholastic theology. Like the Scholastics, Melanchthon explains salvation primarily in terms of the "grace" of God, whose "pledge" (*pignum*) is found in Christ,[56] and whose dispensation is summarized as "the Gospel" (as opposed to "the Law," a Pauline contrast that was a frequent theme of Reformation thinking). But Melanchthon rejects the many Scholastic distinctions regarding the definition of grace. "Grace" for him is finally nothing other than the forgiveness of sin.[57] This grace comes to us by virtue of Christ's act of "satisfaction" or "expiation," in whose saving power we have faith.

> We are justified, then, when having been put to death through the
> law, we are raised up by the word of grace, which was promised
> in Christ—that is, by the gospel forgiving sins, to which we adhere by
> faith, never doubting that Christ's righteousness is our righteous-
> ness, that Christ's satisfaction (*satisfactio*) is our expiation (*expiatio*)
> [for sin], that Christ's resurrection is ours. In short, not doubting
> that our sins have been forgiven (*condonata*) and that now God favors
> us and loves us. Therefore nothing of our works, however good

they may seem or may be, constitutes righteousness, but only faith in
the mercy and grace of God in Jesus Christ is righteousness
(*iustitia*).[58]

Melanchthon is more interested here in the polemical issue of "faith vs.
works" than in a theoretical explanation of the place of the cross in soteriology.
He seems to take for granted that the means of our salvation through the
cross—the "mechanics" of redemption, so to speak—is not an issue in dis-
pute. Hence he uses without further explanation the traditional images ac-
cording to which Christ is "satisfaction" and "victim"[59] who "merited" God's
favor to us.[60] In his 1559 revision of the work, there is a strong emphasis on
the idea that the cross of Christ shows God's anger against sin. In the context
of his treatment of the divinity of Christ, Melanchthon considers the objection
that the divine nature cannot suffer; but that according to the creed, Christ
suffered for us. He responds to this difficulty in terms of the classical Chal-
cedonian distinction of natures and the *communicatio idiomatum* (the predi-
cation to the single person of Christ of what is truly said of either nature). He
cites Irenaeus: when Christ was crucified and died the divine Word was "in
repose" (*requiescente verbo*), precisely so that the suffering and death could take
place. "That is, the divine nature [in Christ] was not in any way wounded, nor
did it die, but it was obedient to the Father, it remained inactive (*quievit*)." In
his explanation of this, we find his idea of the reason for the cross. The divine
Word did not use its power so that "the anger of the eternal Father against the
sin of the human race might cease." This obedience of the Word shows how
horribly offended (*horribiliter offensum*)[61] God was at human sin, and the
greatness of the anger of God that was poured out on Christ, and leads us to
wonder at the humility of the Son.[62]

Somewhat more explicit statements about redemption are found in Mel-
anchthon's "Defense" of the Augsburg Confession (*Apologia Confessionis Au-
gustanae*, 1530; revised 1540).[63] Like Luther, he stresses the power of the devil
over humanity, and sees redemption in terms of Christ's victory in battle on
our behalf. Because of original sin, human nature is in a state of slavery, and is
held in prison by the devil, whom we cannot overcome by our own powers. But
Christ defeats the devil and destroys death and sin[64] through his self-offering
to God.[65] Melanchthon uses a judicial analogy. Christ pays for us, as someone
might pay a debt for a friend. God accepts Christ's merits as redemptive
payment for our debt, for some kind of payment is necessary for our recon-
ciliation,[66] i.e., for the overcoming of God's wrath against sin.[67] Christ's blood
shed for us (as Paul says) blots out the document of debt.[68]

John Calvin

Calvin's theology of the cross and redemption is, like Luther's, highly scriptural in its inspiration and expression. Like Luther, Calvin refers to the whole range of scriptural images for salvation. However, Calvin's theology places particular emphasis on the penal nature of Christ's "satisfaction" on our behalf.

In the *Institutes of the Christian Religion* we find a coherent exposition of Calvin's position. Interestingly, he does not begin his discussion of Christ's work on our behalf with the notion of satisfaction, but with Christ's threefold office of Priest, Prophet, and King, and with the need of a Mediator between God and humanity. Even without sin, such a Mediator would be needed in order for humanity to reach God and become God's children. And it was necessary, not absolutely, but by divine decree, that this mediator should be both God and human.[69]

Although he speaks of the need for a Mediator even in the state of innocence, Calvin does not mean this as speculation about the Scholastic question of whether there would have been an incarnation even if there were no need for redemption. It is true, Calvin says, that Christ was appointed head of all creation before the fall. "But since the whole Scripture proclaims that he was clothed with flesh in order to become a Redeemer, it is presumptuous to imagine any other cause or end."[70] In our actual fallen situation, Christ's work as Mediator is to make us children of God by transforming the "heirs of hell" into heirs of a heavenly kingdom. This work of Christ is presented in terms of "satisfaction," not of God's "honor," but of God's justice:

> Another principal part of our reconciliation with God was, that man, who had lost himself by his disobedience, should, by way of remedy, oppose to it obedience, satisfy the justice of God, and pay the penalty of sin. Therefore, our Lord came forth very man, adopted the person of Adam, and assumed his name, that he might in his stead obey the Father; that he might present our flesh as the price of satisfaction to the just judgement of God, and in the same flesh pay the penalty which we had incurred. Finally, since as God only he could not suffer, and as man only could not overcome death, he united the human nature with the divine, that he might subject the weakness of the one to death as an expiation of sin, and by the power of the other, maintaining a struggle with death, might gain us the victory. . . . clothed with our flesh, he warred to death with sin that he might be our triumphant conqueror; that the flesh which he received

of us he offered in sacrifice, in order that by making expiation he might wipe away our guilt, and appease the just anger of his Father.[71]

Calvin makes clear that the source of redemption is God's benevolent love. To speak of the "anger" or "hostility" of God toward us is a manner of speaking, intended to impress upon us the magnitude of our sinfulness and to excite in us greater gratitude for our deliverance by Christ alone. But

> though this is said in accommodation to the weakness of our ca-
> pacity, it is not said falsely. For God, who is perfect righteousness,
> cannot love the iniquity which he sees in all. All of us, therefore, have
> that within which deserves the hatred of God. Hence, in respect, first,
> of our corrupt nature; and, secondly, of the depraved conduct fol-
> lowing upon it, we are all offensive to God, guilty in his sight, and by
> nature the children of hell.[72]

How did Christ abolish sin, remove the hostility between God and "pur-chase" our righteousness? "It may be answered generally, that he accomplished this by the whole course of his obedience."[73] However, Calvin also insists on the fact that Christ bore for us the punishment that our sins deserved. Indeed, it was important that he actually be condemned as an evildoer:

> To satisfy our ransom, it was necessary to select a mode of death in
> which he might deliver us, both by giving himself up to condem-
> nations and undertaking our expiation. Had he been cut off by as-
> sassins, or slain in a seditious tumult, there could have been no kind
> of satisfaction in such a death. But when he is placed as a criminal at
> the bar, where witnesses are brought to give evidence against him,
> and the mouth of the judge condemns him to die, we see him sus-
> taining the character of an offender and evil-doer... Why was it so?
> That he might bear the character of a sinner, not of a just or innocent
> person, inasmuch as he met death on account not of innocence,
> but of sin.[74]

The very circumstances of Christ's death are meant to remind us that it is a substitution for us:

> Our acquittal is in this that the guilt which made us liable to pun-
> ishment was transferred to the head of the Son of God, (Is. 53: 12.)
> We must specially remember this substitution in order that we
> may not be all our lives in trepidation and anxiety, as if the just
> vengeance which the Son of God transferred to himself, were still
> impending over us.[75]

For the same reason, there is a particular significance to Christ's death *on the cross:*

> The very form of the death embodies a striking truth. The cross was
> cursed not only in the opinion of men, but by the enactment of
> the Divine Law. [Gal. 3:13, 14] Hence Christ, while suspended on it,
> subjects himself to the curse. And thus it behooved to be done,
> in order that the whole curse, which on account of our iniquities
> awaited us, or rather lay upon us, might be taken from us by being
> transferred to him; that Christ, in his death, was offered to the Father
> as a propitiatory victim; that, expiation being made by his sacrifice,
> we might cease to tremble at the divine wrath.[76]

The cross, then, is the symbolic expression of the fact that our sins and their curse were "transferred" to Christ "by imputation." Christ "substituted himself in order to pay the price of our redemption. Death held us under its yoke, but he in our place delivered himself into its power, that he might exempt us from it." As our sins were imputed to Christ, so his righteousness is imputed to us: "Hence that imputation of righteousness without works, of which Paul treats, (Rom. 4: 5,) the righteousness found in Christ alone being accepted as if it were ours."[77] At the same time, the consequence of this new righteousness is a new life in us. That is, the righteousness of Christ not merely externally imputed; we put on Christ, and are inserted into his body.[78]

Calvin goes very far in his use of substitutionary language. It was not enough for Christ to undergo death:

> In order to interpose between us and God's anger, and satisfy his
> righteous judgment, it was necessary that he should feel the weight
> of divine vengeance. Whence also it was necessary that he should
> engage, as it were, at close quarters with the powers of hell and the
> horrors of eternal death . . . like a sponsor and surety for the guilty,
> and, as it were, subjected to condemnation, he undertook and paid all
> the penalties which must have been exacted from them, the only
> exception being, that the pains of death could not hold him . . . after
> explaining what Christ endured in the sight of man, the Creed ap-
> propriately adds the invisible and incomprehensible judgment which
> he endured before God, to teach us that not only was the body of
> Christ given up as the price of redemption, but that there was a
> greater and more excellent price—that he bore in his soul the tortures
> of condemned and ruined man.

More persistently than Luther, Calvin insists that Christ redeemed us by paying the actual price of our sins:

When we say, that grace was obtained for us by the merit of Christ, our meaning is, that we were cleansed by his blood, that his death was an expiation for sin, "His blood cleanses us from all sin." "This is my blood, which is shed for the remission of sins," (1 Jn. 1: 7; Lk. 22: 20). If the effect of his shed blood is, that our sins are not imputed to us, it follows, that by that price the justice of God was satisfied . . . It had been superfluous and therefore absurd, that Christ should have been burdened with a curse, had it not been in order that, by paying what others owed, he might acquire righteousness for them. There is no ambiguity in Isaiah's testimony, "He was wounded for our transgressions, he was bruised for our iniquities: the chastisement of our peace was laid upon him; and with his stripes we are healed," (Is. 53: 5.) For had not Christ satisfied for our sins, he could not be said to have appeased God by taking upon himself the penalty which we had incurred . . . The Apostles also plainly declare that he paid a price to ransom us from death: "Being justified freely by his grace, through the redemption that is in Christ Jesus: whom God has set forth to be a propitiation through faith in his blood," (Rom. 3: 24, 25.) Paul commends the grace of God, in that he gave the price of redemption in the death of Christ; and he exhorts us to flee to his blood, that having obtained righteousness, we may appear boldly before the judgement-seat of God. To the same effect are the words of Peter: "Forasmuch as you know that you were not redeemed with corruptible things, as silver and gold," "but with the precious blood of Christ, as of a lamb without blemish and without spot," (1 Pet. 1: 18,19). The antithesis would be incongruous if he had not by this price made satisfaction for sins. For which reason, Paul says, "You are bought with a price." Nor could it be elsewhere said, there is "one mediator between God and men, the man Christ Jesus; who gave himself a ransom for all," (1 Tim. 2:5, 6,) had not the punishment which we deserved been laid upon him. Accordingly, the same Apostle declares, that "we have redemption through his blood, even the forgiveness of sins," (Col. 1: 14;) as if he had said, that we are justified or acquitted before God, because that blood serves the purpose of satisfaction. With this another passage agrees, viz., that he blotted out "the handwriting of ordinances which was against us,

which was contrary to us," (Col. 2: 14). These words denote the
payment or compensation which acquits us from guilt.[79]

Paying the price for our sins includes experiencing the psychological
pains of damnation: "had not his soul shared in the punishment, he would have
been a Redeemer of bodies only." In the agony in the garden, Christ already
anticipated this pain. Calvin argues that it would have been shameful and "ef-
feminate" for Christ to have suffered such agony merely in anticipation of death,
which so many others (even evil people) have endured with bravery. Rather, he
agonized in anticipation of the pains of hell. "This was the commencement" of
what Christ would endure in his "descent into hell," and "from it we may infer
how dire and dreadful were the tortures which he endured when he felt himself
standing at the bar of God as a criminal in our stead." Those who would avoid
this conclusion have never really considered "what is meant and implied by
ransoming us from the justice of God. It is of consequence to understand aright
how much our salvation cost the Son of God." Hence Calvin also interprets
Christ's cry on the cross, "My God, my God, why hast thou forsaken me?" as the
expression of Christ's own feeling of abandonment by God.[80]

On the other hand, this does not imply a lack of faith on the part of Christ,
although the Spirit was temporarily "hidden" from him: "although the divine
power of the Spirit veiled itself for a moment, that it might give place to the
infirmity of the flesh, we must understand that the trial arising from feelings of
grief and fear was such as not to be at variance with faith." Nor did Christ's
endurance of our curse mean that he was overwhelmed. On the contrary, "by
enduring it he repressed, broke, annihilated all its force. Accordingly, faith
apprehends acquittal in the condemnation of Christ, and blessing in his
curse." Furthermore, although Christ bore God's just anger against our sins,
"We do not, however, insinuate that God was ever hostile to him or angry with
him. How could he be angry with the beloved Son, with whom his soul was
well pleased? or how could he have appeased the Father by his intercession for
others if He were hostile to himself? But this we say, that he bore the weight of
the divine anger, that, smitten and afflicted, he experienced all the signs of an
angry and avenging God."[81] Like Luther, Calvin explains the evil of the cross by
the fact that God uses the works of the ungodly to carry out the divine pur-
poses, while remaining untouched by their evil acts.[82]

Calvin does not hesitate to say that Christ in this way "merited" our sal-
vation, pointing out that Christ's merits are not apart from God's grace, but
depend upon it.[83] Christ's merits are the fruit of God's predestination and
grace; but at the same time they are the "proximate" cause of our salvation.[84]

Moreover, although he places "reconciliation" in the death of Christ, Calvin does not omit the place of the resurrection in salvation; it is the completion of the work of salvation, and the sign of the new life that is given us:

> Although in his death we have an effectual completion of salvation, because by it we are reconciled to God, satisfaction is given to his justice, the curse is removed, and the penalty paid; still it is not by his death, but by his resurrection, that we are said to be begotten again to a living hope, (1 Pet. 1: 3;) because, as he, by rising again, became victorious over death, so the victory of our faith consists only in his resurrection. The nature of it is better expressed in the words of Paul, "Who (Christ) was delivered for our offenses, and was raised again for our justification," (Rom. 4: 25) as if he had said, By his death sin was taken away, by his resurrection righteousness was renewed and restored. For how could he by dying have freed us from death, if he had yielded to its power? how could he have obtained the victory for us, if he had fallen in the contest? Our salvation may be thus divided between the death and the resurrection of Christ: by the former sin was abolished and death annihilated; by the latter righteousness was restored and life revived, the power and efficacy of the former being still bestowed upon us by means of the latter.[85]

The Christian, however, continues to live under the sign of the cross, which we must all bear. Christ's suffering is thus also a model for us:

> Why then should we exempt ourselves from that condition to which Christ our Head behooved to submit; especially since he submitted on our account, that he might in his own person exhibit a model of patience? . . . We may add, that the only thing which made it necessary for our Lord to undertake to bear the cross, was to testify and prove his obedience to the Father; whereas there are many reasons which make it necessary for us to live constantly under the cross.[86]

LATER LUTHERAN AND REFORMED THEOLOGY: STANDARDIZATION
OF CONFESSIONAL AND DOCTRINAL FORMULATION

THE HEIDELBERG CATECHISM. In an effort to reconcile the tensions between the Lutheran and Calvinist movements in the Reformation, Frederick, Elector

of the Palatinate, asked two scholars of his capital city Heidelberg to compose a catechism that would be acceptable to both. Zacharias Ursinus was a professor of theology at the University of Heidelberg; Kaspar Olevianus was the city preacher. They based their work on the outline of a catechism written earlier by Ursinus. The result, the so-called *Heidelberg Catechism*, was published in 1563. Written in question and answer form, the catechism attempts to appeal to common Reformation teaching. It addresses the reader personally (speaking in the second person singular, "tu" in Latin, "Du" in German) concerning his or her faith, and relies as much as possible on direct scriptural teaching. Although the primary occasion for the writing of the work was the controversy over the mode of presence of Christ in the eucharist, it also contains several sections that deal directly with the theme of redemption:

ON GOD THE SON

Question 34. Why do you call him "Our Lord"?

Answer. Because he has saved (*erlöst*) and redeemed (*erkauft*) us, soul and body, from our sins and from the power of the devil, not with gold or silver, [1Pet. 1:18, 19; 1 Cor. 6:20, 7:23] but with his own precious blood, has made us his own property.

Question 36. What profit do you receive by Christ's holy conception and birth?

Answer. That he is our Mediator [Heb. 2:16, 17]; and with His innocence and perfect holiness, covers my sins, in which I was conceived, in the sight of God [Ps. 32:1; 1Cor 1:30; Rom. 8:34].

Question 37. What do you understand by the words, "He suffered"?

Answer. That he, all the time that he lived on earth, but especially at the end of his life, sustained in body and soul the wrath of God against the sins of all humankind [1Pet. 2:24; Is. 53:12], so that by his passion, as the only propitiatory sacrifice [1Jn. 2:2; 4:10; Rom. 3:25], he might free (*erlösen*) our body and soul from everlasting damnation, and obtain for us God's favor, righteousness, and eternal life.

Question 38. Why did he suffer under Pontius Pilate, as judge?

Answer. So that he, being innocent, might be condemned by a temporal judge [Acts 4:27, 28; Lk. 23:14; Jn. 19:4; Ps. 69:4], and might thus free us from the severe judgment of God that should have been imposed on us. [Ps. 69:5; Is. 53:4, 5; 2 Cor. 5:21; Gal. 3:13,14]

Question 39. Is it something more that he was crucified, rather than dying some other death?

Answer. Yes; for in this way I am made certain that he took on himself the curse that lay upon me [Gal. 3:13]; for death on a cross was cursed by God [Deut. 21:23; Gal. 3:13].

Question 40. Why was it necessary for Christ to suffer death?

Answer. Because on account of the justice and truth of God [Gen. 2:17], [the debt of] our sins could in no other way be paid [bezahlt], than by the death of the Son of God [Heb. 2: 9,10].

Question 41. Why was he buried?

Answer. In order to prove that he had really died [Mt. 27:15; Lk. 23: 50-52; Jn. 19:38-42; Acts 13:29].

Question 42. Since then Christ died for us, why must we also die?

Answer. Our death is not a satisfaction [Bezahlung] for our sins, but only an abolishing of sin, and entry into eternal life [Jn. 5:24; Phil. 1:23; Rom. 7:24].

Question 43. What further benefit do we receive from the sacrifice and death of Christ on the cross?

Answer. That by its power, our old self is crucified, killed, and buried with him [Rom. 6:6-8:11; Col. 2:12]; so that the corrupt inclinations of the flesh may reign in us no more [Rom. 6:12]; but that we may offer ourselves unto him as a sacrifice of thanksgiving [Rom. 12:1].

Question 44. Why does [the creed] continue, "he descended into hell"?

Answer. So that in my greatest temptations, I may be assured that my Lord Christ has freed me from the anguish and the pains of hell through the inexpressible terrors, pains and fears that he also underwent in his soul, both on the cross and beforehand [Is. 53:10; Matt. 7:46].

Question 45. What benefit comes to us from the resurrection of Christ?

Answer. First, by his resurrection he has overcome death, so that he might share with us that righteousness which he had obtained for us by his death [1Cor. 15:17, 54, 55; Rom. 4:25; 1 Pet. 1:3, 21]. Secondly, by its power we are already raised up to a new life [Rom. 6:4; Col. 3:1, 5; Eph. 2:5]. Thirdly, the resurrection of Christ is a sure pledge of our blessed resurrection [1Cor. 15; Rom. 8:11].[87]

THE "FORMULA OF CONCORD:" DEFINITIVE STATEMENT OF THE LUTHERAN CONFESSION. In order to reconcile certain theological arguments within the Lutheran tradition, a definitive doctrinal interpretation of the faith was composed in German in 1577 (with a Latin edition added in 1584). Entitled the "Formula of Concord," it took the *Augsburg Confession* as its starting point and used a dialectic of theses and antitheses to clarify points of contention that had developed, while also reaffirming the main tenets of Lutheranism in contrast to the positions of both the "Papists" and the other strands of the Reformation.

As might be expected, emphasis in the *Formula of Concord* is placed on doctrines that were theologically disputed; those that were unproblematic for all Lutherans are generally passed over summarily. For this reason, there is no extensive treatment of the doctrine of the cross; Luther's soteriology is taken for granted. However, we find a number of statements relevant to the meaning of the cross, especially in the sections on "Original Sin" and on "Justification by Faith."

The treatment of "original sin" stresses the total depravity of human nature because of the fall of Adam. Without this, the need for redemption by Christ, and his absolute uniqueness as savior, would be unintelligible. The doctrine presumes the need for "satisfaction:" so great and horrible in God's eyes is the state of humanity because of original sin that only for the sake of Jesus Christ can it be "covered over" and forgiven.[88] It is Jesus' obedience that is named as the primary means of our redemption, rather than his suffering or death itself. However, it is taken for granted that his obedience is "unto death, even death on the cross," and the section on the "The Person of Christ" explicitly states that "the Son of God suffered for us" in his human nature, which was united personally with the divine nature "so that he might suffer and be our High Priest for our reconciliation with God."[89]

Part 2—The Aesthetic Mediation: The Cross in Reformation Art and Music

The Aesthetic Theology of the Reformers

In line with their criticism of the worship practices of the medieval church, and to justify the changes they introduced, the Reformers produced an explicit theology of the use, or the disuse, of sacred art and music.

REFORMATION ICONOCLASM

Some of the Reformers, reacting against the cultic practices of the late medieval church in general, fostered a more or less complete iconoclasm. Most

radical were the Anabaptists, "who regarded art with loathing and contempt, as part of the corrupt culture of their time."[90] Others had very positive and humanistic attitudes toward art in general, but had strong reservations about religious representations. Yet others, Luther in particular, had more ambiguous attitudes that ultimately bore on the history of Protestant sacred art, and in particular on images of the Passion and their use. Luther's influence on the representation of the crucified will clearly be of major interest to our study. But before considering the depiction of the crucifixion in Reformation art, it is necessary to look at the rationale for Reformed iconoclasm, for two reasons: First, precisely because the Reformers placed such emphasis on the cross, the absence of images of the crucified is all the more theologically significant. Second, crucifixes were not only abolished by the iconoclasts, but they were often their favorite target for destruction.

FOREBEARS: LATE MEDIEVAL AND RENAISSANCE CRITIQUE OF IMAGES. As we have seen, the period immediately preceding the Protestant Reformation was one that abounded in the exercise of devotional piety, including the veneration of relics and pilgrimages to their sites, and in the use of images—including, above all, the crucifix—as supports for devotion and sometimes as objects of veneration. Not unnaturally, the excesses occasioned by such piety, which sometimes went considerably over the border of superstition, provoked criticism motivated by both religious and humanistic fervor. We shall mention briefly a few instances in which this criticism bore on images or their use.

The early English reformer John Wyclif (ca. 1329–1384) gives a succinct summary of his position:

> It is clear that [sacred] images can serve good or evil: [they are] good
> [when used] for exciting, facilitating [devotion], and inflaming the
> minds of the faithful, so that they worship God more devotedly; and
> evil when the use of images strays from the truth of faith, so that
> the image is venerated with either *latria* [*latreia*, the worship paid
> to God] or *dulia* [*doulia*, the veneration given to saints], or when
> they produce delight in [their] beauty or richness, or produce emo-
> tions inappropriate to the circumstance.[91]

As an example of a bad sort of image that leads people into error, Wyclif singles out representations of the "seat of mercy" genre that we examined in the last chapter, in which God the Father is portrayed as an old family patriarch with the crucified Christ on his knees and the Holy Spirit flying about as a dove.[92] Another error that Wyclif rejects is the idea that some images can have in them a kind of sacred power; this leads to idolatry.[93] However, Wyclif writes

that images are not forbidden by God's command,[94] and he acknowledges that sacred images can serve good purposes, including instruction of the laity. His complaints are directed above all against the misuse of images (as well as relics), especially in the context of pilgrimage sites. However, some of Wyclif's followers, the Lollards, took a more radical position, holding that honoring any image, including the crucifix, is idolatry; images should not be tolerated on the basis of being means of education for the laity, but should be destroyed. It is the poor who are the image of the Trinity. The cult of images is a means of enriching the clergy; the money spent on them would be better distributed to the poor.[95]

Like Wyclif, Jan Hus (ca. 1369–1415) held that the true church is spiritual, and he correspondingly devalued external rites and objects. He also preached a return to the church of the poor. Some of his radical followers in Bohemia, the Taborites, went a step farther to condemn the use of art in churches as pagan. They put their teachings into practice by storming the churches of Prague and destroying the altar paintings and statues.

We have seen already in the last chapter that preachers such as Savonarola criticized sacred images that distracted from true worship by their excessive luxury and artfulness. While sacred images themselves were not forbidden, and indeed could be useful, richly decorative images that served "vain" pleasures under the pretense of presenting sacred subjects were an offense against the simplicity of life demanded of the followers of Christ. It is poverty that is the supreme ornament of the Christian religion, not luxurious art.[96]

Some of the Italian humanists had a very positive relation to painting and sculpture. However, as Helmut Feld reminds us, many of the northern humanists were essentially book oriented—their interest was in the written and printed word. For example, Desiderius Erasmus, probably the most celebrated among them, had little relation to the visual arts. For Erasmus, in line with the *devotio moderna*, it was *pietas* that was essential in cult and in Christian life. And, like many of the early reformers, (Wyclif, Huss, Savonarola, etc.), he tended to see genuine devotion in terms of a stark contrast between "the flesh" and the spirit, between the external and the internal. He was critical of the cult of relics and of superstitious popular religion. The book was associated with word, thought, concept, and hence with the mind, interiority, and spirit; pictures were associated with the exterior, the material, and the sensible.[97] (This is the other side of the coin of Renaissance Platonism, as, indeed, of every form of "Platonic" dualism. The mind is to rise from the material to the spiritual. The material can aid us in the ascent by pointing beyond itself to the "higher" realm. On the other hand, it is in itself a lower level that is to be left behind once the higher is reached.)

Furthermore, for Erasmus it is the words of the gospel, rather than relics or pictures or statues, that are the true image of Christ.[98] Erasmus was distressed when some Reformation enthusiasts turned to destroying images; he hated violence and disruption of any sort. Moreover, although he was a critic of the misuse of images and other externals of religion, he did not call for their complete abolition. Nevertheless, in his thinking, as in that of many northern humanists, there is an implicit tension—already present among the educated since the time of Bernard of Clairvaux—between word and image, between book and picture. (As Calvin would later point out, even Pope Gregory's famous justification of images as the Bible of the illiterate presupposes that pictures are an inferior mode of communicating the word to those who are incapable of receiving it in its original form.) Although he was not himself an iconoclast, Erasmus's "spiritualist" critique of external religion was a contributing factor to the iconoclasm of those Reformers who were most affected by humanism, especially Zwingli and Calvin.

POSITIONS OF THE REFORMERS. The Protestant Reformation was the occasion of a new and more violent outbreak of iconomachy. Gerardus Van der Leeuw neatly summarizes the various motivations at work in the iconoclasm of the Reformation:

> The Humanistic Enlightenment, with its view that God is too exalted to be represented; its fidelity to the Bible, which values the respect paid to the letter of the Old Testament prohibitions; its ecstatic personalization, which endures neither constraint for image nor sacrament; the protest of the poor against the riches of the Church—all of this together has the effect first of destroying images and then shunning them more or less rigorously.[99]

The question of images was also connected with the critique of the worship practices and the *pietas* of the late medieval church in general, including pilgrimages, relics, cult of the saints, and the Mass,[100] which were often lumped together under the term "idolatry." " 'Idolatry' stood for the sum of all the false, superstitious and devilish practices fostered by the Roman Church; iconoclasm was more a war directed against these than against the things toward which they seemed directed. . . ."[101]

The spread of the ideas of the Reformers led to outbreaks of despoiling churches and the destruction of images. In some places, especially in Switzerland, not only images were destroyed, but also altars and church organs. In many cases in Switzerland, the emptying of churches of their images was orderly and was accomplished by civic authorities. In such cases the action was

sometimes preceded by a "disputation" on the form of worship that the city should follow, including the question of the legitimacy of images.[102] In other instances, the destruction of images was an act of violence, part of the rejection of the heretofore established cult. However, there was a wide spectrum of opinions among the leading Reformers on the specific issue of images, ranging from outright rejection to reserved acceptance.

ICONOCLASM: KARLSTADT, HÄTZER, AND ZWINGLI. In Wittenberg in 1522, partisans of the Reformation stormed the churches and destroyed the sacred images and statues in them. Andreas Bodenstein von Karlstadt provided a theological justification for this activity in a tract on the abolition of images.[103] He claims that sacred images of all sorts are harmful and devilish, and that their destruction is praiseworthy and godly. He bases his position on the first commandment's prohibition of images, which he says remains valid for Christians. Moreover, he explicitly rejects the opinion that it is only idolatry that the Scriptures forbid, but not the worship of the true God through images (as their defenders claimed). If God had wished to be honored through images, Karlstadt replies, God would not have plainly forbidden them.[104] In addition to arguing from Scripture, Karlstadt appeals to a certain "spiritualism." An image of the crucified, for example, can only tell us something about the external, fleshly sufferings of Christ. But Christ himself said that the flesh avails nothing, but only the Spirit (Jn. 6:64).[105] Nevertheless, Karlstadt was not without an appreciation for art in what he thought was its proper place. He dedicated his 1521 tract on the laity's reception of communion from the chalice[106] to the artist Albrecht Dürer, whom he admired.

In Zürich, the Swiss reformer Ludwig Hätzer repeated similar arguments.[107] Hätzer considers the prohibition of images a separate commandment from the first, both of them still binding. He rejects Pope Gregory's argument that pictures are the Scriptures of the laity, as well as the idea that they are means of increasing devotion. Appealing to the same text as Karlstadt (Jn. 6:64), he insists that God alone, not human works, can bring people to Christ. Significantly, Hätzer explicitly refutes the opinion of some that while images should be forbidden in churches, people should be free to have devotional images at home. God's word, according to Hätzer, forbids private sacred images as well.[108]

Zwingli's early position on sacred images was also strongly negative. He rejects the idea that images are means of teaching. God has given us no such means. "Externally, we must be taught by the word of God what devotion (*pietas*) is, and internally we must be taught by the Spirit, not by something shaped by an artist's hand."[109] He explicitly warns about the danger of the

crucifix as being an almost inevitable object of idolatry. The Godhead of Christ cannot be portrayed; his humanity alone should not be prayed to, since it is a creature. Even honoring the suffering of Christ is a form of idolatry.[110] At one point Zwingli states that his critique is only aimed at images that are in some way honored, not at pictures as such.[111] On the other hand, he says that sacred images are intrinsically dangerous. God knows that they will in fact lead to idolatry; that is why God, in divine wisdom, has forbidden them.[112] Toward the end of his life, Zwingli's position softened; images might be allowed, as long as they are not venerated.

Martin Bucer, like Hätzer, considers the prohibition of images to be a separate direct divine commandment that is still binding on Christians. The true God should be known and worshipped everywhere; images locate God in particular places. They thus lead to the forgetfulness of the true God and of the true image of God, which is to be found in God's work of creation and especially in humanity. Against Luther's position, Bucer insists that images are not a "free" or neutral matter; they are forbidden. Their use is a sign of the decadence of the church from its original purity. They should be removed, first by each person from his or her heart, then by the heads of households from their houses, then by the authorities from churches and open spaces.[113]

CALVIN'S ICONOCLASM. John Calvin initially professed a strong iconoclasm: "I approached the task of destroying images by first tearing them out of my heart." But he later said that crucifixes and images were worthy of respect. Nevertheless, he thought they should be removed from places of worship.

His early opposition was based on the biblical prohibition, the danger of superstition, and an insistence on the primacy of the Word. In the first version of his *Institutes* (1536), Calvin repeats Bucer's argument that God is spirit, and cannot be localized. He expands on this in the second version (1539). The first part of the first commandment forbids any attempt to grasp God in a material way; the second part forbids prayer to images. Calvin thus does not accept the idea that images can be harmless, as long as one does not worship them. He explains that "there is no difference whether they simply worship an idol, or God in the idol," because "as soon as a visible form has been fashioned for God, his power is also bound to it."[114] Moreover, he opposes the argument (classical from the time of Gregory the Great) that images are the books of the uneducated. Gregory argued that through pictures the illiterate are able to "read."[115] For Calvin, this view not only implies a class structure in religion, but also assumes that pictures communicate more readily than stories. (This argument was in fact made by medieval and Renaissance authors, but it was not Gre-

gory's original point; in an age of general illiteracy, he merely observed that it was only through pictures that the biblical stories were generally accessible to most of the populace. The invention of the printing press, the spread of literacy, and the evolution of the vernaculars into literary languages had considerably changed the situation by Calvin's time, especially in the cities.)

In his *Commentary on Galatians* (1548), Calvin remarks that the preacher should make the passion present in a living way to his hearers, as St. Paul did to the Galatians. "Those who wish to properly exercise the ministry of the gospel should learn not only to speak and declaim, but also to penetrate people's consciences, so that they feel the crucified Christ and the flowing of his blood." He continues to say that such preaching eliminates any idolatrous physical representations, which were only introduced when the ministry of the word failed. "Where the church has such painters, it needs no more wooden or stone—that is, dead—images. It requires no paintings at all."[116]

It is important to recognize that Calvin does not reject art as such. Indeed, he had a keen appreciation of the arts—perhaps more than any of the other Reformers. But he opposed the use of sacred art and music in the cultic ambit.[117] In this way his thought was in line with the secularization of the arts that was already in process in the Renaissance, and he gave it a theological basis.[118]

ICONOCLASM AND THE CRUCIFIX. As we have mentioned, the crucifix was a particular target for Protestant iconoclasts. Yet, as Koerner remarks, "never is the ambivalence of iconoclasm more evident than when it strikes the image of Christ on the cross."[119] Ironically, the destroyers of crucifixes, in attempting to demonstrate that the images were mere human fabrications, often treated these objects as though they were persons. A crucifix from the Münster in Basel was mocked with the words, "If you are God, then save yourself, but if you're a man, then bleed."[120] In other instances, the image was flogged, or ordered to drink, or otherwise mocked. Strangely, as Koerner points out, the rituals of violence against crucifixes sometimes unconsciously echoed the events of the passion itself.[121] Koerner hypothesizes that the Protestant iconoclasts took "special relish" in the destroying of crucifixes was because they were thought to have special apotropaic powers, especially at the moment of death,[122] and because they "seemed to instance idolatry in its most primary form, as the worship of the image instead of God."[123] Yet at the same time, the Reformers insisted that the passion of Christ had to be received into each person's heart; does this not already imply some kind of image? Martin Luther, at least, would eventually come to this conclusion.

LUTHER: TRUE MEDITATION ON THE PASSION AND THE
DIDACTIC USE OF SACRED IMAGES

LUTHER ON THE USE OF IMAGES. Luther's position on images underwent
several changes during the course of his life. At least in part, these changes
reflected the development of his views on worship and the need for a sacred
space for communal worship. In some early works he speaks of destroying all
churches and worshiping God in common houses and under the open skies.[124]
However, for Luther the essential contrast was not "spiritual" versus "carnal"
worship, but rather a theology of God's grace over against one of human
works.[125] After the destruction of images in Wittenberg, he distanced himself
from the actions of the iconoclasts. At this point, he teaches that images are
religiously indifferent (Lenten Sermons of 1522).[126] In themselves, they are
neither good nor bad, although they can lend themselves to misuse. How-
ever, to take it upon oneself to destroy them is to usurp the authority of the
city magistrates, and indeed might smack of a certain tendency to "works-
righteousness." During the same period (Easter Sermon of 1522), Luther ex-
presses the wish that "the whole Bible [be] painted before everyone's eyes on
the inside and outside of homes."[127]

By 1525, after his struggle against the spiritualist "fanatics" (*Schwärmer*),
who wanted to do away with all externals of worship and during the peasant
uprisings he opposed, Luther's position had significantly evolved. Although the
externals of worship are in themselves neutral, we have a certain need for them,
for example, for a church, a set place in which to worship. Now Luther explicitly
teaches that the Old Testament prohibition of images was directed only at idol-
atry; "a crucifix or other kind of holy image is not to be thought prohibited."[128]
The same applies to other externals of worship. From this point on, Luther's
position becomes more friendly to images. Although one is free to use them or
not, they are "useful" (*nützlich*).[129] Luther can now even recommend the pres-
ence of images in homes, books, and churches.[130] In his tract, *Against the
Heavenly Prophets*, Luther goes even farther, intimating that faith inevitably
uses images, and referring specifically to images of the passion:

> I know for certain that God desires that one should hear and read his
> work, and especially the passion of Christ. But if I am to hear and
> think, then it is impossible for me not to make images of this within
> my heart, for whether I want to or not, when I hear the word of
> Christ, there delineates itself in my heart the picture of a man who
> hands on the cross, just as my face naturally delineates itself on the

water, when I look into it. If it is not a sin, but a good thing, that I have Christ's image in my heart, why then should it be sinful to have it before my eyes?[131]

Luther agreed with the other reformers in condemning images where they became objects of superstition or where they departed from the Scriptures. (Passion piety and the art that served it in particular had incorporated many accretions since the thirteenth century.) But apart from this, as we have already noted, for Luther the basic dichotomy involved in the question of images was not that between spirit and flesh, as it was for the Zwinglians, but that between salvation by faith and salvation by works.[132] It is logical, then, that he should come to the conclusion that there is nothing wrong in images themselves, but only in the kind of misuse that would lead to superstition or would encourage a false spirituality of "works." We have seen examples in the last chapter of the connection made between images, meditation on the passion, compassion, penitence, and good works. It is precisely this connection that disturbed Luther. "Church pictures made 'works-righteousness' concrete in patronage, production and prayer."[133] The solution for Luther and his followers was a reformation in art that corresponded to a new way of considering the cross.

MEDITATION ON THE PASSION. Luther explicitly reflects on the need for meditation on the passion. In this he is in continuity with the spirituality of the late Middle Ages. But, as will be apparent, his views on the purpose of this meditation differ significantly from those of the theologians we considered in the previous chapter.

In two sermons on the passion given in 1518,[134] Luther initially seems close to the older passion piety, explicitly speaking of an appeal to the hearer's emotions (*affectum*), and encouraging us to suffer along with Christ: *quomodo potest ipso plorante non complore, ipso dolente non condolere, ipso tremante non contremere, ipso patiente non compati* ... ("when he weeps, how can we not weep with him, sorrow with him as he sorrows, tremble with him as he trembles, suffer with him as he suffers ..."). Moreover, the passion of Christ is a "sacrament," that is, an efficacious sign, of the death of our old selves and the creation of a new self. It is also an example of virtue, specifically of humility, meekness, love, and long-suffering (*patientia*). However, Luther goes on to make many of the same points as in his later work. We should weep more for ourselves than for Christ, as Jesus says to the women of Jerusalem (Luke 23:28). This saying forbids the "childish and womanly" weeping (*pueriles et muliebres planctus*) that indicates a merely carnal compassion with Christ, but neglects ourselves. "If one does not find and understand oneself in the passion of Christ,

one does not sufficiently understand it, and it is in vain that one suffers along with Christ [*Christo compatitur*]." Luther emphasizes that Christ's sufferings are *pro te*, "for you." In the sufferings of the innocent and divine Christ we should see that our misery is infinite and eternal. The notion of penal substitution enters: we should consider that whatever Christ suffers signifies the eternal evils that should be inflicted on us according to God's judgment. "Christ in his passion took on the person of our sins."

In the second of these sermons, Luther takes up Augustine's meditation on the beauty and ugliness of Christ in the passion, commenting on Ps. 44 (he was "beautiful beyond all humankind") and Is. 53 ("there was no beauty in him"). The beauty is spiritual, and is Christ's; the ugliness of the passion is physical, and is ours. The ugliness we see in Christ's sufferings should be as a mirror held up to us. Again, then, we are led to weep for ourselves and the "infinity" of what we should suffer, were it not for Christ. "Since the one who suffers [Christ] is infinite, anything he suffers is infinite; and no less infinite will be the suffering of others [i.e., the damned]." Consideration of the passion also shows us that our virtues and our sufferings are nothing compared to Christ's. "There is no proportion between the finite and the infinite."

Because we know in faith that the sufferings of Christ were undertaken for our sake, consideration of the passion should lead us to faith and hope, not to despair. "For behold, if one drop of his blood, indeed one part of a drop, suffices for all my sins, how much more the entire passion!" Hence, the message of the passion to the Christian is, "Flee from yourself to him, with true faith, seeing that what is yours [i.e., the suffering due to sin] is absorbed in him and annihilated [*nulla fieri*]."

In another early sermon on "The True And The False Views Of Christ's Sufferings," given between 1519 and 1521, Luther outlines what he thinks is the benefit of meditation on the passion. He first summarizes the "false" or mistaken ways of approaching Christ's sufferings:

1. In the first place, some reflect upon the sufferings of Christ in a way that they become angry at the Jews, sing and lament about poor Judas, and are then satisfied; just as by habit they complain of other persons, and condemn and spend their time with their enemies. Such an exercise may truly be called a meditation not on the sufferings of Christ, but on the wickedness of Judas and the Jews.

2. In the second place, others have pointed out the different benefits and fruits springing from a consideration of Christ's Passion. Here the saying ascribed to Albertus is misleading, that to think once superficially on the sufferings of Christ is better than to fast

a whole year or to pray the Psalter every day, etc. The people thus blindly follow him and act contrary to the true fruits of Christ's Passion; for they seek therein their own selfish interests. Therefore they decorate themselves with pictures and booklets, with letters and crucifixes, and some go so far as to imagine that they thus protect themselves against the perils of water, of fire, and of the sword, and all other dangers. In this way the suffering of Christ is to work in them an absence of suffering, which is contrary to its nature and character.

3. A third class so sympathize with Christ as to weep and lament for him because he was so innocent, like the women who followed Christ from Jerusalem, whom he rebuked, in that they should better weep for themselves and for their children. Such are they who run far away in the midst of the Passion season, and are greatly benefited by the departure of Christ from Bethany and by the pains and sorrows of the Virgin Mary, but they never get farther. Hence they lengthen the Passion by many hours, and God only knows whether it is devised more for sleeping than for watching. And among these fanatics are those who taught what great blessings come from the holy mass, and in their simple way they think it is enough if they attend mass. To this we are led through the sayings of certain teachers, that the mass *opere operati, non opere operantis* [through the work performed, not through the work of the person acting], is acceptable of itself, even without our merit and worthiness, just as if that were enough. Nevertheless the mass was not instituted for the sake of its own worthiness but to prove us, especially for the purpose of meditating upon the sufferings of Christ. For where this is not done, we make a temporal, unfruitful work out of the mass, however good it may be in itself. For what help is it to you, that God is God, if he is not God to you? What benefit is it that eating and drinking are in themselves healthful and good, if they are not healthful for you, and there is fear that we never grow better by reason of our many masses, if we fail to seek the true fruit in them?

He then proceeds to comment on the correct way of meditating on Christ's suffering:

4. Fourthly, they meditate on the Passion of Christ aright, who so view Christ that they become terror-stricken in heart at the sight, and their conscience at once sinks in despair. This terror-stricken feeling should spring forth, so that you see the severe wrath and the unchangeable earnestness of God in regard to sin and sinners, in that he

was unwilling that his only and dearly beloved Son should set sinners free unless he paid the costly ransom for them as is mentioned in Is. 53:8: "For the transgression of my people was he stricken." What happens to the sinner, when the dear child is thus stricken? An earnestness must be present that is inexpressible and unbearable, which a person so immeasurably great goes to meet, and suffers and dies for it; and if you reflect upon it really deeply, that God's Son, the eternal wisdom of the Father, himself suffers, you will indeed be terror-stricken; and the more you reflect the deeper will be the impression.

5. Fifthly, that you deeply believe and never doubt the least, that you are the one who thus martyred Christ. For your sins most surely did it. Thus St. Peter struck and terrified the Jews as with a thunderbolt in Acts 2:36–37, when he spoke to them all in common: "Him have you crucified," so that three thousand were terror-stricken the same day and tremblingly cried to the apostles: "O beloved brethren what shall we do?" Therefore, when you view the nails piercing through his hands, firmly believe it is your work. Do you behold his crown of thorns, believe the thorns are your wicked thoughts, etc.

6. Sixthly, now see, where one thorn pierces Christ, there more than a thousand thorns should pierce you, yes, eternally should they thus and even more painfully pierce you. Where one nail is driven through his hands and feet, you shouldest eternally suffer such and even more painful nails; as will be also visited upon those who, let Christ's sufferings be lost and fruitless as far as they are concerned. For this earnest mirror, Christ, will neither lie nor mock; whatever he says must be fully realized.[135]

Luther clearly presents Christ's redemptive work in the light of vicarious substitution. Strikingly, he echoes a theme of theologians like Savonarola and Biel: one must beware lest Christ's sufferings become "lost and fruitless" for one's salvation. This point he repeats forcefully. One must learn from the passion the extent of one's depravity, "for the benefit of Christ's sufferings depends almost entirely upon man coming to a true knowledge of himself, and becoming terror-stricken and slain before himself. And where man does not come to this point, the sufferings of Christ have become of no true benefit to him."[136] We must "become like the picture and sufferings of Christ," either in this life, or in hell. Nothing other than true meditation on Christ's passion can achieve the necessary and terrifying realization of our sinfulness. Yet we are unable to accomplish this by ourselves; we can only receive the grace of such meditation as God's gift.

In his consideration of the fruit of this meditation, Luther shows his radical distance from the "Pelagianism" of theologians like Biel. Rather than encouraging us to "good works," meditation on the passion should bring us to faith, casting all our sinfulness on Christ:

> When man perceives his sins in this light and is completely terror-stricken in his conscience, he must be on his guard that his sins do not thus remain in his conscience, and nothing but pure doubt certainly come out of it; but just as the sins flowed out of Christ and we became conscious of them, so should we pour them again upon him and set our conscience free. Therefore see well to it that you act not like perverted people, who bite and devour themselves with their sins in their heart, and run here and there with their good works or their own satisfaction, or even work themselves out of this condition by means of indulgences and become rid of their sins; which is impossible, and, alas, such a false refuge of satisfaction and pilgrimages has spread far and wide.[137]

Once meditation on the passage has done its work of terrifying us, we must pass on to confidence in the sufficiency of Christ's saving power. Luther quotes a favorite text, 2 Cor. 5:21: "Him who knew no sin was made to be sin on our behalf; that we might become the righteousness of God in him." He continues:

> Upon these and like passages you must rely with all your weight, and so much the more the harder your conscience martyrs you. For if you do not take this course, but miss the opportunity of stilling your heart, then you will never secure peace, and must yet finally despair in doubt. For if we deal with our sins in our conscience and let them continue within us and be cherished in our hearts, they become much too strong for us to manage and they will live forever. But when we see that they are laid on Christ and he has triumphed over them by his resurrection and we fearlessly believe it, then they are dead and have become as nothing. For upon Christ they cannot rest, there they are swallowed up by his resurrection, and you see now no wound, no pain, in him, that is, no sign of sin. Thus St. Paul speaks in Rom. 4:25, that he was delivered up for our trespasses and was raised for our justification; that is, in his sufferings he made known our sins and also crucified them; but by his resurrection he makes us righteous and free from all sin. . . .[138]

We can then become aware of Christ's "friendly heart, how full of love it is toward you, which love constrained him to bear the heavy load of your conscience and your sin. Thus will your heart be loving and sweet toward him, and the assurance of your faith be strengthened." And from the heart of Christ, we ascend to the heart of God, whose love appointed Christ as our redeemer. We then see God in God's true nature, for we "know God aright, if we apprehend him not by his power and wisdom, which terrify us, but by his goodness and love." The result of this is to turn us from sin, but for a new reason: "When your heart is thus established in Christ, and you are an enemy of sin, out of love and not out of fear of punishment, Christ's sufferings should also be an example for your whole life." Like medieval preachers, Luther then counsels that consideration of Christ's example should be an encouragement to *patientia* in the sufferings we encounter in our lives.

Luther's friend and collaborator Philip Melanchthon later summarized the main points of Luther's ideas in his list of the three-fold function of genuine meditation on the passion (*Annotationes* to the gospels, 1554). First there is a pedagogical function. We must meditate on the facts of the passion, as they are presented in the Scriptures, and learn its causes. Second, there is a spiritual function. We should consider the anger of God at sin, and God's mercy in the act of redemption through the cross. Finally, there is an exemplary function. The suffering of Christ is to be an example for our own lives.[139] All of this, and most of what Luther writes in his sermon, would have received approval from Savonarola or Biel.[140] Conspicuously missing, however, are two important points that late medieval preachers insist on: exciting the heart to compassion with Christ in his suffering, and turning to penance and good works as a result of conversion.

Luther thought that virtually all previous passion piety, based on affectivity and "compassion," almost invariably led people astray in the direction of "works justification."[141] This would apply also to portrayals of the passion that serve such piety. Luther ends the sermon on "The True And The False Views Of Christ's Sufferings" with the statement that true meditation on Christ's sufferings is rare. "We have changed the essence into a mere show, and painted the meditation of Christ's sufferings only in letters and on walls."[142] What kind of representation of the crucifixion could avoid being "mere show," and lead to true meditation on the passion?

The Reformation and Graphic Art: Dürer and Cranach

The nature of Luther's reformation as it affected art may be seen through examining the works of two great artists who adhered to the Reformed cause:

Lukas Cranach the Elder and Albrecht Dürer. Both achieved success and fame prior to Luther's reformation, and both were affected in their art by their conversion to it. It is probably not coincidental that these two great Reformation artists both were printmakers and woodcutters, and were intimately involved with books and printing. Luther's emphasis on the Word of God favored the joining of pictures with words. Moreover, woodcutting and engraving, however naturalistic in their treatment of subject matter, cannot be illusionistically realistic. Both normally lack color. And both these forms of graphic art draw attention to themselves as constructs: the "hand of the artist" is eminently visible, and the interpretive activity of the viewer is necessary. The lines of shading and cross-hatching are apparent, so that the act of constructing the picture into a replica of an act of vision is actively sensed, even if it is subconscious. When we see in a woodcut a representation of a column or pillar, for example, we do not interpret the image as that of a flat surface with lines on it, which is what we actually see; rather, we accept the convention that the distinct and discontinuous lines represent the uniform and continuous shading of a curved body with volume. In this sense, the use of line in woodcuts and engraving to "mean" something visual has something in common with the use of letters in writing.

Cranach and Dürer also provide examples of the difficulties for graphic artist that the new religion involved, both because of its reservations about sacred pictures and because of its insistence on the priority of the Word. And, as we shall see, their conversions to the Reformed cause exemplify two different levels of involvement: somewhat ambiguous in the case of Dürer, highly explicit and committed in the case of Cranach.

A TRANSITIONAL REFORMATION ARTIST: ALBRECT DÜRER (1471–1528)

Unlike Lukas Cranach, whose relation to Luther and his ideas was clear, and who was a major propagandist of the Reformation, Albrecht Dürer presents a certain ambiguity to the historian both of ideas and of art.[143] His place in our study is that of a transitional figure between two religious paradigms, as well that of an influential and classical figure in art, one who produced several masterpieces representing the passion.

There is no doubt that Dürer wished for reform in the church, or that he sympathized with Luther and other reformers who criticized the Papacy and the practices of the Roman church. But he also had a great admiration for Erasmus, who would ultimately break with Luther, and up to the end of his life he associated with and created art works for Lutherans and Catholics alike (including the notorious Cardinal Albrecht von Brandenburg). In fact, at the time

Dürer died in 1528 one could still in practice be both a Catholic and a Lutheran (with a certain "more or less" in either direction). One could still hope for a reconciliation of the parties. Perhaps even more strikingly, one could still be a partisan of reform and have leanings toward the Lutheran Evangelical church on some matters, and the Calvinist or Zwinglian on others. The dispute between Luther and Zwingli on the eucharist, the *Augsburg Confession,* the Diet of Speyr, the Council of Trent (which itself invited Protestant representatives) had not yet taken place. The wars of religion had not yet taken place. There had been excommunications; but these were not infrequent in the Middle Ages, and often ended in reconciliation—not always on Rome's terms. Even those who died excommunicate, like Savonarola, could subsequently be held up as martyrs and even saints of the church.[144]

In this sense, Dürer's confessional stance, defined in terms of what "Protestant" (a word not yet current in 1528) and "Catholic" would later come to mean, is something that cannot be spoken about without anachronism and ambiguity. But there is no doubt that Dürer belonged to the "Reformation" in the wide sense of the word. Like many at the time, including Erasmus and others who remained within the Roman communion, he strongly criticized the abuses of the Papacy and desired a return to a more scriptural religion. Beyond this, it remains somewhat unclear exactly which of Luther's theological and practical ideas Dürer sympathized with, and to what extent. Nevertheless, it is clear that he became and remained essentially, as his best friend Willibald Pirckheimer said, a "good Lutheran." This is all the more striking because for most of Dürer's career he created works of art that were in many respects paradigmatic examples of pre-Reformation piety, particularly with regard to the passion of Christ.

DÜRER AND THE RENAISSANCE. Dürer's religion and art must both be placed first of all within the context of Renaissance humanism. Dürer's success as an artist gave him entry into a high level of society in Nuremberg. He was named a member of the city's Great Council, and associated with educated and cultured members of the gentry. He studied languages, and was able to read Latin. His best friend was Willibald Pirckheimer, a well-educated humanist; it was he who introduced Dürer to the classics, and informed him about philosophy and archeology. Dürer was probably employed by the humanist Emperor Maximilian I because of humanistic qualities as well as for his technical skill.[145]

Dürer made two trips to Italy, including a special journey to Bologna (in 1507) to learn the "secrets" of the art of perspective. So far as is known, however, Dürer never had direct access to the art of antiquity; he received his knowledge of

the ancients through Italian prints, drawings, and art theory.[146] He accepted the Italian Renaissance's estimation of its own importance as a rediscovery of principles of art that had been lost for hundreds of years.[147] In Italy he was befriended by Giovanni Bellini, and was accorded the honors of a great artist. He also came into contact with Italian Renaissance art theory, in particular the ideas of Alberti and Leonardo, and through them began to see the theory of art as a "scientific" endeavor.[148] As we have already remarked, the Northern Renaissance was in general more literary and scholastic than visual and artistic. Its greatest contribution in the field of religion was in biblical philology.[149] Images were appreciated for the historical information they conveyed, rather than as art.[150] At the same time, the Northern Renaissance retained a strong commitment to Christianity. Erasmus, like Savonarola, criticized the Renaissance in Italy for being too pagan. One of Dürer's great contributions was the extension of Northern Renaissance humanism, with its emphasis on rhetoric and its Christian earnestness, to include the visual arts. Indeed, Melanchthon (in his 1531 *Elements of Rhetoric*) compared Dürer's style to the *genus grande* (high or grand style) in the art of rhetoric, while he likened Grünewald's to the *genus mediocre* (middle style) and Cranach's to the *genus humile* (low or humble style).[151]

Dürer eagerly agreed with Leonardo on the status of the artist as a *gentilhuomo*, since painting is a "liberal" art. His estimate of the status of the artist is reflected in his having produced what is, according to Panofsky, possibly the first independent self-portrait in Western art.[152] On the one hand, this self-portrait might be taken as a sign art's movement into the secular sphere and of the new cult of the artist as "genius," specially gifted by God. It may also reflect the new idea of the artist's "self-expression." On the other hand, it has often been remarked that in this picture Dürer deliberately portrays himself in the style of the Savior, in a manner reminiscent of Eyck's famous painting. In this we may see both Dürer's "mystical identification of artist with God" and a reflection of the spirituality of the "imitation of Christ," *noch Christo z'leben*[153] ("to live after the manner of Christ").

Starting around 1500, Dürer embarked on his life-long pursuit of the naturalistic portrayal of human form, taking inspiration from Vitruvius's "Canon" and attempting to reduce the human body to its rational component shapes. It is possible that he also knew the works of the neo-Platonist Ficino, which were available in Nuremberg. Although Dürer could read Latin, he generally wrote in German (employing a translator to put his major works into Latin in order to reach a wider audience). He composed religious poetry to accompany illustrations, and his observations on nature, bodies, measurement, and proportion contributed significantly to the development of the German language in the scientific sphere.

As we have seen, a principal characteristic of early Renaissance art was its "naturalism," the imitation of "nature." Dürer adopted this goal wholeheartedly. He writes: "And you must know, the more accurately one approaches nature by way of imitation, the better and more artistic your work becomes."[154] The purpose of art, according to the Renaissance ideal, is to reproduce the things of nature "as they are." Therefore the artist needs 1) scientific knowledge of how things "really" are; and 2) scientific knowledge of how to reproduce them.[155] Art is thus thought of as essentially "objective." Artists who merely draw or paint according to their inclinations (*nach ihrem wolgefallen*), according to Dürer, produce works with "mistakes" that are laughable to the better educated. In his preface to the *Unterweysung der Messung*, Dürer insists that from learning the art of scientific measurement artists will learn "to be able to recognize real truth and to see it before their eyes, so that they are not only able to portray it, but also come to a correct and general understanding."[156]

As this last statement shows, Renaissance "naturalism," at least as Dürer appropriated it, seems to imply a certain naïve common-sense realism. There is an implicit presumption that how things appear to the eye is how they really "are." In this sense, Renaissance art still holds on to the medieval idea that art's purpose is to convey knowledge. It is to show us what "is." However now reality is associated not with conceptual knowledge, which is best conveyed by symbols, but with "nature" in the sense of what we know by empirical experience. It must therefore be conveyed by accurate representation of what is experienced. Hence Italian art had already embraced a certain degree of "illusionism." It attempted to give a sense of a single "point of view" by adopting a single-point perspective, in order to create an accurate vision of space, rather than simply of the objects occupying that space. Dürer's prints and drawings followed this ideal. "Dürer suggested to the beholder to interpret this paper, not as a material sheet on which letters can be printed as on the pages of a book, but as an imaginary projection plane through which is seen the picture space and its contents."[157]

On the other hand, as we have seen, Renaissance naturalism did not completely coincide with illusionism. For Italian Renaissance art theory the artist was not merely a technician, a mechanical reproducer of things seen. There is need for God-given *ingenio*, talent or genius, and a sense of beauty, all of which had to be developed through culture and learning. Like Leonardo, Dürer thought of art as a divine gift, but also as an achievement of learning, needing liberal culture as well as mathematics. For Dürer, the artist shares with God ability to "create." His naturalism was combined with a certain neo-Platonism. The Platonic "ideas," Christianized as creative ideas in the mind of God, are still thought of as being behind the forms of "nature." But these "ideas" themselves (as Aquinas taught) remain an *incognita prius*, an unknowable "before" existing

things. Therefore they are not models that can simply be directly imitated, but are the source of ever new inventions.[158] "The mind of artists is full of images which they might be able to produce; therefore, if a man properly using this art and naturally disposed therefore, were allowed to live many hundred years he would be capable—thanks to the power given to man by God—of pouring forth and producing every day new shapes of men and other creatures the like of which was never seen before nor thought of by any other man."[159]

Like the Italians, Dürer presumed that beauty and proportion were the concern of the artist, and that the highest aim of art was to capture beauty of human body. But unlike Italians, Dürer did not seek one absolute standard of beauty; he saw beauty as diverse. His theory of proportions was developed not for the sake of providing a single "canon" of beauty, but with the idea of producing specimens that would allow the production of all kinds of figures.[160] Absolute beauty exists only in the mind of God, not in any single human body. Finite beauty can have many shapes. Therefore Dürer sided with Leonardo in demanding variety in art.[161] Nevertheless, he thought that we can seek knowledge of methods of producing beautiful figures through the study of proportions and shapes. At the same time, Dürer thought that the crude, the ugly, and the fantastic could also have a legitimate place in art. In deliberate contrast to Alberti (but in the tradition of Aquinas), he held that the value of a work of art was distinct from value of what it represents.[162]

Finally, it should be remarked that although Dürer's humanism was strongly Christian, and many of his greatest works have sacred themes, we can also see in him the progress of the secularization of art. He had a passionate scientific curiosity, and some of his finest works are close studies of animals and plants; and, of course, his work for the Emperor Maximilian and for other patrons consisted largely of portraiture and decoration.

DÜRER'S REPRESENTATIONS OF THE PASSION. Despite his early criticisms of abuses in the church, prior to the Reformation, Dürer was an earnest and pious practitioner of the Catholic religion of his time, and he spent most of his life creating images that would eventually be judged antithetical to the spirit of the Lutheran reform (let alone that of Zwinglian or Calvinist iconoclasm).

> For three decades, he fashioned art in order to foster devotion in the quest for salvation . . . He felt himself in possession of a gift from God that compelled him to create devotional aids to salvation, including entreaties to the Virgin, the saints, and, above all, emotionally charged devotions of penance, typically grounded in the re-creation of the story of the Passion as the source of penitential piety. Acts of

devotion and acts of penance saved, or, at least, contributed to re-
demption.[163]

Prior to the Reformation, Dürer produced many *Andachtsbilder*, devotional
images with figures that strongly appeal to emotions, some of them directly or
indirectly involving the passion (e.g., several crucifixions and representations of
the dead Christ, *The Seven Sorrows of Mary*, 1496–97; the *Revelations of St.
Brigid*, 1500). In addition, he produced four great series of representations of
the passion. Although in form they are examples of Dürer's innovative work-
manship and Renaissance style, in content they constitute an eloquent example
of late medieval passion piety, with its strong appeal to affective *compassio* and
to penance in response to Jesus' sacrifice, that is, they imply precisely the kind
of passion meditation that Luther would reject. Three of the series were pub-
lished as books of prints; the fourth, the so-called "Green Passion" (because of
the color of the paper) is a series of twelve drawings,[164] perhaps not by Dürer's
own hand, possibly intended as models for another work.

The *Small Woodcut Passion* was begun sometime in 1508 or 1509, com-
pleted in 1510, and published in 1511. It consists of thirty-seven woodcuts in
small format. Facing each plate are Latin verses by the Benedictine monk
Benedictus Chelidonius (= Benedikt Schwalbe, OSB, 1460–1521), a humanist
friend of Willibald Pirckheimer. The series includes the entire history of sal-
vation, beginning with the Fall and concluding with the Last Judgment, but it
centers on Christ's passion. It contains a number of traditional nonscriptural
themes: Jesus taking leave of Mary before going to Jerusalem, Veronica and the
Sudarium, Mary receiving the body of the dead Christ. The relationship between
the artist and the poet in the production of the book is unclear; in some cases,
the pictures were produced before the poems that accompany them, and some
of them were also printed separately, without the poetry, as devotional images.

Chelidonius's poems, which partly derive from older models, are in clas-
sical Horatian style, and essentially consist in an elegantly phrased narration of
the scenes presented, along with frequent apostrophes to the readers/viewers,
exhorting them to compassion, repentance, gratitude, and penance. Thus after
presenting the affecting scene of Christ's parting from his weeping mother, he
asks the reader: "Are you not afflicted with exceeding grief?"[165] And when
Christ is taken to be crucified: "The innocent God freely bears our crime with
the degrading cross—O man, give him constant thanks!"[166] At the scene of the
crucifixion: "Sorrow over him whom the elements mourn; tremble, rend your
breast; o man, why are your eyes not flooded with tears? Here ask for mercy, for
he wishes to forgive even his torturers themselves . . . with tears he calls and
calls you."[167]

The frontispiece to the series is particularly worthy of note. The illustration (here on the same page as the verses) shows Christ seated, crowned with thorns, with the wounds of the crucifixion on his body. He is bent over, head resting on his hand, his eyes are downcast, as though in sorrow. The verses read:

O cause of so many sorrows for me, the innocent,
O cause of my bloody cross and death,
O man, let it be enough that you brought these things upon me
 once—
O cease crucifying me by your new sins.[168]

Obviously, the teaching of the church had always held that Christ suffered for the sins of all humanity, including ours. This was often extended in meditations on the passion to the idea that Christ in his sufferings was conscious (in the union of his human mind with the timeless consciousness of the Logos) that he was undergoing them for *my* sins. But the notion that the suffering of Christ is continued or renewed in the present because of our sins, if taken literally, is of course unorthodox. Nevertheless, it was a common theme of spirituality in the late Middle Ages (and indeed has been heard in preaching since then). In the popular mind, it could no doubt be vaguely associated with the extension of the idea of the eternal validity of Christ's sacrifice into the notion of the mass as an ongoing or new sacrifice for sins. It received prominence in widespread representations of the so-called *imago pietatis,* or "Man of Sorrows" image. Christ here is portrayed alive, frequently standing in his tomb, showing his wounds and with an expression of sorrow and pain.[169]

The *Large Passion* (i.e., large in format or size of the printed sheets) was begun earlier (1496–97) but only finished at about the same time as the more thematically extensive *Small Passion.* Once again, some of the woodcuts were sold as single sheets apart from the published work; and once again, the finished series was accompanied by a Latin poetic text by Benedictus Chelidonius (located on the verso of the prints). While the *Small Passion* emphasized the more human side of Christ's sufferings (even though Chelidonius's poems often refer to him simply as "God"), the *Large Passion* is less aimed at producing the affect of compassion. It represents rather another side of the theology of the cross: the epic battle between good and evil.[170] Its frontispiece, however, once more presents the idea of a perpetual passion of Christ. Jesus is shown sitting before an angry-faced soldier in sixteenth-century clothing who torments him with a reed. Christ has folded hands, already bearing the wounds of the nails: he has already been crucified. His head bears the crown of thorns and rays of light shine from behind it. He looks sadly at the viewer/reader, with slightly parted lips. The words below read:

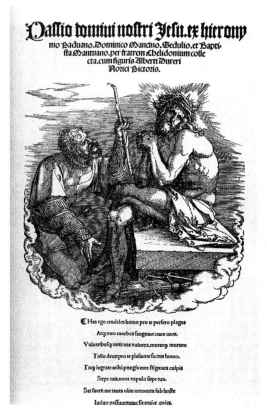

FIGURE 2.3. Albrecht Dürer, *Man of Sorrows*, frontispiece to *Large Woodcut Passion* (*Passio domini nostri Jesu per Fratrem Chelidonium collecta cum figuris Alberti Dureri—Nostri Pictoris.* Nuremberg: 1511). *The Complete Woodcuts of Albrect Dürer*, edited by Willi Kurth (New York: Dover Publications, 1963), 214.

I bear these cruel blows [or wounds] for you, o man,
And by my blood I cure your ills.
I take away your wounds by my wounds, your death by my death,
I, God, for you, a human creature,
And you ungratefully often stab at my wounds with your sins
Often I am flogged by your offences.
It was enough for me to have borne so many torments in the past
Under the Jewish crowd; now, friend, cease.[171]

Sadly, along with the idea of the continuing and renewed sufferings of Jesus because of our sins, we note a recurrent anti-Semitism in the Dürer/ Chelidonius passions. Jesus' historical suffering is attributed to "the Jews,"

even when in the gospel text it is Romans who inflict it (for example in the scene of the mocking and striking of Christ implicitly referred to in the frontispiece). Moreover, although it is not expressly stated in the text, it was a common presumption that the continuing unbelief of the Jewish people was seen as one element in the human sinfulness that constantly renews the Passion.

Dürer's *Engraved Passion* was created between 1507 and 1513. It includes no text; it was intended as a piece of sacred art on its own terms, directed at connoisseurs. It stresses the spiritual rather than the physical suffering of Christ, and never loses sight of his divine status, expressed in human dignity.[172] The frontispiece to this series also shows a version of the "Man of Sorrows." Christ stands at the pillar of the flagellation, holding two scourges, crowned with thorns and showing the wounds of the crucifixion.

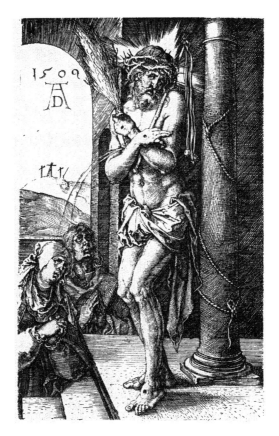

FIGURE 2.4. Albrecht Dürer, frontispiece to the *Engraved Passion* (Nuremberg, 1512). *The Complete Engravings, Etchings and Drypoints of Albrecht Dürer*, edited by Walter L. Strauss (New York: Dover Publications, 1973), 113.

He looks toward the viewer, but the blood from his side flows backward in two streams to land on the heads of the onlooking compassionate Mary and John.

A detailed comparison of the three printed Passions would take more space than is possible in this brief study. The three taken together reveal not only Dürer's constant inventiveness, but also different approaches to the contemplation of Christ's death: some more focused on the evocation of compassion, some showing more emphasis on Christ's divine identity and his triumph. We shall here restrict ourselves to considering the scenes of the crucifixion itself. In the scene from the *Engraved Passion* (1511), Jesus is portrayed already dead. His face has an expression of peace. His body is muscular and heroic. The figure is majestic. One leg is crossed over the other, so that the feet can be shown nailed together; but the body does not appear to sag downward. The loincloth billows out to one side, and then blows in the other direction. Christ's long hair under the enormous crown of thorns also blows away from his face (although nothing else in the picture shows the presence of wind). An open wound in seen in Christ's side (the centurion stands behind), but no blood is seen. Mary and John are dignified in their contemplation of the crucified. Behind the cross, barely visible, Mary Magdalene kneels with an expression of grief. At the bottom of the cross is a skull, representing Golgotha ("place of the skull") and often associated with Adam, whose sin Christ redeems. In the *Small Passion,* by contrast, Christ is sad-faced and sags, dead, on the cross. Blood runs from the wound in his side. Rays of light, signifying his divinity, shoot out in cross-shape from behind Christ's head, crowned with thorns. The onlookers are agitated: soldiers on the right speak to each other, Christ's mother and followers on the left engage in expressions of grief. The *Large Passion* contains the least naturalistic and the most theologically packed representation of the crucifixion. In order to fit all the figures, Dürer has taken liberties with perspective that become apparent if one looks a the relation of the bottom of the cross to the figures gathered around it. A majestic Christ, muscular and well-proportioned, with eyes closed in death, is taut and upright against the cross. His long loincloth floats off behind the cross. Angels collect the blood that flows in streams from each of his wounds. The sun and moon witness to the cosmic significance of the event. To the left Mary sits on the ground, comforted by John and another attendant. The group is posed and dignified. To the right are two mounted figures. One gestures toward Christ with open hand. We recognize him as the centurion making his confession, "Truly this was the son of God."

In 1510 Dürer again collaborated with Chelidonius, each contributing an original poem to accompany a woodcut of the crucifixion attributed to Dürer's student Hans Baldung Grien. Chelidonius's Latin poem is addressed to the

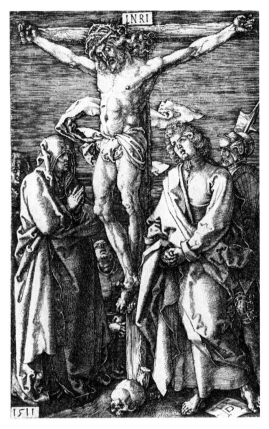

FIGURE 2.5. Albrecht Dürer, *Crucifixion* from the *Engraved Passion*, 1511.
Victoria and Albert Museum, London. Credit: Victoria & Albert Museum,
London / Art Resource, New York.

reader, as though spoken by Christ. He calls the "miserable cause of my death"
to look at his head and open side and see salvation there. To these nailed limbs,
"He draws us, why do we flee?" "Come to me," he invites: "do not flee from my
embraces."[173] Dürer's accompanying poem in German addresses the cross:
"Greetings, thou cross of Jesus! Those who do not believe in you finds no
rest.[174] I pray thee be with me always, in the battle against he world, the flesh,
and the devil, and help me in my last hour of need, when bitter death takes me
away."[175]

Also in 1510 Dürer produced a broadsheet of *The Seven Hours Wherein
Christ Suffered (Sieben Tage Zeit darin Christus auf Erde[n] Leit)*, a version for
laity of the prayers recited in the Office of the Holy Cross. Each canonical hour
(i.e., time of monastic prayer, from Matins in the early morning to Compline
before retiring) represents a different episode of the passion. Dürer composed

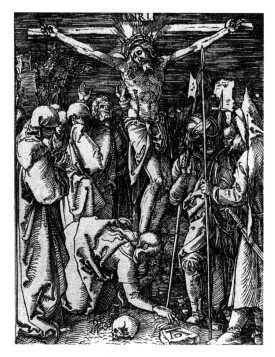

FIGURE 2.6. Albrecht Dürer, *Crucifixion* from the *Small Passion*, 1511. Credit: Foto Marburg / Art Resource, New York.

a German poem that accompanies his illustration of the crucified Jesus with the lamenting Mary and John. Although Dürer's verse essentially derives from the Matins hymn *Patris Sapientia* ("Wisdom of the Father"), he intensifies the drama and gives more prominence to Mary.[176] He also speaks of the events of the passion in the present tense, as though the reader were there, and adds addresses directed to the reader, evoking compassion, empathy, and a sense of penitence. The reader is exhorted to "contemplate this death in your heart always, with great sorrow." Condemnation of the Jews is once again prominent. Dürer writes that Jesus was sold to the "false Jews," and that "all the Jews" shouted "Crucify him!" The redemptive meaning of the cross is summarized in traditional terminology: "his death has merited (*erwarb*) for us eternal life;" "O man, diligently attend to this death, / a medication for your greatest need." Dürer's ending prayer in verse is most explicit in its reference to traditional soteriology: "O Almighty Lord and God / the great martyrdom which suffered / Jesus your only Son / through which he made satisfaction for us (*Damit er für unβ gnug hat thun*) / this we contemplate with intense devotion (*innickeit*). / O Lord give me true repentance and sorrow /over my sins, and make me better.

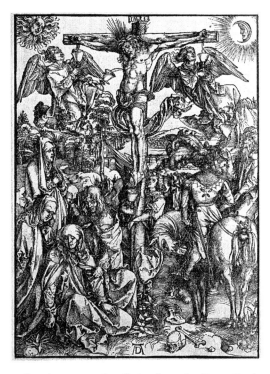

FIGURE 2.7. Albrecht Dürer, *Crucifixion* from the *Large Passion*, 1498. Bayerische Staatsbibliothek, Munich. Credit: Foto Marburg / Art Resource, New York.

/ This I pray Thee with my whole heart. / Lord you have conquered / therefore make me a partaker of the crown of victory."[177]

As we have seen, in his last years Dürer became a follower of Luther's Reformation. This meant, as Panofsky puts it, "conversion from a humanistic and therefore more or less anthropocentric point of view to the uncompromisingly theocentric convictions of Luther."[178] Unlike Cranach, Dürer did not produce a great body of identifiably "Protestant" art, although some attribute the less decorative and simpler style of his later years to his conversion. In any case, he virtually ceased producing the traditional *Andachtsbilder*, with the exception of a few pictures of the crucifixion and the deposition/lamentation of Christ.[179] (These, however, seem still to retain the evocation of *compassio* and *condolatio* that we find in Dürer's earlier treatments.)

In striking contrast to his earlier representations is the drawing *Crucified Christ* of 1521–29. Dürer returns here to the ancient tradition of portraying the feet nailed separately, a mode of representation almost extinct since the beginning of the Gothic era.[180] Since Dürer at this time was occupied by the

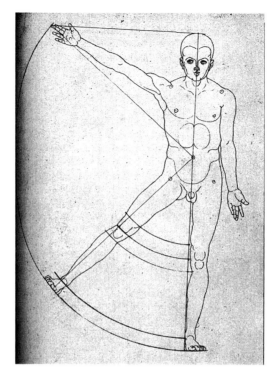

FIGURE 2.8. Albrecht Dürer, *Human Proportions*. From *De Symmetria Partium in Rectis Formis Humanorum Corporum* (Nuremberg: 1532).

question of proportion in nature and in art, particularly in the proportions of the human body, it is not surprising that we find in this figure similarities to his studies of the body in his book on proportion. It can only be a matter of speculation whether there is any "theological" significance in the difference of this crucifixion from Dürer's earlier representations, or whether the differences simply derive from the purposes of this study. From this period also (ca. 1523) art historians date an uncompleted engraving of the crucifixion, with a classically modeled muscular Christ in a similar erect posture standing on a suppedaneum. Unusually, he is tied as well as nailed to the cross. Here his loincloth billows on one side, and hangs low on the other. The picture is crowded with figures who show a dignified grief. The background shows a contemporary German landscape and city.

During this last period of his life, Dürer turned increasingly to engraved portraits, including Cardinal Albrecht of Brandenburg, Pirckheimer, Frederick the Wise, Melanchthon, and Erasmus.[181] In a number of these, a cross appears reflected in the iris of the subject's eyes. From a naturalistic point of view, this can be seen as the reflection of a four-paned window through which light shin-

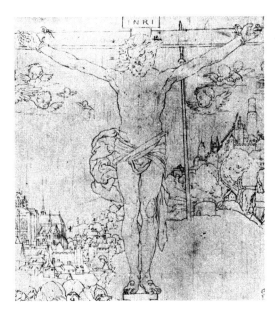

FIGURE 2.9. Albrecht Dürer, *Crucified Christ with Many Figures*. Uncompleted engraving. *The Complete Engravings, Etchings and Drypoints of Albrecht Dürer,* edited by Walter L. Strauss (New York: Dover Publications, 1973), 211.

ing toward the subject. However, it occurs even in the portrait of Melanchthon, who seems to be shown outdoors.[182] This leads to the suggestion that there is a purposeful Christian symbolism intended: the Christian keeps the cross ever before his eyes.[183]

LUTHERAN PAINTING: CRANACH'S "CRUCIFIXIONS" AND REFORMED SACRED ART

The Lutheran Reformation in art was accomplished and exemplified especially by the painter and illustrator Lukas Cranach, directly in response to the spirit of Luther and in fulfillment of the needs of Lutheran sacred art.

By the time of the Reformation, Lukas Cranach (1472–1553; called "der Ältere," "the Elder," to distinguish him from his artist son of the same name) was a famous and rich man, one of the leading citizens of the city of Wittenberg, whence he moved from Vienna in the early 1500s, and where Luther taught. There he became court painter to the Duke-Elector of Saxony, who would be Luther's protector. Cranach had a long and intimate relation to Luther himself. In 1520 Luther served as godfather to Cranach's daughter Anna. The ex-nun Katharina von Bora, Luther's future wife, lived in Cranach's house from 1523 to

1525. Cranach presented to her Luther's proposal of marriage, and with his wife Barbara was witness to their marriage. He was godfather of Luther's first son, Johannes, in 1526. The reformer and the artist were also related professionally and religiously. Cranach supervised the printing of Luther's propaganda booklets, designed woodcuts for the his German version of the New Testament, and painted Protestant princes and reformers, including Luther himself (dozens of portraits) and his wife. Most importantly for our topic, he also worked with Luther and under his influence to create a new style and subject matter to fit the new reformed approach to faith.[184]

We have already seen an example of the results of this collaboration in the didactic and symbolic style of painting in Cranach's celebrated *Crucified Christ with the Centurion*. The characteristics of this series of paintings are all the more striking when we compare such later works with images of the crucifixion done by Cranach earlier in his career, as well as those by his contemporaries.

As we saw in the last chapter, the period immediately preceding the Reformation was one in which Christ's passion was treated with graphic emphasis on the violence of the events and on the sufferings of Christ and of Mary. Their purpose was to evoke compassion and allow the viewer thereby to make the work of redemption his or her own. They used an increasing degree of naturalism in pursuit of this goal. Cranach the Elder's early treatments of the theme fit this pattern.

In Cranach's *Calvary* of 1502 (or 1503; now in the *Kunsthistorisches Museum*, Vienna), the suffering of the crucified Christ is portrayed with a vividness that nearly rivals that of Grünewald's paintings.

The body of the dead Jesus—disproportionate in size to the other figures, but not so obviously as in Grünewald—sags limply on the cross. It is covered all over with bloody wounds. Blood flows abundantly from the wound in the side. The head is crowned with thorns, but is also surrounded with thin golden rays (the style of the "halo" of all the saints in the picture). The mouth of the dead Christ gapes open, a reminder of his last agonized call. His feet are nailed separately, and blood flows from them down the length of the tree of the cross. The feet are deformed and distorted because of the nails passing through them. The two ends of the loincloth pass between Christ's legs and blow out straight in the same direction, in sharp contrast to the decorative drapery in other representations. At the foot of the cross is the swooning Mary, with John and the attendant women. There is also a crowd of soldiers on foot and on horses. Both people and horses are highly individual and lifelike, in contrast to the conventionalized figures in the later paintings. There is a large and detailed landscape, painted in careful perspective. *Compassio* seems plainly to be the point of

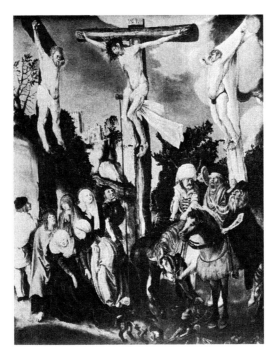

FIGURE 2.10. Lukas Cranach the Elder, *Crucifixion*, ca. 1503. Kunsthistor-
isches Museum, Vienna. Credit: Foto Marburg / Art Resource, New York.

the image: "Instead of Redemption and Triumph, we are urged to contemplate
Mary's bitter emotional suffering, Christ's helpless cry, the pitiless response of
the soldiers and the abject misery of the dead or dying Thieves."[185]

Another Cranach painting, from 1503 (now in the *Alte Pinakothek*, Mu-
nich), presents perhaps an even greater contrast to the late works we examined
in the introduction to this chapter.

Here the cross of Christ is not even in the center of the picture, but is
seen in a three-quarters side view on the extreme right. Christ and the thieves
are already dead; we can see the bruised wounds where one thief's legs were
broken (the feet are unnailed, so that his carcass hangs weightily, like meat in a
butcher shop). The other thief's cross is seen in a three-quarters rear view, so
that the body is barely visible. Cranach has created a *tour de force* of the use of
perspective, foreshortening, and composition to create the illusion of a real
space into which the viewer enters. We see the middle cross of the first thief
in the extreme left foreground, presenting its back and side to us. Our learned
instincts of pictorial realism make us "see" it as though embedded in the
ground outside the picture, in the space of the viewer. In the center foreground
(visually just within the framework of the picture) is the stump of a hewn tree,

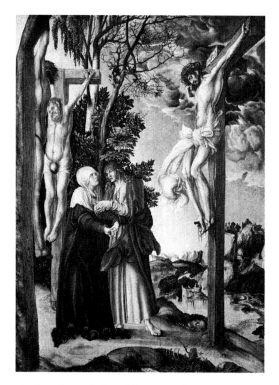

FIGURE 2.11. Lukas Cranach the Elder, *Crucifixion*, 1503. Alte Pinakothek, Munich, Germany. Credit: Scala / Art Resource, New York.

leading us farther into the visual space of the painting. Proceeding to the right, and deeper in, the eye encounters Jesus' cross. To its left, and slightly deeper still, we see the figures of Mary and John.

The gaze of Mary toward Jesus, through empty space on the blue background of the sky, occupies the center of the picture. To the left of Mary and John, and still deeper in the visual space of the painting, is the cross of the second thief. Above (or, in the logic of the painting, behind) it are trees, establishing a further level of depth. One tree is dead; another is flourishing with life. The foliage at the center of the picture points in the same direction as Mary's gaze, reinforcing the visual dynamic. The crosses are made of planed boards, painted with painstaking detail. Christ's cross appears to be at the edge of a precipice. Just above its foot is a landscape with water (symbolizing baptism?), fields, towers, and mountains. Their tiny size tells us that they are far removed. To the left of the cross are what appear to be human remains: bones near the tree stump, what looks like an agonized face at the cross's foot. At the

top of the painting are massed dark clouds and patches of clear blue sky, which our learned visual logic tells us extends from the horizon to over our heads. (Are the clouds about to cover the sky, in nature's mourning over Christ's death—or are they retreating in the face of a brightening sky, sign of the coming resurrection?)

The face of Christ is calm in death. His head, crowned with thorns, hangs forward. The taut body is covered with streams of blood from his wounds. The large loincloth is tied in a bow, and falls in billows in front of him. Mary looks at Jesus with an expression that could be one of wordless sorrow, awe, or reverence, while John looks with concern and compassion at Mary. Both are wringing their hands, a sign of grief. Their arms are interlinked; Christ has given Mary into the disciple's keeping. Once again in this painting we are directed not so much to a contemplation of Christ himself as to an identification with the onlookers and with their emotions.

Such paintings stand in stark contrast to Cranach's later approaches to the crucifixion, such as the various renderings of *Christ Crucified with the Converted Centurion* that we examined in the introduction to this chapter. Joseph Koerner makes the case that Cranach's later religious works clearly exemplify the kind of "crude painting" that Luther thought appropriate to sacred art. What Luther called "crude, external images (*große eusserliche bilde*)"[186] would be unsuitable for idolatry or for a spirituality of "works" based on affective identification with the images. Like Savonarola, Luther wished that religious paintings should not draw attention to the artistry or beauty, but rather should serve uniquely to convey the religious message.

Of course, the decline in quality that many see in Cranach's later works may also be due in part to the expansion of his workshop, his increasing use of assistants, and a certain standardization of images that made their production quicker and easier. Moreover, it is unclear exactly when to date the beginnings of a change in Cranach's style because of Luther's influence. Some elements of change may predate the outbreak of the Reformation in 1517.[187] Nevertheless, after Luther's break with Rome and Cranach's associations with him in spreading the reformed faith, a new form emerges. We can see definite differences not only between Cranach's early sacred pictures and his later ones, but also between the later religious works and his secular works of the same period. The differences regard the content, the degree of naturalism, and the style of the paintings. It seems fair to say, then, that in Cranach's late crucifixions we are faced with a purposeful retreat in sacred painting from a fair degree of realistic naturalism to a more conventionalized "iconic" style. Further, this change is due to Cranach's appropriation of Luther's idea of religious painting

as a primarily didactic medium, what Koerner calls the "mortification of painting through text, gesture and style."[188]

Several more examples will serve to further elucidate the characteristics of Cranach's new "Lutheran" didactic style of painting, particularly in relation to the all-important message of the cross.

In a 1538 crucifixion (now at the Art Institute of Chicago), Cranach presents a scene more typical of the late Middle Ages, with a large crowd of people, those in the foreground divided left and right between the good and the bad. At the bottom left, Mary swoons, while John and two of the women gaze at Jesus. Except for these figures, all the onlookers are dressed in sixteenth-century costume, mostly military. Again, the cross of Christ is portrayed as considerably nearer to the viewer than those of the thieves. The figure of Jesus is of the *Christus Victor* type, with billowing loincloth. He is alive, with no apparent wounds. He appears to be speaking. The body is conventional. Directly below the cross, and in the plane closest to the viewer, is a man in bourgeois clothing holding the hand of a small boy. The man points to Christ on the cross, like the centurion in other paintings, while addressing the child, who looks intently at him. Like the centurion, he indicates the didactic and catechetical purpose of the painting, pointing out to his child the salvific event taking place.

The altarpiece of the church of Saint Wolfgang in Schneeberg (1539), like Grünewald's at Isenheim, consists of a series of panel shutters that can be opened or closed to reveal several different combinations of pictures.[189] It contains two representations of the crucifixion: a large double panel, and a single panel in a series with accompanying texts. In the altarpiece's second open state we see a triptych of the agony in the garden (left), the crucifixion (large center panels), and the resurrection (right). The bottom third of the left and right panels is occupied by portraits of the patrons. Beneath, the predella of the altarpiece shows the Last Supper. The crucifixion scene is reminiscent of that just discussed, except that here Christ is dead, and the wound in his side is clearly visible. In the midst of a crowd of riders, the centurion is identifiable by his pointing gesture. Again, Mary swoons at the bottom left. At the bottom right, the soldiers are engaged in violent dispute over Christ's clothing, with drawn weapons. The first open state of the altarpiece contains a series of panels illustrating the theme of "the Law and the Gospel." Here the crucifixion is presented in a more metaphorical and imaginary context, although the painting of individual figures is quite naturalistic. At the bottom of the pictures runs a series of Scripture quotes that explain what is portrayed. Most significantly, the paintings here are essentially illustrations of texts—for Lutherans, the ideal use of the painted image.[190] (Obviously, this illustrative use of pictures was not new with the Reformation. It was quite common in the Renaissance for texts

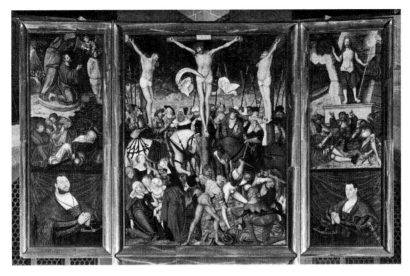

FIGURE 2.12. Lukas Cranach the Elder, *Crucifixion*, 1539. Church of St. Wolfgang, Schneeberg. Credit: Photos Constantin Beyer.

to be incorporated in the frames of paintings, as with Eyck's crucifixion, or sometimes even within the painting itself. But the Lutheran emphasis on this style and function of graphic art ran counter to the Renaissance sense of illusionistic naturalism and to the growing independence of the visual arts as a mediation of meaning.)

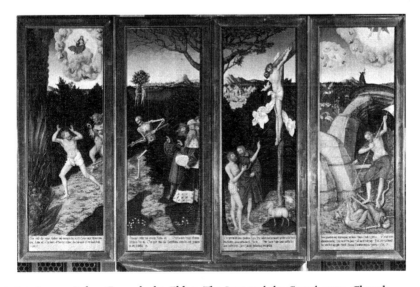

FIGURE 2.13. Lukas Cranach the Elder, *The Law and the Gospel*, 1539. Church of St. Wolfgang, Schneeberg. Credit: Photos Constantin Beyer.

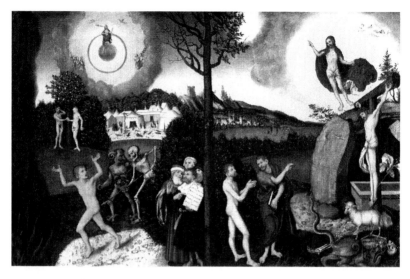

FIGURE 2.14. Lukas Cranach the Elder, *The Law and the Gospel.* Schloss Friedenstein Museum, Gotha, Germany. Credit: Foto Marburg / Art Resource, New York.

Cranach treated this theme several times in a similar manner. Sometimes the work bears the title "The Justification of the Sinner" (for example, the 1535 painting by Cranach's workshop now in the Germanisches Nationalmuseum in Nuremberg), which is in fact the central point. At other times it is called "The Law and the Gospel" (for example, the version of 1551 in the Lutherhalle in Wittenberg)—reminding us that this justification takes place through faith, not through works of the Law. Many different versions of this theme are presented in woodcuts whose content and composition are very similar to those of this painting. All the versions present a sort of résumé of the entire history of salvation, juxtaposing different moments within the same frame (in the case of the woodcut, all within a single picture), as in medieval and early Renaissance didactic paintings. In the altarpiece, the backgrounds of the first three panels (from left to right) constitute a single scene, within which different moments unfold. They are united by the dark green foliage that runs through the middle of the panels; in front of and behind this greenery are glimpses of landscape that serve as the scenes for the events portrayed.

Underneath the first panel we read: "They are all sinners and are all lacking the glory of God" Rom. 3 [verse 23]; "Sin is the sting of death, but the Law is the power of sin" 1 Cor. [15:56]. Under the second: "The Law produces only wrath" Rom. 4 [verse 15]; "Through the Law comes knowledge of sin" Rom. 3 [verse 20]; "The Law and all the prophets spoke until the time of John" Mt. 11 [verse 13]. Under the third: "The just lives by faith. Rom. 1" [verse 17]; "We hold

that a person is justified by faith, without the works of the Law. Rom. 3" [verse 28]; "Behold the Lamb of God, who bears the sin of the world. Jn. 1" [verse 29]; "In the sanctification of the spirit." Under the last, the completion of the quote, "for obedience and aspersion with the blood of Jesus Christ. 1 Petr. 1" [verse 2]; then, "Death has been swallowed up by victory. Death, where is thy sting? Hell, where is thy victory? But thanks be to God, who gives us victory through Jesus Christ our Lord 1 Cor." [15:55].

At the top right of the first panel the Creator and Judge (in the figure of Christ) presides, encircled by a cloud nimbus filled with cherubs. (In one woodcut version, the figure is clearly that of the Christ of the Apocalypse. He is seated on the world-orb, showing his wounds, with a sword and flowering stem proceeding from his mouth, and adored by saints. Hence this is in a sense both the start and the end of the picture. The apocalyptic Christ refers to the Last Judgment; but he is also the Alpha and Omega, the beginning as well as the end.) Below and to his right, in the second panel, we see the sin of Adam and Eve. (In some versions, they are to the left.) Proceeding back to the first panel, in the center of the bottom half we see a man running frightened on a stony path from a demon and from death (whose lance, the "sting" of death referred to in the quotation from Romans, extends from this panel into the second, where we see its bearer, a skeleton). The man is bearded and wears a loincloth in the painting; he is beardless and nude in some woodcuts. At the bottom left rise up the ruddy flames of hell, containing figures of suffering people. To the right of the second panel we see a group of elegantly clothed figures, among whom Moses is recognizable by the stone tables he carries. These figures represent the Law and the Prophets (among whom Isaiah is prominent). To their right, at the frame of the picture, is a bare tree. (In at least one woodcut, this tree, bare on the left (= the Law) and leafy on the right (= the gospel), divides the picture into two distinct parts with different backgrounds.)

At the right side of the third panel is a portrayal of the crucified Christ. The figure is classical and graceful, broad-chested and majestic. The head hangs forward in death. The cross is made from newly hewn wood, still bearing the bark of the tree. At the foot of the cross is a lamb bearing a red banner with a white cross on it, the illustration of John's word, "Behold the Lamb of God. . . ." To the left, John the Baptist looks at a man clothed in a loincloth, the same figure we see in the first panel running from the devil, somewhat reminiscent of early Cranach "portraits" of Adam, but also representative of "the sinner" in general. The Baptist gestures toward Christ. The blood of Christ, mediated by a dove representing the Spirit, flows from Jesus' side onto the man (in some versions, directly into his heart), while he looks reverently upward and folds his hands in a gesture of prayer. The painting gives literal expression to the

quotation from 1 Peter that is written below. However, the "sprinkling" with the blood of Christ refers not only to the general idea of the justification of the sinner through Christ's redemptive death, but also to both baptism and eucharist, its signs and means of communication to us. In the upper left, we see the tents of the Israelites in the desert and Moses' raising of the bronze serpent, a prefiguration of the crucifixion. At the left frame of the panel, the tree that was bare in the preceding picture is now covered with leaves. (In the woodcut, it is clear that it is the same tree, bare on one side, flourishing on the other. The theme of the "tree of death and of life," the tree of Eden and the cross, is a common one in medieval and Renaissance theology, and is frequently represented in art, directly or indirectly.)[191]

The fourth panel completes the theological message about redemption. The background in the painting is no longer continuous with that of the other panels (although it is in the woodcut). In the foreground we see Christ spearing death and hell with the same banner that was borne by the lamb in the previous panel. Behind him is the tomb hewn in rock, with an empty sepulcher in it. Directly above, on a mountain top, a small figure of Mary receives the message of the incarnation. Above and to her left a foreshortened infant flies toward her out of the cloud of glory. (In the woodcut the infant is not present, but the Spirit as a dove flies toward Mary). Below this the shepherds in the field receive news from an angel of the birth of Christ. At the upper right, the legs of Christ are seen as he ascends into a cloud of glory similar to the one from which the infant descends in the same frame. (The ascension is not portrayed in all versions.)[192]

In the different versions of the painting and woodcut the doctrinal emphasis can change. In a 1551 version, for example, only two quotes are given. On the left panel is the crucial message Luther takes from Paul's letter to the Romans: faith is imputed as justice (Rom. 4:22, 23). On the right panel, however, the message is about the annunciation/incarnation scene portrayed in the background. The quote is the familiar one from Isaiah: "The virgin shall be with child . . ." (Is. 7:14, Mt. 1:23). But the incarnation is for the sake of the cross, which is still centrally portrayed. (In at least one version of this scene, an infant is seen descending toward Mary with a cross.) The overall message in all versions is the Lutheran interpretation from the quoted Romans text. Justification is through faith in Christ. His blood, the symbol of his death in obedience to the Father, is the all-sufficient cause of our righteousness before God; the works of the Law are worthless to save us from the inheritance of Adam, sin, death, and hell.

A striking reworking of the theme occurs in the Weimar altarpiece (1555) by Cranach's son, also called Lukas (commonly designated as *der Junge,* "the Younger").

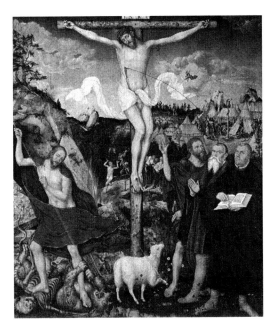

FIGURE 2.15. Lukas Cranach the Younger, *Weimar Altarpiece*. Stadtkirche, Weimar. Credit: Photos Constantin Beyer.

Here the figure of Christ on the cross, while still fairly conventional, is treated somewhat differently. Instead of being taut, as in most of Cranach the Elder's crucifixions, it sags downward, with bent knees. Christ's head rests to one side, with a peaceful expression. That he is dead is shown by the wound in his side; yet his eyes appear slightly open, as though he is looking downward at the group at his feet. The ends of the loincloth billow in the stylized manner. Blood flows abundantly from Christ's wounds, and a stream spurts out from his side toward the group on our right.

At the foot of the cross is the Lamb of God, looking upward. It bears a translucent (and thus easily overlooked) banner with a cross. To the viewer's left, the resurrected Christ spears death and hell with a larger version of the staff bearing the same translucent banner. (The two staves are parallel; but the banners float in opposite directions.) Christ's eyes look directly at us. To the viewer's right, in place of Adam we see three figures. John the Baptist stands closest to the cross, and looks at the other two. With his left hand he points downward toward the Lamb of God, with his right upward to Jesus on the cross. The identity of the two underlines the point that the Lamb of God "takes away the sins of the world." Next to the Baptist is a full-length portrait of Cranach the Elder, who had died in Weimar two years earlier. He looks toward

the viewer. The blood that spurts from Christ's side lands directly on his head. Next to Cranach is a portrait of Luther. He holds a Bible, open toward the viewer, and points to its pages.

On a second visual plane, behind the main figures, we see other scenes from the "Law and Gospel" or "Justification of the Sinner" pictures. From left to right appear the open tomb of Christ, surmounted by a hill with trees; immediate to the left of the cross, a man (who looks like a younger version of Cranach) running toward flames, chased by sin and death, which threatens with its "sting;" immediately to the right of the cross, Moses and the prophets; above them, shepherds in the field, receiving the message of the incarnation from an angel in the sky; to their right, above the heads of the three figures, the tents of the Israelites in the desert, with the bronze serpent raised on a cross. In the final visual plane, at the top of the painting, is a highly naturalistic sky with dispersed clouds and a golden light at the horizon.

Again, the theological message is that of justification through faith in Christ's redemptive work, represented by his blood. But here it has been personalized, so to speak. Cranach the Elder, receiving the blood of Christ on his head, is presented as the type of the person saved by faith, as understood by his friend Luther who stands by his side and teaches what is written in the Scripture and presented graphically in the picture of the crucifixion itself. The painting incorporates highly naturalistic elements: the sky, the painstakingly realistic wood of the cross, the carefully drawn plants, and especially the lifelike portraits. But in its overall composition, it clearly conforms to the didactic style of Cranach the Elder.

On the predella of Cranach the Elder's *Wittenberg Altarpiece* (1547) we find what we might call Cranach's "standard" image of the crucified, but here in a different and revealing context. The main front and side panels of the altarpiece depict scenes of church life: the Last Supper (Jesus with the apostles) in the center panel, flanked by pictures of baptism and confession, in a sixteenth-century Lutheran context.[193] Below, immediately above the altar, is a portrayal of Luther preaching to the congregation at Wittenberg. Luther stands alone in a decorated pulpit on the right; the people are gathered, men separated from women and children, on the left. Between them, in the center, is the crucified. The cross is ambiguously located. It stands on the floor and casts a shadow, as though physically present; but it appears to be *on* the floor, not rooted in it. The blood running down the cross stops abruptly at its foot, and does not continue onto the floor. Christ is stretched, dead, with a bleeding wound in his chest and wearing the crown of thorns, his head gently inclined to the side. There is no halo. The body, clothed in the double billowing loincloth, is without other apparent wounds. In short, this is the conventional image of *Christus Victor*,

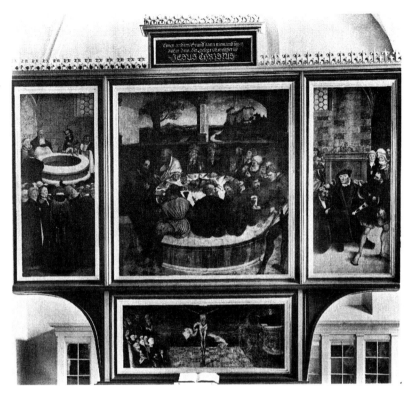

FIGURE 2.16. Lukas Cranach the Elder, *Wittenberg Altarpiece: The Last Supper and Scenes from the Life of Martin Luther.* Marienkirche, Wittenberg. Credit: Foto Marburg / Art Resource, New York.

Christ triumphant through his redeeming death. The light shining on Christ, Luther, and the people comes from outside the painting.

Significantly, the cross is portrayed as standing between Luther, who is preaching, and the people listening to him. He points to the cross with one hand, and rests his other on the Bible on the pulpit. The cross designated with the right hand corresponds to the message in the book under his left. The passion is the message, and it is preached in such a way as to become a living image. Cranach's subject here, as in the panels above, is church life, namely preaching, whose theme is justification through the cross. Notably, it is preaching that is the image of the crucified; Cranach's painting is an artificial image that reminds the viewer of the production of the real image, the message of the cross in the preached word.[194] At the same time, the crucifix in the painting is a visual echo of the standing crucifix that would be on the altar immediately below, so that it also reminds us of what takes place at the Lord's Supper, portrayed above it and celebrated on the altar beneath.

FIGURE 2.17. Lukas Cranach the Elder, *Wittenberg Altarpiece*. Detail: predella: Sermon of Martin Luther. Marienkirche, Wittenberg. Credit: Foto Marburg / Art Resource, New York.

A woodcut from about 1547 by Cranach the Younger illustrates the same theme in a more polemical context.[195] Entitled *"Abendmahl der Protestanten und Höllensturz der Katholiken"* (The Last Supper of the Protestants and the Fall into Hell of the Catholics"), it is possibly a reproduction a now-lost painted epitaph for Luther. (Another, more expansive version of this woodcut also exists). It portrays the reformer in a pulpit in the center, pointing with his right hand to a large crucifix—or rather, to the message of the cross—mounted on the altar (or perhaps rising behind its corner; its physical position is ambiguous, and it casts no shadow). At its base stands the Lamb of God, its floating banner continuing the line of one end of Christ's loincloth. The small Lamb casts a shadow, as though it were standing physically on the altar. Below, the congregation receives communion. Luther's left hand gestures downward— the same gesture used by Christ in many paintings of the Last Judgment— toward a fuming and flaming mouth of hell that gapes to swallow up the Pope and Roman clergy.

The younger Cranach took up his father's artistic/religious legacy in a number of other works portraying the crucifixion. A painting from 1546 imitates the crowded 1538 crucifixion by Cranach the Elder discussed earlier. However, a number of changes in composition and perspectives have been made by the son. If we look directly at Christ's cross, and see the others only in peripheral vision, Christ's cross can still appear to be the forwardmost. However, if we look at the good thief's cross in its relation to the others, it seems to be placed forward of Christ's. Hence the thief can realistically look at Jesus and ask to be remembered in his kingdom. At the bottom of the picture, the placement of the crosses in relation to each other is ambiguous, because the lower ends are hidden by the crowd. The result of this is that we can "realis-

FIGURE 2.18. Lukas Cranach the Younger, woodcut *Last Supper of the Protestants and Fall into Hell of the Catholics*. Photo: Joerg P. Anders. Kupferstichkabinett, Staatliche Museen zu Berlin, Berlin. Credit: Bildarchiv Preussischer Kulturbesitz / Art Resource, New York.

tically" see the picture in two ways. On the other hand, if we presume visual realism, John in left corner would be looking into space, as would other figures placed in front of the cross. The viewer of course ignores this, because we know the story, and recognize the genre of its portrayal as narrative rather than empirically realistic. The picture also moves away from the modern convention of portraying a single moment, returning to the medieval convention that combines different temporal elements in one narrative vision. Christ is already dead; but a bystander offers him a sponge to drink from. The centurion confesses his faith; the thief dialogues with Christ, although his legs should have been broken before Christ was pierced. At the bottom of the painting Cranach has added a small dog, a standard symbol of faith since the Middle Ages, putting the scene in its religious context.

Cranach the Younger's crucifix in the Lutherhaus, Wittenberg (1571), approaches what would become possibly the most common type of image in Lutheran art: a crucifix against a blank ground and surrounded by prayers, mottos, and biblical quotations.[196] Here, the background is a minimal sky, with the cross planted in bare earth. Christ on the cross is alive, looking upward with a sad look. He bears the crown of thorns, but the body is smooth; there is no attempt to portray the wounds of the scourging. The cross itself is highly naturalistic. The standard billowing loincloth moves to right and left. Most

striking in the picture is a printed panel, painted as though it were attached to cross by a cord. It contains a long Latin inscription, a sort of caption indicating words spoken by Christ. It reads in part: "You who look at me, look at yourself, and at your guilt; for I would be without death were it not that you belonged to death. Your guilt created what I suffer. . . . I hang on the cross for you, I who am God and man free of guilt. . . What more could I give, or could you ask? Certainly it is a great love to die for another . . . Salvation has been achieved, and the prophecies fulfilled, therefore the end of my life is the font of yours." Christ asks the viewer to consider his torments and wounds, which, however, are not portrayed in any graphic manner. It is communication of the theological point of our redemption through Christ's suffering that is the goal of the picture, not the production of an emotional or moral response that would be a human "work" leading to salvation.

Examples from the works of Cranach, father and son, could be multiplied; for our purposes, the ones we have discussed will suffice to give an idea of the artistic style inspired by Luther's view of sacred images. Let us attempt to synthesize some of the characteristics that we see in the Cranach works.

As we have seen in the previous chapter, there is an "inherent metaphoricity" in the realism of early Renaissance painting[197] that still connects it to the painting of the Middle Ages. (This is true especially of sacred art. But even ostensibly secular portraits often contain symbolic elements, sometimes of a religious nature, that are unnoticed by unschooled modern viewers, but that would have been easily recognized by the subjects' contemporaries. The distinction between sacred and secular art was not yet completely realized.) However, we have also noticed a growing tendency to naturalism and "empiricism," shown in visual realism and in unity of spatial and temporal composition.

The reformation in pictorial art that accompanied Luther's ecclesial reformation included the tempering of Renaissance naturalism with a more medieval narrative style, in service of the Lutheran conception of sacred art as preaching. Representations of the crucifixion are lacking in volume and detail. In the later crucifixions of Cranach, especially those with the converted centurion, there is little of interest to detain the viewer. Moreover, there is a certain degree of standardization and conventionalizing of Christ's image. We encounter virtually the same stereotyped image again and again in Lutheran woodcuts and paintings. All Christians have the same internal image of Christ, derived from the word of the Scriptures, and this is what the painter is representing. For Lutheranism, then, pictures are not so much replacements for literacy (as in the famous dictum of Pope Gregory) as they are supplements to

it; they exist not for those who cannot read, but for those who can both read the Scriptures and hear them preached.

Both radical "spiritualist" Protestant iconoclasm and Luther's more reserved mature position on sacred art are tied to the Protestant principle of *sola Scriptura*, "Scripture alone" as the source and norm of faith. Zwingli makes explicit what underlies the general Protestant objection to images: pictures are not the way God has chosen for revelation; the Word is.[198] Even for the more tolerant Luther, sacred images do not exist for their own sake, as an independent way of encounter with God, as they frequently were in the imaginative spirituality of the Middle Ages. Rather, they are a reminder of and an incitement to encounter with the Word. Indeed, the Word often intrudes on the picture itself, as in the scriptural quotations prominently visible in the Cranach paintings of Jesus and the centurion. And as we have seen, Luther favored the addition of "mottoes" or inscriptions to pictures.[199] In short, the ideal of didacticism in sacred art means that visible forms are valuable for what they mean, rather than for what they look like.[200]

We can see then that the conflict over images in the Protestant Reformation was an instance of a basic tension in Christianity over the nature of revelation and the place of the human imagination in its accomplishment. The fact that the picture is wordless, and involves only the sense of sight, is precisely what opens it up to being a competitor with the "word" of Scripture. For in reality, the painting is not without "word," in the larger sense of meaning, thought, and even discourse; but the verbal or dialogical element is either recalled in memory or is invented in the imagination. Recall the "talking crucifixes" of the Middle Ages, which are a "miraculous" objectification of what many medieval spiritual writers thought should be happening always when one prays imaginatively. Such prayer, as we have seen in Savonarola, allows the person to go far beyond what is contained in the scriptural text. This is exactly the danger inherent in images if one insists that revelation and its reception in the Spirit are tied exclusively to the historical event of Jesus and to the witness to it contained in the God-given scriptures, and not to some presence of the Spirit in other media either of "tradition" or of new encounters.

Hence the standardization and conventionalizing visible in Cranach's later paintings—although it certainly has other reasons as well—can be seen in part as a response to a theological idea. As Koerner says, "that Christ and his message are the same for all believers, is expressed through the routinization of painting itself."[201] Thus in Dürer and in the early Cranach, as in Grünewald, the feet of Christ are distorted where the nails pierce them; in Cranach's later paintings, the nails have no effect on the appearance of the feet. Frequently the

figures of the thieves are more individual and personal in appearance than Christ. The figure of Christ has become an "icon." There is little realistic detail or individualism in the portrayal of Jesus; we see a conventionalized and stylized human body. The corpus, whether dead or alive, is smooth; there is no detail of contorted limbs, bloody wounds, or frightful grimacing as in the strong expressionism of Grünewald; nor is there the heroic beauty of the classical naturalism of Michelangelo or Dürer.

Although Jesus' face in later paintings again begins to show a bit more individuality and realism, even here we have little more than minor variations on a standard model. The face is mild; where Jesus is represented alive, there is a certain appeal in his eyes; there is a vague intimation of suffering or sadness if he is portrayed dead. The crucifix has become more a symbol of the doctrine of redemption than a realistic evocation of a person (with the danger of idolatry) or of a gruesome event (with the danger of an affective response associated with a theology of "works").

It is also typical of Luther's theology and spirituality that the cross should be a comfort to us, not repel us. Hence Lutheran crucifixions generally have a mild and comforting aspect. They do not present the horrid event, but its theological meaning for us, namely God's gratuitous act of redemption, apart from our works.

The Reformation and Music

Sacred music, like the graphic arts, was affected by the Reformation consciousness of the priority of the Word. The positions of the various Reformers varied widely. Conrad Grebel rebuked Thomas Müntzer for introducing congregational singing. Ulrich Zwingli—although himself a highly skilled musician, probably the most accomplished of the Reformers—in 1525 completely eliminated music from the sacred services, replacing it with scripture readings. This move was in accord with Zwingli's "spiritualism." Like some of the early church Fathers, he argued that Christians should make music only, as St. Paul says, "in the heart;" other forms of music would be signs of external, fleshly religion that is unworthy of those who should worship "in Spirit and in truth."

John Calvin took a somewhat intermediate position. He valued music as a great gift from God, and he affirmed the Platonic idea that music can directly affect the soul.[202] But precisely for these reasons, he feared its misuse in the sacred sphere. In his "Preface" to the printed Psalter and in his *Institutes of the Christian Religion* he explicitly deals with the issue. On the one hand he affirms the value of sacred music; on the other, he echoes Augustine in insisting on its subordination to the Word:

... surely, if the singing be tempered to that gravity which is fitting in
the sight of God and the angels, it both lends dignity and grace to
sacred actions and has the greatest value in kindling our hearts to a
true zeal and eagerness to pray. Yet we should be very careful that our
ears be not more attentive to the melody than our minds to the
spiritual meaning of the words ... Therefore, when this moderation is
maintained, it is without any doubt a most holy and salutary practice.
On the other hand, such songs as have been composed only for
sweetness and delight of the ear are unbecoming to the majesty of the
church and cannot but displease God in the highest degree.[203]

In line with this reasoning, Calvin opts for restraint in the use of sacred
music. He objected to instrumental accompaniment (it was not until the sev-
enteenth century that the organ was permitted in Reformed church music),
and he restricted liturgical music to the singing of the Psalms (in the ver-
nacular), on the basis of Augustine's reasoning that only what comes from God
is worthy of use in praising God.[204] He also recommended that the Psalms be
sung at home. This is indirectly relevant to our theme, insofar as some of the
Psalms were widely considered to be direct prophecies of the Passion of Christ.

The case of music is quite different in Lutheran Protestantism. Luther was
extremely positive in his evaluation of music: "except for theology there is no
art that could be put on the same level with music."[205] "Nothing could be more
closely connected with the Word of God than music."[206] Even apart from the
sacred texts it might accompany, Luther thought that music is "a wonderful
creation and gift of God."[207] A composer and lyricist himself, Luther valued
the use of music in both the secular and sacred spheres. He agreed with the
ancient and medieval theory that the right kinds of music can directly affect the
human heart, disposing it to virtue:

It is music alone, according to God's word, that should rightfully
be prized as the queen and ruler over every stirring of the human
heart ... What can be more powerful than music to raise the spirits of
the sad, to frighten the happy, to make the despondent valiant, to
calm those who are enraged, to reconcile those filled with
hatred. ... [208]

All the more, then, music was valuable when put into the service of the
word. With his collaborator Johann Walter, Luther established the cantorship
as a ministry in the Evangelical church; he established congregational singing
as an integral part of worship; and he wrote religious songs for recreational
use. In his view, music in the church served as a *predicatio sonora,* a resounding

sermon. It was to be valued not only as a vehicle for sacred texts, but also as being in itself a mirror of God's beauty, and thus a means for reaching the soul directly with a message about God that is inexpressible in words.

LUTHER'S HYMNS AND THE THEOLOGY OF THE CROSS

As we have seen, Luther's theology is expressed in sermons as well as in systematic exegesis and theoretical statements. Hence it already contains a mixture of systematic and aesthetic language. Similarly, his hymns are both edifying and didactic. For this reason, it is the victory of Christ, and our confident participation in it by faith, that has primacy. Indeed, if we were to judge by Luther's hymns alone, there would be reason for concurring with Gustav Aulén's contention that his soteriology exemplifies primarily the Patristic *Christus Victor* model, rather than a theology of satisfaction. In what is probably the best known Lutheran hymn, "Ein Feste Burg" ("A Mighty Fortress is Our God"), written in 1529 by Johann Walter (or perhaps by Luther himself?) we find a triumphant statement of the soteriology of victory in battle. It sets forth God's defeat of the demonic powers through Christ. Not only the words, but also the music, likewise composed by Walter, have a military rhythm and a triumphant confidence. Even sung a capella, it evokes the sound of trumpets. It is well described as a "war song of faith" (*Kriegslied des Glaubens*). Here is the original text, with a very close (but still singable) translation:

1. Ein' feste Burg ist unser Gott,
Ein gute Wehr und Waffen;
Er hilft uns frei aus aller Not,
Die uns jetzt hat betroffen.
Der alt' böse Feind,
Mit Ernst er's jetzt meint,
Groß' Macht und viel List
Sein' grausam' Rüstung ist,
Auf Erd' ist nicht seingleichen.

A mighty fortress is our God,
a trusty shield and weapon;
He helps us free from every need
that hath us now o'ertaken.
The old evil foe
now means deadly woe;
deep guile and great might
Are his dread arms in fight;
on Earth is not his equal.

2. Mit unsrer Macht is nichts getan,
Wir sind gar bald verloren;
Es steit't für uns der rechte Mann,
Den Gott hat selbst erkoren.
Fragst du, wer der ist?

With might of ours can naught be done
soon were our loss effected;
But for us fights the Valiant One,
Whom God Himself elected.
Ask ye, Who is this?

Er heißt Jesu Christ	Jesus Christ it is.
Der Herr Zebaoth,	Of Sabbaoth the Lord,
Und ist kein andrer Gott,	and there's none other God;
Das Feld muß er behalten.	He holds the field forever.
3. Und wenn die Welt voll Teufel wär'	Though devils all the world should fill,
Und wollt' uns gar verschlingen,	all eager to devour us.
So fürchten wir uns nicht so sehr,	We tremble not, we fear no ill,
Es soll uns doch gelingen.	they shall not overpower us.
Der Fürst dieser Welt,	The prince of this world
Wie sau'r er sich stellt,	So bitter be his skill,
Tut er uns doch nicht,	He can harm us none,
Das macht, er ist gericht't,	he's judged; the deed is done;
Ein Wörtlein kann ihn fällen.	One little word can fell him.
4. Das Wort sie sollen laßen stahn	The Word they still shall let remain
Und kein'n Dank dazu haben;	nor any thanks have for it;
Er ist bei uns wohl auf dem Plan	He's by our side upon the plain
Mit seinem Geist und Gaben.	with His good gifts and Spirit.
Nehmen sie den Leib,	And take they our life,
Gut, Ehr,' Kind und Weib:	goods, fame, child and wife,
Laß fahren dahin,	Let these all be gone,
Sie haben's kein'n Gewinn,	they yet have nothing won;
Das Reich muß uns doch bleiben.	The Kingdom ours remaineth.

Many Lutheran hymns are directly scriptural in inspiration. The Psalms, naturally, are a major source, frequently adapted to the circumstances of the struggling reformed church (see for example the hymn, "Wär' Gott nicht mit uns dieser Zeit").[209] Many hymns are more directly concerned with exhortation and with the celebration of ecclesial life than with the exposition of doctrine. In these, Luther's soteriology underlies the sentiments of comfort taken from Christ's victory. One example out of many appears clearly in Walter's hymn "Jesus Christus, unser Heiland:"

Jesus Christus, unser Heiland,	Jesus Christ, our Savior
Der von uns den Gottes Zorn wandt,	Who shielded us from us God's anger
Durch das bitter Leiden sein	Through his bitter passion
Half er uns aus der Höllen Pein.	He drew us out of hell's torment.

There were also hymns directly dealing with the Passion of Christ. Luther wrote a prologue for one collection, the *Deutsche Gesänge vom Leiden Christi* ("German Songs on the Suffering of Christ").[210] However, Luther himself composed no pure passion hymns.[211] In music, as in art, he thought the emphasis should be placed on the solace and the encouragement to faith that we find in considering Christ's victory in the battle. References to the cross in the hymns written by Luther are comparatively rare. In the fifth verse of "Ach Gott, von Himmel sieh darein,"[212] he refers to the cross of the Christian:

Das silber, durchs feür siben mal	Silver that is proven seven times by fire
bewert, wirt lauter funden.	will be found more pure.
Am gottes wort man warten sol	One should expect the same
des gleichen alle stunden	of God's word at all times.
Es wil durchs creütz beweret sein;	It is proven through the cross;
da wirdt sein krafft erkant und schein	then its power and light will be known,
und leucht starck in die lande.	and will greatly shine among the nations.

"Wir glauben all an einen Gott," a German paraphrase of the creed, contains these lines about Christ: "für uns, die wyr warn vorloren, / Am kreutz gestorben und vom tod / widder auferstanden durch Gott" (for us, who were lost, died on the cross and was raised again by God).[213] The song "Unser große Sünde und schwere Missetat" refers directly to redemption through the cross in its first two stanzas: "Unser grosse sunde und schwere misethat / Jhesum, den waren Gottes Son ans Creutz geschlagen," (Our great sins and heavy misdeeds Jesus, the true Son of God, has defeated on the cross); "Gelobet seistu Christe, der du am Creutze hingst / und vor unser Sunde viel schmach und streich empfingst / jtzt herschest mit deim Vater," (Praised be you, Christ, who hung upon the cross and for our sins felt great insult and injury, and now reign with your Father).[214] But it is typical that Luther's most explicit musical meditation on Christ's work is not a passion hymn, but the Easter hymn "Christ Lag in Todesbanden" ("Christ lay in the bonds of death").[215]

1. Christ lag in Todesbanden	1. Christ lay in death's bonds
Für unsre Sünd gegeben,	handed over for our sins,
Er ist wieder erstanden	he is risen again
Und hat uns bracht das Leben;	and has life to us;
Des wir sollen fröhlich sein,	For this we should be joyous,

Gott loben und ihm dankbar sein	praise God and be thankful to him
Und singen halleluja, Halleluja!	and sing alleluia, Alleluia!

2. Den Tod niemand zwingen
 kunnt
Bei allen Menschenkindern,
Das macht' alles unsre Sünd,
Kein Unschuld war zu finden.
Davon kam der Tod so bald
Und nahm über uns Gewalt,
Hielt uns in seinem Reich
 gefangen. Halleluja!

2. Death could no one
 overcome
among all of humankind.
Our sin was the cause of all this,
no innocence could be found.
Therefore death came so quickly
and seized power over us,
held us captive in his kingdom.
 Alleluia!

3. Jesus Christus, Gottes Sohn,
An unser Statt ist kommen
Und hat die Sünde weggetan,
Damit dem Tod genommen

All sein Recht und sein Gewalt,
Da bleibet nichts denn Tods
 Gestalt,
Den Stach'l hat er verloren.
 Halleluja!

3. Jesus Christ, God's son,
has come in our stead
and has put aside our sins,
and in this way from death has
 taken
all his rights and his power,
here remains nothing, for
 death's appearance
has lost its sting. Alleluia!

4. Es war ein wunderlicher Krieg,
Da Tod und Leben rungen,
Das Leben behielt den Sieg,
Es hat den Tod verschlungen.
Die Schrift hat verkündigt das,
Wie ein Tod den andern fraß,
Ein Spott aus dem Tod ist
 worden. Halleluja!

4. It was a wondrous battle
where death and life struggled.
Life won the victory,
it has swallowed up death
Scripture has proclaimed
how one death ate the other.
A mockery is made of death.
 Alleluia!

5. Hier ist das rechte Osterlamm,
Davon Gott hat geboten,
Das ist hoch an des Kreuzes
 Stamm
In heißer Lieb gebraten,
Das Blut zeichnet unsre Tür,
Das hält der Glaub dem Tode für,

5. Here is the true Easter lamb
that God commanded
high on the stake of the cross

to be roasted in burning love,
the blood marks our doors.
Faith holds this in the face of
 death,

| Der Würger kann uns nicht | the strangler can harm us no |
| mehr schaden. Halleluja! | more. Alleluia! |

6. So feiern wir das hohe Fest

Mit Herzensfreud und Wonne,
Das uns der Herre scheinen läßt,
Er ist selber die Sonne
Der durch seiner Gnade Glanz

Erleuchtet unsre Herzen ganz,
Der Sünden Nacht ist
 verschwunden.
Halleluja!

6. Thus we celebrate the high
 feast

with heart-felt joy and delight
that the Lord lets shine for us.
He is himself the sun
who through the ray of his
 grace
enlightens our hearts completely,
the night of sin has disappeared.

Alleluia!

7. Wir essen und leben wohl
In rechten Osterfladen,
Der alte Sauerteig nicht soll
Sein bei dem Wort Gnaden,
Christus will die Koste sein
Und speisen die Seel allein,
Der Glaub will keins andern leben.
Halleluja!

7. We eat and live well
on the true Easter bread,
the old yeast should not
be present with the word of grace.
Christ will be our food
and alone feed the soul,
faith will live by no other.
Alleluia!

MUSICAL SETTINGS OF THE PASSION

As we saw in the last chapter, the "Passion" as a polyphonic musical genre developed during the early Renaissance. The musical Passion naturally had a particular attraction for Reformation piety. Luther's collaborator Johann Walther (1496–1570) produced four responsorial Passions (with responses in German) that proved most influential. (The responsorial type Passion was obviously well suited to the Lutheran emphasis on congregational singing.) Despite Luther's reservations about gospel harmonies (which he called "juggling" with the text), the musical setting of the *Summa Passionis* attributed to Obrecht (actually by Antoine de Longeval) was also very influential in Germany (less so in Italy, where the use of John's gospel was more prevalent). Since it is a compilation, Longeval's work has the advantage of containing the "seven words" of Christ from the cross, a popular subject for meditation and preaching. Joachimus von Burgk (1540–1610), whose real name was Möller, seems to have been the first to discard Latin and compose passion music

entirely in German.[216] These developments in the genre set the ground for the great flourishing of the musical Passion in the Baroque period.

Some of the musical settings of the Passion seem originally to have been associated not directly with the liturgy, but with passion plays. However, the civic production of such plays did not accord with the polemics of the Reformation period, and the great passion plays generally died out during the sixteenth century. They would be supplanted in culture by the new genres of Passion music that were now evolving.

The Passion and Soteriology in the Reformed Liturgy

The eucharistic liturgy is obviously one of the major places where theology is reflected, at least indirectly. The mode of presence of Christ in the eucharist was the focus of a great deal dispute, both between the Reformers and Rome and among the various reformed groups themselves. But there was general agreement among the Reformers in rejecting what they took to be the Catholic idea of the "sacrifice of the mass," that is, the notion of the mass as a sacrificial act of worship different from or in addition to the single historical "sacrifice" of Jesus. (As we have seen, this idea was explicitly rejected by theologians like Biel, as it would later be rejected by the Council of Trent. But the emphasis in Catholic theology on the part of the worshipper and the church in appropriating and commemorating Christ's sacrifice could evidently give the impression, especially on the popular level, that Catholics did in practice affirm the position the Reformers so vehemently opposed.)

Although the liturgy obviously does not give a theoretical exposition, in various reformed eucharistic prayers we can see clear reflections of the theologies of redemption we considered in the first part of this chapter.[217] Zwingli, in his *Epicheiresis* of 1523, rejects the idea of the mass as sacrifice; the only sacrifice is that of Jesus. The Canon of the mass is replaced by four prayers, in which the notions of atonement and reconciliation are prominent:

> Most merciful and thrice holy Father, you created man in the beginning to enjoy paradise here and then afterwards to enjoy yourself. From this state of grace man fell though his own fault and was deemed worthy of death: he tainted all who came after him; and then there was simply no hope of life, unless you, who alone are good, decided to relieve man's distress . . . when the appointed time was fulfilled, you offered your Son, our Lord Jesus Christ, who took our flesh through the pure and ever-Virgin Mary, that he might become for us perfect priest and *perfect victim*, unique among the

human race. He gave himself to be the *sacrifice for those who were lost:* and not content with this...he gave himself to be our food and drink...

...We would eat the flesh and drink the blood of your Son in vain, if we did not firmly believe above all things through the faith of your work, that your Son our Lord Jesus Christ was *crucified for us and atoned for the sins of the whole world*...

...as we believe that your Son, once *offered for us, made reconciliation* to the Father, so we also firmly believe that the offered himself to be the food of our souls...you have deigned to reveal that he is the Lamb to take away our sins...For he suffered, that through him we might have perpetual access to you: he wished to be clothed with our weakness, that in him we might have strength....

Luther, in his *Formula Missae et Communionis* (Order of the Mass and Communion) for the church at Wittenberg (1523), eliminates the offertory and canon of the mass and removes every reference to the mass as a sacrifice. In the liturgy, his theology of redemption is perhaps most clearly reflected in the model for the "Admonition after the Sermon" that he gives in the *German Mass* of 1526: "I admonish you...that you remember and give thanks for his boundless love which he proved to us when *he redeemed us from God's wrath, sin, death, and hell by his own blood*."

In the Preface of the Swedish Lutheran mass by Olavus Petri (1531),[218] the celebrant offers thanks and praise

...especially for that benefit which you gave us then by reason of sins we were all in so bad a case that nothing but damnation and eternal death awaited us, and no creature in heaven or earth could help us. Then you sent forth your only-begotten son Jesus Christ, who was of the same divine nature as yourself; you suffered him to become a man for our sake; *you laid our sins upon him;* and *you suffered him to undergo death instead of our all dying eternally.* And as he has overcome death and risen again and now is alive for evermore, so likewise shall all those who put their trust in him overcome sin and death and through him attain to everlasting life.

In 1539 Martin Bucer published *The Psalter, with Complete Church Practice* (the Strasbourg rite). This liturgy influenced both the Geneva liturgy of Calvin and the Scottish prayer book of John Knox. Two of the alternative prayers read as follows:

...help us to understand that in you we live and have our being; and that *our sins are so heavy and grievous that only by the death of your Son, our Lord Jesus Christ, could we be restored to your life and grace*...

...And may all of us, here gathered before you, in the name of your Son and at your table, O God and Father, truly and profoundly acknowledge the *sin and depravity in which we were born,* and sin to which we thrust ourselves more deeply by our sinful life. And since there is nothing good in our flesh, indeed since our flesh and blood cannot inherit your kingdom, grant that we may yield ourselves with all our hearts in true faith to your Son and our only Redeemer and Savior. And since, for our sake, he has not only *offered his body and blood upon the cross to you for our sin,* but also wishes to give them to us for food and drink unto eternal life...

John Calvin was more radically hostile to the Roman mass than Luther. He replaced the eucharistic prayer with preaching, with little commemoration of the redemptive work of Christ. The focus is rather on our union with the resurrected Lord. *The Form of Church Prayers* (1542) became the foundation for many other reformed rites, including that of John Knox. In the formula for communion, it reads: "...let us receive this sacrament as a pledge that the virtue of *his death and Passion is imputed to us for righteousness, just as if we had suffered it in our own persons.*"

Hermann von Wied, the Catholic Archbishop-Elector of Cologne, was excommunicated in 1545 and died a Lutheran. His work *A Simple and Religious Consultation* (1545) greatly influenced Thomas Cranmer in the reform of English worship. It contains this passage on redemption by the cross:

...and whereas we, through the sin of Adam sliding from thee, were made thine enemies, and therefore subject to death and eternal damnation, thou of thy infinite mercy and unspeakable love, didst send the same thy Son, the eternal Word, into this world; who *through the cross and death delivered us from sins and the power of the devil,* and brought us again into thy favor by his holy Spirit....

Thomas Cranmer published *The Order of Communion* for the Anglican church in 1548. It speaks of the single satisfactory sacrifice of Christ:

O God, heavenly Father, which of thy tender mercy didst give thine only Son Jesu Christ to suffer death upon the cross for our redemption; who made there, *by his one oblation once offered, a full, perfect, and sufficient sacrifice, oblation, and satisfaction, for the sins of the whole world....* [219]

In *The Form of Prayers and Ministration of the Sacraments* (1556), John Knox specifies that the Minister should give thanks with these or similar words:

> ... [We give thanks] that thou *has delivered us, from that everlasting death and damnation into the which Satan drew mankind* by the means of sin: from the bondage where of neither man nor angel was able to make us free, but thou, O Lord, rich in mercy and infinite in goodness, has *provided our redemption to stand in thy only and well-beloved son:* whom of very love thou didst give to be made man, like unto us in all things, sin except, that *in his body he might receive the punishments of our transgression,* by his death to *make satisfaction to thy justice,* and *by his resurrection to destroy him that was the author of death,* and so to reduce and bring again life to the world. ...

In some of the texts quoted we can see specifically Protestant doctrinal themes concerning redemption and the cross: the depravity of human nature; the imputation of justice; substitution in punishment. But many of these liturgical texts refer to the cross and redemption in the imaginative language of Scripture and of the Fathers, in terms that could also be accepted by Catholics. What is significant in the polemical context of the Reformation is what is *not* present, reference to the mass as a "sacrifice," and the particular emphases chosen.

Conclusions

The Reformation is a period where—exceptionally—we can see a definite and direct correlation between theological thought and artistic expression, and even a change in style. This correlation, of course, is neither complete or universal; but there did emerge to some extent a reformed style of art that paralleled the new reformed paradigm of thinking. In both theology and art, the cross was a central theme.

The Lutheran Reformation brought about a curious shift—in some cases, one might say a reversal—in the portrayal of the cross and its symbolic meaning. The cross was always, theoretically, a symbol of God's love; but it had also become a symbol human guilt, with the consequent terror of judgment. In Lutheran art it became above all a sign of comfort. Consciousness of sin was of course not lacking in Lutheran meditation on cross. But it is sin as non-imputed; sin to be overcome, but without the fear of punishment. The cross still stands for all that we must suffer, and it still serves as an example for us in

our suffering. But above all, it is the sign of triumph, of God's victory over sin and death shared with us.

On the other side, there is perhaps a potential danger in placing emphasis on the psychological effect of the doctrine of redemption as a means of overcoming anxiety. Luther's emphasis on finding in redemption by Jesus our spiritual "comfort" or "consolation" (*Trost*—a word that occurs again and again in Lutheran writings, in particular in hymns) could make religion above all a remedy for an uneasy conscience. Indeed, "the theoretical liberation of the individual Christian conscience from the anxieties encouraged by late medieval piety" quickly became a "commonplace" in Luther's writings.[220] Luther's formula *simul justus et peccator* ("justified and at the same time a sinner) and his admonition *pecca fortiter sed crede fortius* ("sin strongly, but believe even more strongly") were certainly intended in a thoroughly moral sense, by no means as an invitation to sin or as excuse for immorality on the basis of confidence in God's forgiveness. But for people living in the compromises of life in the world, perhaps without any great religious depth, could it not easily be taken for exactly the latter? Luther himself, to his distress, found that it sometimes was.

Of course, this leaves the question: how does one live a secular life as a Christian, that is, as one who accepts the message of the cross? Savonarola's spirituality of the cross implied that one should live a life as close to that of a monk as possible, presuming, at the same time, that there are levels of perfection that the laity are not called to. Christian humanism and the Reformation both placed a new emphasis on life in this world, on the laity, and on the secular sphere, while still seeing the cross as central. In our next chapter, we shall examine the reaction to and expansion of these themes in the Catholic "Counter-Reformation" and the later development of the Reformation itself.

3

The Cross in the Catholic Reformation and Counter-Reformation

Introduction. Michelangelo's *Pietà* for Vittoria Colonna

The Pietà sculpted by the young Michelangelo during his first so-journ in Rome as an artist established his reputation and eventu-ally became one of the most celebrated works of the Renaissance. Both the artist and his world had radically changed by the time he returned to the subject in the very private and personal drawing made some forty years later for his friend Vittoria Colonna.

Preachers like Vincent Ferrer and Savonarola had warned of the coming of the crisis prophesied by the Book of Revelation; Dürer and Signorelli had illustrated it.[1] Now their predictions seemed to be coming true. Savonarola had been hanged and burned during the reign of a pope who symbolized the church's decadence, the infamous Roderigo Borgia (Alexander VI), who presided over the church while carving out princely dominions for his children. The church had seen the illegitimate daughter of a Pope—Lucrezia Borgia, at twenty-one already once divorced and once a widow—ruling in the Vatican in her father's absence, while the same Pope's illegitimate son Cesare introduced new levels of treachery and bar-barity into the recurrent conflicts among the Italian states.[2] Luther had posted his theses; the Reformation had swept through Europe. Large portions of Germany, as well as Denmark, Norway, Sweden, and England had broken from Rome. Significant parts of France and Switzerland had been converted to Calvinism. Florence had

once again expelled the Medici and declared itself a republic (1527), only to undergo a fierce siege, during which Michelangelo's beloved younger brother Buonarotto died in his arms. The republic was defeated, and was forced to accept a Medici as Duke (1530). Foreign armies battled for control of the Italian states. Syphilis (according to the Italians introduced by the invading French, and hence called il male francese) had become widespread. Because of exploitation of the New World and of new sea routes to the Indies, the center of commerce had shifted from the Mediterranean to the Atlantic, with consequent loss to the Italian economy. Commerce had been further undermined by warfare and foreign control. Poverty and famine struck even in the once-prosperous city-states. The Sultan Suleiman ("the Magnificent") had conquered Belgrade, invaded Hungary, and reached the very gates of Vienna. Georg von Frundsberg, a general in the employ of the Holy Roman Emperor Charles V, had invaded Italy with an army of Lutheran Landsknechte; he was said to be carrying a golden rope with which he intended to hang the Pope. Clement VII, the object of Frundsberg's pious quest, had seen the Swiss guard massacred on the steps of St. Peter's basilica. Faculty and seminarians from the Capranica college (thenceforth to be called the almo collegio) were slaughtered near the Porta Santo Spirito, where they were attempting to defend the Pontiff. Clement himself had had to make a hasty flight from the Vatican to the nearby Castel Sant'Angelo, where, defended by a small number of troops under the command of the artist Benvenuto Cellini, he could watch helplessly as Rome was fiercely sacked and plundered.[3]

The sack of Rome in 1527 shocked and horrified Catholic Europe, perhaps even more than the fall of Constantinople in the previous century. It had disastrous consequences for the economy of the city. (Because the siege of Florence occurred at about the same time, the major sources of patronage for the arts in central Italy were cut off for at least ten years.) Not least significant was the effect of the sack on the psychological mood at the center of the Catholic hierarchy. The Pope had a medal struck showing Christ at the column of the flagellation, with the inscription Post multa, plurima restant ("After many [sufferings], even more remain"). Michelangelo's painting of the Last Judgment above the altar of the Sistine chapel (executed under Clement's successor, Paul III) is widely taken to exemplify the mood of Rome after the sack, which was considered to be a judgment of God on the sinfulness of the church and society.

In addition, Michelangelo had of course himself grown old, and his thoughts seem to have turned increasingly to death and to the austere reforming spirit of the religion he had encountered in the Florence of his youth in the Savonarola's preaching.[4] In refusing an invitation from friends to go dancing (in 1546), he is reported to have reproved their lightheartedness, saying

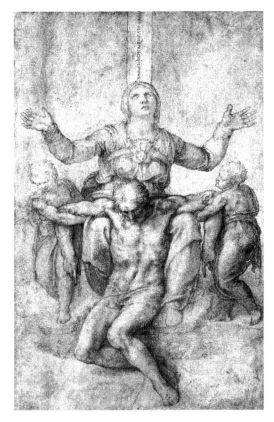

FIGURE 3.1. Michelangelo Buonarotti, study of the *Pietà* for Vittoria Colonna. Credit: Isabella Stuart Gardner Museum, Boston.

"The only thing to do in this world is weep!"[5] In part this attitude seems to have been due to a kind of conversion that he underwent after establishing (beginning in 1538) a friendship with Vittoria Colonna (1490–1547), the Marchesa di Pescara and a member of one of Rome's most ancient and powerful families. She was a member of circle of Juan de Valdès (1509–1541), a Spanish humanist who had settled in Rome (possibly because of fear of the Inquisition in Spain, which was independent of Rome and under the direct control of the monarch). Valdès was interested in biblical studies and in reform of the church. He stressed the need for grace and a life of devotion; his emphasis on grace and faith as the means to salvation seems in ways to approach the ideas of Luther. Indeed, Cardinal Reginald Pole, a member of this circle and Colonna's spiritual adviser, was one of the Catholic reformers who formulated a compromise statement on justification by faith that achieved a brief theoretical accord

between Lutherans and Catholics on the subject at the conference of Regensburg (1541).

Vittoria Colonna was also a poet, and dedicated many of her verses (*Rime*) to spiritual subjects. These poetic exercises in spirituality include a "Trionfo di Cristo" (of which Michelangelo owned a copy) that was clearly influenced by Savonarola's writings (see our discussion of the *Trionfo della Croce* in chapter 1).[6]

In about 1540 Michelangelo gave to Vittoria Colonna the gift of a drawing of the pietà.[7] Much more than Michelangelo's youthful *pietà*, this picture embodies elements associated with the traditional "lamentation" genre. At the same time, it is innovative. Both Jesus and Mary are presented in a frontal position, directly facing the viewer. This gives the image an iconic nature. Although it ostensibly shows a moment in the passion narrative, it also presents a direct address to the viewer in the present. Also contributing to the iconic impression of an eternal moment outside of time are the two angels who hold Christ's arms. The genre itself adds to the iconic nature of the image. A drawing of this kind is in some ways closer to sculpture than to painting. It is monochromatic, and the figures are abstracted from any realistic setting or context except that which it creates. Rather than creating a "window" onto a fictive world, it presents *itself* as something to be viewed.

The drawing is described by Michelangelo's disciple Ascanio Condivi in his "official" biography of the artist:

> At the request of his lady [Vittoria Colonna] he made a naked Christ being taken down from the cross; as His dead body is let go, if Christ were not supported under the arms by two little angels, He would fall at the feet of His holy Mother. But she, seated beneath the cross with tearful and sorrowful countenance, with open arms is raising both her hands to heaven, and utters this sentence, which we see written on the stem of the cross: "They do not know how great the cost in blood!"[8]

The body of Jesus is muscular and classical in form. There is no crown of thorns, and his wounds are barely indicated. The head droops forward, increasing the impression of a weighty downward pull. The body is seated on the ground between Mary's legs, while the arms rest on her knees. The placement of the lower legs and feet is ambiguous. The right leg casts a shadow presumably indicating that it rests on the ground on a level lower than where Christ's body is seated; but if the left foot is presumed to be on the same level as the right, the foreshortening of the leg seems wrong. Despite the apparent

indication of ground, the figure makes more visual sense if the legs are seen as hanging in air, as though the upper body were suspended at a higher level than that of Mary's knees (as in Michelangelo's painting of the *Entombment* and the sculpted *pietàs* from his last period).

The figure of Mary is clothed in a timeless, artificial, vaguely "classical" style—attempting to portray the historical dress of neither the biblical period nor that of the artist's contemporaries. This sort of timeless clothing had become popular in the late Quattrocento, and Michelangelo often used it for female figures. Mary raises her hands in a gesture that is frequently used to represent lamentation, but is also the traditional posture of prayer. Her eyes are not cast down, as in the early pietà, but look upward to heaven. Despite Condivi's assertion of tears, her face seems to express not so much sadness as worship and acceptance, perhaps even ecstatic devotion.

The paper bearing the drawing has been cropped, so that we now see only the bottom of the cross that rises behind the figures. This cross was originally Y-shaped—apparently referencing a cross in Michelangelo's parish church of Santa Croce that he associated with the penitential movement of the four-teenth century in Tuscany.[9] On the cross is a phrase from Dante: *non vi si pensa quanto sangue [costa]*, "they do not think there [on earth] how much blood [it costs]...." In its context, the quote refers to the sacrifices needed to preach rightly the word of God. It is taken from a discourse of Beatrice in Canto XIX of the *Paradiso:*

Voi non andate giù per un sentiero	You do not walk on your path below
filosofando: tanto vi trasporta	seeking wisdom: so much are you moved
l'amor de l'apparenza e 'l suo pensiero!	By the love of appearances and the thought of them!
E ancor questo qua sù si comporta	And here above even this is bourne
con men disdegno che quando è posposta	With less disdain than when they set aside
la divina Scrittura o quando è torta.	The sacred Scripture, or distort it.
Non vi si pensa quanto sangue costa	They do not think of how much blood it costs
seminarla nel mondo e quanto piace	To sow it in the world, and how pleasing
chi umilmente con essa s'accosta.	Is the one who approaches it humbly.

Per apparer ciascun s'ingegna e face	Each strives cleverly to be know
sue invenzioni; e quelle son trascorse	And invents his own ideas, and these are spoken
da' predicanti e 'l Vangelio si tace.	By the preachers, while the Gospel is silent.

By taking the phrase out of context and placing it on the cross behind an image of the pietà, Michelangelo may be implying several extended meanings: how much blood (literally) our redemption (represented by the dead Christ) costs; in a transferred sense, how much "blood" and toil, i.e., suffering, are needed to be Christ's disciple, like Mary, who makes the gesture of lamentation, with hands raised to heaven, but who also lifts her eyes to God with devout (perhaps even ecstatic?) acceptance, and who serves as an example to us.[10]

Presumably the quotation was one that Michelangelo and Vittoria were both familiar with. Perhaps they had discussed it? In any case, Beatrice's discourse in Canto XIX contains other themes that are echoed in Michelangelo's reflections on his life and art. In applying these words to himself, of course, Michelangelo would have been adapting the ideas to his circumstances. He was not directly the kind of preacher Beatrice is speaking of. But he did paint and sculpt "the gospel," and even outside his sacred works he thought that his art was a way of revealing God. Yet, as his late poems reveal, he might have taken to himself Beatrice's reproach about being more concerned with appearance than with truth, with artistry rather than with the message. In his later years he seems to have realized the conflict between the service of beauty and the cross, and to have recalled the warnings of Savonarola that he heard in his youth. In a famous sonnet written in 1552–54, he writes:

Giunto è già 'lcorso della vita mia,	The journey of my life in a fragile bark, through tempestuous seas,
con tempestoso mar, per fragil barca,	has now already reached that common
al commun porto, ov'a render si varca	port, where it goes to give account for
conto e ragion d'ogni opra trista e pia.	every good and evil act.
Onde l'affettuosa fantasia che l'arte mi fece idol e monarca	There I now know how full of error was the affectionate fantasy

conosco or ben com'era d'error
carca
e qual c'a mal suo grado ogn'uom
desia.
Gli amorosi pensier, già gani e
lieti,

che fien or, s'a duo morte
m'avvicino?
D'una so 'lcerto, e l'altra mi
minaccia.
Né pinger né scolpir fie più che
quieti
l'anima, volta a quell'amor
divino
c'aperse, a prender noi, 'n croce le
braccia.[11]

that made art for me an idol and
a king;
I know the value of what every one
desires, against his will.
What shall become of amorous
thoughts, once welcome and
joyous,
now that I approach a double
death?
Of one I am certain, and the other
threatens me.
Neither painting nor sculpting can
any longer quiet
The soul, turned to that divine
love
which opened its arms on the
cross to take us.

Throughout his life Michelangelo was occupied with the theme of the death of Christ, and in his last years returned repeatedly to the theme of the pietà with which he had begun his career. Vittoria Colonna was also preoccupied with the passion and with the place of Mary in it. She wrote a lament on the passion of Christ ("Pianto sopra la Passione di Cristo") which centers on the sorrowing of the Virgin over the dead body of Jesus. The relation of this literary work to Michelangelo's drawing is unknown. It is quite conceivable that one was influenced by or was actually a response to the other; but which came first can only be a matter of speculation. In any case, each of the two certainly illuminates the other.

Colonna's meditation begins with a description of the dead Christ in the lap of the Virgin. She explicitly adverts to the "pious effect" of seeing this scene.[12] In describing the lamentation of the Virgin, she stresses that Mary experiences both pain and joy, and indeed is able to rejoice in her pain (dilettar in questa pena),[13] because she knows that the purpose of her Son's suffering is the redemption of the world. (The idea that Christ knew of and explicitly predicted his passion is contained in the gospels. Some medieval traditions added to this the idea that he privately informed his mother beforehand of the necessity and the meaning of his coming death.)[14] In Colonna's mind, Mary desires that the whole world should be able to share her experience.[15]

Colonna notes that the divine qualities that animated Jesus during his life left "vestiges" (*vestigij*) in his body even after his death. Ever since the council of Chalcedon, Christian theology had agreed that the Logos of God remained united with the body of Christ even after the departure of his human soul. Some medieval legends included a restoration of Christ's body to its pristine beauty during Mary's lamentation, as a divine consolation to her. But Colonna adds another perspective:

> Besides the presence of the divinity, which never left him, I think he
> had his usual great majesty; indeed, even greater, because death,
> which in others comes violently, and which therefore leaves them
> [looking] like persons who have been offended; [but] in Christ, who
> had called death and had desired it with such sweetness, I think that it
> was an act of such sweetness, gentleness, and piety that it would
> soften every hard heart, and enflame every cold mind; the ugliness of
> death was not only beautiful on that beautiful face, but its fierceness
> was converted into a great sweetness.[16]

Nevertheless, Mary is able to perceive that her son is truly dead; that is, that his soul has left his body. Indeed, she sees her own body as a kind of sepulcher.[17] In Colonna's imagination, the recognition that Jesus' soul has departed is the source of an extraordinary affective and voluntary response on the part of Mary to her Son's redemptive sacrifice:

> Thus the Madonna, seeing that the blessed soul of Christ was not
> present, [that soul] which alone was capable of rendering [due] honor
> to the immeasurable greatness of the Divinity, it seemed to her
> that to her alone belonged the great responsibility [*el grand'offitio*]
> of paying this debt; hence she would have wished to liquefy her-
> self, be consumed, indeed be annihilated in the fire of love and in tears
> of compassion, in order to remove ingratitude from the world
> and from herself, and to render to God the honor and the worship
> that are rightly His.[18]

I suggest that this passage is most intelligible when read in light of the "satisfaction" theory of redemption and the notion of *compassio* and its "pious effect" mentioned by Colonna herself. The human soul of Christ, because hypostatically united to the Word, is the only creature capable of restoring God's honor, which is so offended by the sin of humanity that humanity finds itself in a situation of infinite debt. In the absence of this soul, Mary wishes to

take the payment of the debt upon herself. The theologically informed reader knows that the debt has already been paid by Christ through his obedience, which has restored to God the proper honor God should receive from creatures. But Mary's desire to serve as the "redeemer," although in one sense unique to her in that moment between Christ's death and resurrection, is at the same time a model of the response to the passion that should occur in every Christian who contemplates it. Her desire to be the propitiatory sacrifice stems from the love and compassion that meditation on the love of God in Christ inspire. They are opposed to the ingratitude of humans for God's gift of existence and even for the redemption itself (once again, comparison to Savonarola's meditation on the passion is instructive). And, as we have seen expressed (in an extreme form) in the theology of Biel, in Catholic doctrine humans do in fact collaborate with the work of Christ, and truly "merit" salvation for themselves and others—although always because of God's prior grace, mediated to us by Christ, and in response to the example of Christ's unique mediation.

In her sonnets on the passion Colonna expresses the idea that confrontation with Christ's sacrifice imposes on us a responsibility—the "yoke" of Christ that is spoken of in the gospel:

Con la piagata man dolce e soave	With his wounded hand, sweet and gentle,
Giogo m'ha posto al collo, e lieve il peso	He has placed a yoke on my neck,
Sembrar mi face col suo lume chiaro.	And he makes the weight seem light to me with his bright regard.[19]

It is significant to our theme that both Michelangelo and Colonna present the cross—the passion and death of Christ—as something beautiful, in the perspective of the spiritual beauty of God's redemptive act. In contrast to the sometimes gruesome late medieval emphasis on the suffering of Jesus (Grünewald) and the frantic lamentation of Mary, they present the passion in light of its purpose as a revelation of the divine love, to which we are called to respond in faith. For both, the divinity of Christ is primary, and it manifests itself in the physical appearance of his body, even when dead. That both were involved in the movement for reform in the church and for a renewal of personal spirituality, and that they attempted to use humanistic poetry and art in the expression of that movement, casts light on the spirit of early efforts to reform the church from within.

Part 1: The Theoretical Mediation: The Reform in Catholic Theology

The Context: The Catholic Reformation and Counter-Reformation

It is not our purpose here to undertake even a summary history of the complex of elements and aspects of reform in the church both prior to and in response to the Protestant movement. We must however include a few brief remarks to set the general context for our examination of the emergence of the classical statements of a new theological paradigm and of new artistic styles, particularly as they are concerned with the cross.

REFORM MOVEMENTS IN THE RENAISSANCE CATHOLIC CHURCH PRIOR TO THE COUNCIL OF TRENT

As we have already seen, calls for reform and movements to purify the church began before Luther. There was a strong consciousness of the abuses in the church in the apocalyptic spirit of the late Middle Ages, a spirit that continued into the fifteenth century in figures like Savonarola. Erasmus anticipated Luther's complaints about the sterility of scholastic theology, criticized the superstitious nature of many of the church's external devotions, and called for a more personal and interior spirituality. One of the primary goals of the Christian humanists was a return to the Scriptures and the spirit of the early church. Efforts to reform the church in such directions continued for some time within the Catholic community to some extent independently of its response to Protestantism.[20]

Although corruption in the church was obviously a major concern for reformers, other factors were present as well. Intellectual paradigms and societal conditions were changing, as were economic structures; geographical discovery and exploration were expanding the European world and mind; the printing press fostered a new level of education, and with it an impatience with former uninformed practices and attitudes.

An example of the reforming spirit put to practical effect prior to Luther may be found in the Spanish church under the leadership Cardinal Francisco Ximenes de Cisneros, archbishop of Toledo and primate of Spain from 1495, and chancellor of the Kingdom of Castile. Ximenes joined the Franciscan order after having been a secular priest. He was personally austere, and worked hard for the reform of the clergy and the renewal of spiritual life. A humanist, he established a university at Alcalá primarily for the education of clergy. The

University of Alcalá strongly emphasized a return to the Scriptures, and produced the Complutensian Polyglot Bible ("Complutum" being the Latin name for Alcalá), including the texts of the Old and New Testaments in the original languages, Hebrew, Chaldean (Aramaic), and Greek, with a Latin translation. Its Greek New Testament was the first ever to be printed (1514), preceding that of Erasmus by two years.[21]

Several official efforts at reform were made both before the appearance of Luther and in response to the spread of his ideas. The Fifth Lateran Council (1512–17) was intended to be a reforming council. It began with a moving address by Egidio da Viterbo, the General of the Augustinian Order. A humanist influenced by Marsilio Ficino, Egidio was also, like Vincent Ferrer and Savonarola, a preacher of the Apocalypse. He stressed the need for renewal in the church, starting with its clergy (he himself reformed the Augustinian order) and its hierarchy.[22] (Unfortunately, very little of practical significance resulted from the council, which Pope Leo X wished to use primarily to buttress papal authority.) In 1537, Pope Paul III appointed a commission to examine the need for reform in the church. Its report, the Consilium de emendanda ecclesia ("Advice on Changes to be Made in the Church") outspokenly blamed church leadership for widespread abuses and recommended practical steps for their correction. Even in doctrinal matters there was an attempt to reform teachings in such a way that reconciliation could be found between Catholic and Lutheran positions. A conference at Regensburg (Ratisbon) in 1541 actually reached agreement on the crucial question of justification (through the proposal of a "double justification"—a formulation later rejected by Trent); but other issues prevented an effective accord.

An important part of the reforming movement was the foundation of new lay societies and confraternities and new orders of priests and religious. The Oratory of the Divine Love was founded in Genoa in 1497 by Ettore Vernazza, a layman inspired by Saint Catherine of Genoa. Along similar lines, an Oratory for priests was founded in Rome prior to 1517. It included among its founding members Gaetano da Thiene and Gian Pietro Carafa (later Pope Paul IV), who also founded the order of Theatines[23] that would play a significant part in the renewal of the church in the Counter-Reformation period. Consecrated to the cross, which was their emblem, they founded oratories and were particular patrons of art in their churches.

The order of Capuchin Franciscans (Third Order of St. Francis, Capuchin) was founded around 1520 by Matteo da Bascio, an "observant" Franciscan who desired to return even more radically to the primitive rule and spirit of St. Francis. After some difficulties from his own order, which wished to arrest him, he won approval of the new order in 1528 from Pope Clement VII. (The hood

or capuche that characterized the order's habit and provides its name is a tribute to the Camaldolese monks who gave Matteo refuge in his early days.) Significantly, in theology the Capuchins abandoned the proto-nominalist thought of Scotus and returned to the more classical scholasticism of Bonaventure.

Among the new orders, the one that would eventually be most among the most significant in numbers and influence was the "Company of Jesus" or *Societas Jesu* founded by Eneko (Spanish Iñigo) López de Loyola. Having begun his adult life as a soldier, Ignatius (to give him his adopted Latin name) retained his feudal and military mentality even after his religious conversion. He explicitly thought of his society as a kind of militant order, (*militia Christi*) fighting a spiritual battle under "the standard of the cross."[24] The order would eventually be notable for its role in active opposition to Protestantism. But its roots lie in a fervor for a fervent missionary activity stemming from the sort of personal conversion to the crucified Christ, and inspiration to follow and imitate him, that typified the spirit of Catholic reform.

THE COUNCIL OF TRENT AND THE "COUNTER-REFORMATION"

As we have mentioned, there were calls for a general church council to address the question of reform in the church even before Luther's appearance. The Fifth Lateran Council was an abortive attempt at such a council. Once the Reformation had broken out in force, the urgency of a council was even more apparent. Luther called for a general council in 1518; the Diet of Nuremberg demanded one in 1523; and the Emperor Charles V energetically pursued the goal for many years. However, for various reasons, including the opposition of Pope Clement VII and of Francis I of France, the council was not called until 1542. It did not begin until 1545, in the city of Trent in northern Italy (chosen because of its proximity to Germany). The council lasted for eighteen years, with many interruptions. By the time the council met, positions had hardened. Although the council was ostensibly for the purpose of reforming the church, reviewing its theology, and reconciling the now separate communions, the Protestants generally refused to attend (with the exception of one session in 1552). For this reason the council, largely under the influence of "hard line" Roman theology, did not settle the theological and pastoral controversies or reconcile the disputing parties, but rather defined and legislated the Catholic position alone, frequently in conscious opposition to the positions of the Reformers.

In this sense Trent can be seen as the symbolic beginning of the Catholic "Counter-Reformation" as a negative and aggressive response to Protestantism. At the same time, the council was also a continuation and strengthening of the Catholic Reformation that had begun already prior to the Protestant

controversy. Trent embodied the Catholic position in opposition to the Protestant Reformation, but not in opposition to reformation itself. On the contrary, the Council of Trent explicitly took up "the business of reform" (*de reformationis negotio*) and issued decrees entitled "On Reformation."[25]

THE DOCTRINE OF TRENT ON SALVATION. The Roman Catholic response to the Reformers' doctrines concentrated on the question of justification, insisting on the need for human meritorious works, not in place of Christ's grace, but as its appropriation and realization in us. It therefore united two subjects that for the Lutherans had to remain doctrinally separate: justification and sanctification. The Council of Trent's "Decree on Justification" adopts the schema of Aristotelian "causes" that we have already seen in the Scholastics. The "final" cause of justification, i.e., its goal, is the glory of God and Christ, and our eternal life. Its "efficient" cause is God, who gratuitously forgives and sanctifies us. Its "meritorious" cause is Christ, who "by his most holy passion on the wood of the cross merited justification for us and gave satisfaction to God the Father for us." The "instrumental" cause is the sacrament of baptism. And the sole "formal" cause (what actually constitutes the state of being justified) is "God's justice, not insofar as God is just in God's self, but insofar as God makes us just." That is, justification is not merely "imputed" to us: we are made just by receiving in ourselves a new life in the Spirit (DS 1529). (The council thus rejected not only the Lutheran formulation of justification "by faith alone," but also the compromise position of a "double justification" that had been adopted by Catholic and Lutheran representatives at the conference of Ratisbon [Regensburg] in 1541.)

The Council agrees with the Reformers that "no one can be just, unless the merits of the passion of Our Lord Jesus Christ are communicated to [a person]." But this happens because, "by the merit of that same most holy passion, through the Holy Spirit, the love of God is diffused in the hearts of those who are justified, and inheres in them" (DS 1530; cf. 1561). Hence, since Christ is the head of the body of which the faithful are members, they are able, by God's gift, to cooperate with grace, to perform good works so as to satisfy God's law and merit eternal life (DS 1546, 1559).[26]

Hence Trent essentially repeats the medieval doctrine of the cross, without going into detail concerning specific theological questions except those directly concerned with the refutation of the Reformers' supposed errors. Christ's passion "satisfies" God on our behalf and merits salvation; but we must collaborate with the grace freely given us.

THE CATECHISM OF THE COUNCIL OF TRENT (THE ROMAN CATECHISM). Following the example of Luther and other reformers, the Council of Trent called for the

publication of a catechism for instructing the laity in doctrine. It was directed to pastors, as a compendium of the faith to be used in teaching. The parts of the *Catechism* most directly relevant to the doctrine of salvation are those concerned with the sections of the creed on the death of Christ and its meaning: Article IV, "Suffered under Pontius Pilate, was crucified, dead, and buried" and Article V, "He descended into Hell, the third day He rose again from the dead." Other relevant sections are found in the treatments of the eucharist, baptism, and penance. Each phrase of the creed is analyzed and expanded dogmatically.

The *Catechism* stresses the importance of teaching about Christ's passion, in order that "the faithful 'being moved by the remembrance of so great a benefit' may turn themselves entirely to the contemplation of the goodness and love of God towards us."[27] Analyzing the word "suffered," the *Catechism* stresses that the "lower part" of Christ's soul really underwent pain. Moreover, even though his divine nature remained impassible and immortal, the entire human soul of Christ experienced a sorrow just as bitter as if it were not conjoined hypostatically to the divinity. Concerning the mode of Christ's death, it repeats the traditional idea of reversal of Adam's sin: "The fact that He suffered death precisely on the wood of the cross must also be attributed to the counsel of God, [which decreed it] so that life should return by the way whence death had arisen; and so that the serpent who had triumphed over our first parents by the wood (of a tree) was vanquished by Christ on the wood of the cross."[28] Although one might find in the Fathers many other reasons for the suitability of the cross, "it is enough for the faithful to believe that this kind of death was chosen by the Savior because it appeared better adapted and more appropriate to the redemption of the human race; for there certainly could be none more ignominious (*turpius*) and humiliating (*indignius*). Not only among the Gentiles was the punishment of the cross held accursed and full of shame and infamy, but even in the Law of Moses the man is called accursed that 'hangs on a tree.' "[29]

Salvation through the cross is affirmed to be the very foundation of the faith, and should be presented to the people frequently.[30] But it is also a great mystery. "Indeed, if there is anything that presents difficulty to the human mind and understanding, assuredly the mystery of the cross beyond all doubt must be considered the most difficult of all; so much so that only with great difficulty can we grasp the fact that our salvation depends on the cross itself, and on Him who for us was nailed thereon."[31]

The pastor should also explain, the *Catechism* says, that Jesus really died, and that he took his death upon himself freely. "It was unique to Christ the Lord to have died when He Himself decreed to die, and that his death was brought

about not so much by external powers as by his own will. Not only His death, but also its time and place, were ordained by Him."[32]

Having stressed the importance of teaching the historical facts of Christ's death and burial, the *Catechism* devotes special sections to the meaning of the passion and the benefits of meditating on it. The thought of Christ's death should excite our love and gratitude.

> [When we meditate on the sufferings and all the torments of the Redeemer], nothing is better calculated to stir our souls than the thought that He endured them voluntarily. For if anyone were to endure all kinds of suffering for our sake, not because he chose them but simply because he could not escape them, we should not consider this a very great favor to us; but were he to endure death freely, and for our sake only, having had it in his power to avoid it, this indeed would be a benefit so overwhelming as to deprive even the most grateful heart, not only of the power of returning but even of feeling due thanks. From this we may form an idea of the supreme and intense love (*charitas*) of Jesus Christ towards us, and we can perceive his divine and immeasurable merit.[33]

Among the "Useful Considerations on the Passion" are the dignity of the one who suffered and the reasons for his suffering.

> The reasons for the passion are also to be explained, that thus the greatness and intensity of the divine love towards us may the more fully appear. Should anyone inquire why the Son of God underwent His most bitter Passion, he will find that besides the guilt inherited from our first parents the principal causes were the vices and sins which humans have perpetrated from the beginning of the world to the present day and those which will be committed to the end of time. In His Passion and death the Son of God, our Savior, intended to atone for (*redimeret*) and blot out (*deleret*) the sins of all ages, to offer for them to his Father a full and abundant satisfaction. Besides, to increase the dignity of this mystery, Christ not only suffered for sinners, but even for those who were the very authors and ministers of all the torments He endured. Of this the Apostle reminds us in these words addressed to the Hebrews: Think diligently upon him that endured such opposition from sinners against himself; that you be not wearied, fainting in your minds. [Heb. 12:3] We should judge that all those who fall frequently into sin are above all involved in this guilt. For, since our sins moved Christ

the Lord to undergo the death of the cross, most certainly those who wallow in sin and iniquity again crucify the Son of God within themselves, as far as in them lies, and make a mockery of Him. This guilt seems more enormous in us than it was in the Jews, since according to the testimony of the same Apostle: If they had known it, they would never have crucified the Lord of glory [1 Cor. 2:8]; while we, on the contrary, professing to know Him, yet denying Him by our actions, seem in some way to lay violent hands on him.[34]

At the same time, it must be stressed that "Christ Was Delivered Over To Death By The Father And By Himself," as the sign of God's love for us. The cross shows how much we should trust in "the boundless mercy and goodness of God," for "He that spared not even his own Son, but delivered him up for us all, how hath he not also, with him, given us all things? [Rom. 8:32]"[35]

Particular attention is given to the extent of Christ's suffering in the passion: The pastor should next teach how great was the bitterness of the passion. If we bear in mind that his sweat became as drops of blood, trickling down upon the ground at the anticipation of the torments and agony which He was about to endure, anyone will easily perceive that His sorrows could not be greater. For if the very idea of impending evils was so bitter, as the sweat of blood shows that it was, what are we to think their actual endurance must have been?

That Christ our Lord suffered the most excruciating torments of both mind and body is certain. In the first place, there was no part of His body that did not experience the most agonizing torture. His hands and feet were fastened with nails to the cross; His head was pierced with thorns and smitten with a reed; His face was befouled with spittle and buffeted with blows; His whole body was covered with lashes. Furthermore people of all ranks and conditions were gathered together against the Lord, and against his Christ [Ps. 2:2]. Gentiles and Jews were the instigators, the authors, the ministers of His Passion: Judas betrayed Him, Peter denied Him, all the rest deserted Him. And while He hangs from the cross are we not at a loss which to deplore, His agony, or His ignominy, or both? Surely no death more shameful, none more cruel, could have been devised than this. It was the punishment usually reserved for the most guilty and atrocious malefactors, a death whose slowness aggravated the exquisite pain and torture. His agony was increased by the very constitution and frame of the body of Jesus Christ. Formed by the power of the Holy Spirit, it was more perfect and better organized than the

bodies of others can be, and was therefore endowed with a superior susceptibility and a keener sense of all the torments which it endured.

And as to His interior anguish of soul, no one can doubt that this too was extreme in Christ; for those among the Saints who had to endure torments and tortures were not without consolation from above, which enabled them not only to bear their sufferings patiently, but in many instances, to feel, in the very midst of them, filled with interior joy, as the Apostle says: "I rejoice in my sufferings for you, and fill up those things that are wanting of the sufferings of Christ, in my flesh, for his body, which is the church" [Col. 1:24] and in another place: "I am filled with comfort, I exceedingly abound with joy in all our tribulations" [2 Cor. 7:4]. But Christ our Lord permitted no admixture of sweetness to temper the bitter chalice of his passion that he drank. He permitted His human nature to feel as acutely every species of torment as if He were only human, and not also God.[36]

The "fruits" of Christ's passion are four. First, "the Passion of our Lord was our deliverance from sin." Second, "He has rescued us from the tyranny of the devil." Third, "He discharged the punishment due to our sins. And since no sacrifice more pleasing and acceptable could have been offered to God, He reconciled us to the Father, appeased Him and made Him favorable to us [eumque nobis placatum et propitium reddidit]." Finally, "by taking away our sins He opened to us heaven, which was closed by the common sin of humankind." The Catechism repeats the belief that even the just had to await Christ's resurrection before the "gates of heaven" were opened to them. "For those who were prohibited to return into their native country before the death of the high-priest signified that no one, however just and holy may have been his life, could gain admission into the celestial country until the eternal high-priest, Christ Jesus, had died, and by His death immediately opened heaven for those who, purified by the Sacraments and gifted with faith, hope, and charity, become partakers of His Passion."[37]

The next section expands on the dogmatic understanding of the passion as a satisfaction, a sacrifice, a redemption, and an example to us:

The pastor should teach that all these inestimable and divine blessings flow to us from the Passion of Christ. First, indeed, because it was a full and satisfaction, complete in every respect, which Jesus Christ in an admirable manner made to God the Father for our sins. The price which He paid for our ransom was not only adequate and equal to our debts, but far exceeded them. Again, it [the passion of Christ] was a sacrifice most acceptable to God, for when offered by His Son on the

altar of the cross, it entirely appeased the wrath and indignation of the
Father. This word [sacrifice] the Apostle uses when he says: Christ
has loved us, and has delivered himself for us, an oblation and a
sacrifice to God for an odour of sweetness [Eph. 5:2]. Furthermore, it
was a redemption, of which the Prince of the Apostles says: You were
not redeemed with corruptible things as gold or silver, from your vain
conversation of the tradition of your fathers: but with the precious
blood of Christ, as of a lamb unspotted and undefiled [1 Pet. 1:18–19];
while the Apostle teaches: Christ has redeemed us from the curse
of the law, being made a curse for us. [Gal. 3:13] [38]

In its section on penance, the *Catechism* expands on the notion of "satis-
faction." The "satisfaction" offered to God by Christ on the cross was full and
complete, and no created being could offer a satisfaction that could free us of
the debt of our sins. At the same time it affirms the need for a different kind of
"satisfaction" that is associated with the sacrament of penance. Penitential acts
of satisfaction depend entirely on our reconciliation with God through Christ;
without this, no human actions can have any value before God. However,
having been reconciled, we are obliged to make acts of "satisfaction" or penance
for our sins—although the *Catechism* leaves way for various theories of the exact
nature of such "satisfaction." [39]

The passion of Christ, however, is not merely satisfaction to God for our
sins, but is also an example for us:

Besides these incomparable blessings, we have also received another
of the highest importance; namely, that in this one Passion we have
the most illustrious example of every virtue. For He so displayed
patience, humility, extreme charity, meekness, obedience and un-
shaken firmness of soul, not only in suffering for the sake of righ-
teousness, but also in meeting death, that we may truly say on the day
of His Passion alone, our Savior offered, in His own Person, a liv-
ing exemplification of all the moral precepts inculcated during the
entire time of His public ministry. [40]

The section concludes with an "Admonition" that stresses the need to in-
teriorize and live what the doctrines express. "Would that these mysteries were
always vividly present to our minds, and that we learned to suffer, die, and be
buried together with our Lord; so that from henceforth, having cast aside all
stain of sin, and rising with Him to newness of life, we may at length, through
His grace and mercy, be found worthy to be made partakers of the celestial
kingdom and glory." [41]

In the explanation of the next article of the creed, "He descended into hell, the third day he rose again from the dead," the *Catechism* emphasizes the glory of Christ's victory. "Hell," it explains, includes several regions: not only the "bottomless pit" of Gehenna, but also the cleansing fire of purgatory (whose reality should be emphasized by the pastor, the text stresses), and the peaceful and painless abode of the just who died before the coming of Christ. It was to liberate these, as well as to proclaim his power that Christ "descended into hell" with his divine majesty. The *Catechism* takes the opportunity of meditation on the descent into hell to stress the universality of the efficacy of Christ's redemption. ". . . not only the just who were born after the coming of our Lord, but also those who preceded Him from the days of Adam, or who shall be born until the end of time, obtain their salvation through the benefit of His Passion."[42]

Finally, the resurrection is to be understood also as a manifestation of Christ's divine nature:

> By the word Resurrection, however, we are not merely to understand
> that Christ was raised from the dead, which happened to many
> others, but that He rose by His own power and virtue, a singular
> prerogative peculiar to Him alone . . . This divine power, having never
> been separated, either from His body in the grave, or from His soul
> in hell, there existed a divine force both within the body, by which it
> could be again united to the soul, and within the soul, by which it
> could again return to the body. Thus He was able by His own power
> to return to life and rise from the dead.[43]

The resurrection of Christ was necessary in order to manifest God's justice, to confirm our faith and hope, and to complete the mystery of our salvation. "By His death Christ liberated us from sin; by His Resurrection, He restored to us the most important of those privileges which we had forfeited by sin. Hence these words of the Apostle: 'He was delivered up for our sins, and rose again for our justification' [Rom. 4:25]. That nothing, therefore, should be wanting to the work of our salvation, it was necessary that as He died, He should also rise again."[44]

The resurrection of Christ is the "efficient cause" of our eventual resurrection at the end of time, and is also a model for our moral regeneration in the present:

> From the Resurrection of Christ, therefore, we should draw two
> lessons: first, that after we have washed away the stains of sin, we
> should begin to lead a new life, distinguished by integrity, innocence,
> holiness, modesty, justice, beneficence and humility; second, that
> we should so persevere in that newness of life as never more, with the

divine assistance, to stray from the paths of virtue on which we have
once entered. . . . For as His death not only furnishes us with an ex-
ample, but also supplies us with strength to die to sin, so also His
Resurrection invigorates us to attain righteousness, so that thence-
forward serving God in piety and holiness, we may walk in the
newness of life to which we have risen. Our Lord accomplished this
especially by His resurrection, so that we, having first died with
Him to sin and to this world, should rise also with Him to a new
manner and order (disciplinam) of life.[45]

It is significant that the Catechism attributes to the resurrection a certain
"causality" with regard to salvation, although the separation of its effects from
those of Christ's death also serves to reinforce the notion that salvation itself
is by means of "satisfaction" and "sacrifice." And of course we may see a re-
sponse to Lutheran ideas—or at least the Catholic perception of them—in the
emphasis on the need for a truly regenerated life, which is made possible not
only by Christ's death, but also as an effect of his resurrection.[46] The Catechism
does not explicitly take up the controverted point of human freedom, but in the
section on creation simply states that God gave humanity free will,[47] and takes
for granted in its discussions of repentance and grace the teaching of Trent that
this freedom is not completely destroyed by the fall, nor is it overwhelmed by
the reception of an irresistible grace.[48]

The section of the Catechism that deals with the eucharist emphasizes that
the sacrifice of the mass is one and the same sacrifice that was offered once for
all times on the cross in a bloody manner by Christ.[49] Moreover, the mass is not
merely a sacrifice of praise, or a bare commemoration of the sacrifice of the
cross; being the very same sacrifice as that of the cross, but in sacramental
mode, it is also an offering of propitiation, by which God is appeased and is
made favorable to us (quod Deus nobis placatus et propitius redditur). The over-
flowing benefits of the bloody sacrifice reach us through our celebration of this
unbloody sacrifice. "God is so pleased by the sweet odor of this sacrifice
(huius . . . victimae odore) that God forgives our sins and grants us the grace of
penitence. Moreover, the church joins itself to the sacrifice of Christ: we "im-
molate" and offer the sacrificial victim who once offered himself on the cross.[50]

ROBERT BELLARMINE. As we have seen, Tridentine Catholic theology repre-
sented little change in soteriological theory from the teachings of the Middle
Ages. However, we can see a strong emphasis on the notions of "satisfaction"
and sacrifice, especially in the Roman Catechism. In the Catechism of Robert
Bellarmine (1542–1621) we see an even further strengthening of these concepts

in an attempt to accommodate to the popular mentality doctrines that are stated abstractly in the Roman Catechism. In his short catechism, written in Italian and meant to be memorized, Bellarmine gives only passing attention to soteriological doctrine. In the context of the "fourth article" of the creed, the student's answer is: "I believe that Jesus Christ, to buy back (*ricomprare*) the world with his most precious blood, suffered under Pontius Pilate, governor of Judea, having been flogged, crowned with thorns, and placed upon the cross, on which he died...."[51]

The longer version of the *Dottrina Cristiana* contains not only an explicit reference to the "satisfaction" theory, but an explanation of its principle of "honor" in terms of aristocratic society. The teaching is put in the form of a dialogue:

Student: Why did Christ, being innocent, allow himself to be unjustly crucified and killed?

Teacher: For many reasons: but the first is to satisfy (*soddisfar*) God for our sins. For you must know that an offense is measured by the dignity of the one who is offended; and, conversely, satisfaction is measured by the dignity of the one who satisfies. So, for example, if a servant were to strike a prince, it would be considered the gravest offense, because of the greatness of the prince; but if the prince were to strike the servant, it would be a small matter (*cosa di poco momento*) because of the low condition (*viltà*) of the servant. If the servant doffs his hat to the prince, it means little; but if the prince were to doff his hat to the servant, it would be a great honor, according to the rule already stated. Now, because the first man, and with him all of us, have offended God, whose dignity is infinite, the offense given requires infinite satisfaction. And since there was no human nor angel of such dignity, the Son of God came. As God, he is of infinite dignity, and having taking mortal flesh, in this flesh he submitted himself to death on the cross, for the honor of God. And thus by his suffering he satisfied completely for our sins.

Student: What is the other reason why Christ wished to suffer such a bitter death?

Teacher: To teach us, through his example, the virtue of long-suffering (*pazienza*), of humility, and of obedience, and of charity, which are four virtues signified by the four extremities of the cross, since one cannot find greater long-suffering than to suffer unjustly such an ignominious death; nor greater humility, than for the Lord of all lords to be crucified between thieves; nor of greater obedience, than to wish to die, rather than not fulfill the command

of the Father; nor of greater love, than to give one's life, to save one's own enemies. And you must know that love is shown more by deeds than by words; and more by suffering (*patire*) than by doing. Hence Christ, who not only wished to bring us infinite benefits, but also to suffer and die for us, has shown that he loves us most fervently.[52]

It is notable that the ideas of "honor," "dignity," and "satisfaction" are taken as nearly self-explanatory. Bellarmine lived in an age when gentlemen commonly demanded "satisfaction" for insults, and which saw the development of an impressive literature about points of honor.[53] (It is also interesting that Bellarmine, who was personally involved in the trial of Galileo and the condemnation of Giordano Bruno, explains the "descent into hell" in terms of a descent into caverns in the center of the earth, "as a king sometimes goes down to the prisons to visit them and pardon whom he pleases.")

Bellarmine also speaks of the cross later in the catechism, as the "remedy" for original sin:

> Teacher: It has already been stated above that the remedy [for original sin] was the passion and death of Christ our Lord: because God willed that the one who wished to satisfy for the sin of Adam should be the one without sin; indeed, should be God and human, so that he would be infinitely acceptable to God, and should obey not in any easy matter, like the commandment given to Adam, but in a most difficult matter, like the horrible death on the cross. And this remedy is applied to us through holy Baptism, as we have said. However, God did not wish to give back to us immediately the seven gifts [given to Adam before the fall], but he gave us back the most important one, that is, God's grace, through which we are made just, friends and children of God, and heirs of paradise. The other gifts will be returned to us in even greater measure in the next life, if we behave well in this one.[54]

Part 2: The Aesthetic Mediation: The Cross in Art and Music in the Crisis of the Renaissance[55]

Response to Iconoclasm

TRENT ON THE QUESTION OF IMAGES

In its twenty-fifth session, in the year 1568, the Council of Trent explicitly took up the questions raised by Protestant iconoclasm. Significantly, it treats the question of images together with those of relics and of the veneration and in-

tercession of the saints. As we have seen, many of the Reformers' objections—as well as those of the humanists—were directed not so much against images themselves, as against the practices that accompanied them, which were frequently associated with cult images, relics, and places of pilgrimage. But the council also deals briefly with strict iconoclasm, dismissing it with an appeal to the Second Council of Nicaea and referring to that council's principal argument. However, even while defending the use of images, the council agreed with the reformers not only that abuses were possible in the use of art, but also that much of the art itself was "inappropriate" for sacred use because of its worldliness. The decree is short enough and significant enough to be quoted in its entirety:

> Moreover [this Synod decrees] that images of Christ, of the Virgin mother of God, and of other saints, should be kept and preserved, especially in churches, and that they should be given due honor and veneration; not because it is believed that there is in them any divinity or power that makes them worthy of worship, nor because one should pray to them for anything, nor because one should have trust in images, as the pagans formerly did who placed their hope in idols; but because the honor that is given to them is referred to the originals (*prototypa*) that they represent: so, though the images that we kiss and take our hats off to and kneel before, we adore Christ, and we venerate the saints whom they picture—as the decrees of the councils establish, and especially those of the second Nicene Council against the opponents of images.
>
> Bishops should diligently teach that through the recounting of the mysteries of our redemption, expressed in pictures and other representations, the people are educated and confirmed in the articles of faith that should be remembered and assiduously called to mind; moreover, that sacred images are very fruitful, not only because they recall to the people the benefits and gifts that have been granted them by Christ, but also because they bring before the eyes of the faithful the miracles performed by God through the saints, and their example, which is helpful to salvation (*salutaria exempla*); so that the faithful may give thanks to God for them, and may pattern their lives and habits according to the examples of the saints, and may be encouraged to adore and love God and practice piety.
>
> If anyone should teach or hold anything contrary to these decrees, let that person be excommunicate. But if any abuses have been introduced into these holy and salvific practices, this Synod forcefully (*vehementer*) desires that they be totally abolished; hence no images

should be permitted that represent false dogmas, nor any that give occasion to the uneducated for dangerous errors. And if there are sometimes stories and narrations of the holy Scriptures pictured and represented because they are useful for the instruction of the ignorant, the people should be taught that this does not mean that the divinity can be pictured, as though it could be seen with bodily eyes, or be represented with colors or forms. Every superstition in the invocation of the saints, in the veneration of relics, and in the use of holy images must be done away with; every sordid commerce must be eliminated; and every lasciviousness avoided. Hence images must not be painted nor adorned with scandalous sensual beauty (venustate), and the celebrations of the saints and pilgrimages to visit relics must not be abused as an excuse for feasting and drunkenness, as though luxury and lasciviousness were the way to honor the saints' days. Finally, let the bishops observe such diligence and care about this that nothing appear that is disordered or inappropriate and confusing, nothing that is profane or illicit; for holiness is fitting for the house of God. And so that these things be observed with greater fidelity, this sacred Synod decrees that no one is permitted to place or to cause to be placed any unusual (insolitam) image in any place or any church, even one not under the bishop's authority, except with the permission of the bishop. No new miracles are to be recognized, nor new relics accepted, unless they are recognized and approved by the same bishop; and when he is certain about them, having consulted with theologians and other pious persons, he should do what he judges right according to truth and piety. If there are doubts, or if there is a difficult case of abuse to eliminate, or if there occurs some grave question on these matters, let the bishop wait for the judgment of the Metropolitan and the provincial bishops in the provincial Council before resolving the controversy. However, nothing new or hitherto uncustomary in the church may be decided without consulting the Roman Pontiff.[56]

It is notable that the decrees of Trent do not give any very specific guidelines for sacred art. On the one hand, the use of art is strongly affirmed. Indeed, highly ornamented churches would become typical of the Counter-Reformation. The bareness of Protestant places of worship was opposed by splendor in Catholic churches. The Jesuit Peter Canisius defended such ornamentation: "the innovators [i.e., the Protestants] accuse us of prodigality in the decoration of churches; they are like Judas reproving Mary Magdalene for pouring per-

fume on the head of Christ."[57] The buildings of the militant church on earth were to be the image of the triumphant church in heaven.

On the other hand, while the use of sacred art was strongly affirmed, its mode of execution was to be restricted. The tension between religion and the independent spirit of renaissance aesthetics could only be increased by the Council's reaffirmation of traditional images, the prohibition of "novelty," and the rejection in sacred art not only of "sensual beauty," but also of the presence of anything "profane" or "inappropriate" (terms that could be and sometimes were interpreted very widely). Of course, the desire to "purify" sacred art of secular and sensual elements was by no means new. We have seen it already in Savonarola, and Pope Paul IV ordered Daniele da Volterra to cover up of some of the nudes in Michelangelo's Sistine Chapel "Last Judgment" already in 1559, before Trent's decrees.[58] The Council therefore was simply reiterating and reinforcing a tendency to a certain "artistic puritanism" that had already arisen in reaction to the real or supposed paganism of Renaissance art. As Arnold Hauser remarks, perhaps the most important aspect of Trent's decree was the placing of judgments about art in the hands of bishops. This created the possibility of a complete subjection of sacred art to dogmatic concerns, with little concern for aesthetic values in themselves.[59] (As we shall see, El Greco would be affected by the enforcement of such priorities.)

Naturally, the implementation of the decrees of Trent on art of varied from place to place. For political reasons, the Kingdom of France did not officially "receive" the council's decrees until 1615. Even in Italy and Spain, where the council was quickly accepted, the reform of art was not the first concern of most bishops; they had other more pressing matters to attend to. As late as the beginning of the seventeenth century the Jesuit author Maselli complained about the "grave negligence" of those responsible for executing the Council's decrees on art.[60] Nevertheless, by the later part of the sixteenth century, after 1560 there was a perceptible reaction against "paganizing" or "worldly" tendencies in church art, at least in Italy and (perhaps especially) in Spain.

This reforming attitude took special aim at the portrayal of the nude in religious art. The saintly and influential archbishop Carlo Borromeo ordered the removal of paintings including nude figures wherever he found them in churches of his archdiocese of Milan. The Bishop of Ghent, Jacques Boonen, later bishop of Malines, had paintings burned and statues destroyed if he found them too lascivious. Numerous post-Tridentine ecclesiastical authors condemned the use of the nude in sacred painting.[61]

Not surprisingly, Michelangelo's *Last Judgment* came in for particular criticism. As we have mentioned, already before Trent there were complaints and repaintings. The influential humanist Pietro Aretino in a public letter of

1545 wrote that such nudity would not be inappropriate in a decorative loggia, but was out of place in the central chapel of Christianity. The Dominican Ambrogio Catarino echoed his sentiments: "I commend the art used in the matter, but I vehemently vituperate and detest the matter itself. For this nudity of limbs appears most indecent on altars and in the most important of God's chapels."[62] Even Michelangelo's great champion Vasari seems to have been influenced by the post-Tridentine ecclesiastical opinion. In the first (pre-Trent) edition of his *Lives* (1550) he expresses disapproval of artists who have little personal faith and who in their paintings "excite dishonorable appetites and lascivious desires, so that the work is blamed for what is disreputable, while praise is accorded to its artistic excellence." However, he also notes that the use of beautiful figures, presumably like Michelangelo's nudes, can serve religion. But in the same passage in the second edition (published in 1568, after the Council of Trent and the censorship of the *Last Judgment*), he writes that he does not approve of "those figures in the churches that are painted practically nude, because in them one sees that the painter has not had the appropriate respect for the place."[63]

Even artists sometimes took umbrage at "indecorous" paintings. For example, the sculptor Ammanati, who died 1589, in a letter to Academy of Florence invites artists to renounce nude figures that dangerously move the imagination. It was generally tacitly agreed that pagan fable would be a legitimate artistic domain for the portrayal of the adult nude, but that religious art should be free of this genre.[64]

Although "Tradition" was accepted by Trent as a legitimate repository of revelation (in opposition to Luther's *sola Scriptura* principle), the concern for "right" doctrine led to suspicion of the uncritical acceptance of many traditions. In some places, as we have seen, miracle plays were forbidden because of the many noncanonical accretions that had been introduced from popular piety and devotion. Similarly, images were subject to censorship if they were thought to propagate "false doctrine," which could sometimes mean lack of fidelity to the scriptural sources, even if this was simply a matter of introducing subject matter not mentioned in the Scripture. (As we shall see, Veronese and El Greco, among others, were criticized on these grounds.)

The preferred Catholic art of the period generally tended to be affectively charged, but also naturalistic. Post-Tridentine writers about religious art appealed to medieval (especially Aristotelian/Thomistic) epistemology and psychology to justify these preferences. The Jesuit Louis Richeôme in his book *La Peinture Spirituelle* explains that the "species" of things, i.e., their "form" abstracted from matter, comes from things to the human mind through the senses. Hence the naturalistic portrayal of things, that is, their representation

as they appear to the senses, is associated with "truth." Moreover, since all things—world and senses and mind—are created by God, they all share to some extent in the divine essence, and there is a natural communion between them.[65] At the same time, religious art was meant to serve a spiritual purpose, and it was thought to do so best by its affective quality. As medieval psychology held, vision can create an emotional response. The emotions in turn affect the will, which is the instrument of personal transformation. Therefore religious images were directed at attracting the will. The emotion intended might vary; penitence might be inspired by a realistically gruesome picture of the passion, for example. But frequently spiritual attractiveness was taken to mean a "sweetness" that would appeal to unsophisticated emotions.

The post-Tridentine religious spirit was also critical of the introduction into sacred art of any element that did not directly serve a religious purpose. Comparing the religious art of the high Renaissance to that which arose after the Council of Trent, Émile Mâle writes:

> [the sacred art of the Quattrocento] welcomed all of nature . . . The most touching beauties of this world were in correspondence with the beauties of the Gospel; everything breathed tenderness, love of the divine creation; the Virgin and Child were the most beautiful wonders of this universe that contained so many wonders. Now [after the Council of Trent], the religious art that the Church likes is a severe, concentrated art, where nothing is superfluous, where nothing enters in to distract the attention of the Christian meditating on the mysteries of salvation. Everything that does not serve this end must be banished, for it is the greatness of the Gospel that should move us, not the beauty of nature.[66]

One effect of this move was a deepening of the separation between sacred and profane art. Previously, religious art had in a sense been "total:" it was the primary sphere for art, and—especially in the early Renaissance—it served as a locus for many genres, including landscape, the nude, and portraiture. Now the latter are increasingly recognized as "secular" subjects, to be avoided in church art. At the same time, a secular market for art, even art with ostensibly religious subject matter, was developing. The works of Titian (Tiziano Vecello, 1488?—1576), for example, exemplify the transition to the "gallery" type image, as opposed to the painting intended to be incorporated into a church structure as an altarpiece.[67] As we have seen in speaking of Cranach and Dürer, the medium of print and new techniques for reproducing engravings also provided new contexts for religious art outside churches. This separation of the secular and sacred spheres of art allowed the adoption of strictly religious criteria for the latter.

One famous example of the enforcement of the principle that nothing should distract the viewer from the pious purposes of religious pictures is found in the objections raised to Veronese's celebrated painting of *The Feast in the House of Simon* (i.e., the Last Supper) done for the refectory of the convent of SS. Giovanni e Paolo. The painter was called before the Inquisition in Venice in 1573 to explain the introduction of superfluous figures into the scene. "Did anyone commission you to paint Germans, buffoons, and similar things in that picture?" he was asked. Veronese replied that he used artistic license in his painting. The Inquisitor persisted:

> Are not the decorations which you painters are accustomed to add
> to paintings or pictures supposed to be suitable and proper to
> the subject and the principal figures or are they for pleasure—
> simply what comes to your imagination without any discretion or
> judiciousness? . . . Does it seem fitting at the Last Supper of the
> Lord to paint buffoons, drunkards, Germans, dwarfs and similar
> vulgarities? . . . Do you not know that in Germany and in other places
> infected with heresy it is customary with various pictures full of
> scurrilousness and similar inventions to mock, vituperate, and scorn
> the things of the Holy Catholic Church in order to teach bad doc-
> trines to foolish and ignorant people?[68]

The Tribunal decreed that Veronese was to "improve" and change his painting at his own expense or face penalties. But he was ultimately able to avoid changing the picture by renaming it *The Feast in the House of Levi,* thus evading the accusation of introducing inappropriate subject matter into a Last Supper scene. In other cases there was no active pursuit by religious authorities, but the need to attain patronage and commissions was itself a motive to conform to ecclesiastical norms and taste. (As we shall see, El Greco's failure to win the patronage of Philip II of Spain was an object lesson on the consequences of nonconformity.)

IMAGINATION AND IMAGES IN THE EXERCISES OF ST. IGNATIUS

As we have noted, the new order of the Society of Jesus (Jesuits) was one of the major forces in the Catholic reform. Its founder, Ignatius of Loyola, designed a series of "exercises," parallel to physical exercises, to strengthen the spirit and dispose it to get rid of all its "disordered" inclinations, and having gotten rid of them, to seek and perform the divine will in all things.[69] His method was strongly influenced by late medieval spiritual writings like the *Vita Jesu Christi* of Ludolf of Saxony (1300–1378), which was one of the books that was influential in

his conversion, the *Meditationes Vitae Christi* of pseudo-Bonaventure (late thirteenth or early fourteenth century), and the writings of the *devotio moderna*, particularly its great classic *The Imitation of Christ* by Thomas à Kempis. Ignatius uses and expands on the traditional medieval view of the place of imagination in prayer. The imagination excites the affects, which lead to a disposition toward conversion of the will and intellect. In contrast to Luther, he places great stress not only on contrition for sin and acts of satisfaction, but also on the corresponding affective state of sorrow (*contrición, dolor, lágrimas por sus pecados*).[70] Meditation on the cross is seen as a primary motive for sorrow and contrition, leading to conversion and to positive dedication to working for God's reign.[71]

Prior to the properly dialogical part of prayer, Ignatius recommends a series of mental "compositions," in which one makes present to oneself the object of prayer: a biblical scene, for example, or a doctrinal idea. Even in the case of immaterial things, one should begin with an imaginary scene or appropriate image. The first exercises provide a good example of the method. After asking God's grace, the first "preamble" is the "composition of place." "Note that in a visible [subject of] contemplation or meditation, for example, Christ our Lord, who is a visible person, the composition will consist in an imaginary view of the physical place in which the thing I want to contemplate takes place... like a temple or mountain, where Our Lord or Our Lady are found... With an invisible subject, like our sins... the composition will consist in an imaginary view, [for example] considering my soul as being imprisoned in this corruptible body...."[72]

There follows a dialogue, in which imagination also plays a part: "Imagining Christ our Lord before me, on the cross, [I] begin a dialogue: [on] how, being Creator, he came to become human, and came from eternal life to temporal death, and thus to die for my sins. Then, looking at myself: what I have done for Christ, what I am doing for Christ, what I should do for Christ; and seeing him thus nailed to the cross, converse about the reason that he offered himself."[73] In other exercises, Ignatius recommends the use of all the senses in "composing" a scene for meditation, and gives specific suggestions for imagining not only seeing, but also hearing, tasting, smelling, and touching the scene.

ROBERT BELLARMINE ON THE CORRECT USE OF IMAGES

An explicit defense of images in the light of the Reformers' objections and in the wake of Trent's doctrine was given by the Jesuit cardinal Robert Bellarmine.[74] He replies in particular to the teachings of Calvin in his *Institutes*, which are the most fully developed and erudite expression of the "iconoclast" position.

After giving a history of ancient iconoclasm—which gives him the opportunity to remind the present-day iconoclasts that their antecedents were "impious"[75]—Bellarmine considers the essential question, "Whether it is permissible to make and to have [sacred] images." The argument against images from the first commandment (Ex. 20), according to Bellarmine, is a "manifest" error. The first commandment prohibits not any image at all, but only idols, i.e., images that are taken for God, or that represent as being God some thing that is not God. If the prohibition of images were a commandment, there would be eleven commandments, not ten. (As we have seen, some of the iconoclasts among the Reformers did in fact consider the prohibition of images a separate commandment; but others simply thought it a corollary of the commandment to worship only the true God.) Moreover, God actually commands the making of some images: the cherubim on the arc of the covenant (Ex. 25), the bronze serpent (Num. 21), etc. To the Jewish response that God can do what God nevertheless forbids us to do, Bellarmine replies that the Decalogue, except the Sabbath command, is an expression of the laws of nature. But in natural law, things are prohibited because they are evil, not vice versa. Thus if they are wrong for us, they are by nature wrong, and God cannot order them or do them. Furthermore, images that are not made to be venerated are not opposed to the purpose of the law, which is the service of God. Bellarmine admits that such images may accidentally be occasions of idolatry; but so is nature itself. Even the sun and moon can be and have been taken for divinities and worshiped. The possibility of abuse does not take away legitimate use.

In addition, the Scriptures testify that the arts of painting and sculpting are good, for the artistic talent of Beseleel [Bezalel] and Ooliab [Oholiab] is a gift from God (Ex. 31, 35). Indeed, God is an artist, insofar as God is the author of all images, natural and artificial. The Father generates the Son in his image, and creates humanity in his image. Within the created world, images are natural and necessary; all natural things produce something similar to themselves, which is a kind of image. And, recalling the Aristotelian and Thomist position that all knowledge comes through sensible phantasms ("it is impossible even to think without a mental picture," says Aristotle),[76] Bellarmine reminds us that humans can know, whether sensibly or intellectually, only through mental images. Finally, arguing from practice, he states that the Jews of Christ's time used coins that had the image of Caesar on them (Mt. 22).[77]

Having given arguments for the legitimacy of images, Bellarmine goes on to criticize the position of Calvin as expressed in the *Institutes* (book 5, ch. 11). He divides Calvin's conclusions into three. First, it is wrong to "locate" the invisible and incorporeal God in a visible and bodily image. Second, images of Christ and the saints are not absolutely prohibited, but they must not be placed

in churches. Third, illustrated narratives can be useful for instruction, but images without words that recount actions have no use except to give pleasure, and therefore should be avoided.[78]

Bellarmine notes that some Catholics agree with the first part of Calvin's position, regarding the portrayal of God. (He cites Abulensis, Durand, and Peresius.) He concedes that the legitimacy of making images of God or of the Trinity (as opposed to images of Christ or the saints) is a matter of opinion, not of faith. But even if one concedes this point, Calvin's logic is poor, for he goes from impossibility of picturing the invisible God to a condemnation of images in general. However, Bellarmine argues that it is in fact legitimate to portray even the invisible God symbolically, for example, the Father as an old man and the Spirit as a dove. He points out that invisible angels are depicted in the Old Testament as having human form; and indeed so is God (Gen. 3, Ex. 33, Is. 6, Mic. 3, etc.). Calvin argues that the Old Testament use of images was educative, for a childish stage of religious development that is now past. But this is irrelevant to the question of whether the invisible can be portrayed. Further-more, if the Old Testament was childish compared to the New, our present state is childish compared to our future in the heavenly vision of God. Why, then, should God not be portrayed as God has in fact appeared?[79] Anticipating an observation made by many modern scholars, Bellarmine observes that the Scriptures themselves are highly imaginative in their portrayal of God. Words describing the invisible God are no less "images" than pictures are. "Why then could one not show God in a picture as the Scriptures depict God [in words]?"[80] It is true that the Scriptures also tell us that God is incorporeal, and thus lead us to understand that its images are merely metaphors. But why could this not be equally true of pictures? Indeed, the Council of Trent insists that this point must be carefully explained to the uneducated by pastors. Nevertheless, Bel-larmine admits that such pictures are not without dangers for simple people; he is not recommending them, but is only saying that they cannot be universally condemned.[81]

In addition, Bellarmine argues, we depict intrinsically invisible abstrac-tions and accidents, like the virtues; why then could we not similarly portray God? Finally, humanity is the image of God. If we can portray humans, we can also portray what humans are the image of. Some may say that the image of God in us is the spirit, not the body. But if this were true, one could not really depict a human being, either, for only the body is visible. But pictures in fact represent the whole person, not just the body. Furthermore it is the whole person who is the image of God, not just the spirit. Of course, the human person is a very imperfect, obscure, and dissimilar image of God; and it fol-lows that any image of God in human form is likewise imperfect, obscure, and

dissimilar to God.[82] (And, as we have seen, this applies to the Scripture's verbal images of God as well as to visual depictions.)

For Bellarmine sacred images, properly understood, do not claim to be anything other than metaphorical or allegorical or narrative devices. There are three ways in which one may depict something. First, one may attempt to give a perfect similitude of the form or the nature of a thing. Only purely bodily things can be depicted in this way. (Note that Bellarmine shares the Renaissance supposition that art can and should attempt to depict the "nature" of physical things.) If one tried to picture God this way, it would be idolatry. Second, one may depict things in order to tell a story. It is in this way that the Scriptures portray angels, or God walking in the garden of Eden, for example. And in this way painters may depict the same scene. But "one who paints such a scene certainly does not intend to portray the nature of God or of an angel, but only to represent to the eyes, through a picture, what another might represent to the ears by reciting the Scriptures. And in this way, God can be depicted."[83] Third, something can be depicted outside the context of a narrative in order to portray the nature of that thing not by an immediate and direct representation or similitude, but by an analogical or metaphorical and mystical mode of signi-fying. The human being as image of God is a representation of this kind, and it is in this way that one can portray God the Father, for example, with a human form outside a narrative.[84] The image of God, or of the Trinity, when visibly depicted, is intended to educate. We neither mistake it for God, nor is it in-tended to inform us what God looks like; it is made in order to give us some knowledge of God through analogical similarities.[85]

Finally, it should not be objected that we depict only what is absent, and therefore should not depict God because God is present everywhere. "Although God is present, nevertheless God is not visible, and therefore God may be represented, as though God were absent. If it were not so, it would also be wrong to pray to God with audible words; for speaking is for the sake of those who cannot intuit our thoughts; but God scrutinizes our hearts and minds."[86]

Bellarmine next argues that images may rightfully be placed in churches, citing many historical examples, and calling Calvin's claim that there were no images in churches for the first five hundred years of Christianity "a lie."[87] He also contends, once more against Calvin, that images are useful for other purposes than narration of sacred history. He cites first of all the authority of a number of non-narrative images of supposedly sacred origin: the image made by Christ himself and sent to King Abagarus (the image of Edessa); an image made by the woman cured by Christ of a flux of blood (mentioned by Eusebius); an image of Christ by Nicodemus; an image of the Virgin painted by St. Luke.

He then lists six aspects of the utility of images: 1) They instruct and educate. Pictures indeed teach better than the written word does. And he notes significantly that even "solitary" images—what we might call "iconic" pictures—when they are made by Christians, always have an implicit reference to narrative. They "summarize" the narrative in the portrayal of a person.[88] 2) They encourage love of God and the saints; for anyone who loves likes to see the image of the absent beloved, and looking on it is strengthened in love. 3) They incite us to imitation of those they represent. 4) They remind us of Christ and the saints, and in our troubles they teach us that we have patrons whom we can call on. 5) They serve as a profession of faith; for when we love and honor the images of the saints, we testify that their faith and teaching and holy ways of life are pleasing to us. 6) They honor God and the saints; as common human experience shows, making an image of someone is a way of praising that person.

Bellarmine then spends several chapters in arguing that images may be honored and in refuting the arguments of adversaries of his position. He tries carefully to separate the honor given to images from any superstition, repeating the doctrine of Trent that we honor images, but do not have faith in them, nor pray to them, nor find in them any divinity or power. We honor them the way we honor the Scriptures, or liturgical vessels, and other sacred objects. In an interesting analogy, Bellarmine states that human beings are venerable or honorable because they are the image of God. Thus "just as a human being is related to God, whose image we are, so a picture is related to Christ, whose image it is; and therefore if a human is honorable, because we are an image of something honorable, then certainly an [artistic] image may be called honorable because it is an image of something honorable."[89] Images are themselves honored, but they are always honored because of their "exemplar," that is, the person(s) they portray; and the honor given them "goes to" that exemplar, through the mediation of the honor paid to the image. Hence the "cult" that is given to images is "imperfect"; it does not have its end in itself, but is analogous to the cult given to what the images represent.[90]

JOHN OF THE CROSS ON IMAGES

It is instructive to compare the treatment of images in Bellarmine—a Jesuit, an intellectual, an active figure in the world, occupied with polemical and pastoral concerns—with that of John of the Cross (Juan de Yepes Alvarez)—a Carmelite, a mystic, a monk concerned above all with the individual "soul" attempting to live "the way of perfection." John is careful to affirm the Catholic position on images. They are useful and even necessary for the two goals the church proposes for them, namely to reverence the saints through them and to move the

will to devotion. Yet John approves of the use of images only with reserve. "The truly devout person directs devotion above all to what is invisible, and has little need of images, and uses few of them . . . [such a person] is little troubled if images are removed, because she seeks the true image, which is Christ crucified, within herself. . . ."[91] Even when they are used, one should pass beyond them to a spiritual and immaterial level of presence to their content, and forget the image (olvidando luego la imagen).

John notes that "we do not wish in this teaching of ours to agree with those plague-infested people (pestíferos hombres) who, persuaded by the pride and envy of Satan, would like to remove from the eyes of the faithful the holy and necessary use of images of God and the saints, and the rightful cult (adoración) given to them."[92] There is no question of doing away with images or their cult. But John makes it clear that the "devout" soul is not interested in sacred art as art. "One should select those [images] that are most proper and lifelike and that most move the will to devotion, putting one's attention [los ojos] more on this than on the artistry [valor] and interest [curiosidad] of the work and its style [ornato]."[93] He criticizes those who take sensible delight in the beauty of pictures. Their wills are stuck in a sensible level, which is an impediment to the true spirit (lo cual totalmente impide al verdadero espíritu), which requires the annihilation of our affections for all particular things.[94] If we need images at all, we should be indifferent to the form of the image, and not prefer one to another. John is even harsher on those who adorn images themselves with worldly clothing and ornaments (a custom one can still find in some Italian and Hispanic churches) that the saints themselves would have abhorred. Such practices are "vanities" and works of the devil; they are little more than idolatry, and they dishonor the saints rather than honoring them.

Images are seen, then, only as a means to spiritual recollection of God, a material means that is to be transcended as quickly as possible (haciendo en ello más presa de la que basta para ir a lo espiritual).[95] The means is necessary to attain the end; but it would be wrong to mistake the means for an end in itself. The only thing that is valued in sacred images is their content, i.e., what they represent.[96] The soul wishes to fly from what is pictured (lo pintado) to the living God, forgetting every creature and every creaturely thing.[97]

Despite the differences in context between Bellarmine and John of the Cross, they are agreed in assigning to sacred art a role that is essentially functional and practical. The Jesuit is more positive about the uses of images and imagination—as one would expect of a follower of Ignatius and one concerned with spirituality in the world. The Carmelite agrees with the Thomistic principle that imagination is the necessary medium of all our knowledge of the world;[98] but precisely for this reason it is irrelevant to the higher

spiritual way of "contemplation,"[99] being at best a useful lower stage that is to be passed through and then left behind by those called to a higher spiritual communion. Even at the lower level of prayer, as we have seen, images are to be used as little as possible and with caution. It is significant that neither figure speaks of artistic or aesthetic values in sacred art, nor about beauty as a means to God; both see religious art essentially as a means of conveying content, whether it be the narrative of events or the recollection of a presence.

Meditation on the Cross

THE PASSION IN THE SPIRITUALITY OF IGNATIUS OF LOYOLA

For Ignatius, Jesus is above all the bearer of the cross. As Alex Stock points out, there are three major elements in the imaginative field of Ignatius's vision of Christ: the name "Jesus," the sun (Christ seen as the sun in a mystical vision), and the cross. All three are represented in the seal and "arms" of the Jesuits.[100] Ignatius places great emphasis on the Incarnation as the Trinity's plan to "accomplish the redemption of the human race,"[101] and also on Mary's collaboration with it. But it is above all the cross that is taken as the center of the accomplishment of salvation. Ignatius devotes an entire week of the four-week exercises to meditation on the details of the passion. He recommends that during this week the person undertaking the exercises should begin each day with an effort to be sorrowful and pained over how much Christ suffered for us, and to avoid any happy thoughts, even if they are good and holy, but rather "keeping frequently in mind the labors, exhaustion, and sorrows of Christ our Lord."[102] The effect of such meditation is to sorrow over one's sins, to attain to true conversion, and finally to joyously take up the cross oneself as the banner of salvation.

Exemplifying his own advice to spiritual directors, Ignatius does not give detailed descriptions or images of the events of the passion or other subjects of meditation. He advises that it is best for each person to create such imaginings individually.[103] In this he follows the medieval tradition of Bonaventure and others. He encourages a creative use of imagination, rather than an effort to seek a historically accurate representation of the scene. (Bonaventure had explicitly stated that one could imagine the same scene in different and irreconcilable ways.) It is presumed that the general outline of meditation is taken from the Scriptures, which are assumed to be historical. Nevertheless, their meaning is not exhausted by historical fact. In prayer, the purpose of the imaginative picturing of sacred history is not historical, but practical. It is aimed at producing the proper affective reaction, and whatever images serve this end are "correct" spiritually, even if they are not historical in their detail. (Obviously, if

applied to public works of art, this attitude would come into conflict with the concern for "truth" expressed in visual realism and fidelity to the sources.)

THE CROSS IN ROBERT BELLARMINE. Bellarmine ends his treatise on images with a special consideration of the cross. He examines first the true cross, then "permanent" images of the cross, and finally "transient" images, i.e., the sign of the cross "which we paint in the air."[104] The section on the true cross is devoted principally to a defense of the honoring of the cross as a relic. But in it Bellarmine makes several remarks relevant to the depiction of the cross and to soteriology. He holds that the cross of Christ is properly depicted with three lines: the horizontal beam, the vertical beam, and the suppedaneum. It is uncertain, he says, whether the transverse beam was affixed on top of the vertical one or across its upper part. Although pictures generally show Christ nailed to the cross and the thieves tied, this is a mistake: nailing to the cross was usual, and therefore all three should be shown crucified the same way.[105]

The cross is to be honored because Christ "himself freely chose the cross and chose it to be the altar of the supreme sacrifice, by which God would be appeased (quo placaretur Deus), as his own ladder to the kingdom, and the instrument of the liberation of the human race, and finally as the instrument by which he would conquer the Devil and triumph over him." The cross, as Augustine says, signifies faith by its depth, hope by its altitude, charity by its width, perseverance by its length. The cross also signifies the effect of the passion. The upper part represents heaven opened and God appeased (Deum placatum) by Christ's passion; the part in the ground signifies hell emptied, and the Devil vanquished; the transverse beam, facing the rising and setting of the sun, represents the redemption of the entire world.[106]

The image of the cross is honored because even without the corpus it represents the crucifixion, that is, Christ's work of redemption itself.[107] Against those who say the cross should not be honored because it was the means of Christ's shame and death, Bellarmine replies: if it were only this, we would rightly hate the cross. But in fact, it is more. It brings joy and glory, because it is the means of our redemption and of the Devil's defeat.[108]

BELLARMINE ON MEDITATION ON THE PASSION. In addition to his general considerations on images and on prayer, Bellarmine also gives explicit attention to meditation on the passion, in the context of his treatise on the goodness of tears or of sorrow.[109] The work as a whole defends the Catholic tradition of sorrow and repentance as being necessary and fruitful means to salvation. After demonstrating the need for tears or sorrow from the Scriptures and tradition, in a second book Bellarmine considers the sources of tears, each of which is

correlated in the third book with particular fruits that come from sorrowful consideration of each source. Our primary concern here will be the consideration of the passion of Christ, whose fruit is the imitation of Christ's virtues.[110]

Of most direct interest to our study is Bellarmine's third font of tears, meditation on Christ's passion. First of all, Bellarmine must face an objection: why should we weep over the passion, when it is not only is it long past and over, but when we know that it resulted in great glory, and when indeed the church celebrates it? (We recall Bellarmine had used exactly this point to justify honoring the cross, rather than holding it in execration as the vile means of Christ's execution.) Why should we have compassion for Christ, when his suffering is over? In his own parable, a woman weeps in childbirth, but forgets the weeping in joy once the child is born. Should this not be our situation?[111]

The answer is that the passion is a source of both joy and sorrow, exaltation and weeping. The passion may be considered in three ways: in itself; as a cause; and as an effect. If the passion is considered in itself, "and especially if it is represented to the meditating soul as being present, without doubt it would make streams of tears spring forth even from a heart of stone."[112] If it is considered as the cause of our redemption, the key that opens the kingdom of heaven, and the triumph over the prince of this world, then it is the source not of tears, but of joy and exultation. But if it is considered as the effect of our sins, then once again it brings us to sorrow and weeping. The church in fact considers the passion both ways: at Easter, as something past, and in conjunction with the resurrection; but during Holy Week it is celebrated in itself, as something present and calling for our sorrow. For Christ did not merely merit for himself the glory of his exaltation; he also merited redemption for us, and the passion of Christ is still present and at work in the sacraments. Hence we must celebrate the passion both as past and as present.

Having established this dual face of the passion, Bellarmine proceeds to consider it insofar as it is a source of tears, that is, as represented to the soul as a present reality and as the effect of our sins. He refers first to the lesson we learn from the example of St. Francis, as recounted by Bonaventure. The love of God, which is central to salvation, is excited above all by gratitude for all God has done for us; and the height of all God's gifts is the passion of Christ, in which God gives God's only Son for us. But "how could we conceive a strong and ardent love of God from this singular gift of God, if we consider the passion of the Lord simply as the story of something past that no longer exists?"[113] If we wish to draw out the treasure of the love of God, we must consider Christ's passion in each of its elements as though it were present, thinking about what he suffered, why he suffered, through whom he suffered. (We see here a reflection of the style of meditation in Ignatius's *Exercises*.)

Bellarmine does not merely discuss meditation on the cross, but also gives an example, including consideration of the events, dialogue with Christ, and moral lessons. Taking inspiration from St. Paul's admonition to consider the "length and width and height and depth" (Eph. 3:18) of the divine mysteries, Bellarmine applies these attributes metaphorically to the passion. Its length is its duration; its width is its variety; its height is its eminence; and its depth is its purity. In each it exceeds all other sufferings of the martyrs, and supremely exemplifies the virtues that we must follow. Bellarmine first examines the duration (length) and variety (width) of the passion. He closely enumerates the many hours the passion endured and the many kinds of suffering Christ bore. In the midst of the meditation he inserts an apostrophe to Christ:

> O good Jesus, once, seeking a single soul, you sat, tired from your journey, at a fountain; now, seeking me and my fellows, exhausted by a long journey, and the most cruel flagellation, and the carrying of your own cross, you are seated not at a fountain, but on the cross, which cannot lessen but can only increase your exhaustion. Is it not right that I also should exhaust myself in assiduously working for your sake, or that I should certainly work, in my groaning, until I bear the fruit of your exhaustion, through true penance and the gift of remission (*indulgentiae*)?[114]

He also addresses himself (and the reader), meditating on Christ's words, "I thirst" (Jn. 19:28): "You, my soul, if you were wise, would bring to the thirsting Lord not vinegar, but the tears of your heart shed out of sorrow for your sins, and expressing love for your spouse. For this is the water that the Lord so vehemently thirsts after."[115]

The "height" of the passion is seen in that it surpasses all others in extent, intensity, painfulness, and bitterness. Bellarmine writes that Jesus anticipated his passion his whole life long, knowing in detail every torment he would undergo and how painful it would be. Moreover, because of the perfection of his humanity, Jesus was more sensitive to sorrow and pain than others. And in his love for us, for the sake of a "more copious" redemption, he purposely retained his strength through the entire passion, so that he would suffer it in its entirety.[116] Again Bellarmine draws a moral:

> Thus, Lord Jesus, your work was perfect, and you offered to God the Father a full and complete sacrifice when you wished to drink the chalice of the Passion to the bottom, with all your senses and all your powers, so that no part of the bitterness should be lacking to you. And may we, your servants, who have been given such an example,

learn to perform fully and perfectly the works that are for your honor
or for the salvation of souls. Else we will lament the imperfection
of our copious tears for you, so that what is lacking in our work may
be made up for by true penitence, and that humility may compensate
for what is lacking in our devotion.[117]

The depth of the passion is its purity. The passion of the Lord was pure
suffering, with no admixture of consolation. He was abandoned by his disci-
ples, and even by the Father. Not, Bellarmine hastens to add, in that God's
presence or love were absent from him, but only in the sense that God per-
mitted him to suffer intolerable pain, with no consolation. Bellarmine explains
that Jesus' cry from the cross to God is intended to show to those present that
he really suffered. This was needful because Jesus underwent all his pains with
such equanimity and peace that he uttered not a sound of complaint. Bellar-
mine prays: "Fix in our hearts a perpetual remembrance of your sorrows, so
that they may be a supremely strong restraint from all evil, and the sharpest
stimulus toward all good."[118]

Bellarmine then considers another manner of looking at the "dimensions"
of the cross, namely their symbolizing of the virtues. His enumeration here
differs slightly from that in the defense of images. The length of the cross is
patience (*patientia*); its width is charity; its height is obedience; its depth is
humility. "Patience" is taken in its original sense of "long suffering." In all of
the injuries Christ suffered, Bellarmine says, his voice was never heard in
anger or abuse or threatening; but like the Lamb brought to the slaughter, he
opened not his mouth. The charity of Christ was supremely wide in that he
forgave even his tormentors. Christ's obedience to the Father shines out
through the entire passion. This obedience to God is "true self-abnegation; this
is mortification of one's own will; this is the noblest sacrifice to God...."[119]
Christ's humility must be an example to us, even as he said: "Learn from me,
for I am meek and humble of heart" (Mt. 11:29). He humbled himself, as Paul
says, even to death on the cross (Phil. 2:8), for no one could force him to endure
this death; he accepted it as an example to us.

Bellarmine ends with a consideration of the reasons for the innocent
Christ's free acceptance of the passion. The passage is worthy of being quoted
at length as an eloquent example of the ideal process of compassion leading to
repentance and ultimately to the active love of God:

What then scourged God's Son, nailed him to the cross, killed him?
My disobedience (*impietas*), the love of the Father, and the obedi-
ence of the Son ... Thus my sins, your sins, the sins of Adam and of

all his children were the cause of the passion and death of God's Son. No thorns, however sharp, could pierce that head, fearsome with heavenly powers, unless my pride added to their powers. No scourges, however many, could touch that flesh, unless aided by my carnal desires. No iron nails, however hard, could pierce those hands or feet, unless my greed and my other faults sharpened them. Moreover, even death itself would have dared approach that life to extinguish it, unless my iniquities had opened the way for it. Do human sins then have such power that they could prevail against the Son of God? No, it was not sins themselves that accomplished this, but God's hatred for sin, and the love of God the Father for the human race, and the obedience of the Son to the Father. But let us acknowledge this for sin, and rightfully, that without them the passion of the Lord would not have happened. For that reason, the Son of God could blame our sins for his passion; but because he is sweet and loving (*pius*) he attributes his passion not to our sins, but to love (*charitati*) and mercy. Thus he himself says in the gospel: No one takes my life from me, but I myself lay it down, and the Apostle [Paul] says on his own behalf and on behalf of all of us: Christ loved us, and gave himself over as an offering for us, and a sweet-smelling sacrifice to God.

What then will you return to God, my soul, for all that God has given you? Will you offer nothing to such a benefactor, who gave himself over to death so that his death might be a sweet-smelling sacrifice to God for you, in order to take away your sins and cleanse you? I shall offer a heart totally contrite and humbled; I shall offer tears of repentance as witness to my hatred of sin, and I shall offer my prompt willingness to perform all he deigns to ask of me. Ask, therefore, Lord, for we can deny nothing to you, because you have wounded our hearts with your superabundant love. And what do you think the Lord will ask of you, my soul, except the salvation of your soul? For this is what he asks, when he said on the cross "I thirst." Is it so, good Lord, that so very superabundant is your love—you who labored for us unto death, even the death of the cross—that you require no reward except that we should cooperate in the salvation of our souls? This, clearly, is the exemplar of the truest love. Give, then, Lord, what you ask, and ask what you will. Thus may your will be done, and may our obedience be accomplished, for our salvation and your glory.[120]

Bellarmine's writings speak for themselves, and there is little need for comment. It is clear that he affirms the Catholic view of compunction, repentance, and collaboration in salvation in response to the Protestant view of salvation, at least as he saw it. We may draw attention, however, to several points. Although Bellarmine emphasizes the obedience of Christ as the essence of his sacrifice, there is also a resurgence of the Anselmian perspective. Christ's death is a sacrifice in satisfaction for sin. The causality of redemption and of its extension in the sacraments is attributed totally to the passion. There is no mention of the other works of Christ, nor of the resurrection as a cause. And the moral drawn from our recognition of Christ's suffering is gratitude, expressed in sorrow for sin, the need for penance, and good works that collaborate in our salvation.

MYSTICISM AND THE CROSS. The Catholic reformation was characterized by a continuation and renewal of the medieval spirit of mysticism: an effort to attain intimate communion with God, especially through a life of mental prayer. This is not to say that the mystics were necessarily representative of the "official" stance of the Counter-Reformation church. On the contrary, they were frequently viewed with suspicion because their views and practices were seen as illuministic and verging on unorthodoxy—possibly even Lutheranism. In any case, their emphasis on individual and personal experience of God was in tension with the institutional stress on the external and public means of salvation. Even some of those who were eventually recognized as saints and held up as champions of the Catholic cause met with opposition during their lifetimes. The Carmelite John of the Cross was imprisoned for a time by the Spanish Inquisition, as was the Augustinian mystical poet and scholar Fray Luís Ponce de León.[121] Teresa of Avila's works were criticized for their lack of orthodox doctrine. Nevertheless, such figures were eventually to be accounted among the great representatives of resurgent Catholicism. They represent a reaffirmation and reform of the traditional ideals of monastic life, which had been so discredited and rejected by the northern reformers. Among the mystics must also be counted Ignatius of Loyola, who formulated a militant kind of mysticism that took its place in the midst of the world rather than in the convent or monastery. Common to all was the Catholic confidence in the power of grace to actually transform life, and the need for personal collaboration with the work of Christ.

For all their emphasis on the cross, the writings of the great Spanish mystics contain comparatively little about the crucifixion of Jesus. St. Teresa of Avila recommends detailed meditation on the passion, apparently countering

a certain resistance on the part of some of her sisters.[122] She recommends contemplating in detail "the things there are to think about it and feel about it;"[123] but she gives little indication what those things are, except in very general and traditional terms. She takes for granted the traditional doctrine and spirituality of the cross as a means of redemption; her emphasis is more on the cross as the symbol of our present life in Christ, voluntarily undertaken. The cross is the banner of Christ's soldiers, to be lifted on high.[124] It is the source of our ability to follow and to take joy in union with God. The contemplative "enjoys the fruit that Our Lord Jesus Christ drew from his passion, watering that tree with his precious blood with such wondrous love!"[125]

The Carmelite Juan de la Cruz (St. John of the Cross) left a remarkable drawing of Christ on the cross, very original in its perspective. Christ is seen from above, an emaciated figure hanging heavily with bent knees and bowed head and blood spurting from his wounds. This rough drawing no doubt testifies to the nature of John's personal meditations on the cross. Yet in his writings he, like Teresa, usually speaks of the cross more in general and symbolic terms. There is no concentration on the doctrine of redemption as such; John simply repeats common medieval doctrine and images. What is important is the appropriation of cross: death to self and mystical union by grace with God, as a present (ongoing) reality. The cross is the image and symbol of the means of this union. As we have seen, John holds that the devout soul "seeks within itself the living image that is Christ crucified, in whom it takes joy in having everything taken from it . . . ;"[126] one should be a "friend (*amiga*) of the passion of Christ;"[127] one should seek no consolations from God, but "raise up the cross, and, fastened to it, desire to drink gall and pure vinegar, and you will gain great happiness, seeing that, dying thus to the world and to yourself, you will live for God in delight of spirit . . . ;"[128] "exercise the virtues of mortification and long-suffering (*paciencia*), desiring to make yourself in suffering something similar to our great God, humiliated and crucified; for this life, if it is not for his imitation, is not good."[129]

A similar spirituality of the cross as death to self, but in the context of the Jesuit mission to the world, is exemplified in Ignatius's companion and fellow Basque, Francisco de Jasso y Azpilcuetade (Frantzisko Xabierkoa, or Francis Xavier, so called from the castle where he was born). He writes in one of his letters:

> Those who savor the cross of our Lord Christ find their rest, it
> seems to me, when they encounter these sufferings; they die
> when they are removed from them and are separated from them.
> Is there a worse death, when once one has known Christ, than

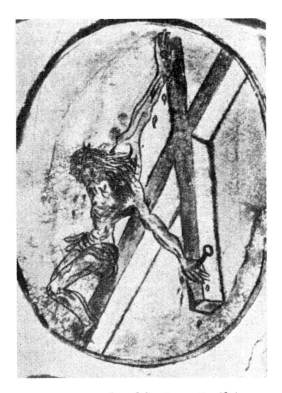

FIGURE 3.2. John of the Cross. *Crucifixion.*

to continue living after having abandoned him to follow one's own ideas and affections ?... On the other hand, what rest [it is] to live in daily death, going against our own will, seeking *non quae nostra sunt, sed quae Jesu Christi* [not what is ours, but what is Jesus Christ's].[130]

THE CATECHISM OF TRENT. The Roman Catechism also contains a brief section explicitly concerning meditation on the passion, with the title "The Thought Of Christ's Death Should Excite Our Love And Gratitude."

When we meditate on the sufferings and all the torments of the Redeemer, nothing is better calculated to stir our souls than the thought that He endured them thus voluntarily. Were anyone to endure all kinds of suffering for our sake, not because he chose them but simply because he could not escape them, we should not consider this a very great favour; but were he to endure death freely, and for our sake only, having had it in his power to avoid it, this indeed would be a benefit so overwhelming as to

deprive even the most grateful heart, not only of the power of re-
turning but even of feeling due thanks. We may hence form an idea of
the transcendent and intense love of Jesus Christ towards us, and
of His divine and boundless claims to our gratitude.

The change of life that this affective stirring of the soul to gratitude should
lead to is described in other sections of the Catechism. These sections detail the
nature of our response to grace in repentance and good works.

The Cross in the Art of the Catholic Reformation: High Renaissance, Mannerism, and Anti-Mannerism

GENERAL CHARACTERISTICS OF CATHOLIC PASSION ART OF THE REFORMATION ERA

The Catholic religious art of the Reformation era (in which we include both
the art associated with the Catholic reform movement before the Council of
Trent and that of the Counter-Reformation) coincides with three somewhat
overlapping artistic periods or tendencies: the classicism of the High Renais-
sance; the reaction against classicism that is frequently called "Mannerism;"
and the reaction against Mannerism, which was at least in part occasioned
by the artistic preferences of the Counter-Reformation, and which led to the
earliest manifestations of what would become the Baroque style. In addition,
sacred art was influenced by Protestant iconoclasm and eventually by the offi-
cial Catholic reaction to it, as well as by the polemic against Reformation
theology in general.

For centuries, sacred art had been more or less taken for granted in the
Western church. The objections of the humanists and the iconoclasm of some
Protestants precipitated a more self-conscious stance. Reports of the Protestant
destruction of images frequently made ordinary Catholics all the more devoted
to them. Because the objections were frequently connected with a critique of
the cult of the saints, many Catholics whose faith was characterized by a highly
personal devotion to them, and especially to Mary, reacted with shock and
indignation. Teresa of Avila commented that the "traitors" to the church were
crucifying Christ a second time.[131] The Jesuit Peter Canisius in his book on
Mary (*De Maria Virgine*) catalogued the "insults" that the Protestants heaped
upon her. In Italy, old images from roadside shrines were brought into
churches to be protected. Books were written on the miracles performed by
images, especially those of the Virgin. Images of Mary began to be adorned
with crowns, especially in Rome. There was a new interest in the so-called

"St. Luke Madonnas"—images deriving from one supposedly painted by the evangelist, and therefore having a kind of divine sanction.[132]

At the same time, although the Catholic world generally reacted strongly against Protestant iconoclasm, the questions that it raised, combined with the critique of art and the scholarly spirit of the humanists, were not without resonance for reform-minded Catholics. They inspired a new concern for fidelity to the Scriptures. On the other hand, the polemic against Protestant doctrines led to an increased emphasis on certain themes, several of which (for example, the "real presence" of Christ's body in the eucharist) had a direct bearing on the art of the passion. Perhaps most significantly, the crisis of iconoclasm, combined with the increasingly secular character of art itself, led to an explicit posing of the question of the nature and purposes of sacred art.

As we have seen, with the Renaissance the West entered into what Hans Belting calls "the age of art,"[133] that is, the period of the development of "serious" (as opposed to merely decorative) art as a secular pursuit, one no longer governed nearly exclusively by religious interests. In the Protestant north, with the limitation or even abolition of sacred painting and sculpture, the arts were increasingly secularized. In Italy, where sacred art still flourished, its nature was more volatile; the function and nature of sacred art were increasingly the object of discussion and dispute.[134] There was an increasing shift in patronage from the church to private individuals, often artistic connoisseurs. At the same time, there was a breakdown in the *bottega* system in which artists had traditionally been trained. Many artists become traveling virtuosi in the employ of courts.[135] This tendency coincided with and reinforced the development of the ideal of the individual artist, working in his (or rarely, her) personal style. These factors led to an unprecedented variety in artworks, even within particular stylistic tendencies.

Although sacred art, and particularly the representation of the cross, was governed by certain conventions, even here we find great diversity. Nevertheless, a few general remarks may be made about the form of the crucifix in the sixteenth century, before we consider individually a few of the major artists and works of the period. (The characteristics we will note appear above all in the art of Italy, France, Spain, and, to some extent, Flanders; German art tended to be more influenced by the medieval tradition and, of course, in Lutheran art, by doctrinal considerations. Nevertheless, with the exceptions noted, these remarks generally apply even to the art we considered in the previous chapter.)

Under the influence of rediscovered classical sculpture and neo-Platonic philosophy, artists portray the body of Christ as muscular and athletic. "Prometheus replaces the thin and bloody Christ on the cross."[136] Physical strength

and bodily beauty are the external sign of the great soul and of the divine. The anatomy of the body is increasingly precise, especially in Italy (but, as we have seen in Dürer, also to a certain extent north of the Alps). The general line of the figure is little changed from the fifteenth century; at the same time, the overall presentation shows more imagination and novelty. The face of Christ, on the other hand, is increasingly conventionalized, with little individuality.

In the cross itself the *suppedaneum* is generally lacking, and the arms of Christ once more approach the horizontal, rather than inclining downward under the sagging weight of the body.[137] (This is in accord with the new heroic and classical conception of Christ's body, but, as we have seen, it also finds justification in the old legend of the stretching of Jesus' body to fit the holes bored in the crossbeam; see Dürer's study for a soldier drilling these holes, and a similarly occupied figure in El Greco's *El Expolio*.) Most frequently Christ is presented alive on the cross, without the wound in his side, and often with his lips parted, presumably commending himself to the Father or emitting his spirit, and with his eyes lifted to heaven.[138] The dead Christ on the cross is also seen, although less frequently. In this case the representations tend to have an iconic or doctrinal purpose (as in Dürer or in Raphael's *Mond Crucifixion*, with Christ shedding his blood into a chalice), and hence are less naturalistic and less concerned with narrative consistency, sometimes synthesizing different moments into a single scene, as in medieval crucifixions. At times the medieval tradition of showing a skull at the base of the cross is retained. Scholars of the period explain that this is not to indicate that Christ was crucified over the burial place of Adam (St. Jerome says that Adam was buried in Hebron), but because symbolically Christ's blood falls on head of Adam and remits his and all human sin.[139]

Generally little blood is shown in Italian crucifixions; in Germany, the late medieval tradition of bloody suffering is sometimes retained. The face of Christ is normally calm and peaceful or even ecstatic; but there are exceptions (in German art and in the later crucifixions of Michelangelo, for example). The personages around the cross are the standard ones represented in earlier art,[140] but after the Council of Trent, vast crucifixion scenes with large numbers of people become rare; they are considered distractions to pious meditation on the scene.[141]

The habit of critical historical thinking encouraged by the humanists led to doubt about some of the circumstances of the passion, and artists to attempt a more "historical" portrayal. The paleo-Christian revival drew attention to the short column in the church of St. Prassede in Rome, which was brought from Jerusalem in 1223 with the claim that it was the column of the flagellation of Christ. By the end of the Cinquecento, this short column begins to appear in

paintings of the flagellation, replacing the high column that had been usual. To the objection that St. Jerome said that he saw the column of the flagellation in Jerusalem, holding up a portico, it was answered that there were in fact two columns. St. Jerome saw the one in the temple portico, where Jesus was flogged in the night of his arrest; the short column of St. Prassede would be the column from the Roman praetorium, which was made specifically for inflicting the punishment of flagellation.[142]

Questions were also raised about the manner of the crucifixion itself. Tradition and legend had established many conventions that were now subjected to critical examination in light of the New Testament texts. Was the cross already in place before Jesus was nailed to it, so that Jesus had to be raised up onto it, or was he nailed to it on the ground before it was lifted into place? The mystical writers of the Middle Ages generally assumed the latter (as we have seen, this was how Savonarola imagined the event); artists generally followed them.[143] This scenario allowed them to draw the dramatic picture of Christ's wounds opening and gushing blood when the raised cross thudded into the hole prepared for it to stand in. Was Jesus attached to the cross with three or with four nails—that is, was each foot nailed separately? From the thirteenth century onward, the artistic tradition had insisted on only three nails, with the feet nailed together. The visions of St. Brigid of Sweden held that Christ's legs were crossed, and then nailed separately. This version had few followers, but it is illustrated by a painting by Montañes in Seville cathedral.[144] The Jesuits adopted the tradition that the feet were nailed together, and the three nails appear in their coat-of-arms. But Robert Bellarmine saw in Paris an old gospel book portraying a crucifixion with the feet nailed separately; he wished artists to return to what he considered this older tradition. The Jesuit theologian Molanus leaves artists free on this point.[145] Artists of the period vary in their portrayals; individual artists even adopt different traditions for individual works.[146]

Was Christ totally nude on the cross? In Italy, Christ is sometimes so represented, for example by Brunelleschi, by Michelangelo in his youthful crucifix, and by Cellini in his marble Christ.[147] But in general through the sixteenth century Christ is portrayed with a loin cloth or *perizonium* that is short (unlike the knee-length covering in some medieval images), but with falling ends that are long and frequently agitated, especially in German art (see our comments in the preceding chapter on the loincloth in Cranach's and other crucifixions). In painting, the loincloth is often filmy and translucent (as we have noted, this is justified narratively by the legend that the loincloth was in fact Mary's veil, placed on Jesus by her to cover his shameful nudity). Was Jesus crucified with the crown of thorns, or would it have been removed? Through most of the Cinquecento, the crown of thorns on the head of the crucified

Christ is normal; but some significant artists (most notably Michelangelo) omit it. Which side was the lance wound on? In the Middle Ages, the right side was preferred, for symbolic reasons: the church comes from the right side of Christ. On the other hand, the heart was thought to be on the left side of the body. But theologians of the Cinquecento leave this matter open.[148]

A major point raised by historical critics regarded the crosses of the thieves crucified with Christ. Frequently these crosses had been portrayed very differently from that of Jesus, sometimes having an irregular shape. But the new theological art criticism, represented by the influential writer Giovanni Andrea Gilio (writing in 1564) held that the crosses must all have been the same; otherwise, how could St. Helena have been in doubt as to which was the true cross when she discovered them in Jerusalem?[149]

There is a continued interest in moments of the passion other than the crucifixion itself—especially the descent from the cross, the lamentation over Christ's body (pietà), and the entombment. They began to be used widely as altarpieces in the earlier part of the Cinquecento, at the same time that there was a movement to place tabernacles on altars.[150] These tendencies increased in the later part of the century in the reaction against the Protestant rejection of the doctrine of the "real presence" of Christ in the eucharist. The theological point of associating portrayals of the dead body of Christ with the eucharistic species is twofold: to emphasize the real "bodily" presence of Jesus in the sacrament, and to underline the "sacrificial" character of the eucharist.

In representations of the deposition and lamentation some art historians notice the influence of features of the late medieval "man of sorrows" icon. The imago pietatis is the portrayal of the living Christ, sometimes standing in the tomb, but still showing his suffering. It does not coincide with either deposition or entombment images, although it may ultimately derive from them. In the Renaissance, however, there is a tendency to join features of the ahistorical Man of Sorrows image with particular narrative moments: Christ taken down from the cross, lamented over by Mary, being deposed in the tomb, or even lying in the tomb itself.

Of particular interest was the proliferation of images of the child Jesus with the cross or the instruments of passion. It was common for medieval and Renaissance representations of the Virgin and Child to include some symbolic reference to the passion. But in the Cinquecento the theme is made more explicit. Theologians repeated the phrase of St. Thomas Aquinas that from the moment of his conception, Christ's first thought was for his cross.[151] In the early years of the century Garofalo painted the Virgin contemplating the infant Jesus the while angels descend with crown of thorns, the cross, and the nails. An engraving by Giacomo Francia di Bologna shows the child sleeping on the

cross itself. The picture bears the inscription, "I sleep, but my heart is awake." This became a favorite subject for Bolognese painters. In the last years of the century Hieronymus Wiericx produced an engraving of the child Jesus with the instruments of passion and the IHS symbol used by the Jesuits.[152]

Having considered some general characteristics of representations of the passion, we turn now to an examination of examples from several artists and styles that dominated Cinquecento art.

MICHELANGELO

As we have seen, artists and humanists of the Italian Renaissance were acutely conscious of rediscovering the classics. This of course implied the explicit recognition that art had a history. Hence they were also aware of the changes that they were producing in art, especially of the conscious turn to antiquity for artistic models in place of the accepted forms of medieval piety. This turn, as we have seen, was a cause of concern to some religious leaders even before the Reformation. At least among some, there was an awareness that the new artistic ideals were perhaps not entirely consistent with the religious purposes of sacred art. Savonarola for example protested both against the paganization and against what we would call the secularization of religious painting, and he seems to have convinced even such a classically inspired artist as Botticelli. He apparently had an influence on Michelangelo's thinking as well, even though its effects were perhaps delayed.

Michelangelo was very aware of his age's departures from tradition,[153] and was especially concerned by the changes in sacred art. On the one hand, he was committed to the classical ideals of the Renaissance; on the other hand, he was genuinely concerned for piety. Despite the changes in his style from his early to his later years (changes that are sometimes characterized as marking the shift from the balance of High Renaissance classicism to the beginnings of the turmoil of Mannerism), there is a certain consistency in his sacred works. He retained a life-long interest in spiritual matters, and returned continually throughout his life to the theme of the death of Christ.

Michelangelo thought that artists of the recent past had been overly preoccupied with portraying the physical sufferings of Christ. Among reform-minded Catholics, he was not alone in this opinion. For example, his contemporary Gian Matteo Giberti, the reforming bishop of Verona, ordered the removal of painted blood spouting from the wounds of Christ in crucifixion scenes, because it was unfitting to show Christ in agony when he is in fact resurrected.[154] He wished to return to the spirit of pre-Gothic art, which showed the meaning of the crucifixion by portraying the glorious Christ on the

cross. Michelangelo, in the humanist spirit, in all his portrayals of the passion presents Christ, whether living or dead, with a classically beautiful form based on antique sculpture. The figure's bodily beauty of the is the sign of divinity and of God's triumph over sin and death.

This characteristic of Michelangelo's treatment of the passion is seen already in his youthful wooden crucifix and in his first great sculpted *pietà* (both discussed in chapter 1). We can see much the same spirit in an unfinished painting of the *Entombment* (ca. 1500–1501; now in the National Gallery in London) generally accepted as a work of Michelangelo.

The picture shows several figures carrying the dead body of Christ up steps, away from the viewer, toward a tomb in the background. Christ is majestic and glorious in death. Although a preparatory drawing shows that one of the incomplete figures would have been holding and meditating on the crown of thorns and the nails of the crucifixion,[155] the body of Christ shows no wounds at all. The hair, beard, and moustache, as in the Rome *pietà*, are elegantly groomed. The figures carrying the body seem to strain at its weight; but, as Alexander Nagel remarks, to the viewer it seems to float upward, independently of the bearers. The frontal position of Christ's body gives the painting a certain iconic quality, despite the narrative setting. The people present at the scene do not so much react to it as to contemplate it; their attitude is parallel to that of the

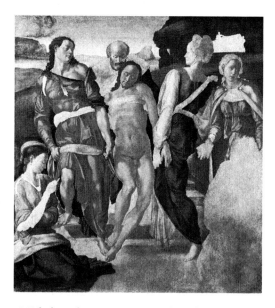

FIGURE 3.3. Michelangelo Buonarotti (attributed), *Entombment*, 1510.
Credit: Photo © The National Gallery, London.

viewer of the painting, who, incorporated into its perspective, can imagine him or herself at the scene, as medieval books of piety recommended.[156]

In the ceiling of the Sistine Chapel (1508–12) the passion of Christ is not depicted, but it is alluded to symbolically through Old Testament prefigurings. The central panels of the ceiling are dedicated to the beginnings of Genesis. Proceeding from the end near the altar, we are presented with the creation of the material world, the creation of Adam and Eve, the Fall and the expulsion from Paradise, and the story of Noah, including the thanksgiving sacrifice of Noah, the flood, and the nakedness of the drunken Noah after planting the first vineyard. The last panel illustrates Gen. 9:20–23. Noah plants the first vines, drinks wine, gets drunk, and lies naked in his tent. His son Ham discovers his father's nakedness and tells his brothers, who then cover Noah. This scene was traditionally taken as a prefiguration of the passion of Christ; both Augustine and Jerome understood it this way,[157] and the theme was thought to be echoed in the prophecy of Jeremiah: "my heart is broken, all my bones tremble; I am become as a drunken man, and as a man full of wine" (Jer. 23:9). Drunkenness was also frequently taken as a symbol of the state of spiritual ecstasy; in this sense, it could refer not only to the passion, but also to the union with God attained through the blood of Christ present as wine in the eucharist. And of course the nakedness of Noah and the impiety of his son was understood as a prefiguration of the stripping and mocking of Christ at the crucifixion.

In his painting Michelangelo orients us to the symbolic meaning by undermining the "historical" point of the story, the shame of Noah's nakedness, by presenting all the characters in the nude (the only clothed figure is Noah in the background, planting the vine). If we read the painting as a symbol of the passion, then the next two panels going back toward the altar also make sense: salvation through the waters of the flood is a traditional symbol of baptism, and the sacrifice of Noah prefigures the eucharist. (From the narrative point of view, these two panels are in reverse order, for in Genesis the sacrifice of Noah takes place after the flood, in thanksgiving for his salvation; but symbolically, it makes perfect sense for the eucharist to follow baptism.) Both sacraments, of course, are seen as founded on the passion of Jesus, and as a participation in it. In this way the ceiling may be read in both directions: from the altar wall to the entrance wall, and back. Read historically, it is the story of the descent from God to sin. But one may also read the ceiling in the opposite direction, in a neo-Platonic way, as an ascent from the realm of sin and darkness to the realm of light, from the many to the One. In this way it illustrates the *exitus-reditus* ("departure-return," i.e., from and back to God) schema that typified Platonic theology and deeply influenced even the more Aristotelian scholasticism of

St. Thomas. The pivotal point, the point of the world's turning back to God, is the passion of Christ, symbolized by Noah.

Another symbolic reference to the cross is found in the portrayal of the raising of the brazen serpent in the desert (Num. 21:9), a prefiguring of the "raising up" of Christ: "the Son of Man must be lifted up as Moses lifted up the serpent in the desert" (Jn. 3:13). Michelangelo has placed the main theme of the painting, the bronze serpent, in the background, while the foreground is filled with a confused mass of highly foreshortened figures battling with entwining and biting serpents.[158] The symbolic emphasis is thus placed on the dominion of evil from which the cross delivers humanity. This painting occupies one of the triangular panels at the four corners of the ceiling. It is located at the altar end of the chapel, diagonally opposite the figure of David slaying Goliath, another symbolic type of Christ's victory over evil. The paintings in the other two triangles represent Old Testament prefigurations of Mary. On the entrance wall is Judith, having beheaded Holofernes (Jdt. 13:10); on the altar wall, nearest the brazen serpent, is the story of Esther. Significantly, Michelangelo has centered his picture not on Esther, but on the crucifixion of Haman (Est. 6:10), who is portrayed as a Promethean figure affixed to a tree. The picture is reminiscent of the highly imaginative way many Renaissance artists portrayed the execution of the thieves crucified with Christ.[159] Hence here also, we have an indirect reminder of the passion.

Again in the *Last Judgment* (completed in 1541) we encounter references to the passion, now as a past event. Above the Herculean figure of Christ, angels bring to the scene the instruments of his passion. On the right, a group is entwined around the column of the flagellation; on the left, another group strains under the weight of the cross, while a single figure holds the crown of thorns. These are all traditionally seen as the means of humanity's redemption; but here, like the instruments of torture held by the martyrs, they seem to serve more as witnesses to the crimes for which the damned are condemned. (The pessimism of the work can be seen when we look at the two angels below Christ holding respectively the book of life and the book of condemnation. The former is a small volume; the latter a huge tome. Most of humanity is destined for hell.)

In his late period (from after his "conversion" of 1538 to perhaps 1556) Michelangelo produced at least six studies of the crucifixion. All have in common the grandeur and majesty of Christ's body, modeled on antique heroic forms. But they vary widely in mood and message. In a drawing from about 1541, Christ is presented alive on the cross, his arms nearly horizontal, his muscular body twisting as though to break free and ascend to the heavens where his gaze is directed. According to Condivi, Jesus is presented "in a godlike attitude, raising his countenance to the Father, and appearing to say

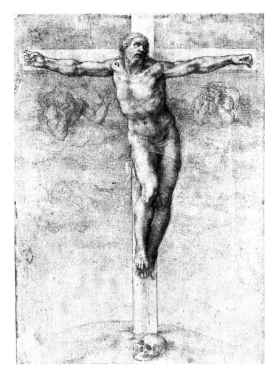

FIGURE 3.4. Michelangelo Buonarotti, *Crucifixion*, ca. 1538–41. British
Museum, London (Malcolm collection). Credit: © British Museum / Art
Resource, New York.

'Eli, Eli': and thus the body does not fall as if slumped in death but is seen as a
living being, wracked and contorted by a bitter torment."[160]

In other drawings Christ is presented dead, attended by grieving figures
(presumably Mary and John) on each side of the cross. Two drawings show
Christ hanging downward with his arms nearly straight above his head—a pose
that may be intended to evoke ancient images of Marsyas,[161] whose story was
frequently used in Renaissance painting and literature as a Christian symbol.
Raffaello painted it in the *Stanze* of the Vatican; Michelangelo himself wrote
a poem (possibly for Vittoria Colonna) using it. In the ancient myth, Marsyas
contended in music against Apollo, and when he failed to surpass the god, was
hanged from a tree and flayed alive in punishment for his presumption. (He
is commonly shown hanging by his hands, arms above his head.) In the neo-
Platonic understanding, the flaying of Marsyas signifies God's stripping the
soul of its bodily impediments in order to make it able to commune with the
divine. Christ would thus be seen in the crucifixion as the example of will-
ingness to undergo the pain of this stripping, but in contrast to Marsyas, not

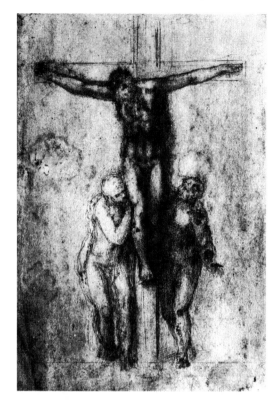

FIGURE 3.5. Michelangelo Buonarotti, *Crucifixion with Mary and John* (or Nicodemus?). British Museum, London. Credit: Alinari / Art Resource, New York.

in punishment for challenging God's supremacy, but precisely in obedience to it. It is notable that in these drawings considerable attention is given to the grieving figures at the foot of the cross. Their postures vary, but all represent lamentation and sorrow. In one case they embrace the cross. If they are taken to represent the attitude that the viewer should emulate, then they seem to invite us to feel the compassion for Christ so emphasized in late medieval spirituality.

In his last years Michelangelo also returned to the theme of the deposition/ *pietà*, producing several studies and at least two incomplete sculptures.[162] The sculpted group now located in the *duomo* in Florence, was probably intended for a niche over his own tomb. He worked on it between 1547 and 1553, but smashed it in 1555 because one of the legs broke off, and because he found flaws in the marble. However, he allowed a former servant of Vittoria Colonna (who had died in 1547) to take the pieces.[163] The servant sold them, and the new owner eventually had them reconstructed according to Michelangelo's models,

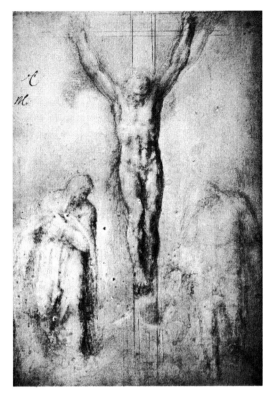

FIGURE 3.6. Michelangelo Buonarotti, *Marsyas Crucifixion* (*Christ on the Cross with the Virgin and Saint John*). Musée Condé, Chantilly. Credit: Giraudon / Art Resource, New York.

giving us the uncompleted but still impressive sculpture that stands today. The figure of Christ is classically formed, but slumps as a dead weight, limbs contorted, held up by Mary and Nicodemus and a small female figure (the last thought not to be by Michelangelo). Despite the extreme contortion of the limbs, the overall pose of the body is a graceful curve. The visual structure of the whole is a triangle atop a square. The focal point of the triangle is the face of Christ, which shows mildness and repose. The head of Mary is only roughly sculpted, but her expression seems to be one of tenderness. The head of Nicodemus rises above Christ at the apex of the triangle formed by the figures. According to legend, Nicodemus was a sculptor (he was reputed to have made the *Volto Santo* crucifix in Lucca). His face here is a self-portrait of Michelangelo. Its look shows concentration and sorrow. All the figures are both literally and figuratively statuesque. The gravity and majesty of the work express the grandeur of the work of salvation. We may see in it both dimensions of *"pietà."*

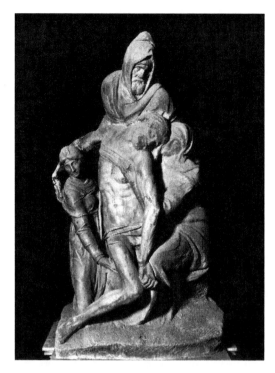

FIGURE 3.7. Michelangelo Buonarotti, Florence *Pietà*. Museo dell'Opera del Duomo, Florence. Credit: Alinari / Art Resource, New York.

God's loving compassion for the world, expressed in the great sacrifice of his Son; and our compassionate response in communion with Mary and Nicodemus.

The Rondanini *pietà* was begun in 1555. Michelangelo worked on it intermittently until shortly before his death. The final version, significantly changed from the sculptor's first effort, was left in a state of incompletion that is itself evocative. The treatment of the legs of Christ, the most finished part of the statue, is reminiscent of the London *Deposition* and of the artist's earliest *pietà*. But here both Mary and Christ are upright, with Mary, on a higher level, serving as the only support for her son's body leaning against her; the two figures are inseparable as they emerge from the marble. The face of Christ is barely sketched in, so our attention is drawn to that of Mary above it. Her features appear to express sorrow, and perhaps contemplation; but the unfinished state of the carving leaves more to our imagination than to any clear statement by the artist. Arnold Hauser's appreciation of this last work of Michelangelo is worth quoting: "Primarily it seems not to be a work of art at all, but an ecstatic confession, moving at the extreme limits of what can be expressed in sensuous form or conceived in aesthetic terms."[164]

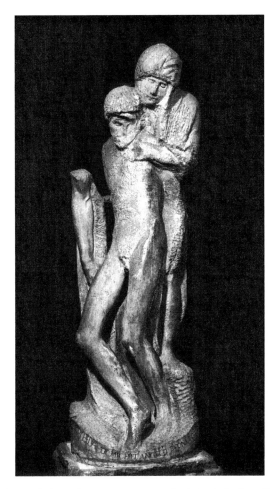

FIGURE 3.8. Michelangelo Buonarotti, Rondanini *Pietà*. Castello Sforzesco, Milan (formerly in the Palazzo Rondanini, Rome). Credit: Alinari / Art Resource, New York.

THE CROSS AND PASSION IN MANNERIST ART

The genius of Michelangelo dominated Italian sacred art in the first half of the Cinquecento. Stylistically, his works mark both the highpoint of Renaissance classicism and the beginnings of the crisis of Renaissance art and the turn from the classical ideal.

Art historians frequently take the death of Raffaello (1520) as a convenient date for the end of the High Renaissance. However, in Michelangelo's works even earlier than this date we can see the beginnings of a move away from the

ruling principles of the period. Although his works embody both classicism and naturalism, Michelangelo believed in the primacy of imagination over imitation in art. Many of his figures, including those of the Rome *pietà*, are disproportionate in their size. Michelangelo thought that the "grace" of figures was more important than scientific measurement. For him, the artist "needed to have his measuring tools (*seste*), in the eye, not in the hand, because the hand operates, but the eye judges."[165] He reportedly found Dürer's careful studies of measurement to be worthless. He popularized, if he did not "invent," the *figura serpentina*—the gracefully (but artificially) curved body that is in some respects reminiscent of Gothic figures (as we have seen, Michelangelo consciously espoused a certain archaism for sacred works). [166] On the other hand, many of his figures of this kind show an upward movement that foreshadows the dynamism of the Baroque. In him the inherent tension between the Renaissance ideal of "objective" naturalism and that of *ingenio* comes to a crisis.[167] In these features, as well as in their artful concern for the *concetto*, the "idea" to be presented by an artwork, Michelangelo's later works are often considered to be examples of the tendencies of "mannerism."

A detailed discussion of "mannerism" as a style—or indeed, of the usefulness of the term itself—is beyond our present scope. [168] However, despite the diversity of styles of the individual artists who are designated as "Mannerists," we may in general identify mannerism as a rejection of or a (partial) reaction against the ideal of naturalism and the use of classical models in favor of a more expressionistic (and hence a more self-consciously "artistic") mode of representation. The term "mannerism" is sometimes used to signify a universal stylistic tendency;[169] but in our context it refers principally to certain central Italian and Spanish painters of the Cinquecento. (Obviously, the term will apply to different degrees even among these.) The emphasis on artistry for its own sake, frequently with the consequent subordination of the subject matter, was in accord with the general secularizing tendency in art of the period. (Although Michelangelo seems to have been a deeply religious person even before his middle-aged "conversion," other painters of church art of the period seem to have had little or no personal Christian commitment; Pontormo, for example, although most of his commissions were for sacred works, seems to have been totally irreligious.)[170]

Mannerism in the narrow sense was largely a deliberate development from the late style of Raffaello and the mature style of Michelangelo (although the beginnings of Mannerism can be seen even prior to the painting of the *Last Judgment*). It involved a conscious reaction against classical aesthetics, while still using many of its forms. As Arnold Hauser notes, Mannerism was not simply anti-classical, but was the product of the tension between classicism and anti-

classicism, rationalism and irrationalism, naturalism and invention; the tension is of its essence.[171] "To the new, conflict-torn generation the repose, balance, and order of the Renaissance seemed cheap, if not actually mendacious."[172]

The characteristics of Mannerist painting included concentration on the nude; convoluted and artificial poses; exaggerated musculature; the elongation of figures; extremes of foreshortening; the neglect of perspective and the use of irrational and unreal spatial constructions; the choice of difficult subject matter, or the rendering of obscure intellectual "conceits" (*concetti*), often involving the placement of the main subject in the background; displays of technical virtuosity; the use of vivid and sometimes unnatural hues; the choice of colors for emotional impact, rather than for descriptive realism.[173]

Mannerism was self-consciously elitist art, striving not for naturalism, either visual or ideal, but rather for aesthetic effect that would be appreciated by connoisseurs. Classical art was anthropocentric—hence, the concentration on the nude—and considered humanity as a microcosm of the universe. It presupposed a certain epistemological realism. Nature was associated with objective forms, and art with the mastery of form. Mannerist art was in a sense parallel to epistemological nominalism; it concentrated on the irreducible variety of phenomena. But the denial of universal forms does not lead (as it did in nominalism) to a strict empiricism, but rather in the other direction: to a self-conscious creation of an artificial artistic world. For this reason Arnold Hauser sees in the Mannerism of the Cinquecento a radical revolution in art: "for the first time art deliberately diverged from nature. True, non-naturalistic and anti-naturalistic art had previously existed, but its makers had been hardly conscious of deviation from nature, which they certainly had no intention of defying."[174]

Hauser's judgment may seem overly general when we remember the conscious medievalism that modifies the naturalism of Fra Angelico, or the expressionistic tendency of Hellenistic early Christian art, following the striking illusionism that had been achieved in classical Roman art. Nevertheless, it is true that the Cinquecento Mannerists consciously chose an aesthetics that was revolutionary in comparison to previously accepted medieval or Renaissance standards. Their idea of artistic beauty was based neither on natural forms measured against a model (as it was for Dürer) nor on ideal forms (as it was for Michelangelo), but on the basis of the artist's subjective criteria of harmony and design.[175] The Mannerist painter portrayed objects neither as they are actually seen, nor as they "ought" to be, but simply as the artist wished to portray them.[176] Correspondingly, Mannerist works were less inspired by nature than by other works of art.[177]

These characteristics naturally had a significant effect on the Mannerist approach to sacred art. In contrast to the early Renaissance confidence in the

capacity of body to symbolize and express spirit through the perfection of form, "the crisis of the Renaissance began with the doubt whether it were possible to reconcile the spiritual with the physical, the pursuit of salvation with the pursuit of terrestrial happiness. Hence, Mannerist art—and this is probably its most unique and characteristic feature—never confronts the spiritual as something that can be completely expressed in material form. Instead it considers it so irreducible to material form that it can only be hinted at (it is never anything but hinted at) by the distortion of form and the disruption of boundaries."[178]

We shall look briefly at how these characteristics are exemplified in the two most significant Italian Mannerists (apart from Michelangelo, if we include him under this designation), Pontormo and Rosso Fiorentino; we shall then proceed to look somewhat more extensively at the work of El Greco, who (again apart from Michelangelo) was perhaps the most successful practitioner of the Mannerist style in sacred art.

The essential marks of Mannerism may be seen even before Raffaello's death in the early works of Pontormo (Jacopo Carucci, 1494–1557). As Linda Murray remarks, with Pontormo painting seems no longer to be bound by perspective or by rational objective order; the various parts of a composition need have no intrinsic relation to each other; color is evocative and beautiful in itself, rather than an imitation of visual experience.[179] These characteristics are evident in Pontormo's most celebrated work, and the one most relevant to our topic, his *Deposition* (ca. 1525) in the Capponi chapel of the church of Santa Felicità, Florence. The body of Christ, which seems to be inspired by Michelangelo's Rome *pietà*, is carried by two young men, while a female figure, leaning down from above, cradles his head. The face of Christ is youthful and shows repose. The body is disproportionate, with a huge torso and very small limbs and tiny feet. The wounds of the passion are indicated only slightly; there is no blood seen anywhere. The two young men, both with curly blond hair, have similarly disproportioned bodies. Their faces seem worried rather than sorrowful as they look not toward Christ or Mary, but out of the painting, in the general direction of the viewer. The figure of Mary rises above and to the right of Christ. Her youthful face expresses sorrow, and she raises a hand in the direction of Jesus. Of all the figures in the picture, she alone looks at Jesus. Several women attend her. The bright torso of Jesus, striking in its nudity and its color against the light blue backdrop of his bearer's elaborate pastel-hued garments, first draws the eye. The curve of the body leads us to his calmly reposed head, and from here we are attracted to the grieving face of Mary that visually and psychologically counterbalances it.

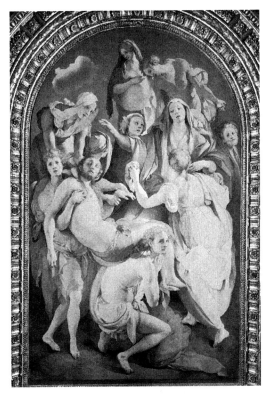

FIGURE 3.9. Giacomo Pontormo, *Deposition*, 1526–1528. S. Felicita, Florence. Credit: Scala / Art Resource, New York.

Both the disposition of the limbs and the facial expressions of the characters in the picture bespeak motion as well as emotion. Several of the figures wear a highly revealing form-fitting garment that is in effect merely a colored nudity. Although the picture is called a "deposition," and thus evokes a narrative context, one would be hard put to say what physical situation would permit the spatial relation of the figures to each other. Those whose feet we can see all seem to be on the ground, which appears to recede upward toward the right. But there is no visible explanation of the position of the others, who seem to be floating in air. Similarly, there is no naturalistic explanation for the gray background in which a single dark cloud floats, or for the bright light that shines on the figures against this dark background.

Above all, the picture is an exercise in dramatic coloration. Its artificiality is striking—as though the characters had agreed on color-coordinated clothing. The rectangle below the semicircle formed by the arched top of the picture

contains two triangles: to the bottom right, pink and light gold predominate; in that above it, a powder blue. The pink color is repeated in the head scarf of the woman above Christ and in the clothing of the static figure at the summit, drawing the eye upward in a curve whose center is Christ's brightly-lit torso. In the right of the semicircle at the top a woman with a salmon-colored cloak balances a similarly colored robe at the bottom left. The colors of the solitary cloud at the top left echo those in Christ's loincloth and winding sheet.

The artistry of this painting, the cleverness of its composition, the technical expertise of the artist, are all apparent. But what religious message does all this artistry serve? Obviously, the Christian viewer brings to it a knowledge of what is being represented, both narratively and affectively. But one might ask—and, as we shall see, critics of Mannerism did ask—whether such highly posed and artificially arranged figures effectively reinforce that message, or whether they distract from it.

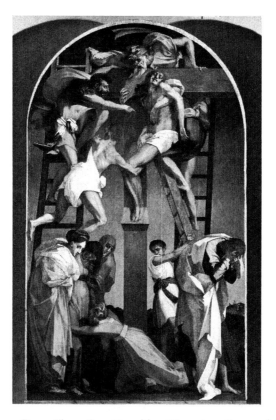

FIGURE 3.10. Rosso Fiorentino, *Deposition*. Pinacoteca Comunale, Volterra. Credit: Scala / Art Resource, New York.

Perhaps the most strikingly Mannerist painting by Rosso Fiorentino (Giovanni Battista di Jacopo Rosso, 1495–1540) is his *Descent from the Cross* of 1521 in the Cathedral of Volterra. Three ladders are leaned against a high, massive, and perfectly shaped cross with a *suppedaneum*. On the ladders are four men who let down the body of Christ, from whose hands and feet the nails have already been removed. In the bottom half of the painting, Mary, at the left, bows her head in grief, supported by two women; a third (presumably Mary Magdalene) embraces her knees. On the right the disciple John buries his bowed head in his hands. A small figure looks on while holding one of the ladders.

As in Pontormo's *Deposition*, we find here ambiguities in the spatial relationships. The placement of the ladders relative to the cross and to the ground is unclear, as is the location of the figures in relation to each other, to the ladders, and to the cross. The placement of two of the ladders seems irrational; the upper figures on them cannot even reach the body of Christ, and a third, who grasps the legs, hangs acrobatically between the ladder and the cross. The cloaks of the figures atop the ladders blow as though in a violent wind; but there is no stirring of any the other figures' clothing. Several of the

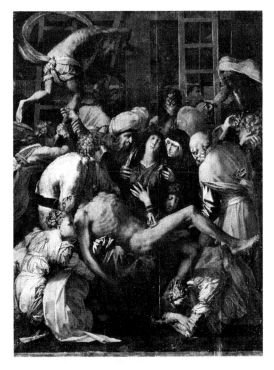

FIGURE 3.11. Rosso Fiorentino, *Descent from the Cross.* S. Lorenzo, Sansepolcro. Credit: Scala / Art Resource, New York.

forms are notably elongated, particularly John's. The figures are as though frozen in a moment of time, lit as though by a flash or by a stage light. Above all, it is the vivid color in the painting that is striking. The body of Christ, apparently modeled on a drawing by Michelangelo from 1519–20, is classical in form, with a peaceful (clean-shaven) face, but has a green hue in death.

An unusual treatment of the passion is found in Rosso's drawing of *Christ on the Cross* in the Uffizi museum in Florence. The figure of Jesus is nude. The legs are crossed and the feet are nailed with a single nail. The torso of Christ is bent forward from the waist, as though performing a deep bow. The head droops so far that we see the back of Christ's neck. The hair falls down in a long stream almost to the knees. The picture emphasizes the reality of Christ's death; his body has become an inanimate object, without even a face for us to identify with. The unusual posture gives the picture an immediate dramatic impact. But a moment's reflection raises a question: is such a forward position of the torso physically possible, if the hands were nailed with the arms extended on the crossbeam? Because of the lack of a sense of depth between the cross and the torso, the position appears plausible, at least at a first glance. But once we think about it, the picture becomes puzzling. The cross itself has the appearance of being made from sections of a tree. The crossbar apparently has a hole in it that has been slid into place on the vertical beam; it is held in position by two staves extending from its ends to a position on the vertical beam at the level of Jesus' feet. With the crossbeam, it thus forms an equilateral triangle that frames Christ's body. Below, Mary Magdalene kneels at the foot of the cross, looking upward toward Jesus' face, which is invisible to us. The Virgin Mary is on the right, with both hands crossed over her heart, looking upward into space; and the apostle John stands leaning with one elbow on a convenient table formed of three large blocks of stone, his legs crossed and head bowed. The picture draws our attention to the pathos of the situation, without any specific reference to its theological meaning; this must be brought to the picture by the viewer.

Rosso's painting of the *Dead Christ with Angels* (1525–26; now in the Boston Museum of Fine Arts) once again takes its inspiration from Michelangelo's drawing for a *pietà*. The divinity of Christ is implied by the perfection of the body, even in death. Elements associated with the "Man of Sorrows" motif are present: the head still bears a small crown of thorns; at the feet are the nails and a small staff bearing the sponge from which Jesus was offered to drink. But there is no trace of suffering here. The face bears a gentle smile of sweet repose. As in Michelangelo's early Rome *pietà*, the veins of Christ (especially visible in the foot) are prominent and full, unlike those of a corpse. The body is large, muscular, and completely nude; but the genitals are discretely hidden by the crossed legs. The body is seated on what looks like a sort of elegant bench—

perhaps the slab on which Jesus was lain in the tomb?—and the angels are behind it, resting their candles on it. The wound in Christ's side is plainly indicated—one of the angels touches it. But there is no blood, despite the full veins. The angels bear large multi-wicked candles whose flames bend in a current of air, which has no other apparent effects. Two of them seem to be looking behind Christ's body; only one is apparently looking at him, and this one is facing the back of his head. The light obviously does not come from any such natural source as the candles; it shines on the scene from without. Although it is possible that Rosso intended this painting to convey a narrative moment, namely, Christ in the tomb on Holy Saturday, its genre is more iconic than narrative. (Compare the brutal naturalism of Holbein's nearly contemporary [1521] painting of the dead Christ lying on a stone slab, presumably in the tomb.)

Rosso's late *Pietà* (1537–40; now in the Louvre) in some ways returns to a more traditional mode of representation. The body of Christ is again reminiscent of Michelangelo's works. But here the face, with half-opened mouth and furrowed brow, expresses agony. Mary flings her arms wide in lamentation, and looks directly at the viewer; an appeal to *compassio* seems clearly implied. Hints of landscape in the background indicate an outdoor scene; yet Christ's

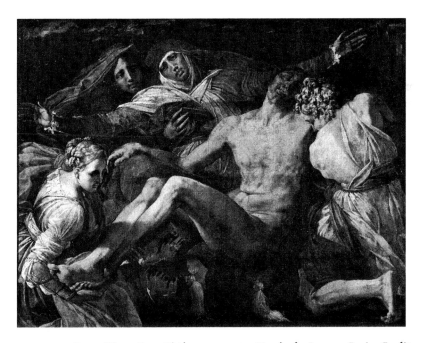

FIGURE 3.12. Rosso Fiorentino, *Pietà*, ca. 1530–35. Musée du Louvre, Paris. Credit: Scala / Art Resource, New York.

body reposes on plush decorated and tasseled cushion. The female figure who holds his feet is elegantly coiffed and dressed in courtly garments. The color scheme is comparatively muted, but the colors are still strong. The strong effect of the painting is achieved partly by concentrating attention on Christ and Mary precisely by the device of placing them out of the bright light that shines (from where?) on the attendants.

EL GRECO

The work of El Greco (Domenikos Theotokopoulos, 1541–1614) was perhaps the most successful attempt to reconcile Mannerist artistry with the demands of sacred painting. El Greco embodied an unusual combination of artistic and religious traits. He was in content and spirit an orthodox Counter-Reformation artist and at the same time stylistically a Mannerist painter. In his time, such a combination was unusual; it was perhaps only in Spain that it could achieve success. In any case, it was in Toledo that El Greco established himself and attained celebrity after failing to win the status he aspired to in Italy. Even there, however, his Mannerist style and the conscious elitism of his painting led to conflicts with Counter-Reformation ideas on art.

As we have seen, the church in Spain was involved in self-reform well before the emergence of the Reformation in the north of Europe. The Catholic reaction against Protestantism reinforced both the movement toward spiritual renewal and the emphasis on orthodoxy, tradition, and fidelity to the institution. In some cases, these two aspects of Catholic reform ended up being in tension with each other. The implementation of the decrees of the Council of Trent was an important aspect of Spanish "orthodoxy." While the Kingdom of France took years to officially receive the Council (except in purely dogmatic matters), Philip II accepted the Council immediately, and in July of 1564 he ordered the Spanish church to reform itself according to its decrees. Indeed, with regard to orthodoxy, the Spanish church attempted to be literally "more Catholic than the Pope." Fernando de Valdés, the Inquisitor General from 1547 to 1568,[180] began to arrest university professors, especially those who propagated the ideas of Erasmus, despite Erasmus's final rejection of Luther's ideas and his strong influence on Catholic reformers, including Pope Paul III (reigned from 1534–49). He also arrested on suspicion of heresy the Archbishop of Toledo, Bartolomé de Carranza y Miranda, a Dominican scholar who had been an official theologian at the Council of Trent and who had himself served the Inquisition. The King resisted attempts by the Pope to take judgment of the case out of Spanish hands.[181] Cardinal Gaspar de Quiroga, Inquisitor General from 1573 and archbishop of Toledo from 1577, was more attuned to the

humanist side of the Catholic reform. He encouraged biblical studies and pardoned the Scripture scholar Luís de León, who had been arrested in 1572. But he also instructed the Holy Office to scrutinize the works and activities of mystics, *alumbrados* (illuminists), *beatas*,[182] and other spiritualists.

We have seen that one aspect of the Catholic reform in Spain was a flowering of mysticism, especially represented by Teresa of Avila and John of the Cross. Although their teachings and example were eventually adopted as an important part of the triumphant spirituality of the Counter-Reformation, in their time they had many admirers, but few followers. Moreover, they were highly suspect to the Inquisition. Their emphasis on individual inner piety was regarded as dangerous, because it might lead to minimizing the importance of the sacraments, the hierarchy, and the externals of church life. [183] (As we have seen, John of the Cross was suspected of "illuminism," and spent time in an Inquisition prison; Teresa of Avila was also looked upon with some suspicion, and her works were accused of containing unorthodox ideas.)

The reform and Counter-Reformation spirit in Spain had direct consequences for art; consequences that were to be felt by El Greco. El Greco lived and practiced his art a generation later than Pontormo and Rosso Fiorentino; and unlike them, he felt the full effect of the decrees of the Council of Trent on art. The Archbishops of Toledo, the primatial see of Spain, took Trent's decrees very seriously. A provincial council held in Toledo in 1582 addressed the question of sacred art, and ordered bishops "to prohibit paintings that cause laughter and those that are nothing more than profane, popular decoration."[184]

The last phrase, if strictly interpreted, could be fatal to Mannerist painting, which tended to subordinate content to aesthetic values. El Greco experienced this early in his career in Spain. He had hoped to find favor with King Philip II, known to be a great collector of art. But the King rejected his painting of *The Martyrdom of St. Maurice* because it obscured the devotional content. Fray José de Sigüenza, who was a witness to the king's decision, remarked *à propos* of El Greco's painting that "The saints should be painted in a way that does not remove the desire to pray before them."[185] El Greco's painting was certainly artistically better than the competition, but it was judged not to be sufficiently conducive to devotion. Later, in a dispute over the price to be paid for his great work *El Expolio* ("The Disrobing [of Christ]," 1577–79), painted for the cathedral of Toledo, the cathedral's appraisers denigrated the picture's worth by citing religious "improprieties" in it: some characters in the painting are represented with their heads on a higher level than that of Christ; and the presence of the three Marys in lower left is something not found in the gospels.[186]

The Counter-Reformation idea of religious art stressed accessibility to the masses. This conflicted with both El Greco's notions of art and his personal

temperament. He was in many ways the quintessential Mannerist painter. He was an elitist and an intellectualist in art; he despised popular taste.[187] Like Alberti, Leonardo, and Michelangelo, he thought of the artist as an intellectual and a gentleman, not a mere craftsman. While both Lutheran painting and the so-called Jesuit style used religious paintings essentially as illustrations of words, El Greco evidently thought that painting is an independent way of knowing, a mode of thinking. In a marginal note to his copy of Vitruvius he wrote: "Painting, because of its universality, becomes capable of speculation...."[188]

Correspondingly, El Greco declined the naturalism that was favored by Counter-Reformation art. His early training in the neo-Byzantine style had accustomed him to an iconic ideal for sacred art, to which the imitation of nature was foreign. It is not known whether, like Michelangelo, he was influenced by a neo-Platonic metaphysics of "light;" but he clearly thought of painting as creative intellectual invention rather than as mimetic reproduction of an external scene. Like the Mannerists in general, he prized intuition, facility, complexity, novelty, liveliness, and variety.[189] Like Michelangelo, he thought that in the painting of figures, "grace" was more important than scientific measurement. The extreme elongation and the flame-like *figura serpentina* visible in many of his forms are the expression not of spiritual visions or of emotionalism or of degenerating eyesight, but of a Mannerist theory of art.[190] Other Mannerist characteristics abound. In El Greco's paintings there is a general absence of inanimate nature; he avoids the use of linear perspective to create the illusion of depth; he uses light and shadow arbitrarily, and he treats color as an expressive device.[191]

Given that El Greco's style was in so many ways opposed to the religious aesthetics of the late Cinquecento, we might wonder how he attained the success he achieved as a sacred painter. First is must be recalled, as Jonathan Brown points out, that most of El Greco's altarpieces were designed for places with very limited public access,[192] primarily private chapels which by their nature would be frequented by a small and select group of patrons. El Greco found friends and patrons among the intellectual class of Toledo, including clergy who shared his religious assumptions and ideals and could also appreciate his art. Moreover, although Mannerist and intellectual in style, El Greco was thoroughly committed to the Counter-Reformation ideal of art in the service of religion. The themes of his paintings typically embody the doctrines emphasized in the reaction against Protestantism: the saints, intercession, penitence, Mary.[193]

Perhaps most importantly, El Greco was able to achieve what the Italian Mannerists did not, at least in the eyes of church authorities of their time: clear expression of doctrinal orthodoxy, combined with conduciveness to devotion.

The influential late Cinquecento theorist Giovanni Andrea Gilio da Fabriano formulated a key point of post-Tridentine theological aesthetics: "A thing is beautiful in proportion as it is clear and evident."[194] Perhaps El Greco learned a lesson in this regard from his early disappointment in seeking royal patronage. In any case, he was ultimately successful in meeting this criterion. As Jonathan Brown writes: "El Greco's paintings represent their religious subjects with un-mistakable clarity. The artists of the Maniera in Italy foundered exactly on this requirement of Counter-Reformation thought. Unable to reconcile artistic com-plexity with doctrinal orthodoxy and authentic spirituality, Maniera lost its vitality as a style and withered away. El Greco, almost alone among the practitioners of artificial art, found the means to reconcile the seemingly irreconcilable goals of Mannerist aesthetics and Counter-Reformation theology and practice."[195]

El Greco's paintings frequently portray events or ideas connected with the passion, including the crucifixion. In his *Crucifixion with Two Donors* (1580; now in the Louvre) and *Christ on the Cross with Landscape* (ca. 1605–1610; in the Cleveland Museum of Art) we see a nearly identical treatment. (The subject was also repeated similarly many times in paintings from El Greco's workshop.) The body of Christ is elongated and twisted in the flame-like *figura serpentina* that El Greco so admired. Its upward dynamism is such that it almost appears to be ascending rather than hanging. The face of Jesus is turned ecstatically toward the heavens. The skies in the background are violently rent. In the earlier version the naturalistic portraits of the donors contrast with the Man-nerist spiritualization of the beauty of Jesus' figure. The two are painted as though present at the event, looking up at Christ with devotion. As we have seen, this inclusion of contemporary figures accords with the "iconic" style, and has its theological basis in the notion of the eternal presence and significance of Christ's sacrifice; in faith, we can be present to it and it to us.

The ecstatic look on Christ's face, even in his suffering, illustrates the traditional theological doctrine that Jesus willingly "gave himself" on the cross, and that the "upper part" of his soul enjoyed the beatific vision, even while his body and the "lower" parts of the soul suffered more than any other human. There seems to be no reason to posit that El Greco was influenced in this kind of portrayal by the mystics, although he may have known John of the Cross.[196] The notion of a kind of ecstasy in suffering coincides with some of their teachings, but in this they were simply pushing to an extreme what was a common theme in Catholic piety; we have seen it in Michelangelo and others as well. In any case, the viewer seems to be invited to join in the exaltation of the vision of faith in Christ's triumph through self-sacrifice.

In a *Crucifixion* painted circa 1600–1605 (now in the Prado Museum, Madrid), El Greco takes up the traditional theme of the saving blood of Christ,

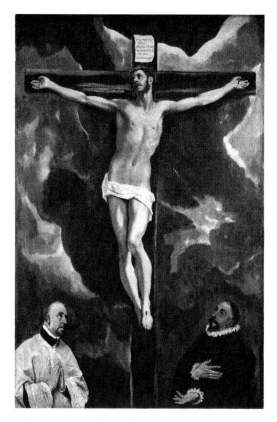

FIGURE 3.13. El Greco, *Crucifixion with Two Donors*, 1576–79. Musée du Louvre, Paris. Credit: Scala / Art Resource, New York.

which represents his sacrifice as now present in the eucharist. Although Jesus is dead, blood pours copiously from all his wounds and streams down his arms. In late medieval and Renaissance art, in such images an angel frequently collected the blood from the side of Christ in a chalice. Here three angels receive the blood from all his wounds in their hands and, in one case, a cloth (or could this possibly be a sponge, as is used in the Byzantine liturgy for purifying the chalice?) Mary Magdalene also wipes the bottom of the cross with a cloth. Manneristic elements abound. The angels are painted in a totally different scale from the other figures. The one at the bottom of the cross is shown bending backward, in an extraordinary exhibition of foreshortening. In contrast to the naturalistic bodies of the donors in the Louvre *Crucifixion*, all the figures here are extremely elongated. Christ's body is still, but radiant and majestic. Mary, with hands joined, seems to look up at Jesus with devotion as well as sorrow. John appears as though experiencing an ecstatic vision.

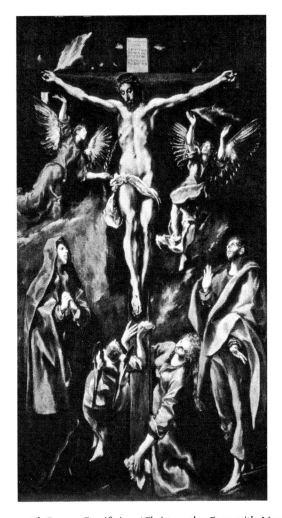

FIGURE 3.14. El Greco, *Crucifixion (Christ on the Cross with Mary, Mary Magdalen, John the Evangelist, and Angels)*, 1590–1600. Museo del Prado, Madrid. Credit: Scala / Art Resource, New York.

El Greco also painted several passion scenes that take place before the crucifixion. Probably the best known of these is *El Expolio* (the stripping of Christ; 1577–79). Jesus looks calmly and resolutely toward heaven as rough hands begin to strip off the bright red garment in which he is clothed. The mass of dark figures around him creates an atmosphere of tumult and violence. In the midst of it, Jesus is calm, above the storm, in communion with the Father. There is no need of a halo to show his divinity. In the background, we can see rays of light that shine down from heaven; but the brightness of

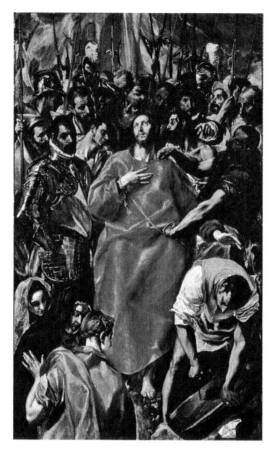

FIGURE 3.15. El Greco, *El Expolio* (The Despoiling of Christ). Cathedral, Toledo. Credit: Scala / Art Resource, New York.

Jesus might be taken to emanate from his figure itself. In the right foreground a man drills a hole in the crossbeam in preparation for receiving a nail, while at the left Mary and two attendant women look on.

El Greco also painted at least eleven versions of *Christ Carrying the Cross*. This was a traditional subject for narrative painting, but El Greco treats it in a more iconic way, giving a half-length or bust-length frontal portrait, in which Jesus is presented in his divine majesty. Despite the evidence of suffering (blood from the crown of thorns on his head), he lifts his eyes intently to heaven, and seems almost to embrace the cross rather than carry it. Light shines from behind his head; the somewhat irregular pattern creates a more visually dramatic emanation than found in the traditional round halo. The

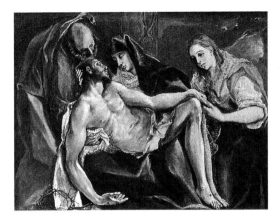

FIGURE 3.16. El Greco, *Pietà*. Private Collection.

exaltation of the figure encourages an imitative psychological exaltation on the part of the viewer in adoring Christ as savior and imitating his spirit.

An early *Pietà* (1574–76) seems to imitate features of Michelangelo's drawing for Vittoria Colonna. But here the Virgin's face shows more anguish as she looks toward heaven, and the angels have been replaced by apparently human figures, although they are unnaturally small in proportion compared to Christ and Mary. The figure of Christ is massive in its upper body, with very small legs and feet. A later *Pietà* (1580–90) shows El Greco's mature style. There are still elements that are reminiscent of Michelangelo, specifically the Florence and Colonna *pietàs*. The body of Christ, draped across Mary's lap, is white and gray in more than deathly pallor; this body is in a different sphere of existence from the others. (Curiously, however, the arm of Mary Magdalene has the same pallid color, as though infected by touch.) The wounds show red, and the side still drips blood. But the body is painted in swatches of color from which physical detail (like the veins, so prominent in other mannerist paintings) are eliminated. The contours of the body and limbs are disproportionate nearly to the point of abstraction. The exception is the face, which bears an almost theatrical nobility. Mary looks directly into it, with a meditative countenance.

The *Trinity* of 1577–79, in the Seat Of Mercy tradition, may also be accounted as a kind of *pietà*, but with God the Father in the place of Mary, and the heavens in place of the foot of the cross or the tomb. Such a non-narrative iconic image designates the eternal validity and acceptance of Christ's sacrifice. The scene "takes place" in heaven, mixing elements of pathos and glory: the Father's will for the salvation of humanity has been accomplished, at great cost. The Father's face is impassive and at the same time loving as it looks on Jesus' face; this is how it had to be, if humanity was to be saved, and Jesus has

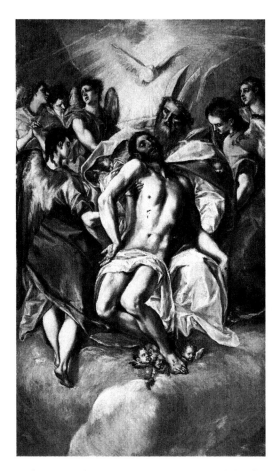

FIGURE 3.17. El Greco, *The Trinity*, 1577–1579. Painted for the convent church of Santo Domingo el Antiguo, Toledo. Museo del Prado, Madrid. Credit: Erich Lessing / Art Resource, New York.

performed the Father's will. The face of Jesus expresses complete calm, as though in peaceful sleep. The body of Christ here is modeled on images by Dürer and Michelangelo. The Holy Spirit, in the traditional form of a dove, of course expresses no human emotion, but floats over the scene in a background of gold as a sign of glory. Some of the angels express anguish; others are calmly meditative. Their reactions correspond to the different and ambiguous attitudes that are appropriate to the viewer meditating on the sacrifice of Christ. As theologians from St. Anselm to Savonarola had pointed out, the passion is the source of sorrow and joy: sorrow at the cost of our salvation to Christ, joy at the result for us.

COUNTER-REFORMATION ART

The Protestant Reformation has often been blamed for the "decline" of sacred art (where it survived at all) in northern Europe in the later sixteenth century; similarly the Counter-Reformation has been blamed for the decline of sacred art in the Catholic world in the same period. In both cases, religious art was frequently used for polemics and for propaganda, to which aesthetic values were subordinated. Whether this in itself must necessarily lessen art is a debatable point. In fact, however, the subjugation of religious art to doctrinal purposes frequently led if not to a decline in quality at least to a standardizing and conventionalizing of sacred art. In the judgment of one art historian, "Religious art assumed an official character and lost its intimacy, subjectivity, and directness. It came to be more and more dictated by liturgical considerations and less and less by personal faith, and thus led to modern 'church art,' the modern 'devotional picture' in the worst and most insipid sense of the word."[197]

As we have noted, the Council of Trent gave bishops responsibility for ensuring the appropriateness of church art. In the latter part of the century a number of treatises on painting were written by clerics to assist in this task. Among the more noted authors were Giovanni Andrea Gilio da Fabriano (1564), Carlo Borromeo (1577), Gabriele Paleotti (1582), and Jan Molanus (1619).[198] Giovanni Paolo Lomazzo, the greatest authority of his time in art, explicitly called for painters to submit to spiritual advisers in executing sacred art.[199] Obviously, the amount of control exercised by church authorities and theologians depended on individual artists and on their patronage. An all-embracing ecclesiastical direction of art, as in the Middle Ages, had become impossible; society had become secularized, and artists had become more independent.[200] Some artists, like Vasari, welcomed theological advice; in his sacred works he strictly followed the advice of the Dominican Vincenzo Borghini.[201] Similarly, Federico Zuccari actively sought theological direction in executing his religious commissions. Others, Benvenuto Cellini in particular, boasted of their independence of church patrons. Tintoretto was preoccupied with the problem of religious renewal, and his art was directly influenced by the spirit of Trent; Titian was apparently indifferent.[202] But despite the relative independence of some artists and the inconsistency of ecclesiastical control, by about 1570 a certain "official style" had become prevalent, at least in Rome.[203] This is often apparent if one compares the sacred and profane works of the same artists during this period.

We have seen earlier that the decadence of Renaissance art, including sacred art, was a major theme already for Savonarola. But if he found a lack of

religious spirit in the classically-inspired art of the early and high Renaissance, Borromeo and the bishops at the Council of Trent found religion even more lacking in Mannerist painting. It has sometimes been implied that this feeling was due to the philistinism or the aesthetic puritanism of churchmen concerned solely with a religious message, while ignorant or unappreciative of art. And perhaps this view is not entirely without basis. But it must also be recognized that as great an artist as Michelangelo was concerned with the same issue. Ironically, however, for some Counter-Reformation churchmen Michelangelo's own constant use of the nude and the contortion of his figures made him one of the worst offenders against propriety in sacred art,[204] while his intellectualism was thought to make his art difficult and inaccessible.[205]

One of the major features of the new sacred art would be a rejection of the artificial beautifications and elitist intellectual conceits of Mannerism:

> Mannerism is essentially formalistic, unrealistic, intellectual, difficult, complicated, and sophisticated, while the outlook of the Counter-Reformation is realistic and rational, its artistic bent is governed by instincts and sentiments, its sentiments are intellectually leveled, aimed at simplicity, clarity, and ease of understanding. Mannerist forms of expressions are affected, distanced, intended for an *élite*, while those of the Counter-Reformation are emotional, direct, and generally popular in tone. The Counter-Reformation rejected the wit, piquancy, ambiguity, and obscurity of mannerism chiefly because its way of expressing itself in veiled allusions, abstruse conceits, far-fetched associations and esoteric metaphors was unsuited to its objective of propagating the faith.[206]

The Counter-Reformation wished sacred art to be functional in the service of religion—just at the time when in the secular world art had become an end in itself. Giovanni Andrea Gilio wrote that the simple truth of a wooden cross was more conducive to religious values than richness of ornament and artistic excellence. Nevertheless, he did not wish to reject artistic values altogether. Sacred art should seek to be a *regolata mescolanza* (ordered mixture) of beauty and piety, with neither the crudeness of earlier art nor the excessive artistry of the Mannerists.[207]

We may discern several tendencies in Catholic art of the post-Tridentine period that attempted to redress the perceived faults in early Cinquecento art and especially in Mannerism: 1) purposeful archaism, i.e., the return to pre-Renaissance models; 2) the influence of scholarship, especially of the paleo-Christian movement; 3) concern for doctrine above artistry, and the use of art as

a means of education, indoctrination, and propaganda; 4) popular appeal and affectivity in art; 5) the valuing of visual naturalism, in contrast with both idealism and expressionism; and 6) polemical concentration on certain contested dogmatic themes. Obviously, these tendencies are found in different mixtures and to different degrees in the art of the period. Indeed, their adoption was to a certain extent the result of a combat of post-Tridentine theologians and bishops against the prevailing spirit in art, and it took some time for the reforming spirit to achieve its victory.

ARCHAISM. In our discussion of Fra Angelico we noted that the Friar's concern for the spiritual message of his paintings seems to have led him to a purposeful and conscious retention of certain features of medieval painting. As the Cinquecento progressed, an archaizing taste in art often accompanied the preoccupation with reform, "a preoccupation that is by definition backward-looking. The idea of renovation went hand in hand with the idea of returning to an earlier age."[208] Hieronymus Esmer, writing in 1522 against Karlstadt, concedes some of the iconoclast's points about sacred art; but he considers that the misuse of art that had become prevalent was not a reason for its abolition. In particular, he defends the "simple images" of the past. They were crafted as they were, says Esmer, way not because of lack of skill, but because the faithful preferred to spend on the poor the money that was now lavished on art, and because "the more artfully images are made the more their viewers are lost in contemplation of the art and manner in which the figures have been worked" rather than in subject matter.[209]

Michelangelo's close friend Vittoria Colonna in one of her poems goes so far as to say that lack of artistry in early paintings of the Madonna ascribed to St. Luke was a sign of their spiritual depth.

In parte finse l'aer dolce e grave;	In part [this style] created a sweet and serious atmosphere;
Quel vivo no l'mostro, forse sdegnando	It was not lifelike, perhaps disdaining
De l'arte i gravi lumi e la fiera ombra;	The sharp lights and proud shades of art;
Basta che l'modo umil, l'atto soave,	It is enough that the humble style, the sweet performance,
A Dio rivolge, accende, move, e quando	Turns [us] toward God, enflames and moves [us], and when
Si mira il cor d'ogni altra nebbia sgombra.[210]	One looks at it the heart is relieved of every other shadow.

Colonna was an early patron on the new Capuchin order, and their religious aesthetic became marked by a preference for archaism.[211] Michelangelo himself purposely returned to earlier models in his sacred art,[212] although their influence was more in content and spirit than in style or technique. It is significant that Vasari, in his 1550 edition of the lives of the artists, singles out Fra Angelico for special praise precisely because of the devoutness of his art. The Dominican theologian Giovanni Andrea Gilio, writing in 1564, praised the old images "which to modern eyes look vile, awkward, lowly, old, humble, without skill or art" as being *imagini oneste e devote*, "honest and devout images."[213] He also lauds the use of frontal images in sacred painting, as in portraits; a device that, in the case of sacred subjects, makes the image more iconic, more a medium for evoking personal presence than a pure exercise in artistic skill.

THE INFLUENCE OF SCHOLARSHIP. At the same time, the critical spirit of the humanists and their concern for the Scriptures were also appropriated within the church. Knowledge of the classics led to increased interest in ancient Christianity. The paleo-Christian revival was reinforced by the rediscovery of the catacombs in 1578. The archeologist Baronius and his disciples in the Roman Oratory began to publish their research on the catacombs in 1588. In 1599 the body of the martyr Saint Cecilia was found, becoming the source of much inspiration.[214] Scholarship on the ancient church led to the critique of certain artistic traditions that were based on legend or that were not true to the sources. To a certain extent it reinforced the tendency to archaism. At the same time, it implied a certain empirical spirit.

CONCERN FOR DOCTRINE. Like Luther, the post-Tridentine church embraced the use of art as a means of education, indoctrination, and propaganda. The founders of the new orders and congregations—the Jesuits, Capuchins, Theatines, and Oratorians—thought of art as a good means of expressing the Catholic faith and attracting the common people.[215] For this reason, there was often a preference for art that was simple, clear, and easily understood, in contrast to the complex and élitist art of the Mannerists.

However, we can discern two different tendencies in Counter-Reformation art, sometimes in combination and sometimes in tension with each other. On the one hand, there was a desire for art that is affective and emotionally appealing; on the other hand, there was a preference for art that is naturalistic, realistic, and directly illustrative of a doctrinal message.

POPULAR APPEAL AND AFFECTIVITY. In scholastic rational psychology, it was thought that an emotional response would affect the will, which was the faculty

directly involved in faith and love. It was thought that sweetness and affective appeal in art would lead a person to be attracted to the persons and the values pictured, and hence to conversion of the will.

Such affective art was preferred especially by the Theatines and Oratorians. The influential Dominican writer Giovanni Andrea Gilio also called for greater affectivity in art, and complained of the coldness of much religious painting.[216] A major contributor to the development of a sweet, emotional religious art was Federico Barocci (1535–1612). St. Philip Neri, the founder of the Roman Oratory, commissioned him to paint the *Visitation* in the order's church, the Chiesa Nuova. Not surprisingly, Barocci's preferred themes included scenes with the Virgin and Christ child. His portraits of a charming young Madonna and radiant Christ child—which decorate many a Christmas card—are a good example of the affective style. His *Deposition* (1569) in the Duomo of Perugia, with its heroic Christ and its sweet-faced fainting Madonna, is his major work with a passion theme. Annibale Caracci's *Crucifixion* of 1583 is unabashedly emotional in appeal. Jesus' body radiates light, while the Virgin and saints present at the scene look upward with adoration and make expressive gestures. Similar affectively charged images are found in the *pietàs* of the period. We may cite in particular those of Caracci, Tintoretto, and Pulzone, which we shall mention in our discussion of Mary in the passion.

VISUAL NATURALISM. In contrast with purposely affective art was a more narratively oriented painting that was essentially used for the illustration of words, rather than as an independent and self-standing mode of knowing or expression. Here the goal was naturalism and narrative realism—truth, rather than beauty, charm, or sweetness. If there is emotional appeal, it is more to feelings of courage, exaltation, determination. This sort of painting was especially seen in the so-called "Jesuit style" in art.

As we have seen, Ignatius did not provide images, even mental ones, for those engaged in his "exercises," but left this task to the creative imagination of each person. However, he praises sacred images in general,[217] and it was not long before an illustrated edition of the *Exercises* was produced. Jerónimo Nadal (1507–1580), a companion of Ignatius, designed a book of illustrations of the gospels for the use students with over a hundred and fifty prints by the Dutch artists Jerome and Johann Wiericx (or Wierix).[218] This was expanded to include the text of the *Exercises* interspaced with the illustrations. These prints have several notable features. In accord with their didactic function, they list the Scripture passages that the picture illustrates. Moreover, important elements in each picture are labeled with letters which correspond to a caption printed below, telling the reader exactly what is being shown, that is,

connecting the picture with the narrative and the major points of meditation. (Such captions were used also in the painting cycles in the Jesuit-run seminaries in Rome.[219]) It is notable that despite Ignatius's emphasis on Christ's sorrow and suffering, the figure of Jesus in these illustrations is clearly divine, with rays of light proceeding from his head, a classical and graceful body, and a countenance that shows transcendence of suffering rather than immersion in it. (This is of course in line with the theological idea that the "upper" part of Christ's soul was constantly in the "beatific" presence of God, and that he uttered no complaint during his passion. However, it seems somewhat in tension with Ignatius's stress on Christ's sorrow and pain, in which he was nevertheless, in the words of Isaiah commonly applied to the passion, "silent as the lamb before the shearers.")

In the later part of the Cinquecento, the example of the ancients was one factor that led to an admiration for naturalism, particularly in painting. But

FIGURE 3.18. Jerome Wierix, *Arrest of Jesus*. Bibliotheque Nationale, Paris. Credit: Snark / Art Resource, New York.

visual naturalism was also seen to be the presentation of "truth." It is for this reason that Bellarmine explicitly endorses naturalism in painting. [220] A rising appropriation of a common-sense empiricism found itself opposing the anti-naturalism of early and mid-century art in both the idealism of High Renaissance classicism and the (somewhat overlapping) expressionism of the Mannerist style. (We shall return to this tension in considering specific works and styles of the period.)

Dominican critic Giovanni Andrea Gilio, arguing that the purpose of sacred art is primarily to convey a clear spiritual message, denounces the artist's concern for the beauty of the picture above all other values. He specifically laments the prevalence of a beautiful Christ in paintings of the passion. He complains of painters "who do not know or do not want to know how to express the deformity evident in [Christ] at the time of the Passion." "It would be a stronger inducement to devotion to see him bloody and misshapen, than to see him beautiful and delicate." It is appropriate to show Christ glorious in his resurrection, ascension, etc.; but "in the flagellation, *Ecce Homo,* crucifixion, deposition, and entombment let him be shown bloody, ugly, misshapen, afflicted, ravaged, and dead." By portraying Christ's suffering realistically, art can lead us to see his extreme humility and love. But artists, Gilio complains, resist such naturalism. "Many times I have discussed this with painters, and all with one voice they responded: 'Painting does not allow it; it would go against the decorum of art.' "[221] However, a new emphasis on naturalism did in fact begin to appear in the art of the passion, particularly those commissioned by the Jesuits; and by about 1600, with the art of painters like Carracci and Caravaggio, a new classicism and naturalism had triumphed.

POLEMICAL CONCENTRATION ON CONTESTED OR THREATENED DOGMATIC THEMES. The reaction against Protestantism eventually affected the themes and the mood of Catholic religious art. Art begins to be involved in struggle against heresy; it is no longer serene and balanced, like the art of the early Renaissance, but is ardent, impassioned, partisan, engaged in struggle.

Emphasis was placed on doctrines and ideas that the Reformers denied, or were thought to deny: the primacy of Peter, and hence of the Pope; Mary, and especially her immaculate conception and her place in redemption; purgatory; prayers for dead; the battle of angels and devils; martyrdom; the sacraments, especially penance; the body of Christ present in the eucharist; the works of charity; the cult of the saints; the efficacy of relics. Both Protestant and Catholic reformers attempted to restore emphasis on Christ's sacrifice, "in opposition to the quasi-polytheistic saint worship of the late Middle Ages."[222] But for Tridentine Catholicism this did not mean elimination of the cult of the saints or

of Mary; on the contrary, they were all the more held up as examples of the personal transformation and the collaboration with Christ's grace that all Christians are called to.

The cross of Christ was seen as implying the cross of the Christian. This was of course also true in Protestantism. But in opposition to the Protestant doctrines of predestination and "grace alone," Catholic theology emphasized free will and human responsibility. In the spirit of Erasmus's *Enchiridion*, meditation on the passion was seen as a means for overcoming sin and vices, and as a call to virtue.[223] The cross conveys a message about the human task of collaboration in the salvation of the world and the suffering that witness to the faith involves. The saints, especially the martyrs, were seen as exemplars of the exalted and heroic embrace of the cross effected by the triumph of grace even here on earth. Gabriele Paleotti, in his *Discorso intorno le immagini sacre* (*Discourse Concerning Sacred Images*) of 1582 writes: "If we see the martyrdom of a saint rendered in lively colors without being shattered by it, if we see Christ being fastened to the cross with dreadful nails, we must be of marble or wood if we do not feel deeply moved, if our piety is not stimulated afresh and our inner being is not deeply affected by remorse and devotion."[224]

Early Jesuit painting cycles emphasize the model not only of Christ's example in suffering his passion, but also the cross in the lives of the saints. The Jesuit novitiate in Rome was decorated with gruesome scenes of martyrdom, as were also the German College, founded by St. Ignatius, and the English college, which was run by the Jesuits, and whose students, when they returned to England, often faced the same fates that they saw pictured on the walls. (Naturally, in Germany there were also prints of the persecuted Protestant martyrs; but the Catholic devotion to the saints allowed a wider scope for the use of such scenes.)

THE SECULARIZATION OF THE TRANSCENDENTAL

A result of the turn to naturalism in late sixteenth-century religious art was what Walter Friedlander calls "the secularization of the transcendental": "if the religious element is transposed into the realm of the existing and actual, then the distance between them is abolished and religion comes close to the world... Worldly things are then permeated with religion, with other-worldly aspects... Hence religious art could well become realistic, as long as it was saturated with religion."[225]

The permeation of the world with the sacred was precisely the goal of the new religious orders, especially the Jesuits. In the realm of sacred art, however, the empirical naturalism of Counter-Reformation art carried with it certain

dangers, both theological and aesthetic. This was especially the case because naturalism was combined with an emphasis on doctrine, heavy emotional content, and a desire for popular appeal. In religious art naturalistic forms are used to express something beyond nature; the empirical is used to express the spiritual. But how can naturalistic art express the "supernatural" or sacred quality of what is portrayed? In expressionist forms of art, whether Romanesque or Mannerist, the style itself proclaims its symbolic function; the purposeful artificiality of the forms points beyond them to an invisible or intellectual reality. In the high Gothic style and in Renaissance classicism it was the idealization of nature and humanity that served the same purpose: there was no need to place a halo around the head of Michelangelo's Christ; the beauty of his form proclaimed his divinity. But when the supernatural is portrayed as an element in the empirical world, there is a danger that it may become reduced to the secular, rather than transforming the secular. Naturalism may be taken as a kind of religious empiricism, in which the "ontological difference" between the divine being and the world is forgotten, and God is reduced to an element within the cosmos. Theologically, this might signify the loss of a genuinely transcendental notion of the analogy of being, and its replacement with an implicitly nominalist or "common sense" notion. At the same time, there is a threat to the genuine secularity of the world, since it is seen as something to be incorporated into the sphere of religion; there is a mistaken identification of the holy with the religious. Aesthetically, there is the danger of religious kitsch; the sacred becomes identified with an idealized sweetness or conventionalized prettiness, producing a "holy card" type of art.

MARY IN THE PASSION

Counter-Reformation spirituality placed a great deal of emphasis on Mary. But there were ambiguities concerning how she should be portrayed in her role in the passion. On the one hand, there was a tendency to reinforce traditional piety, which from the late Middle Ages on had particularly emphasized her suffering and invited compassion with her. The Jesuit turned Franciscan Juan de Cartagena exemplifies the tendency to expand Mary's role in the passion. In his homilies he depicts how after the deposition from the cross, Mary closed the eyes of Christ. Removing the crown of thorns, she wounded her fingers, and mixed her blood with his, and then took his body to her breast.[226]

On the other hand, critical scholarship and increased attention to the texts of Scripture tended to lead in the opposite direction. The Council of Trent had condemned artworks that propagated "erroneous" doctrine. Some theologians applied this idea very strictly, rejecting anything in art that could not be found

in Scripture or in official church teaching. (As we have seen, Veronese and El Greco were criticized for including in paintings figures who were not mentioned in Scripture).

Since the Scriptures say little about Mary (as compared to the many legends and traditions), the application of a "historical" (i.e., Scriptural) criterion could have serious effects on art. For example, there is no mention in the Scriptures of the presence of Mary at the deposition of Jesus from the cross or at his burial, let alone of a *pietà* scene. Late medieval and early Renaissance artists frequently portrayed Mary sitting in agony at the foot of the cross, or even fainting. Now this seemed improper. The influential Jesuit theologian Jeremias Drexel wrote: "Does the Gospel say that the Virgin was sitting down, or that she was lying at the foot of the cross? No; it says that she stood, *Stabat.*"[227] Theologians repeated the words of St. Ambrose about Mary at the foot of the cross: *Stantem illam lego, flentem non lego,* "I read [in the Scriptures] that she stood; I do not read that she wept." In Rome, several paintings were removed from churches because they showed Mary fainting. The Master of Sacred Palace refused permission to engraver Abraham Bloemaert (1564–1651) to print a copy of a painting by Annibale Caracci (or Carracci; 1560–1609), because it shows the Virgin lying at the foot of the cross.[228]

In place of the sorrowful and weeping Mary who appeals to our sympathy and compassion, one branch of the Catholic reform movement and the Counter-Reformation proposed Mary as a model of virtue and collaboration with Christ. Even Savonarola, for all his emphasis on compassion with Mary, had written that her grief was tempered by her knowledge of outcome of the passion, and complained about those who would think of Mary simply as a grieving mother.[229] In 1506 Rome permitted the extension of the liturgical feast of the "Sorrows of Mary" to the nuns of the Annunciation, under the title *Spasmi Beatae Mariae Virginis,*" "the fainting (or convulsions) of the Blessed Virgin Mary" [i.e., at the foot of the cross].[230] But when in that same year Pope Julius II considered extending such a feast commemorating Mary's sufferings at the passion to the whole church, he was dissuaded by the Dominican cardinal Cajetan, who argued that Mary was ruled by reason, and would not have swooned with grief at the foot of the cross.[231]

Marian theologians of the Counter-Reformation tended to espouse and expand on Cajetan's view, which was in accord with the Fathers and the more ancient iconic tradition. Mary's attitude at the passion was dignified and noble; she looked with gratitude on wounds of her Son, because she knew they were the salvation of the world.[232] Moreover, Catholic theology of the period almost universally accepted the idea of Mary's Immaculate Conception. Although the special status this bestowed was not held to exempt her from pain or sorrow,

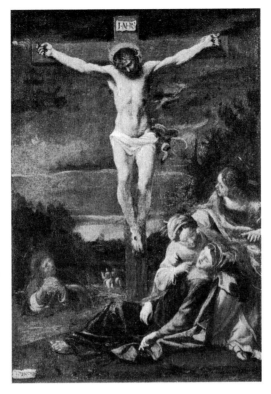

FIGURE 3.19. Annibale Caracci, *Christ on the Cross*, 1594. Gemäldegalerie, Staatliche Museen zu Berlin, Berlin. Credit: Bildarchiv Preussischer Kulturbesitz / Art Resource, New York.

it meant that she was free from the rule of passion and gifted with original holiness. Hence, as Cajetan implied, excessive or irrational grief would be unbecoming to her, while willing collaboration in her Son's work for humankind's salvation would befit her.

A full discussion of the genres of the *pietà* and lamentation in the art of this period would need a volume to itself. Here we can only mention a few examples of the opposed ways of presenting Mary in such scenes.

The portrayal of the position of the bodies of Mary and Jesus in the *pietà* genre follows two major patterns. From its beginnings in the Middle Ages, the image had generally placed Christ on the knees of Mary. This obviously had spiritual and mystical significance; it purposely evoked the image of the infant on his mother's lap (which in turn usually contained some symbolic reference to the passion). A number of Renaissance artists follow this tradition (Michelangelo in his Rome *pietà*; also Vasari, and Pulzone in his 1591

Lamentation). Others, however, place Christ's body on the ground, with his torso leaning against Mary (for example Correggio, in his painting of 1522).[233]

More significant are the opposed ways of presenting Mary's psychological and spiritual attitude. Many artists present Mary as an example of nobility, devotion, and faith as she holds the sacrificed body of Jesus, which she recognizes (as the viewer does) as the means of the world's salvation. Grief and suffering are subordinated to the theological meaning of Jesus' passion, which Mary grasps and collaborates in. We have already discussed Michelangelo's versions of the *pietà*, which present Mary as a figure of dignity. The stress is on her faith and self-abandonment to God. In the crucifixion drawings the artist presents Mary with conventional gestures of pathos; but even here there is classical restraint. In the 1523 *Pietà* by Andrea del Sarto, all the participants, including Mary, look on with gentle devotion; at the bottom forefront are the host and chalice of the eucharist, making clear the theological meaning of the scene. Bronzino (Agnolo di Cosimo, 1503–72) gives two versions of the *Deposition* (1545 and 1565). One is iconic and non-historical, with Christ on the

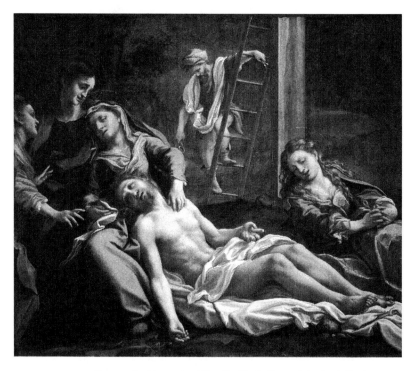

FIGURE 3.20. Correggio (Antonio Allegri), *Pietà* (Deposition). Galleria Nazionale, Parma. Credit: Scala / Art Resource, New York.

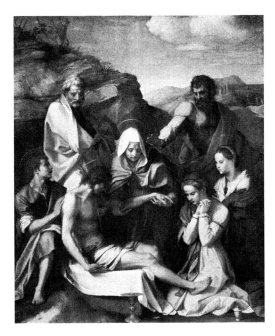

FIGURE 3.21. Andrea del Sarto, *The Deposition*, 1523–1524. Galleria Palatina, Palazzo Pitti, Florence. Credit: Scala / Art Resource, New York.

lap of Mary, who looks devoutly at his face while angels hold the instruments of the passion. The later version is in a narrative context. Here Mary looks up to heaven, with Christ's arm on her lap. Annibale Carracci (1550–1604) in his *Pietà* (1599–1600), a timeless non-narrative scene with angels, shows Mary as a woman of beauty, expressing dignified sorrow, gesturing with her hand in a manner that recollects Michelangelo's Rome *pietà*.

On the other hand, there are many works that appeal to the emotional impact of the vision of the grieving mother, stressing Mary's sorrow, and presenting her as an object (and presumably a model) of compassion. We have seen that the *Entombment* by Pontormo and the *pietà* of Rosso Fiorentino both fall into this category; the latter in particular contains a dramatic and direct appeal to the viewer by Mary. A number of paintings illustrate the *spasmi*, convulsions or fainting, that Cajetan objected to. In Correggio's *Deposition from the Cross* (1525) Mary holds the head of Christ in her lap, while her head falls back onto the shoulder of John. In a *Deposition* (1541) by Daniele da Volterra (Danielle Ricciarelli, 1509–1566), Mary lies prone at the foot of the cross. Similarly in two versions of the *Descent from the Cross* (1556 and 1559) by Tintoretto (Jacopo Robusti, 1518–1594), Mary lies in a faint; in the first, at the foot of the cross as the body is removed, in the second bearing Christ's legs on

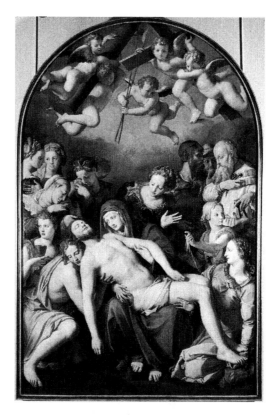

FIGURE 3.22. Agnolo Bronzino, *The Deposition*. Photo: Bulloz. Musee des Beaux-Arts. Credit: Réunion des Musées Nationaux / Art Resource, New York.

her lap on the ground. In the same artist's *Entombment* of 1592 she is portrayed fainting in the background as the body of Jesus in lain in the tomb in the foreground. In Annibale Carracci's *Lamentation* (1604–1605) Mary lies next to Christ with eyes closed, pale and corpse-like, parallel to her dead Son; in his *Descent* (1606) she lies unconscious on the ground.

The Passion in Music

SACRED MUSIC IN GENERAL

The sacred music of the Cinquecento in general reacted against the intricacies and discordances of the earlier "Flemish" style. In music as in painting, a trend toward simplicity and clarity was fostered by the decrees of the Council of Trent, which forbade "lustful and impure" elements in ecclesiastical music and condemned the "sensualism" of sacrificing religious meaning in favor of

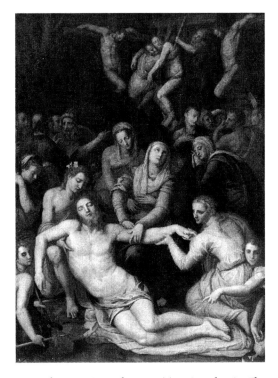

FIGURE 3.23. Agnolo Bronzino, *The Deposition*. Accademia, Florence. Credit: Alinari / Art Resource, New York.

sensible pleasure, losing the sense of sacred texts by placing them in intricate musical settings. Some bishops at the Council favored the idea of a return to chant alone for the celebration of the liturgy, forbidding all polyphony. There is a story that Palestrina (Giovanni Pierluigi da Palestrina, 1525?—1594) quickly composed his famous *Missa Papae Marcelli* in order to dissuade the bishops at the council from this radical step by showing that polyphonic music could serve the liturgical texts with clarity as well as beauty and elevated feeling. The story is apocryphal, since the Mass dates from after the council, but it might be taken as a symbol for what did occur in church music as a result of Trent's decrees. In 1564, pope Pius IV appointed a commission of cardinals to attempt a reform of church music. In 1577 Gregory XIII continued this work, employing Palestrina and Annibale Zoilo to revise the collections of chant and remove the "errors" from them. Palestrina gave the example of conveying above all the sense of the words that were to be sung; decorous polyphony was used not to draw attention to itself, but to produced elevated feeling; harmony rather than artful dissonance prevailed.

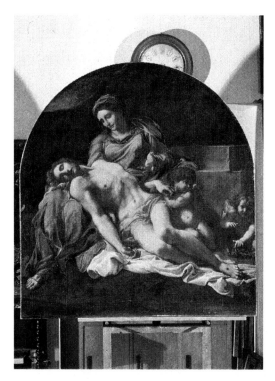

FIGURE 3.24. Annibale Caracci, *Pietà*. Museo Nazionale di Capodimonte, Naples. Credit: Scala / Art Resource, New York.

SETTINGS OF THE PASSION IN THE HOLY WEEK LITURGY

The primary context for Catholic passion music was the Holy Week liturgy. The passion according to Matthew was traditionally chanted on Palm Sunday; Luke's version was sung on Wednesday of Holy Week, John's on Good Friday. The passion story was often simply chanted, with three clerics taking the main parts; but increasingly in the Renaissance polyphony was introduced as well. (There were also some extraliturgical settings based on a harmony of the four gospels.)

The "choral" type passion was most widely used in sixteenth century Italy. This generally meant that the bulk of the narrative was sung in the traditional chant style, with clergy taking the solo parts of the narrator and Jesus, but with the part of the *turba* or crowd set in polyphony and sung by a choir. However, the words of Christ were also sometimes set in polyphony. Examples are found in the passion settings of Giovanni Matteo Asola (1532–1609), and Francesco

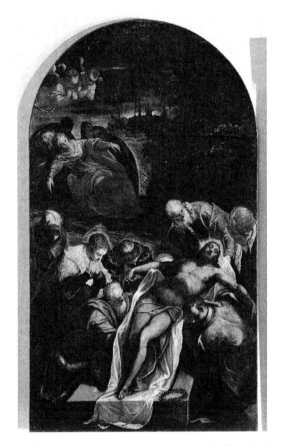

FIGURE 3.25. Tintoretto, *Entombment*, 1593–1594. S. Giorgio Maggiore, Venice. Credit: Cameraphoto / Art Resource, New York.

Soriano (1548–1621). Occasionally sung meditations were added to the gospel text, as in the *St. John Passion* (1527) of Francesco Corteccia (1504–1571).[234]

The Flemish composer Orlando di Lasso (Orlandus Lassus, 1534–1594) frequently substituted his own original melodies for the liturgical ones, and sometimes used a chorus not only for the crowd (whose part is always set in five-part polyphony), but also for texts spoken by a single character.[235] The great Spanish composer Tomás Luís de Victoria (ca. 1548–1611), working after Trent's reform, retained plain chant for single persons in the narrative, and makes the same chants serve as *canti fermi* (the melody on which the polyphony is based) for the ensemble in the *turbe*.[236] Of particular interest both because of its beauty and its context is the choral Passion (chant with polyphonic *turbe*) by William Byrd (ca. 1543–1623). A Catholic working in

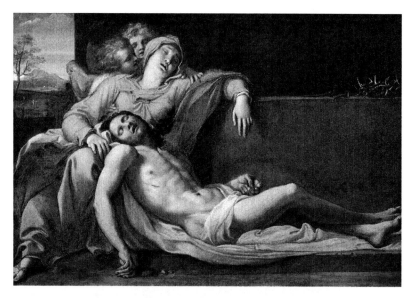

FIGURE 3.26. Annibale Caracci, *Pietà* (*Lamentation*), ca. 1603. Kunsthistorisches Museum, Vienna. Credit: Erich Lessing / Art Resource, New York.

the England of Elizabeth I, Byrd composed music for Catholic services then forbidden. Since his works could only be performed in underground secret services, presumably with few resources available, they employ a remarkable economy of means and yet achieve great power in their simplicity.[237]

Although less common than the "choral" passion, the through-composed or "motet" passion (in which the entire text, including the narrator's role, was set polyphonically) had been created already by composers of the fifteenth century (Jacob Obrecht, for example). An interesting variant was developed by the Franco-Flemish composer Cipriano de Rore (ca. 1515– ca. 1564)[238] in his *St. John Passion*, written in midcentury (sometime between 1544 and 1557). De Rore abandons the motet form, in which the music is internally undivided, and instead differentiates the roles of the narrator, Christ, the crowd, and the individual characters by giving each its own polyphonic form: the narration in four parts, Christ in three parts for low voices, the *turbae* in six parts, and the individual roles in "dialogue" form for two voices. At the same time, the polyphony here differs from the "madrigal" (freely-composed) style in that it remains closely tied to the original Gregorian melodies. Indeed, the polyphony of the narrator's part is essentially an ornamentation of the chant. The rhythm of speech is kept throughout, giving an essentially narrative character to the work, with emphasis added in the dialogue sections.

OTHER PASSION SETTINGS: MOTETS AND ORATORIO;
THE STABAT MATER

In addition to the passion itself, the "Lamentations" of Jeremiah, which were taken as prophecies of Christ's suffering and death, were sung during the last three days before Easter. The Good Friday liturgy also contained the great hymn to the cross *Crux Fidelis*. All of these were subjects for polyphonic musical settings by some of the great musicians of the Cinquecento.[239]

The Cinquecento was the period of the greatest flourishing of the motet, the Latin counterpart to the vernacular "spiritual madrigal," which was in turn a generally more restrained counterpart to the secular madrigal. (While the madrigal, secular or sacred, was freely composed, not based on a preexisting chant, motets frequently took a liturgical chant melody as the base line on which the polyphony was built. The motet was also distinguished by having a Latin rather than vernacular text.) Motets and spiritual madrigals frequently took their texts from liturgical antiphons or sacred poems. A number of them explicitly deal with passion themes, for example, Orlando di Lasso's meditation *In Monte Oliveti*.[240]

In Lasso, as in Mannerist music in general, certain conventions in counterpoint and melody are used to represent various rhetorical figures and thus evoke different affects. In Mannerist theory, the music was intended to "imitate" the words (*imitar le parole*). At its extreme, Mannerist music could be similar to Mannerist painting in being highly "artful" and intricate; a tendency that brought a reaction from the bishops at Trent. Lassus, however, does not allow the art of his music to take over; he gives primary importance to clear rendering of the words of the text. Most hearers would be affected only subliminally by the musical codes used to associate the music with rhetorical conventions; only cognoscenti would be explicitly aware of them. For the ordinary hearer, the function of the polyphony is to beautify the word; its "illustration" of them is subtle rather than theatrical, although even the musically uneducated listener can be moved by certain dramatic emphases. The elevation of the spirit produced by the music is as it were a complement to the sense of the words. The sense is received from the words themselves; the music puts them in a context that is like a halo surrounding them—analogous to the gold background, solemn postures, and expressive gestures of medieval sacred paintings, even of the passion. The ultimate context of such sacred art is beauty, which is permissible and indeed necessary because of the message of God's majesty and victorious love.

Of particular interest for our theme is Lasso's last great work, finished only six weeks before his death, the set of twenty "spiritual madrigals" that comprise the dramatic meditation *Lagrime di S. Pietro* ("Tears of St. Peter").[241]

Based on a poem by Luigi Tansillo (died 1568), the *Lagrime* madrigals recount at length the remorse felt by Peter when he recognizes the enormity of his betrayal of Christ after the latter's arrest. The first two verses set the context for the dramatic unfolding of the apostle's repentance. The poet expands on the gospel passage Lk. 22:61, in which we are told that Jesus looks at Peter just as the cock crows while Peter is denying knowledge of the Lord. In the poem, the remembrance of this look remains a source of life-long sorrow for Peter.

Il magmanimo Pietro, che giurato	Great-souled Peter, who had sworn
Havea tra mille lancie, e mille spade	That amidst a thousand spears and swords
Al suo caro Signore morir a lato,	He would die beside his dear Lord,
Poi che s'accorse vinto da viltade	When he realized that, overcome by cowardice,
Nel gran bisogno haver di fe mancato,	He had failed to keep faith in the moment of great need,
Il dolor, la vergogna, e la pietade	Sorrow and shame and pity
Del proprio fallo, e de l'altrui martiro	For his own failure and for Christ's suffering
Di mille punte il petto gli feriro.	Wounded his breast with a thousand sharp darts.
Ma gli archi, che nel petto gli avventaro	But the bows that shot into his breast
Le saete più acute e più mortali,	The sharpest and deadliest arrows
Fur gli occhi del Signor quando il miraro;	Were the eyes of the Lord when they looked at him;
Gli occhi fur gli archi, e i sguardi fur gli strali	The eyes were the bows, and his glances were the arrows
Che de cor non contenti seri passaro	That, not content with piercing his heart, passed
Fin dentro a l'alma, e vi fer piaghe tali,	Through to his soul, and there created such wounds
Che bisognò mentre che visse poi	That as long as he lived thereafter, he had to
Ungerle col licor de gli occhi suoi.	Annoint them with the balm of his tears.

The poem presumes that Peter was an old man (*il miserabil vecchio*, v. 5) at the time of the passion, who carries with him the searing impression of Christ's look for the rest of his life. The poem concentrates on remorse, rather than

forgiveness. We are told that "the King of Heaven" immediately restored Peter to the grace he had lost by his betrayal (*immantenente a la perduta gratia il ritornasse*—v. 11), and we are told that Peter saw in Christ's eyes words full of love as well as indignation (*parole di sdegno e d'amor piene*). But the strong emphasis in the poem is on a message of reproach.

Più fieri (parea dir) son gli occhi tuoi	"More cruel" (He seemed to say) are your eyes
De l'empie man, che mi porranno in croce;	Than are the impious hands that will place me on the cross;
Ne sento colpo alcun, che sì m'annoi	Nor do I feel any blow, of all those
Di tanti, che'l reo stuolo in me ne socca,	That the guilty crowd inflicts on me, that grieves me more
Quanto il colpo, ch'uscio de la tua bocca.	Than the blow produced by [the words of] your mouth."
Nessun fedel trovai, nessun cortese	"I found none faithful, none gentle,
Di tanti c'ho degnato d'esser miei;	Of all those I deigned to make my own;
Ma tu, dove il mio amor via più s'accese,	But you, toward whom my love burned so much more brightly,
Perfido e ingrato sovra ogn'altro sei:	Are treacherous and ungrateful above every other:
Ciascun di lor sol col fuggir m'offese,	Each of them offended me only by fleeing,
Tu mi negasti; ed hor con gli altri rei	But you have denied me; and now, with the other guilty ones,
Ti stai a pascer del mio danno gli occhi,	You remain to feast your eyes on my suffering,
Perche la parte del piacer ti tocchi.	Because you choose ease for yourself."

There is here a good deal of psychological insight into the admission of guilt as a step toward conversion and repentance. The fear in Peter's heart is likened to a snowflake that lies hidden and frozen all winter, but melts with the spring sun of Christ's glance:

Così la tema, che entro al cor gelata	Thus the fear that was frozen within the heart

Era di Pietro allhor, che'l vero tacque,	Of Peter, and made him silence the truth,
Quando Christo ver lui gli occhi rivolse	When Christ turned his eyes toward him
Tutta si sfece, e in pianto si risolse.	Entirely melted, and was turned into weeping.

The poem leaves Peter in a state of such remorse that he rejects life itself. "Life, that before he cared for so much, now he hates above all . . . and, because it made him sin, he wishes it no more" (v. 14). Yet he refrains from killing himself for fear of a yet greater sin (v. 14). In reflections that may owe more to pagan Roman thinking than to Christianity, the Peter of the poem renounces the cowardice that caused him to fear death, and considers that an early death might have been better than living to betray his Lord: "My faith would not have found such a hard obstacle if you [life] had not been with me so long . . ." (v. 18). The last madrigal verse expresses a desire for death, combining with repentance a Platonic philosophical disdain for life itself, because it is illusory: "Depart, vain life, and quickly disappear; since I denied the true Life, I do not desire the shadow" (v. 20).

The last section of the work, following the twenty madrigals, is a Latin motet. It makes no direct reference to the remorse of Peter, but is an imaginative presentation of a discourse of Christ himself addressing us from the cross. Implicit is the idea that we, like Peter, have betrayed Christ, and are being called to similar tears of repentance. The text stresses the suffering of Christ. But, as in the meditations of Savonarola, the primary cause of this suffering is our ingratitude, humanity's lack of response to this great act of self-sacrifice.

Vide homo, quae pro te patior	See, O man, what I suffer for you
Ad te clamo, qui pro te morior.	I cry out to you, I who die for you.
Vide poenas, quibus afficior	See the pains with which I am afflicted
Vide clavos, quibus confodior!	See the nails with which I am pierced!
Non est dolor, sicut quo crucior?	Is there any suffering like that of my cross?
Et cum sit tantus dolor exterior,	And while my physical suffering is so great,
Intus tamen dolor est gravior,	Yet my inner suffering is worse,
Tam ingratum cum te experior.	When I experience your ingratitude.

A number of features of the Counter-Reformation spirit mark both the poem and its setting. It is taken for granted that the cross of Christ is the means and price of redemption; but the primary message is about the need for human transformation in response to it. The Counter-Reformation, even while affirming the sufficiency of Christ's "satisfaction" for our sins, opposed the Lutheran concept of salvation by "faith alone" (as they understood it) by stressing the need for genuine conversion and meritorious works. In the passion story, an exemplar for such conversion, change of heart, and subsequent mission, could be found in the person of Peter. On the one hand, he represents every Christian, standing in the need of conversion, repentance, and penance. On the other hand, the emphasis on Peter was also an implicit reminder of the claim of his "successors" in Rome. Lasso's lengthy work, featuring a dramatic portrayal of Peter's feelings, in some ways foreshadows the development of the Baroque *sepulchro* (an oratorio-style meditation at the tomb of Christ, stressing the reactions of the disciples, especially Peter and Mary Magdalene), after his death.

The origins of the oratorio genre itself are traditionally traced to the practice of the *essercizi spirituali* (spiritual exercises) of the *Congregazione dell'Oratorio* in Rome. St. Filippo Neri founded the Oratory (following earlier models) in 1575. He stressed the use of the arts, especially music, to make the Christian message accessible and attractive to large audiences. He wrote that the priests of his Congregation "together with the faithful, should rouse themselves to the contemplation of heavenly things by means of musical harmony," and employed Palestrina and others to compose *laudi spirituali*, artistic spiritual songs of praise. Already by the end of the sixteenth century the quasi-operatic form of the oratorio was also taking shape: a dramatic sacred subject (at first usually stories of the saints or allegories of the virtues; later the passion itself), set to music with soloists, a prominent choir, and an orchestra.

In the context of a general flourishing of Marian music and devotion, the Cinquecento saw the composition of a number of new polyphonic versions of the traditional hymn "Stabat Mater." Palestrina's eight-part setting[242] may be his single most famous work (apart, perhaps, from the *Missa Papae Marcelli*). The interplay of voices is totally subordinated to the clear rendering of the text. This poem would receive highly dramatic settings in the Baroque and Romantic periods. By contrast, Palestrina's restrained and formalized music, sometimes alternating choirs, sometimes uniting them for emphasis, always attending to the sense of the words, is more meditative than theatrical. The serious and ethereal beauty of the music both carries and contrasts with the pathos of the text, placing it a context that combines a sense of inner peace with ineffable spiritual longing.

Envoi

The Reformation and Counter-Reformation established paradigms of theo-
logical thinking that would prevail for several centuries. During the period of
intense polemics, church leaders, scholars, artists, and musicians emphasized
the doctrinal differences between these paradigms. Today it is easy to see the
underlying similarities and even unnoticed agreements in them. This is par-
ticularly true with regard to their soteriologies.

Clearly we can still note differences. In the light of contemporary dia-
logues, we can recognize that some of them were and are more "aesthetic" than
strictly doctrinal. The "feeling" of Protestantism, especially the Lutheran va-
riety, placed emphasis on taking comfort in the fact that God has accepted us,
prior to our merit, because of Christ's sacrifice. But we must respond through
our acceptance of the cross, and follow him. Catholicism, accepting—and al-
most taking for granted—the fact that God has paid the price for our redemp-
tion, placed more stress on the need for our response and on the actuality of
the transformation of human life. Both Protestantism and Catholicism em-
phasized the cross, that of Christ and that of the Christian. Both also recog-
nized the effects of the cross: the resurrected life in us. But the Catholic
Counter-Reformation spirit seems to have been more triumphal and more
militant in its proclamation of God's work in us.

If we compare Cranach's picture of his father receiving the blood of Christ
on his head with El Greco's ecstatic crucifixions and saints, we certainly see a
vast difference in style and in emotion. But is the spiritual or theological
message so very different? Cranach tells us that in the everyday reality of life,
we are redeemed; El Greco seems to say that redemption produces a different
way of being, an ecstasis, even now. Two emotionally different variants on the
same theme?

The differences between the Protestant and Catholic doctrines of the cross
seem less significant when we look at both in the light of their unexamined
presuppositions. Both the Protestant and Catholic reform movements em-
phasized the doctrine of redemption, and both retrieved versions of the An-
selmian schema in which Christ substitutes for humanity in payment of a
debt owed to God. Both therefore stressed elements that would shortly be ex-
posed to radical critique in the European Enlightenment. In a dialectical pro-
cess of development, both the Reformation and Counter-Reformation con-
cluded that:

1. Humanity is somehow radically alienated from God, in a situation of "debt," both because of an inherited condition and because of personal sin.
2. We are unable "of ourselves" (presuming, therefore, that there is such a condition as existing "of ourselves") to overcome this alienation or pay the debt.
3. Christ in some way pays a price that overcomes this alienation.
4. The cross, in the sense of personal suffering, is to be embraced by the Christian, even after this "payment" of the debt, as an intrinsic element in the process of reconciliation with God (whether it be called "justification" or "sanctification").
5. We know this on the authority of the Scriptures and/or of the church.

All of these ideas would come into tension, if not conflict, with the secular and scientific rationality that would characterize the coming age. The historical critique of the Scriptures and of received authority in general would be a leading factor in the reevaluation of Christian faith, particularly the doctrine of redemption. The encounter with non-Christian religions and the collapse of the Ptolemaic cosmology and the Aristotelian physics (and metaphysics) associated with it would further throw into doubt the presuppositions of the very context of Christian doctrines.

At the same time, the age of the dawning of modernity also saw a flowering of religious faith and religious art, in particular with regard to the representation of the cross. It might well be argued that the supreme aesthetic expression of the Reformation doctrine of redemption would be found in the flourishing of the Lutheran chorale and in the great oratorio Passions of Bach and Telemann, that the true art of the Counter-Reformation was the Baroque, and that the true crisis of both would occur in the confrontation of both aesthetics and religion with a newly independent secular and scientific paradigm of thought. This chapter of the story of the cross must await another volume.

Appendix

Albrecht Dürer's Religion

The question of the precise nature of Albrecht Dürer's religious beliefs after the Lutheran reformation has been much discussed. His sympathy with the Reformation is clear; but it is less clear how far this sympathy extended, or, to put it in other terms, in just what sense Dürer was what his friend Pirckheimer described as a "good Lutheran."

The question raises some methodological issues. Do Dürer's religious attitudes help interpret his late art? Conversely, does his art tell us something about his religious attitudes? Are both so conditioned by other factors that it is impossible to draw any certain conclusions on the matter? Do we have enough information about this very personal aspect of Dürer's life, or must we ultimately suspend judgment and be satisfied with more-or-less probable and sometimes conflicting hypotheses? The purpose of this appendix is not to settle any of these questions, but merely to give the reader a somewhat broader, but still partial and summary, acquaintance with the data that raise the issues. For a more detailed discussion, I refer the reader to the works cited in the notes and to their bibliographies.

Some of the data that scholars consider significant include Dürer's writings, in particular his journal entries, his patronage, his known friendships and contacts, and his works themselves.

Prior to Luther's appearance, Dürer's art and practices were strongly and traditionally pious. We have noted in the text the late-medieval tenor of his treatment of the passion and his Marian

devotion We might also note the theology of "merit" that underlies Dürer's words written concerning his father's death: "We serve God so that we earn [*erberben* for *erwerben*] a blessed life and for the sake of a good end."[1] And he also asks for prayers for his father's soul, presumably in accord with the belief in purgatory.

However, there is possible evidence of a "reformist" spirit in Dürer even before Luther's appearance on the scene. His *Apocalypse* (1498)—credited as being the first European book designed, illustrated, and published by an artist—seems to contain a certain amount of anti-papal sentiment.[2] But the context here is apocalyptic, and the pope, who was of course a secular as well as a spiritual ruler, represents one of the powers of the world. In addition, the book was created in the era of the Borgia papacy; a time when, as we have seen, others than Dürer also interpreted the crises in the church and society in apocalyptic terms. We might compare Dürer's art to Savonarola's nearly contemporary apocalyptic preaching and condemnations of the corruptions of the papacy. As we have also seen, the desire for reform was in the air long before Luther appeared to crystalize the movement. It is entirely possible, although it is not documented, that Dürer might have come into contact with the initial movements of the Catholic reform in Italy during his visits there. He may have had some knowledge of Christian Platonists like Marsilio Ficino, whose works were available in Nüremberg. He was certainly well acquainted with and admired the writings of Erasmus. On the other side of the reforming movement, Dürer was friendly with and highly respected by Melanchthon, who was also friendly with Pirckheimer. He also knew Zwingli, and was at least known to Andreas Bodenstein von Karlstadt; but in both of these cases it is unclear how far the acquaintance went.

From 1496 onward Dürer was frequently employed by Frederick "the Wise," Elector of Saxony, who was also a patron of Cranach and who would be Luther's protector. (Frederick never openly espoused Lutheranism, and engaged in the very un-Lutheran pursuit of collecting relics of the saints.) In Nüremberg Dürer was a member of the *Sodalitas Staupitziana,* named for the Vicar General of the Observant Augustinians, and Luther's mentor and teacher. As a member of this group, Dürer would have been one of the first outside Wittenberg to read Luther's Ninety-five Theses.[3] In 1518 Luther acknowledges a gift received from Durer.[4]

By the early 1520s Dürer seems definitely associated with Lutheranism, at least in his sympathies. In a much-cited passage from a letter written in 1520 to Georg Spalatinus, the chaplain to Frederick the Wise, he writes: "If God helps me to see Dr. Martinus Luther, I will diligently make his portrait and engrave it as a lasting memory of the Christian man who has helped me out of great

anxieties."[5] (In fact, the two never met, and the engraving was never made.) By the early 1520s, Dürer owned a number of works by Luther, and wrote to request imprints from Luther's further works. As we have seen, he also admired Erasmus of Rotterdam, met with him at least four times during his trip to the Netherlands.

One of the most frequently cited pieces of evidence regarding Dürer's beliefs is his May, 1521, journal entry from his trip to the Netherlands. While there, he received the report, erroneous, as it turned out, that Luther had been arrested. Dürer's reaction to this news is contained in several lengthy and uncharacteristically vehement paragraphs in the journal, inserted in the midst of his usual records of everyday affairs. The passage in question has often been quoted out of context as evidence concerning Dürer's religious beliefs. Here is the journal quotation in its entirety.

On the Friday before Whitsuntide, in the year 1521, the report reached me at Antwerp that Martin Luther had been treacherously taken prisoner, for the herald of the Emperor Charles, to whose care he was committed under the Imperial safe-conduct, on arriving at an unfriendly place near Eisenach, rode off, saying that he dared stay no longer with him. Immediately 10 horsemen appeared, who treacherously carried off the pious man sold into their hands. He was a man enlightened by the Holy Ghost, and a follower of the true Christian faith. Whether he lives still, or whether his enemies have murdered him, I know not, but he has suffered much for Christ's truth, and because he has rebuked the unchristian Papacy which strives against the freedom of Christ with its heavy burdens of human laws, and for this we are robbed of the price of our blood and sweat, that it may be expended shamefully by idle, lascivious people, whilst thirsty and sick men perish of hunger; and, above all, this is most grievous to me, that God will perhaps suffer us to remain under their false blind teaching which the men, whom they call the Fathers, have invented and set down, whereby the precious Word is in many places falsely explained or not set forth at all.

O God in heaven, have mercy on us! O Lord Jesus Christ, pray for thy people, redeem us in thy right time, keep us in the true Christian faith, collect thy far-separated sheep by thy voice, heard in thy Holy Word! help us to recognize thy voice so that we may not follow any device (Schwigeln) of man's invention. And in order that we may not turn away from thee, Lord Jesus Christ, call together again the sheep of thy fold of whom part are still to be found in the Romish

Church, with others amongst the Indians, Muscovites, Russians, and Greeks, who through the burdens and avarice of the Papacy have been separated from us. O God, redeem thy poor people who are constrained by means of great torments to follow men's ordinances, none of which they would willingly observe, and thus constantly sin against their consciences by embracing them! Never were any people so horribly burdened with ordinances as us poor people by the Romish See; we who, redeemed by thy blood, ought to be free Christians.

O almighty, heavenly Father, pour into our hearts, through thy Son Jesus Christ, such light that we may recognize that messenger whom we ought to obey, so that we may put aside the burdens of the others with a safe conscience, and serve thee, the Eternal Father, with happy, joyful hearts; and in place of this man, who has written clearer than any other has done for 140 years,[6] and to whom Thou hast given such a large amount of thy Holy Spirit, we pray Thee, O heavenly Father, that Thou wilt again give Thy Holy Spirit to one who will again assemble thy Christian Church from all parts of the world, so that we may live again in a Christian manner, and that Turks, heathens, and Hindoos, and all unbelievers, seeing our good works, may be converted and accept the Christian faith. But, Lord, remember ere Thou judgest how thy Son Jesus Christ was made to suffer death of the priests and rose again from the dead, and afterwards ascended into heaven; and this fate has also in like manner overtaken thy follower Martin Luther, whom the Pope treacherously betrayed and took away his life, whom Thou wilt quicken. And as after my Lord was crucified Jerusalem was destroyed, so wilt Thou now, after this one has been taken, destroy the power of the Papal chair. O Lord, give unto us that New Jerusalem that shall come down from heaven, whereof the Apocalypse writes; the holy clear Gospel that is not darkened by human doctrine. This may every one see who reads Martin Luther's books, how his teaching sets forth clearly and transparently the holy Gospels; therefore his books are to be held in much honor, and not to be burnt. It would be better indeed to cast his adversaries into the fire, with all their opinions, who would make gods of men, and always oppose the truth.

O God, is Luther dead! Who will henceforth explain to us so clearly the holy Gospel? Alas! what might he now still have written for us during the next 10 or 20 years? Oh, all pious Christian men, bewail with me this God-inspired man, and pray to God to send us

another enlightened teacher! O Erasmus of Rotterdam, where dost thou remain? Behold how the unjust tyranny of this world's might and the powers of darkness prevail! Hear, thou knight of Christ;[7] ride forth in the name of the Lord, defend the truth, attain the martyr's crown; thou art already an old mannikin (*Männiken*), and I have heard thee say that thou givest thyself only two years longer in which thou wilt still be fit for work. Employ these well, then, in the cause of the Gospel and the true Christian faith. Lift up thy voice, and so shall not the gates of hell (the See of Rome) as Christ saith, prevail against thee. And although, like thy master Christ, thou hast to suffer shame on earth, and even die the sooner from death unto life, and be glorified through Christ. For if thou drinkest of the cup of which He drank, so wilt thou reign with Him, and judge justly those who have not acted righteously. O Erasmus, hold to this, and put thy boast in the Lord, as it stands written in David, for thou canst do this, and, in truth, thou mayst prevail to fell this Goliath; for God will uphold His holy Christian Church according to His divine will. May He give us eternal bliss, who is God the Father, Son, and Holy Ghost, one eternal God. Amen.

O, all ye Christian men, pray to God for help, for His judgment draws night, and His righteousness shall be made plain. Then we shall see the blood of the innocent, which popes, bishops, and monks have spilt, rise up in judgment and condemn them. (Apocal.) And these are the souls of the slain that lie under the altar of God and cry for vengeance, to which the voice of God replies, Fill up the measure of the innocent who are slain, then will I judge.[8]

Several things might be noted regarding this unusual outburst in Dürer's otherwise very prosaic journal. (Immediately prior to it we read: "Item: I have taken my host's portrait very correctly and diligently in oils. And his wife I have likewise painted again in oils." And immediately after, Dürer again takes up his everyday observations: "And I have changed 1 florin for living expenses; I have given the doctor 8 stiver....") It is significant that Dürer's admiration for Luther, as expressed here, is based primarily on two interrelated points. First, Luther's Biblical scholarship and his denunciation of the religious practices that had superceded the simplicity of New Testament religion. Implicit in this we might see both a humanistic and a religious "scripturalism:" the religion of the New Testament is taken to be normative, in contrast to what are conceived to be merely human accretions (which Dürer—not quite accurately, even from Luther's perspective—attributes wholesale to appeal to the authority of the

"Fathers of the Church"). Also significant are Dürer's reference to the Apocalypse; his complaint about the diversion of his hard-earned money to support a lazy clergy; his strong invective against the Papacy; and his concern about the burden of human laws on conscience.

The last, in conjunction with Dürer's statement that reading Luther had helped him out of "anxieties" may give us some clue to the psychological motivations of Dürer's attraction to Luther's teachings. Many sources from the late Middle Ages testify to widespread anxiety about salvation. Most people expected severe punishment in purgatory, at the very least. Human sinfulness, the need for penitence, and the inadequacy of the human response to God's love, as we have seen, were constantly and insistently preached. Did Dürer, who was described as "melancholic" by Melanchthon[9], live in terror of death and judgment and did he find in Luther's doctrine a "comfort" because it relieved him of the burden of a conscience made uneasy by his inability to live a sufficiently "meritorious" life? What are we to make of Dürer's 1522 self portrait in the figure of Christ as the "Man of Sorrows," bearing the scourges of the passion—or of the penitent? The impression that Dürer valued Luther's doctrine as a remedy for his religious anxiety might be reinforced by one of Dürer's prayers: "Heavenly Father on highest, pour such a light into our hearts through your son, Jesus Christ, that we recognize which commandments we are obliged to obey so that we can dismiss all other burdens with a clear conscience and can serve you, eternal God, heavenly Father, with joyful, happy heart."[10]

Many authors comment of Dürer's appeal to Erasmus, but interpret it in rather different ways. Panofsky notes regarding this rhetorical appeal: "Dürer had lost access to the world of Erasmus, and the very fact that he could imagine him as a martyr of Luther's cause shows a pathetic misunderstanding of the man who was to defend the freedom of the human will against the tyranny of Luther's God." Panofsky even intimates that this lack of true sympathy was a reason why Dürer's portrait of Erasmus could not capture the true spirit of the humanist: "[Erasmus] belonged, not to Dürer, but to Hans Holbein."[11] However, this influential passage from Panofsky has been criticized by David Price, who points out that at the time that Dürer wrote in his diary the differences between Erasmus and Luther would not have appeared as great as they did after the former's rejection of Luther's view of human freedom (and implicitly of his entire theology of justification), which was not published until 1525.[12] Panofsky obviously was aware that Erasmus's critique of Luther had not yet been written, for he speaks of "the man who *was to* defend" human freedom. Presumably his point is that someone who really knew Erasmus's character would have been able to discern that he would sooner or later part company with Luther. Obviously, Dürer did not know Erasmus this well—if indeed anyone did. But

whether this justifies speaking of a "pathetic" misunderstanding might well be questioned. As Price points out, Panofsky's apparent vehemence may well have other motivations. Other scholars point to the same text in Dürer as evidence of his perspicacity and/or of his genuine feelings about the direction in which reform should go. Adding to the ambiguity is the fact that some historians entertain doubts about the authenticity of the text.[13] Presuming that the text is genuine, did Dürer misread Erasmus? Or was he perhaps more concerned with what united the great humanist with Luther, their concern for the Scriptures and critique of the corruption of the church, than with the latter's theology? (Is it significant that Dürer's great, but apparently not very lifelike, portrait of Erasmus dates from 1526, after Erasmus's separation of ways with Luther?)

It is probably fair to say that for the last eight years of his life, Dürer lived, as his friend Pirckheimer said, as a "good Lutheran." But he appears to have lived his Lutheranism as he had lived his Catholicism: not uncritically, possibly with certain reservations, and retaining much in common with those on the other side of the (not yet totally rigid) confessional divide. As Donald McColl says, after the beginnings of the reformation: "Dürer seems never to have been anything but a confirmed 'Lutheran,' although he often acted in ways that push this definition to the breaking point, perhaps indicating that he himself did not know how it would 'turn out' and thus took an appropriately cautious path."[14]

In a passage written perhaps in the 1520s, Dürer expresses his faith in terms that some see as "Lutheran." "The person to whom Christ comes is alive, and that person lives in Christ. For that reason all things are good things of Christ. There is nothing good in us, except that it becomes good in Christ. Therefore whoever wishes to make himself totally righteous, that person is unrighteous. We can will the good, [only] if Christ wills it in us. No human repentance is so great, that it can make satisfaction for mortal sin. . . ."[15] The emphasis here may be Lutheran, but there is nothing in these words that could not also be understood as orthodox by a Catholic; although whether Dürer understood it in such a way is impossible to say.

Despite his early Lutheran sympathies, Dürer did not act in a partisan way—unlike Cranach, he is not known to have produced any polemical works, and he did not abandon either his former religious practices or Catholic patronage. He records that both he and his wife went to confession during their Netherlands journey. (Luther approved of private confession, although not as a sacrament, and without penance.) During this same trip he gave presents to the Bishop of Bamberg, and received recommendations from him; he executed and sold paintings of the *Sudarium,* a subject associated with a non-canonical legend and with the cult of relics; he gladly received a present of a rosary of cedar wood; and he painted an image of St. Jerome (whom Luther thought not

fit to be a doctor of church because of his Vulgate translation) for the Portuguese factor Rodrigo Fernandez d'Almeda. He visited shrines associated with relics and intercession of saints, and witnessed without recording any protest at least two major religious processions.

It is also significant of the ambiguities of the times that like Cranach, Dürer continued to work for Cardinal Albrecht von Brandenburg.[16] Albrecht was in a sense the immediate cause, or at least the immediate occasion, for Luther's protests that led to his eventual conflict with Rome. Tetzel's infamous sale of indulgences was undertaken in order to finance Albrecht's election to his see. Nevertheless, Albrecht remained an ambiguous figure. He supported the humanists, was in contact with Erasmus, and did not oppose the principles of the Reformation. He even sent a wedding gift to the Luthers in 1525. At the Diet of Augsburg, Lutherans still thought that Albrecht might serve as a mediator between the Lutheran and Catholic parties.

In 1521 Andreas Bodenstein von Karlstadt, then one of Luther's most vehement supporters, dedicated to Dürer his book on the veneration of the eucharist, *Von anbettung und eer erbietung der zeychen des neüen Testaments*. The motivation of the dedication is unclear, since it is uncertain to what extent the two men were acquainted. At this time Karlstadt still believed in the real presence. Some find it significant in this connection that Dürer's woodcut of the Last Supper of 1523 displays the chalice quite prominently on the table, while the bread plate, empty, is relegated to the floor in front of the table. (But others interpret the large "plate" as the basin used in the washing of the disciples' feet). Does this prominence of the chalice represent sympathy with the Lutheran restoration of communion under both forms (bread and wine) to the laity?[17] (Luther had proclaimed this "utraquist" position in his 1520 "Sermon on the New Testament, that is, on Holy Mass.") Some also note that the symbolic figure of the Lamb of God is absent from the picture, and take this as an indication of rejection of the idea of the mass as a sacrifice.[18] But the lamb could also signify Christ's taking away of the sins of the world, a central belief for Luther; and, as we have seen, the Lamb is prominent on the altar in Cranach's portrayals of Lutheran worship. On the other hand, the absence of the lamb may be due to other factors, for example, a purer naturalism in representation, perhaps under the influence of Leonardo, who does not include such symbolic elements.

It is surely significant, in any case, that Dürer did not follow Karlstadt in his iconoclasm, but explicitly rejected it. He writes in the dedicatory letter (to Pirckheimer) in his *Art of Measurement:*

Now among us and in our own time the art of painting has been greatly attacked by some people, and it is said that it serves ido-

latry. But a good Christian (*eyn reglich Christen mensch*) is drawn
to superstition by a painting or a statue as little as a good per-
son is drawn to murder because he carries a weapon at his side.
A person who would wish to worship a painting, piece of wood,
or stone, would really have to be very unintelligent (*müst warlich
eyn unnerstendig mensch sein der gemel, holz oder steyn anbeten
wölt*).[19]

Luther is last mentioned in Dürer's writings in 1521; but after this time,
commentators mark in him even more "evangelical sensibility."[20] In a note
written in 1523, Dürer criticizes the abuses associated with the cult image of the
"Beautiful Madonna of Ratisbon." But a number of good Catholic preachers
had also done so, even before Dürer; indeed, the Bavarian bishops attempted to
end the cult.[21] Perhaps more significant is the fact that in 1524 Dürer refers to
himself and friends as ones who "stand in contempt and danger for the sake of
Christian faith and are sneered at as heretics."[22]

McColl thinks it significant that while Dürer's early account of his father's
death included a prayer of St. Bernard and a plea to the reader for prayers for
his father's soul, these are omitted in his later account in the *Family Chronicle*
(1524).[23] On the other hand, one cannot be certain that this omission is sig-
nificant or is evidence of a Lutheran sensibility, especially since Dürer's ac-
count of his mother's death in the same *Family Chronicle* expresses satisfaction
that she died (in 1514) with the sacraments and a papal indulgence.[24]

Panofsky believes that the effects of Dürer's conversion to Lutheran views
can be observed in his art. For example, he says, Dürer's *St. Jerome* of 1514 is in
the spirit of Erasmus; that of 1521 in the spirit of Luther.[25] He comments:

> Dürer's art reflects this conversion—for it was a conversion—both in
> subject matter and in style. The man who had done more than
> any other to familiarize the Northern world with the true spirit of
> pagan Antiquity now practically abandoned secular subject matter
> except for scientific illustrations, traveler's records and portraiture;
> and the designer-in-chief of the *Triumphal Arch* and the Prayer-Book
> of [Holy Roman Emperor] Maximilian I turned his back upon the
> "decorative style." . . . His style changed from scintillating splen-
> dor and freedom to a forbidding, yet strangely impassioned austerity;
> and engraving and painting—the media antipathetic to the ten-
> dencies of the 'decorative' style and all the better adapted to a non-
> linear, emphatically three-dimensional mode of expression—
> returned to favor.[26]

It is true that there is an observable difference in Dürer's style after the Reformation. However, could there be nonreligious factors that were operative in this change?[27] Dürer was getting older. Did he change in attitude and style partly because of age? Dürer remarked to Melanchthon: "When I was young I craved variety and novelty; now, in my old age, I have begun to see the native countenance of nature [*naturae nativam faciem*] and come to understand that this simplicity is the ultimate goal of art."[28] And Panofsky himself remarks concerning Dürer's 1522 self-portrait as the "Man of Sorrows:" "...physical pain and decay are interpreted as a supreme symbol of the likeness of man unto God."[29] Like Michelangelo in his old age, Dürer has renounced the "fables of the world."[30]

Dürer's last great project consisted of two painted panels representing Saints John and Peter, Paul and Mark. Usually called *Four Apostles* (although "four New Testament writers" would be more accurate, since Mark was not an apostle), this work was originally intended to form the side panels for an altarpiece whose center would have been a *sacra conversazione*, a portrayal of the Virgin and Child in the midst of saints. With the acceptance of Lutheranism as the official religion in Nüremberg, this had become an unsuitable subject.[31] However, without the *sacra conversazione*, the panels can be taken as a Lutheran affirmation of the centrality of Scripture. (Indeed, the figure of John is shown reading his own gospel in Luther's translation.) The four writers also represent the four "temperaments" of medieval biology: John the sanguine; Peter the phlegmatic; Mark the choleric; Paul the melancholic. The temperaments in turn were associated with the four seasons, the four times of the day, and the four ages of humankind.[32] G. Pfeiffer sees in the figures of the "Four Apostles" idealized portraits of the Christian humanists Melanchthon (John), Baumgartner (Mark), Camerarius (Paul), and Roting (Peter).[33] Below the panels are inscriptions inveighing against false prophets and heresies. These are possibly directed against the Roman church, but might equally well envision other reform movements that were unorthodox from the Lutheran point of view, such as the Anabaptists.[34]

Perhaps the most convincing testimony to Dürer's adherence to Lutheranism came from his good friend Pirckheimer, after the artist's death, in the context of Pirckheimer's explanation of his own return to Catholicism: "I admit that in the beginning I was also a good Lutheran, just like our late Albrecht, for we hoped that the Roman corruption along with the thievery of the monks and priests would be remedied. But as one now sees, the matter has gotten so much worse that the evangelical criminals make the other criminals look pious."[35]

But we return to the question: what exactly did it mean for Dürer to be a "good Lutheran?" As Price remarks, the real question is, what is it in Luther

and the Reformation in general that really mattered to Dürer?[36] Was he concerned with the theological questions at issue, or was he primarily interested in a humanist protest against abuses, and in the spiritual insights of Luther? As we have noted, Dürer seems to have been particularly taken by the "comfort" he found in Luther's doctrine. Given the lack of clear evidence from Dürer himself, it is impossible for us to read his mind on this point. It is interesting, however, that his art became a model for post-Tridentine Catholic artists—a testimony to the universality of his spirit, whatever his confessional beliefs.

Notes

INTRODUCTION

1. Richard Viladesau, *The Beauty of the Cross: The Passion of Christ in Theology and the Arts—from the Catacombs to the Eve of the Renaissance* (New York: Oxford University Press, 2006).

2. See for example Oliver Sacks, "A Neurologist's Notebook. Recalled to Life" in *The New Yorker*, Oct. 31, 2005, 46–53. The article summarizes neurological research on patients with aphasia, loss of language, who nevertheless both show and testify to an ability to think in nonverbal ways. Research on very young children also supports the idea that thinking can be preverbal. See Paul Bloom, "Children Think Before They Speak" in *Nature* 430 (vol. 6998, July 22, 2004): 410.

3. See Antonio Damasio, *Descartes' Error: Emotion, Reason, and the Human Brain* (New York: Avon Books, 1994).

4. For a fuller discussion of the relationship of different forms of art to theological texts, see my *Theological Aesthetics* (New York: Oxford University Press, 1999), 141–82; *Theology and the Arts* (New York: Paulist, 2000), chap. 3.

5. On the tensions between sacred art and music, on the one hand, and verbal/conceptual theology on the other, see *Theological Aesthetics*, 39–72; *Theology and the Arts*, chapter 1.

6. Hans Belting, *Likeness and Presence. A History of the Image before the Era of Art*, trans. Edmund Jephcott (Chicago and London: University of Chicago Press, 1994).

7. See my *Theology and the Arts*, chapter 2: "Paradigms in Theology and in Art." Also, Thomas S. Kuhn, *The Structure of Scientific Revolutions*. (Chicago: University of Chicago Press, 1962). On the theological use of the

"paradigm," see especially the collection of symposium papers edited by Hans Küng and David Tracy, *Paradigm Change in Theology* (New York: Crossroad, 1984). Küng's programatic essay, "Paradigm Change in Theology: A Proposal for Discussion" also appears, with few changes, in his *Theology for the Third Millennium*, trans. Peter Heinegg (New York: Doubleday, 1988).

8. Kuhn, ibid. 175; quoted in Küng, *Theology for the Third Millenium*, 132.

9. Lutheran World Federation and the Pontifical Council for Promoting Christian Unity, *Joint Declaration on the Doctrine of Justification* (Grand Rapids, Mich.: Eerdmans; Lutheran World Federation and the Pontifical Council for Promoting Christian Unity, 2000).

10. Arnold Hauser, *Mannerism. The Crisis of the Renaissance and the Origin of Modern Art* (Cambridge: Harvard University Press, 1986), 18.

11. Ibid., 19.

12. David Tracy, *The Analogical Imagination: Christian Theology and the Culture of Pluralism* (New York: Crossroad, 1981), 163.

13. James Hall, *Michelangelo and the Reinvention of the Human Body* (New York: Farrar, Straus and Giroux, 2005), 165.

14. Frank Burch Brown, *Religious Aesthetics: A Theological Study of Making and Meaning* (Princeton: Princeton University Press, 1989), 168.

15. Unfortunately, Web sites are notoriously unstable, and there is no assurance that those listed below will continue to be online. Excellent examples of images of the Crucifixion will be found at the following sites:

- Web Gallery of Art: http://www.wga.hu/index1.html, search "crucifixion";
- The New Testament Gateway: www.ntgateway.com, search "Art and Images";
- Artcyclopedia: www.artcyclopdeia.com, search "crucifixion" or the names of individual artists; and
- Many libraries have access to the online collection "Artstor," which has a wealth of materials relevant to this theme as well as to the history of art in general.

CHAPTER I

1. Laurence Kanter, "Fra Angelico: A Decade of Transition (1422–32)" in Laurence Kanter and Pia Palladino, *Fra Angelico* (New York: Metropolitan Museum of Art, 2005), 79.

2. Vasari in his *Lives of the Painters* (1550–68) says that Angelico was born in 1387 and entered the convent at the age of twenty in 1407. Giorgio Vasari, "Fra Giovanni da Fiesole pittore" in *Vite de' più eccellenti architetti, pittori, et scultori Italiani*, Edizione Torrentiniana (Florence: 1550). (The entire original text is accessible online, along with the Edizione Giuntina, at http://biblio.cribecu.sns.it/vasari/consultazione/Vasari/indice.html, accessed August 17, 2007.) Most scholars now think that Angelico was born perhaps in the second half of the 1390s, if not about 1400. In any case, he was a mature artist by the time of the San Marco commission.

3. The *Cronaca* of Fra Giuliano Lapaccini, a resident in San Marco until death in 1458, attributes the entire San Marco fresco cycle to Angelico: "Nam tabula altaris maioris et figurae capituli et ipsius primi claustri et omnium cellarum superiorum et Crucifixi refectorii omnes pictae sunt per quendam fratrem ordinis praedicatorum et conventus Fesulini qui habebatur pro summo magistro in arte pictoria in Italia, qui frater Iohannes Petri de Mugello dicebatur, homo totius modestiae et vitae religiosae." Quoted in Magnolia Scudieri, "The Frescos by Fra Angelico at San Marco," in Kanter and Palladino, 188n1.

But Scudieri summarizes the judgment of most contemporary art historians on such attribution: "a fresco cycle such as this one surely demonstrates how the notion of individual authorship by necessity should be extended to include those parts of the series not executed directly by the master, but—as was the case with Angelico—invented, drawn, and overseen by him." Ibid., 179.

4. Luciano Berti, *L'Angelico a San Marco* (Florence: Sadea editore, 1965), iv.

5. The imitation of their predecessors was a significant part of Dominican spirituality, and their visual evocation was a part of that tradition. The general chapter of the order in 1294 prescribed that images of Saint Dominic and Saint Peter Martyr be placed in every Dominican church. We can see representations of these and other great Dominican saints among the frescos by Angelico at San Marco.

6. See Michael Baxandall, *Giotto and the Orators. Humanist Observers of Painting in Italy and the Discovery of Pictorial Composition 1350–1450* (Oxford: Clarendon, 1971).

7. Erwin Panofsky, *The Life and Art of Albrecht Dürer*, with a new introduction by Jeffrey Chipps Smith (Princeton: Princeton University Press, 2005 [1943]), 33.

8. The term seems to have been first used in Italian by Leon Batista Alberti, in the mistaken belief that the style entered Italy with the barbarian invasions.

9. Vicent Ferrer, O.P. *Sermones sancti Vincentii Fratris ordinis predicatorum De Sanctis* (Norimbergae: Antonius Koberger, 1492; online facsimile ed.: http://www.cervantesvirtual.com/FichaObra.html?Ref=12850; Biblioteca virtual Miguel de Cervantes; accessed August 17, 2007).

10. The seven reasons given by St. Thomas why the cross was a "fitting" means of salvation are these:

1. It gives us an example of virtue.

2. It was fitting that a tree be used for satisfaction for the first sin, which was committed by taking fruit from a tree against God's ordinance.

3. By being lifted up, Christ purifies the realm of the air—as the earth is purified by his blood shed on it.

4. Christ's exaltation above the earth prepares our ascension to heaven: as it says in Jn. 12: 32–33—"If I am lifted from the earth, I shall draw all things to myself."

5. The cross was a suitable symbol for the universal salvation of whole world: for the figure of a cross extends in all directions.

6. Diverse virtues are designated by the cross (as Augustine says): length and depth and height; it also symbolizes the chair of the magister.

7. This type of death corresponds to several figures: the wooden ark of Noah; the staff of Moses; the wood placed by Moses in the water to sweeten it; the ark of the law made of wood; etc. *S.T.*, part 3, q. 46, art. 4.

11. Ferrer, *Sermones*, fol. 103, recto.

12. Ibid., fol. 103, v.

13. Ibid., fol. 104, r.

14. Ibid., fol. 104, v.

15. Biel's birth date is unknown. Since he was ordained in or before 1432, he must have been born in the first quarter of the fifteenth century. See Heiko Augustinus Oberman, *The Harvest of Medieval Theology: Gabriel Biel and Late Medieval Nominalism* (Grand Rapids: Baker House, 2000), 9–10.

16. In his "Disputatio contra scholasticam theologiam" of 1517, Luther explicitly directs some of his theses against *all* the scholastics. But he appears to have known the scholastic tradition primarily through Biel. See Heiko A. Oberman, *The Dawn of the Reformation. Essays in Late Medieval and Early Reformation Thought* (Grand Rapids: Eerdmans, 1992), 104.

17. Like Aquinas, however, Biel affirms that cognition is the first activity of the human soul. In this sense, he may be called an "intellectualist." However, the human intellect is inadequate to comprehend God or God's actions, which are the result of God's free choice. In this sense, Biel is a "voluntarist." On rationalism and voluntarism in Biel, see Oberman, *Harvest*, 63–64. The dichotomy itself rests on a rational faculty psychology that divides spirit into two "faculties," intellect and will, and considers one or the other as "prior." This presupposition of scholastic thinking is critically examined in the modern period.

18. Oberman, *Harvest*, 69.

19. Gabriel Biel, *Sermones dominicales de tempore* (Hagenau, 1510), 14 A, quoted in Oberman, *Harvest*, 51.

20. Biel, *Sermones dominicales*, 64 D, E, quoted in Oberman, *Harvest*, 183.

21. See Oberman, *Harvest*, 229–30, and the texts cited there.

22. See the summary of the Ockhamist doctrine of justification in Steven Ozment, *The Age of Reform: 1250–1500* (New Haven: Yale University Press, 1980), 233–34; and of Biel's teaching in Oberman, *Harvest*, 175–78.

23. Oberman, *Harvest*, 178. Oberman goes farther: the theology of Biel, like that of most of the nominalists, is clearly Pelagian. Ibid., 177, 181.

24. Gabriel Biel, *Collectorium circa quattuor libros Sententiarum*, ed. Wilfridus Werbeck and Udo Hofmann (Tübingen: J. C. B. Mohr, 1979), book 3, dist. 19, art. 3, *dubium* 3.

25. Biel's language is awkward here. He says that satisfaction could not be made, *nisi reddatur maius quam sit illud, pro quo non debuit peccare*, "unless something be restored that is more than that for the sake of which humanity should not have sinned." But humanity should not have sinned for the sake of all creation . . . etc., ibid. The awkward phrase is an attempt to make a single explicit argument out of two separate statements of Anselm: 1) that it were better for the universe to perish than

for a person to commit sin (*Cur Deus Homo*, book 1, ch. 20), and 2) that the "price" paid to God must be greater than all the universe besides God (ibid., book 2, ch. 6).

26. We must refrain here from a discussion of how exactly Anselm understood the "necessity" of the incarnation and redemption, as distinguished from the simple "congruence" that Biel affirms. On this, see the treatment of Anselm's theology in my previous volume, *The Beauty of the Cross* (New York: Oxford University Press, 2006), 70–75.

27. However, such an act of satisfaction, elicited by grace, could not be said to "merit" the erasure of the individual's guilt, since guilt would already be removed by the infusion of grace itself, prior to any elicited act, ibid.

28. Biel, *Collectorium circa quattuor libros Sententiarum*, dist. 20, art. 3, *dubium* 1.

29. Ibid., dist. 20, art. 3, *dubium* 2.

30. Ibid., dist. 18, Summary of the Text: "Pro nobis Christus meruit sua passione et morte, ut nobis esset virtutis forma et causa gloriae."

31. Gabriel Biel, *Gabrielis Biel Canonis Misse Expositio*, ed. Heiko A. Oberman and William J. Cortenay (Pars quarta; *Veröffentichungen des Instituts für Europäische Geschichte Mainz*, band 34; *Abteilung für Abendländische Religionsgeschichte*; Wiesbaden: Franz Steiner Verlag GMBH, 1967), 115–16.

32. Biel, *Collectorium circa quattuor libros Sententiarum*, book 3, dist. 19, q. 1, art. 2, conclusion 5.

33. Ibid., conclusion 4.

34. Ibid., dist. 15, q. 1, art. 2, part 2.

35. Ibid., dist. 18, art. 2, conclusion 6: "Non aliud, sed idem quod Christus meruit in passione, prius meruerat in conceptione;" art. 1, note 6: "notandum quod successio non est de ratione meriti."

36. ". . . satis et supra pro omnibus laboravit, offerens passionem suam efficaciter pro electis tamen" (he labored sufficiently and beyond for all, but offered his passion efficaciously only for the elect); Biel, *Sermones dominicales de tempore* (Hagenau, 1510), quoted in Oberman, *Harvest*, 269.

37. "Cui [scl. Christi merito] nisi nostrum meritum iungatur insufficiens, immo nullum erit," Biel, *Sermones de festivitatibus christi* (Hagenau, 1510), 2 G; quoted in Oberman, *Harvest*, 268.

38. For Biel's exposition of the idea of human merit and its relationship to grace, see *Collectorium circa quattuor libros Sententiarum*, book 1, dist. 17; book 2, dists. 27, 29; book 3, dist. 30. In particular, on the relationship between grace and the "natural" love of God above all things that immediately disposes a person for grace, see book 3, dist. 27.

39. Biel, *Collectorium circa quattuor libros Sententiarum*, book 3, dist. 4, q. 1. For a comparison of Biel's views with those of other scholastics, see Oberman, *Harvest*, 299–300.

40. Biel, *Sermones de festivitatibus gloriose virginis marie* (Hagenau, 1510), 13 B, C; quoted in Oberman, *Harvest*, 303.

41. Biel, *Canonis Misse Expositio*, 32.

42. Biel, *Sermones de festivitatibus gloriose virginis marie*, 22 I; quoted in Oberman, *Harvest*, 312.

43. Helmut Feld, *Der Ikonoklasmus des Westen*. Studies in the History of Christian Thought 41 (Leiden: E. J. Brill, 1990), 98.

44. It is known that members of Botticelli's family, including his brother Simone, were disciples of Savonarola. According to Vasari, the painter himself was also a *piagnone* (weeper) as Savonarola's followers were mockingly called (Vasari, *Vite*, Edizione Giuntina, 517). Some point to the preacher's influence as the reason for the change in Botticelli's late style, as well as for his apparent abandonment of mythological themes. Some have seen Botticelli's *Mystic Crucifixion* of 1498(?) (online: http://tinyurl.com/2vma49) as a tribute to Savonarola. It certainly reflects the later's apocalyptic warnings to the city of Florence. The crucified Christ is shown against the background of the city, in which we can recognize Brunelleschi's cathedral dome and the tower of Giotto. Behind the cross, flames appear through dark clouds. At the top left sits God with a book (the Apocalypse?). Crusader-like shields bearing a red cross fly through the air. Mary Magdalene, the symbol of repentance, throws herself at the foot of the cross, looking not at Christ but at an angel standing to the right. The angel holds a flaming scourge, threatening an animal that seems to be intended to be a lion (symbol of the city of Florence) that he holds in the other hand. (If the animal is a lion, it is much out of proportion to the human figures. It would be tempting to interpret it as a weasel, which medieval bestiaries list as a symbol of those who hear the word of God and lose it because of the cares of the world [Matt. 13:22], or perhaps an otter, the symbol of a tyrant and killer. However, the thickness of the neck of the animal seems most easily explained as an attempt to portray a lion's mane.) The painting is now in the Fogg Museum at Harvard University.

45. See for example Marsilio Ficino, *El libro dell'amore* (Florence: Olschki, 1987), oratione 7, ch. 12, "Del danno dell'amore volgare."

46. It is illuminating to observe the "theology of the cross" that underlies what Pico writes in his commentary on the "Our Father" concerning the reception of the eucharist. Note also the emphasis on the need for active imitation of Christ, without which the cross does not help us:

> If the soul wishes to live by this bread, which is nothing other than Christ crucified, it must totally transform itself into the crucified Christ. This transformation takes place in three ways: by meditation, compassion, and imitation. We chew this bread by meditation, that is, contemplating Christ's entire life, from beginning to end, because his entire life was a cross, as is clear to anyone who reads the gospel, which must be the constant reading of any Christian. Then we digest this chewed bread, by means of compassion: just as digestion creates natural heat, so the digestion of this bread creates the heat of love, which makes us share in the sorrows and sufferings of our beloved and dear Jesus Christ. After digestion, it remains that the digested food become part of our body, so that it may restore and nourish us. Thus it also remains for us after the chewing of meditation and the digestion of compassion, to join ourselves to him by imitation. And just as that bodily

food, once chewed and digested, does not nourish us unless it is used by the bodily members that it becomes part of, just so, if we chew over the entire life and cross of Christ by diligent meditation, and even digest [the message] through compassion with him, with much heartfelt affect and even many tears—yet, unless we make ourselves similar to him through imitation, the soul receives no nourishment from this bread, and Christ does us no good. (Giovanni Pico della Mirandola, *In orationem Dominicam expositio*. Rome: Biblioteca Italiana, 2004. Online: http://tinyurl.com/yveru7)

See also the emphasis on the cross, on voluntary suffering, and on weeping with Christ in Pico's "Twelve Rules" (Pico della Mirandola, *Duodecim regulae, Duodecim arma, Duodecim conditiones amantis* [Rome: Biblioteca Italiana, 2004]).

47. See for example his prison meditation on Ps. 50, in which he appropriates to his preaching St. Paul's words in 1 Cor. 2:2.

48. Girolamo Savonarola, *Prohemium in festo Sancti Thome de Aquino*, quoted in Giulio Cattin, *Il primo Savonarola. Poesie e prediche autografe dal Codice Borromeo* (Biblioteca di "Lettere italiane" 12; Florence: L. S. Olschki, 1973), 300.

49. Girolamo Savonarola, *Libro di Frate Hieronymo da Ferrara dello ordine de Frati predicatori: della verita della Fede Christiana sopra el Glorioso Triompho della Croce di Christo* (Vatican Library microfilm; WFM 209/6).

50. Ibid.

51. *Il Breviario di Frate Girolamo Savonarola*, photocopy of manuscript Banco Rari 310 of the Biblioteca Nazionale Centrale di Firenze, ed. Fondazione Ezio Franceschini (Savonarola e la Toscana 6; SISMEL-Edizioni del Galluzzo; Florence: Societa' Internazionale per lo Studio del Medioevo Latino; University of Florence, 1998), col. 63r, 238.

52. "Cosi etiam la privatione della iustitia originale in noi no[n] si chiamerebbe peccato, ne li huomini nati senza quella iustitia nascerebbeno in peccato originale: seno[n] fussino stati in tale privatione i[n]troducti & mossi per generatione dal primo parente: la cui mala volu[n]ta essendo stata causa di muovere in questo modo tucti gli membri, ha facto dima[n]dare questa i[n]ordinatione, che sitrova nel huomo dalla sua nativita peccato originale. Et pero se a principio no[n] fussi stata data & dapoi p[er]sa tal iustitia [non?] sipotrebbe dire che li huomini nascendo con la inordinatatione con laquale nascono nascessino in peccato originale: Perche dove no[n] è inordinatione di voluntà no[n] puo essere peccato" (ibid., book 3, ch. 9).

53. Ibid., ch. 10.

54. Ibid.

55. Ibid.

56. Ibid.

57. Ibid.

58. Ibid., ch. 11.

59. "This contemplation will be our bread and our food, night and day. Let our life and our death be continually in the wounds and in the bowels (*nelle viscere*) of the most sweet incarnate Word," Girolamo Savonarola, "La Passione di N[ostro] S[ignore]" in *Guida Spirituale*, vol. 1, *Vita Cristiana*, ed. Enrico Ibertis, O.P. and Gundisalvo Odetto, O.P. (Turin: R. Berruti, 1952 [1492]), 250.

60. Girolamo Savonarola, *Semplicità della Vita Cristiana*, in *Guida Spirituale*, vol. I, *Vita Cristiana*, ed., Enrico Ibertis, O.P. and Gundisalvo Odetto, O.P (Turin: R. Berruti, 1952 [1495]), book 5, 154. Cf. "L'Amore di Gesù Cristo," in ibid., IV. 241.

61. Savonarola, "La Passione," 251.

62. Ibid., 257.

63. Ibid., 252.

64. Ibid., 254.

65. Ibid., 251.

66. Ibid., 252, 253. Pico della Mirandola expresses a similar opinion: "In regard to what the Parisian theologians call the higher part of the mind, Christ most freely underwent death. But in the lower part of his mind, he was sorrowful; and he freely chose to loosen the reins of the sensitive and imaginative parts of his mind to the power of suffering, so that he might pour out his goodness for the sake of the redemption of the human race to the greatest extent possible," *De imaginatione* (Rome: Biblioteca Italiana, 2004; online: http://www.bibliotecaitaliana.it:6336/dynaweb/bibit/autori/p/pico_gianfrancesco/de_imaginatione).

67. Ibid., 257.

68. Ibid., 256.

69. Ibid., 261.

70. Savonarola, "Breviario," 114r. (324).

71. Savonarola, "La Passione," 257.

72. Ibid., 261.

73. Ibid.

74. Ibid.

75. Ibid.

76. Ibid., 258.

77. Ibid., 271.

78. Ibid., 273.

79. Girolamo Savonarola, *Scelta di Prediche e scriti di Fra Girolamo Savonarola*, ed. by P. Villari and E. Casanova (Florence: G. C. Sansoni Editore, 1898), 410–11, my translation.

80. Savonarola, "La Passione," 259.

81. Ibid., 262.

82. Ibid., 262.

83. Ibid., 270.

84. Ibid., 262.

85. Ibid., 269.

86. Ibid., 264.

87. Ibid., 255.

88. Ibid., 258. At the same time, it should be noted that Savonarola criticized those who had a purely sentimental spirituality that wanted to "weep with the Virgin" (of which he approved) but who missed the theological point of the passion. He also corrects those who think that the Virgin lamented in an uncontrollable and hysterical way. In a sermon from Good Friday of 1496, he notes that Mary's sorrow was dig-

nified, and that indeed she was both glad and sorrowful at the same time, since she knew the purpose of Christ's suffering, *Prediche sopra Amos e Zaccaria* (Lent, 1496), quoted in Alexander Nagel, *Michelangelo and the Reform of Art* (New York: Cambridge University Press, 2000), 226n25.

89. Savonarola, "La Passione," 270.

90. Girolamo Savonarola, "Il Mistero della Croce," in *Guida Spirituale*, vol. 1, *Vita Cristiana*, ed. Enrico Ibertis, O.P. and Gundisalvo Odetto, O.P. (Turin: R. Berruti, 1952, 274–75.

91. Girolamo Savonarola, "L'Amore di Gesù Cristo" in *Guida Spirituale*. 1. Vita Cristiana. Edited by Enrico Ibertis, O.P. and Gundisalvo Odetto, O.P. Torino: R. Berruti, 1952 [1492], part 1, 231.

92. Ibid., 232.

93. Ibid., part 4, 238.

94. Ibid., part 4, 239.

95. Ibid., 241.

96. Augustine explains Christ's immunity to original sin, despite his sharing in human nature, from the fact that he inherits from Adam only materially (because he has a human body), but does not inherit the *ratio* or "reason" for his being, which comes from God. (This idea is obviously tied to Augustine's theory of *rationes seminales*.) Aquinas in the *Summa Theologica* follows Augustine on this. Later theologians would explain Christ's exemption from original sin more explicitly on the basis of the grace of the hypostatic union.

97. Arnold Hauser, *The Social History of Art* (New York: Random House, 1985), 2: 32–33.

98. Ibid., 33.

99. The humanists could claim no less an authority than Pliny the Elder (23–79 CE) for the elevation of the graphic arts to "liberal" status: "Throughout all Greece, free-born children were first of all taught drawing (*graphicen*), that is depiction (*picturam*) on wood, and this art was accepted as the first step in the liberal arts (*recipereturque ars ea in primum gradum liberalium*). However, this art has always been honored and practiced by free-born persons, and more recently, by highly-born persons, and it has always been forbidden that it be taught to slaves," *Natural History* (*Naturalis Historiae Libri*), 35. 36.77. Alberti and others included sculpture (as opposed to mere stone carving) in the higher arts as well, since the sculptor's activity is primarily mental (as Michelangelo claimed). In 1539 Pope Paul III would issue a brief that affirmed this view of sculpture as an art. See Milton Kirchman, *Mannerism and imagination: a Reexamination of Sixteenth-Century Italian Aesthetic* (Salzburg: Institut für Anglistik und Amerikanistik, Universität Salzburg, 1979), 59 and 59n100.

100. Leonardo da Vinci, *Libro di Pittura di messer Lionardo da Vinci pittore et scultore Fiorentino*, Codex Urbinas Latinus 1270, fols. 002v, 005r, and *passim*. Text online at http://www.letturelibere.net/.

101. Albrect Dürer, *Outline of a General Treatise on Painting*, in *A Documentary History of Art*, vol. 1, *The Middle Ages and the Renaissance*, ed. by Elizabeth Gilmore Holt (Garden City, N.Y.: Doubleday, 1957), 309.

102. Leon Batista Alberti, *Della Pittura libri III*, in *Opere volgari*, ed. C. Grayson (Bari: Gius; Latenza & Figli, 1973), book 3, ch. 52. 90, 92.

103. See for example the treatise "On Painting" by Antonio Averlino (called "Il Filarete"), in *A Documentary History of Art*, vol. 1, *The Middle Ages and the Renaissance*, ed. Elizabeth Gilmore Holt (Garden City, N.Y.: Doubleday, 1957), 39–40.

104. See, for example, Lorenzo Ghiberti, *The Commentaries*, in *Artists on Art from the XIV to the XX Century*, ed. Robert Goldwater and Maco Treves (New York: Random House, 1972). In fact, the "naturalism" that renaissance artists thought to be the obvious goal of art was quite foreign to the Middle Ages. As Erwin Panofsky remarks, "In the Middle Ages paintings and sculptures were not thought of in relation to a natural object which they seek to imitate but rather in relation to the formative process by which they come into being, namely the projection of an 'idea' existing in—, though by no means 'created' by—, the artist's mind into a visible and tangible substance. Master Eckhart's painter paints a rose, as Dante draws the figure of an angel, not 'from life' but from the 'image in his soul'." For this reason, medieval artists generally took their models from other works of art, not from personal observation. See Erwin Panofsky, *The Life and Art of Albrecht Dürer*, with a new introduction by Jeffrey Chipps Smith (Princeton: Princeton University Press, 2005 [1943]), 243. One might add that medieval art, especially religious art, was not so much concerned with portraying objects found in the world as with conveying a message or "knowledge" about reality; it was a "metaphysically" rather than a "physically" centered art.

105. This is not to say, of course, that in speaking of "nature" Renaissance artists and theoreticians of art are necessarily thinking of the concept in an explicitly philosophical way, or that they understand "nature" in a "realistic" (Platonic) as opposed to a nominalist or a "modified realist" (Thomistic) way, although some indeed were influenced by Platonism.

106. Panofsky, *Life and Art of Albrecht Dürer*, 243.

107. Lorenzo Ghiberti, *The Commentaries*, in *A Documentary History of Art*, vol. 1, *The Middle Ages and the Renaissance*, ed. Elizabeth Gilmore Holt (Garden City, N.Y.: Doubleday, 1957), 156.

108. As Erwin Panofsky notes, this conception of art is radically at odds with the medieval view, in which a picture was "a material surface covered with lines and colors which could be interpreted as tokens or *symbols* of three-dimensional objects," *Life and Art of Albrecht Dürer*, 247, emphasis added.

109. Alberti, *Della Pittura*, book 2, ch. 30, 52.

110. Leonardo da Vinci, *Libro di Pittura*, fol. 005r.

111. Antonio Manetti ascribes the formulation of the rules of perspective to his contemporary Brunelleschi. He opines that the ancients must have used such rules, but wonders whether they did so consciously. Antonio Manetti, *The Life of Filippo di Ser Brunellesco* in Holt, *A Documentary History of Art*, 1:170–71.

112. Cf. Hauser, *The Social History of Art*: "The fundamentally new element in the Renaissance conception of art is the discovery of the concept of genius, and the idea that the work of art is the creation of an autocratic personality . . .", 2:68.

113. Leonardo da Vinci, *Libro di Pittura* fol. 6ov.

114. Alberti, *Della Pittura Libri III*, book 3, ch. 55, 96. Cf. the Latin version, *De Pictura*, ad loc., 97. The word that I have translated as "beauty" is *vaghezza* (charm, loveliness, beauty) in the Italian text; but in the Latin, Alberti uses the classical word *pulchritudo* (beauty).

115. Ibid., book 3, ch. 55, 96.

116. The word "form" as used by renaissance artists seems to have a certain elasticity. At times it seems to refer simply to the physical shape of things, as in modern usage; but it also frequently retains at least an echo of the philosophical notion of "form" as the intelligible essence of a being that is grasped by the intellect. So, for example, Piero della Francesca speaks of the "form" of a thing as both that which allows the intellect to judge, and what the eye sees (*la forma de la cosa, perhò che senza quella l'intelletto non poria giudicare nè l'ochio comprendare essa cosa*), *De Prospectiva Pingendi*, ed. Giustina Nicco-Fasola (Florence: Le Lettere, 1984), book 1, Prologue. In Michelangelo's thought, on the other hand, the Platonic idea of "form" is explicit.

117. See Walter Friedlander, *Mannerism and Anti-Mannerism in Italian Painting* (New York: Schocken Books, 1967), 5.

118. Alberti, *De Pictura*, book 2, ch. 35.

119. See James Hall, *A History of Ideas and Images in Italian Art* (New York: Harper & Row, 1983), 259.

120. Michelangelo Buonarroti, *Rime* (Bari: Universale Laterza, 1967), book 2, 151.

121. Hall, *A History of Ideas and Images in Italian Art*, 239–43.

122. Panofsky, *The Life and Art of Albrecht Dürer*, 33.

123. See William Durandus, *Rationale Divinorum Officiorum*, book 1, quoted in Holt *Documentary History of Art*, 1: 121, 123.

124. Quoted in Michael Baxandall, *Painting and Experience in Fifteenth Century Italy: A Primer in the Social History of Pictorial Style* (Oxford: Oxford University Press, 1988), 41.

125. Antoninus of Florence, *Summa Moralis*, part 1, title 2, ch. 3, quoted in ibid., 43.

126. Baxandall, *Painting and Experience*, 46.

127. Alberti, *Della Pittura Libri III*, book 2, ch. 41, 70.

128. Albrect Dürer, *Outline of a General Treatise on Painting*, in Holt, *Documentary History of Art*, 1: 309.

129. Ghiberti, *Commentaries*, 161.

130. Alain Besançon, *L'image interdite. Une histoire intellectuelle de l'iconoclasme.* Collection Folio/essais, 362 (Paris: Gallimard, 1994), 313–14.

131. Ibid., 321.

132. Quoted in Baxandall, *Painting and Experience*, 43.

133. Karl Borinsky, "Der Streit um die Renaissance und die Enschehungsgeschichte der hist. Beziehungsbegriffe Renaissance und Mittelalter," in *Sitzungsberichte der Bayrische Akademie der Wissenschaften*, 4 (1932), 32–33, cited in Arnold Hauser, 75.

134. Besançon, *L'image interdite*, 323.

135. This section depends heavily on the comprehensive survey of Paul Thoby, *Le Crucifix des Origines au Concile de Trente. Étude Iconographique* (Nantes, France: Bellanger, 1959), 187–212.

136. Besançon, *L'image interdite*, 315.

137. Vasari, *Vite*, "Donato," Edizione Torrentiniana, 204–5. The same story is told again in the section on Brunelleschi.

138. Baxandall, *Painting and Experience*, 46–47.

139. Ibid., 56–57.

140. In later versions, the fictional governor's name is given as "Publius Lentulus."

141. Quoted in Baxandall, *Painting and Experience*, 57. The version quoted by Baxandall was published at the end of the fifteenth century in the introduction to Ludolph the Carthusian's popular *Vita Christi* (Life of Christ).

142. For Marsilio Ficino, as for the high Scholastics, God is supreme beauty. See for example, among many similar passages, *El libro dell'amore*, oration 7, ch. 12, which speaks of "el [sic] desiderio della bellezza divina." Giovanni Pico della Mirandola, on the other hand, was influenced by Plotinian thought, and held that God is purely simple (*somma e inestimabile simplicità*) and is beyond both being and beauty, although the divine simplicity is their creative source and goal. See for example his, *Commento sopra una canzone d'amore di Girolamo Benivieni* (Rome: Biblioteca Italiana, 2004), book 1, ch. 8.

143. A large image of the crucifix may be viewed at the Web Gallery of Art: http://www.wga.hu/art/m/michelan/1sculptu/1/2crucifi.jpg.

144. The one who loves properly must proceed "from exterior bodily beauty, to see the beauty of the soul of the beloved, from which the bodily beauty emanates . . . and, rising still higher, elevate oneself to a more sublime level of contemplation, so that one comes to the first fount of all beauty, which is God," Giovanni Pico della Mirandola, *Commento sopra una canzone d'amore di Girolamo Benivieni* (Rome: Biblioteca Italiana, 2004), book 3, commento particolare, strofa 1.

145. "Opere [creationis] consummato, desiderabat artifex esse aliquem qui tanti operis rationem perpenderet, pulchritudinem amaret, magnitudinem admiraretur," Giovanni Pico della Mirandola, *Oratio de hominis dignitatae* [sic] (Critical edition of the text online at www.brown.edu/Departments/Italian_Studies/pico/).

146. Michelangelo Buonaroti, *Rime*, book 2, 107.

147. Thoby, *Le Crucifix*, 188, 211, 212.

148. Leonardo da Vinci, *Libro di Pittura*, fols. 25v. and 26r.

149. At the same time, this depiction bears a particular resemblance to the drawing of Christ on the cross, now in the Albertina Museum, Vienna, that is generally ascribed to Angelico, and is thought by many to have been intended as a model for the San Marco crucifixions. See the discussion of this drawing by Pia Palladino in Kanter and Palladino, *Fra Angelico*, 111–13.

150. Scudieri, "The Frescos by Fra Angelico at San Marco," 181.

151. Ibid, 184.

152. The pinnacles of the altarpiece frame are by Lorenzo Monaco, Angelico's presumed teacher, who was originally commissioned to do the painting, but who died in 1423 or 1424.

153. See for example Alberti, *Della Pittura*, book 2, ch. 43. Leonardo also recommends the use of gesture, and even suggests that the painter study the signs used by the deaf.

154. In the *Deposition* painting, there are several figures dressed in contemporary Florentine clothing. One of them, kneeling, adores Christ. If we look closely, we can see that his head is surrounded by rays of gold. This is usually taken to be Blessed Alessio degli Strozzi (died 1383), an ancestor of the humanist Palla Strozzi, who commissioned the painting. His head bears a thin gold crown. Another figure (also with an aureole of gold rays, now barely visible) holds up the crown of thorns and the nails of the crucifixion to a man who crosses his arms on his breasts (usually a sign of humility), honoring them. I have not seen an adequate explanation for the identity of these figures. The clothing seems to indicate that they are not intended to represent contemporaries of the crucifixion; yet one holds the crown of thorns and the nails that have just been removed from Christ. The gold halos indicate sanctity; but their thin rays distinguish them from the solid halos of the other saints. The identification of Blessed Alessio (or Alessandro) degli Strozzi seems plausible; but he was a Dominican friar, the prior of Santa Maria Novella. Why should he be dressed in lay clothing? And why is there a crown on his head? Is it possible that he and the other haloed figure are meant to be present at the scene in the character of others who were involved with the cross or the relics of the crucifixion, such as Constantine or St. Louis of France (either of whom would explain the crown)?

155. One example is Angelico's own small crucifixion panel that stands at the bottom of the great altarpiece for the church at San Marco. In book illustrations throughout the century we find examples of more medieval-looking passion scenes. These include not only pictures by lesser artists, but also such accomplished works as Dürer's 1489 narrative and didactic woodcut.

156. Vasari attributes the invention of oil painting to Eyck (whom he calls Giovanni da Bruggia), Vasari, *Vite*, 3: 302. But this is certainly an exaggeration. Ghiberti says that Giotto already painted in oil (*lavorò a olio*), *I Commentari* (Napoli: Ricciardi, 1947), commentario secondo. Nevertheless, Eyck apparently introduced important innovations in the successful use of the medium.

157. The artist's real name appears to have been Master Mathis Neithardt, to which he later added Gothardt. For a brief discussion of what is known of his career, see Franziska Sarwey, "Afterword. Grünewald and the Isenheim Altar," in Gottfried Richter, *The Isenheim Altar: Suffering and Salvation in the Art of Grünewald* (Edinburgh: Floris Books, 1998), 59.

158. For a close study of the altarpiece as a whole in its historical context, see Andrée Hayum, *The Isenheim Altarpiece: God's Medicine and the Painter's Vision* (Princeton: Princeton University Press, 1989).

159. One of these paintings is now in Basel, Switzerland; the second in the National Gallery in Washington, D.C.; the third in Karlsruhe, Germany. While the

precise dates are uncertain, the Basel and Washington paintings are thought to have been completed before the Isenheim altarpiece (between 1501 and 1512), and the Karlsruhe version after it (1523–24).

160. A full discussion of the meaning of this crucifixion would have relate it to the paintings visible in other stages of opening the altarpiece, in particular the pre-della below (the lamentation over the dead body of Christ); the Annunciation, the mystery of the Incarnation (in which Mary holds the baby Jesus on the same torn cloth that we see as the loincloth in the crucifixion scene), and the Resurrection; and the shrine with the patron saints of the hospital in which the altarpiece was located.

161. Art historians sometimes use the term *imago pietatis* ("Man of Sorrows," *Schmerzensmensch*) to designate one specific type of representation, namely the por-trayal of the half-length figure of the dead Christ with his arms crossed over his abdomen. But the term is also used more widely, as I am using it.

162. For a detailed study of the early history and development of this image, see Hans Belting, *Das Bild und sein Publikum im Mittelalter: Form und Funktion früher Bildtafeln der Passion* (Berlin: Grbr. Mann Verlag, 1981).

163. Irenaeus of Lyon, *Contra Haereses*, book 1, ch. 25, PG 7a, col. 685.

164. The dating of the picture has been much discussed, with opinions ranging from 1430 to 1450. The medium is tempera and gold on a wooden panel. The picture was probably made for private meditation. But the possibility has been raised that it is the "volto santo" that was once located in Servite church of Santissima Annunziata in Florence. It currently belongs to the Parrocchia di Santa Maria del Soccorso, Livorno, and is on deposit in the Museo Civico Giovanni Fattori, Livorno. See Laurence Kanter, "Fra Angelico: Artistic Maturity and Late Career (1433–55)," in Kanter and Palladino, *Fra Angelico*, 172.

165. Ibid.

166. Ibid. Kanter states that this is the first known instance of a fusion of the Eyck-style portrait with the *sudarion* type image. Angelico's painting also shows af-finities with the *ecce homo genre*, although this normally shows at least the whole torso of Christ, and became popular only later in the century.

167. *Revelations*, Book VII, as quoted in ibid., 174.

168. Sant'Antonino, *Opera a ben vivere*, part 3, chap.11, quoted in Miklós Bos-kovits, *Immagini da meditare. Richerche su dipinti di tema religioso nei secoli XII–XV* (Milano, 1994), 138.

169. This is sometimes also true of representations of the *sudarium*, or Ver-onica's veil. See for example the double representation by the Master of St. Veronica (ca. 1420) in the National Gallery, London.

170. Gioacchino Barbera, *Antonello da Messina. Sicily's Renaissance Master* (New York: The Metropolitan Museum of Art; New Haven: Yale University Press, 2005), 25–26.

171. Image available at http://www.kfki.hu/~/arthp/html/m/memling/5late/38sorrow.html (accessed August 16, 2007).

172. Image available at http://www.wga.hu/frames-e.html?/html/m/masaccio/trinity/trinity.html (accessed August 16, 2007).

173. The painting is now in the Museum der Bildenden Künste, Leipzig. An image can be seen at the Web Gallery of Art: http://www.wga.hu/frames-e.html?/html/c/cranach/lucas_e/index.html (accessed August 17, 2007).

174. See in particular the fifteenth-century manuscript of the *Speculum Animae* from Valencia in the Bibliothèque Nationale Française, BNF Richelieu Manuscrits Espagnol 544.

175. Probably the most famous example of this type is the upper part of Raffaello's *Disputa del Sacramento* (1510–11) in the Stanza della Signatura of the Vatican.

176. It is notable that Aquinas's objection to the idea of the immaculate conception of Mary is based not on a rejection of the principle of maximal honor to her, but on philosophical grounds. Salvation from original sin could only be by means of the acceptance of grace. For the acceptance of grace, a person must be present. But Aquinas held the Aristotelian view that the human soul, and therefore the human person, was not present at conception, but only from the moment of "quickening" some weeks after conception.

177. For an extensive treatment of the debate over the immaculate conception, and a discussion of late medieval Mariology in general, see Oberman, *Harvest*, 281–322.

178. Oberman, *Harvest*, 290–91. Oberman remarks that history has proven Gregory right. The Immaculate Conception was declared a dogma of the Roman Catholic Church in 1854; the Assumption of Mary was defined in 1950.

179. The term *pietà* is sometimes also used for images in which Mary is not present or does not hold his body: the dead Christ appears by himself, with onlookers, sometimes including Mary (the "Man of Sorrows"); or held by angels; or in the arms of the Father (the "Seat of Mercy").

180. The skull probably first of all designates the name of the place of the crucifixion, Calvary ("place of the skull"). St. Jerome, the great Biblical authority for the Western church, rejected the legend that Adam was buried there. But the theological symbolism of Adam's skull remains valid, even without the legend: Christ's sacrifice reverses the sin of Adam, which brought death into the world.

181. Originally made for one of Michelangelo's earliest Roman patrons, the French cardinal Jean Villier (or Bilhères) de la Grolaie (or Lagraulas), the sculpture is now located in St. Peter's basilica.

182. This sculpture was commissioned probably for Cardinal Villier's tomb in the French chapel of St. Petronilla, located near St. Peter's; the chapel was destroyed when work began on the new basilica.

183. Alexander Nagel makes a point of mentioning the Byzantine theory of the presence of the Spirit to explain the life in Christ's dead body. See Alexander Nagel, *Michelangelo and the Reform of Art* (New York: Cambridge University Press, 2000), 17. Specifically, the theory had to do with blood flowing from the side of the corpse and with the preservation of Christ's body from corruption. But this theory was in fact unnecessary after the church decreed at Chalcedon that the divine Logos remained united to Christ's body after the soul departed.

184. Nagel, *Michelangelo*, 101.

185. In this regard I think Nagel is right to point to a similarity between Michelangelo's treatments of the passion, especially the London *Deposition*, and the *imago pietatis*. Nagel sees in Michelangelo a continuation of what he speaks of as the Renaissance tendency to place the "man of sorrows" icon into a historical setting, especially the deposition or lamentation. This of course would signify a change in the meaning of the icon, since the essence of the *imago pietatis* is to show Christ alive after the entombment, in a timeless "presence" of the passion; but it is at least true that certain Renaissance images have transferred some of the pictorial features of the *imago pietatis* into narrative contexts. See Nagel, *Michelangelo*, 54–57.

186. Oberman, *Harvest*, 311.

187. Biel, *Canonis Misse Expositio*, 99.

188. Biel, *Canonis Misse Expositio*, 99.

189. Ibid., 103.

190. Ibid., 104.

191. Girolamo Savonarola, *Il Sacramento e i misteri della Messa* in *Guida Spirituale* 1: 292–93.

192. Girolamo Savonarola, *Semplicità della Vita Cristiana*, in *Guida Spirituale*, 1, 76–77. Savonarola notes that the priests of his day, who receive the sacrament frequently, but without devotion, are "worse than the laity."

193. Girolamo Savonarola, "La Comunione Frequente," in *Guida Spirituale* 1: 204–5. Savonarola cites receiving communion frequently (*spesso*) as the first rule for living in a Christian way during times of troubles, but without specifying what he means by "frequently." Here also he insists on confession before communion, "Nel tempo delle tribolazioni," in *Guida Spirituale*, 1: 189.

194. Girolamo Savonarola, "Regola del Vivere Cristiano," in *Guida Spirituale* 1: 177.

195. Baxandall, *Painting and Experience*, 71.

196. The performances of the *Confrèrie de la Passion* in Paris were ended in 1548 because of Protestant opposition. Most of the plays met a similar fate during the course of the sixteenth century.

197. Baxandall, *Painting and Experience*, 72.

198. For an overview see s.v. "Passion" in *The Grove Concise Dictionary of Music* (London: Macmillan, 1988).

199. "Cujus sanguine delicta nostra deleta sunt, solemniter legitur passio, solemniter celebratur; ut annua devotione memoria nostra laetius innovetur, et ipsa frequentatione populorum fides nostra clarius illustretur," *Sermo CCXVIII*, ch. 1, PL 38, 1084.

200. *Egeria and Her Travels*, trans. Robert E. Van Voorst, in Robert E. Van Voorst, ed., *Readings in Christianity*, 2nd ed. (Belmont, Calif.: Wadsworth, 2001), 83. Original text: *S. Silviae Peregrinatio* in *Corpus Scriptorum Ecclesiasticorum Latinorum*, vol. 39, edited by Paul Geyer (Vienna: Teubner, 1900), 3–747.

201. Karl Heinz Schlager, s.v. "Passion. A.," MGG 7, 1454.

202. Herbert Thurston, "Devotion to the Passion of Jesus Christ," s.v. "Passion" in *The Catholic Encyclopedia* (1913), available at www.newadvent.org/cathen/11527b.htm.

203. A more technical description is given by Joseph Otten, "Passion Music" in *The Catholic Encyclopedia* (1913):

The juxtaposed melodic phrases extend over an ambitus, or compass of the whole of the fifth and two tones of its plagal, or the sixth mode. The evangelist, or *chronista*, moves between the tonic and the dominant, while the *suprema vox*, representing the crowd, etc., moves between the dominant and the upper octave. The tones upon which the words of our Lord are uttered are the lower tetra-chord of the fifth mode with two tones of the sixth. Later the fourth tone of the fifth mode, b, was altered into b flat, to avoid the tritonus between the tonic and the fourth. (Online: www.newadvent.org/cathen/11525a.htm)

For an example of the chanting of the Passion: *Death and Resurrection: Gregorian Chant for Good Friday, Easter Sunday and Ascension Day*, Benediktinerabtei Münsterschwarzach, conducted by Fr. Godehard Joppich, O.S.B., Archiv Produktion CD 427 120-2, (1989). According to the notes by Fr. Joppich, the Passion tone used in this recording is that officially established in Rome in 1917. It represents a simplification of the original tones, and is thus not "authentic;" but it "gives an impression of the oldest type of chant used in divine service: liturgical 'recitative'."

204. Kurt von Fischer, *Die Passion. Musik zwischen Kunst und Kirche*. Kassel: Bärenreiter; Stuttgart: Metzler, 1997), 24.

205. Ibid., 25.

206. "Verba vero impiissimorum Judeorum clamorose et cum asperitate vocis ... loquebantur." Quoted in von Fischer, *Die Passion*, 1458.

207. Schlager, "Passion," 1453.

208. Von Fischer, *Die Passion*, 1457.

209. Schlager, "Passion," 1453.

210. The music is found in the "Windsor" Manuscript (Egerton 3307). A recording of this work is available, along with the Mass of Tournai, sung by the group Tonus Peregrinus, Naxos CD 8.555861, (2003).

211. "In commemorationem infidelium ... horribilium Judeorum," quoted in Von Fischer, *Die Passion*, 1458.

212. Ibid., 35.

213. See the notes by Ulrich Mehler to the recording *Bordesholmer Marienklage*, performed by the group Sequentia, Deutsche Harmonia Mundi CD 05472 77280 2, (1993).

214. Johannes Reborch, "Nota" to the text of the *Bordesholmer Marienklage*, in ibid., 10.

215. Johannes Reborch, *Bordesholmer Marienklage*, transcribed by Ulrich Mehler, translated by Ian Wiltshire and Leyla Turkay, ibid., 17.

216. Ibid., 23.

217. Ibid., 24. My translation.

218. Ibid., 35.

219. Ibid., 37.

220. Ibid., 44. My translation.

221. Ibid., 56. My translation.

222. Ibid., 29. My translation.

223. Ibid., 57. My translation.

224. See Hans Belting, *Likeness and Presence: A History of the Image before the Era of Art*, trans. Joseph Jephcott (Chicago: University of Chicago Press, 1994).

225. For a number of examples, see Baxandall, *Painting and Experience*, 48–56.

226. Helmut Feld, *Der Ikonoklasmus des Westens* (Studies in the History of Christian Thought 41: Leiden: E. J. Brill, 1990), 75.

227. Netter adds that God does not communicate "divinity" (*numen*) itself to images: "Virtutem hanc Deus his sanctis picturis aut sanctis reliquiis certe communicat; non autem numen, quod potius Divinitatem ipsam secundum naturam, aut eius maiestatem designat," *Thomae Waldensis Carmelitae Anglici Doctrinale Anntiquitatum Fidei Catholicae Ecclesiae adversus Wiclefitas et Hussitas*, ed. Bonaventura Blanciotti (Venice: 1757–59), 971f., quoted in Feld, *Ikonoklasmus*, 96n53.

228. Mitchell B. Merback, *The Thief, the Cross and the Wheel: Pain and the Spectacle of Punishment in Medieval and Renaissance Europe* (Chicago: University of Chicago Press, 1998), 288.

229. Ibid.

230. Ibid., 272.

CHAPTER 2

1. Joseph Leo Koerner, *The Reformation of the Image* (Chicago: University of Chicago Press, 2004), 229–230.

2. Koerner, *Reformation*, 238–239.

3. Leo Steinberg, *The Sexuality of Christ in Renaissance Art and in Modern Oblivion* (New York: Pantheon, 1983), 93.

4. Located in Dresden.

5. The painting is now in the Uffizi gallery in Florence.

6. The original of this drawing is in the Kunsthalle, Hamburg. Note not only the floating end of Orpheus's cloak, but also the billowing open dress of the woman on the left, and the scroll-like ribbons on the sleeve of the woman on the right. Obviously, there are cases where the floating drapery can indicate either wind or motion, as, for example, in Dürer's engraving of *Apollo and Diana* (1502), where Apollo's hair flows in the same direction as the two ends of the long cloth that holds his quiver. On the other hand, there are cases where the billowing or flowing cloth occurs in a setting where everything else appears still, or where the flowing goes in opposite directions (for example in the dry point illustration of *Death and the Youth* by Dürer's older anonymous contemporary called the Housebook Master).

7. This is not to say, of course, that the artist was necessarily explicitly thinking in these terms. A great deal in religious art is done simply by convention, and as we have seen, billowing cloth could often be used simply as a decorative element (although it seems most frequently used in conjunction with mythical or supernatural

figures). But the fact that the coverings of the thieves (which in Northern Renaissance images are frequently more like a kind of underwear) normally do not exhibit this strange decorative billowing seems to testify to its character as a signifier of Christ's meaning, even if there was no specific symbolic point explicitly present in the artist's mind. (There are of course exceptions. In a painting by Hans von Aachen of about 1517 both thieves wear clothing one a loincloth, the other a kind of long shirt that blows and billows in an apparent wind, in the same direction as the banner on a soldier's lance. Interestingly, in this case Christ's loincloth flows in the opposite direction.)

8. "Ergo in Christo crucifixo est vera theologia et cognitio Dei." WA 1:362, 15, 23. (Citations from the *Weimar Ausgabe* will normally include volume, page, and line numbers, where appropriate.)

9. WA 5:42, 8:45, 30, 38. Cited in Paul Althaus, *Die Theologie Martin Luthers*. (Gütersloh: Gütersloher Verlagshaus Gerd Mohn, 1962), 38.

10. Althaus, *Die Theologie Martin Luthers*, 36–37.

11. Althaus lists the following as the major sources for Luther's understanding of suffering of Christ on the cross: *Sermon von der Betractung des heiligen Leidens Christi* (1519): WA 2, 136ff.; *Sermon von der Bereitung zum Sterben* (1519): WA 2, 685ff.; the interpretation of Ps. 22 in the *Operationes in Psalmos* (1521): WA 5, 598ff.; the exegesis of Gal. 3:13 in the *Grossen Galaterkommentar* (1535): WA 40 I, 432ff.; *Predigt über das vierte Kreuzeswort* (1525): WA 17, I, 67ff.

12. *Der große Katechismus deutsch nach der Fassung des deutschen Konkordienbuches* (Dresden, 1580). My translation. Online at http://www.achimkh.net/luther/luther_-cabs.html. For an English translation of the whole document, see *The Large Catechism*, translated by F. Bente and W. H. T. Dau, in: *"Triglot Concordia: The Symbolical Books of the Ev. Lutheran Church"* (St. Louis: Concordia Publishing House, 1921), 565–773.

13. *Epistle Sermon, Twenty-fourth Sunday after Trinity* (Lenker Edition, vol. 9, nos. 43–45), quoted Hugh Thomson Kerr Jr., ed. *A Compend of Luther's Theology* (Philadelphia: Westminster, 1943).

14. Although Luther says "we will not tolerate the word 'satisfaction' in our schools or preaching," he is here referring to the traditional use of the word as an aspect of penance. With regard to Christ's work, he generally avoids the Latin word for polemical reasons; but he frequently uses the German equivalents *genugtun* and *Genugtuung*: WA 10 I:, 1, 720, 18; 10 III: 49, 10f.; 17 II: 291, 7; 29: 578, 4; 579, 5; 30 I: 187, 2; 40 II: 405, 28-30; 31 II: 339, 14; 39 I: 46, 11. On the other hand, this word is not enough to designate all that Christ accomplishes by his passion. Althaus, 178n., 193.

15. "... Dass Gottes Sohn für uns steht und alle unsere Sünde auf seinen Hals genommen hat und ist die ewige Genugtuung für unsere Sünde und versöhnet uns vor Gott dem Vater," WA 10 III: 49, 10, quoted in Althaus, *Die Theologie Martin Luthers*, 178n7.

16. WA 40; LW 26. Quoted in in Timothy Gorringe, *God's Just Vengeance: Crime, Violence and the Rhetoric of Salvation* (Cambridge: Cambridge University Press, 1996), 133.

17. Gerard S. Sloyan, *The Crucifixion of Jesus. History, Myth, Faith* (Minneapolis: Fortress, 1995), 148–49.

18. Henry Nutcombe Oxenham, *The Catholic doctrine of the atonement: an historical review, with an introduction on the principle of theological developments* (London: W. H. Allen, 1895), 231

19. "Omnes homines . . . sunt peccatores vere. Hoc ipsum deus per prophetas testatus est et tandem per passionem Christi idem probavit; quia propter peccata hominum fecit eum pati et mori," W 3: 287–8; cf. W 3:171 and 174; "Ignoravit enim omnis homo se esse sub ira dei, donec evangelium veniret et eam manifestaret," WA 4: 50; 4: 310.

20. "Justitia enim dei ipse deus est," WA 6:127, 37, quoted in Althaus, 151n3.

21. WA 32:328, 37, quoted in Althaus, *Die Theologie Martin Luthers*, 152n10.

22. WA 40 II: 417, 11, quoted in Althaus, *Die Theologie Martin Luthers*, 152n10.

23. WA 42: 356, 23, quoted in Althaus, *Die Theologie Martin Luthers*, 152n13.

24. "Deus enim nos non per domesticam sed per extraneam justitiam et sapientiam vult salvare, non quae veniat et nascatur ex nobis, sed quae aliunde veniat in nos, non quae in terra nostra oritur, sed quae de caelo venit." WA 56:158, 10.

25. "Ideo recte dixi, quod extrinsecum nobis est omne bonum nostrum, quod est Christus . . . Quae omnia in nobis sunt non nisi per fidem et spem in ipsum." WA 56:276.

26. "Non sic gratis dat gratiam, ut nullam satisfactionem exegerit, sed satisfactorem Christum pro nobis dedit, ut sic satisfacientibus per alium ipsis tamen gratis gratiam daret . . . 'Quem proposuit deus' (i.e. ab aeterno ordinavit et nunc ita posuit 'propitiatorium per fidem' (i.e., ut sit propitiatio pro peccatis, sed non nisi credentibus), quia per incredulitatem propitiatorium potius in tribunal et judicium mutatur 'in sanguine ipsius,' quia non voluit hoc propititatorium nobis fieri, nisi per sanguinem prius pro nobis satisfaceret. Ideo in sanguine suo factus est propitiatorium credentibus." WA 56: 269.

27. "Wir könnten also—theoretisch gesehen—mit Christus eins sein im Glauben, ohne dass er hun hülfe, wenn nicht der Vater Christi diese Gerechtigkeit für unsre, von Gott geschenkte Gerechtigkeit erklären würde," quoted in Erich Seeberg, *Luthers Theologie* (Darmstadt: Wissenschaftliche Buchgesellschaft, 1969), 2: 96.

28. WA 40 I: 440, 10,31. Quoted in Althaus, *Die Theologie Martin Luthers*, 186.

29. Althaus, *Die Theologie Martin Luthers*, 184.

30. Disputation 280; quoted in Seeberg, *Luthers Theologie*, 2: 407. "Sic duplex his erit justitia, perfecta, quae est imputatione perfecta, imperfecta, quae per suam naturam ita est, et haec est ex operibus nostris, non ex fide." Disputation 149; quoted in Seeberg, *Luthers Theologie*, 2: 408.

31. WA:40; LW 26, quoted in Gorringe, *God's Just Vengeance*, 133.

32. David Hotchkiss Price, *Albrecht Dürer's Renaissance: Humanism, Reformation, and the Art of Faith* (Ann Arbor: University of Michigan Press, 2003), 243.

33. "Sacramentum passionis Christi est mors et remissio peccatorum; exemplum autem est imitatio poenarum eius. Ideo qui Christum vult imitari quoad exemplum, necesse est, ut credat primum firma fide Christum pro se esse passum et mortuum quoad sacramentum. Vehementer ergo errant, qui peccata delere parant primumper

opera et labores poenitentiae velut ab exemplo incipientes, cum deberent a sacramento incipere." WA 57 III: 114.

34. WA 3: 463, 38.

35. "Credunt passum et mortuum, sed nolunt imitari nec illius passionem suam facere; hoc autem certe durissimum est, quia sensibilissimum," WA 1: 125.

36. "Sequitur caritas...sc. Christum mortalem et passum confiteri, viva confessione passionem et mortem eius in semet ipso exprimere, ut, sicut ille mortuus est, ita et ipse libentissime mori velit, WA 1: 123; cf. WA 4: 653.

37. LW 35: 361.

38. Aulén sees Luther's theology as embodying primarily the "classical" soteriology of the victory of God over sin and death, even though he acknowledges that Luther also affirms the idea of penal substitution. See Aulén, 101–122.

39. Althaus, *Die Theologie Martin Luthers*, 183–184. See WA 17 II: 292, 7; WA 2: 691, 20.

40. Althaus, *Die Theologie Martin Luthers*, 184.

41. *Table Talk*, #197, in Kerr, *A Compend of Luther's Theology*.

42. "Nunc mysteria. Primum de Christo, qui egressus est de ore diaboli, qui eum devoravit; ipse enim est cibus noster, pascha nostrum, panis noster de coelo descendens. Comedit eum leo, et nisi eum comedisset, nobis non fuisset egressus cibus animae nostrae. Sec nec exisset, nisi occidisset leonem. Occiso autem eo, factus est in ore eius favus mellis, qui sic oportuit pati Christum et exire de ore leonis per resurrectionem...," WA 1: 59, 83.

43. "Hoc per fidem recipto statim initur duellum maximum, committuntur invicem fortissimi gigantes, qui vel totum mundum devorarent, sc. Duae mortes, mors ipsa et mors Christi. Sed statim exclamat Christus: mors mortis, infernus inderni, diabolus diaboli, ego sum...ego vici." WA 39: 1, quoted in Seeberg, *Luthers Theologie* 2: 402.

44. "Ut faciat opus suum alienum opus eius ut oparetur opus suum peregrinum est opus ab eo" (Is. 28:21).

45. See Odo Cluniacensis, *Sancti Odonis Abbatis Cluniacensis II Collationum Libri Tres*, PL,133.

46. "Ecce ad hoc ipsum opus suum proprium non potest pervenire, nisi assumat opus alienum et contrarium sibi, ut Is. 28..., ut operetus opus suum: alienum autem opus est facere peccatores, injustos, mendaces, tristes, stultos, perditos, non quod revera tales ipse faciat, sed quod superbia hominum, cum tales sint, adeo nolit tales fieri aut esse, ut deus maiori tumultu, immo solum hoc opere utatur, ut eos ostendat tales esse, ut fiant id in oculis suis, quod sunt in oculis dei. Igitur cum non possit justos facere nisi eos, qui non sunt justi, cogitur ante proprium opus justificationis laborare alieno opere, ut faciat peccatores. Sic dicit: Ego occidam et vivificabo, ego percutiam et sanabo. Huic autem alieno operi, quod est crux Christi et mors Adae nostri, vehementissimi inimici sunt, qui se justos et sapientes et aliquid esse existimant," WA 1: 112, 94–95.

47. "Die Christen sint dei 'facta dei,' die Gott zu dem, was sie sind, gemacht hat, indem er zuerst 'das fremde Werk' der Busse und Bestrafung, und dann 'das eigene

Werk' der Liebe und der Lebendigmachung an hinen durchführt, wie es urbildlich an Christus geschehen ist," WA 1: 112, 94.

48. "Utitur quidem Deus diabolo ad affligendos nos et accidendos, sed Diabolus id not potest, nisi Deus hoc modo vellet puniri peccatum," WA 40 III, 519, 13, quoted in Althaus, *Die Theologie Martin Luthers*, 150n27.

49. "Nam et Christus plus quam omnes sancti damnatus est et derelictus. Et non, ut aliqui imaginantur, facile fuit passus. Quod realiter et vere se in aeternam damnationem obtulit deo patri pro nobis. Et humana eius natura non aliter se habuit quam homo aeternaliter damnandus ad infernum. Propter quam caritatem eius in deum deus statem eum suscitavit a morte in inferno et sic momordit infernum..." WA 56: 391-392.

50. See WA 37: 59, 24; 8: 519, 9. Cited in Altaus, *Die Theologie Martin Luthers*, 179.

51. Luther's collaborator Melanchthon revised Luther's position, understanding the descent into hell in more traditional terms as the triumphal entry of Christ into hell (the medieval "harrowing of hell"): Christ shows the powers of hell his superior power. Later Lutheran orthodoxy remained true to Melanchthon rather than Luther: the descent into hell is the first act of the raising of Christ. Althaus points out the irony that when Lutherans polemicized against the Reformed (Calvinist) understanding of the descent into hell, they were unwittingly criticizing Luther's own position, Althaus, *Die Theologie Martin Luthers*, 182.

52. "Quia non credo, quod Christus fuerit in inferno damnatorum ullo modo," WA 4: 23.

53. "Sic et Christus in ultima et maxima passione sua maxime aestuavit charitate. Immo secundum b. Hilarium summo gaudio gavisus fuit se summo dolore dolere. Sic enim mirabilis deus est in sanctis suis, ut summe dolentes simul summe gaudere faciat." WA 56: 289.

54. Althaus, *Die Theologie Martin Luthers*, 186, 188.

55. Philip Melanchthon, *Loci Communes Rerum Theologicarum seu Hypotyposes Theologicae*, ed. Hans Engelland, in *Melanchthons Werke in Auswahl*, ed. Hubert Stupperich, vol. 2, part 1 (Gütersloh, C. Bertelsmann Verlag, 1952).

56. Melanchthon, *Loci Communes*, 67.

57. In summa, non aliud est gratia nisi condonatio seu remissio peccati," Melanchthon, *Loci Communes*, 87.

58. Melanchthon, *Loci Communes*, 88. Melanchthon here expressly rejects as unscriptural the scholastic distinctions between faith that is informed by love and that which is not, as well as distinctions between "infused" and "acquired" faith, and other such "inventions" of theology. Such distinctions are found prominently in the theology of Gabriel Biel, for example (see for example *In sent. Lib. III*, distinction 23, q. 2). Here we also find the principal theological complaint against scholastic theology: it substituted human acts of satisfaction for faith ("Scholastica theologia pro fide, pro ancora conscientiarum opera, satisfactiones hominum docuit"), ibid., 93. Not surprisingly, Melanchthon rejects also the nominalist "Pelagian" opinion about the goodness of human free acts prior to "justification." They are not a predisposition to salvation; on the contrary, they are all cursed fruits of a cursed tree ("Quid igitur

opera, quae praecedunt iustificationem, liberi arbitrii opera? Ea omnia maledictae arboris maledicti fructus sunt"), ibid., 107–108.

59. "[Petrus] credit pro se Christum victimam ac satisfactionem fuisse, adeoque nullo opere suo, sed simpliciter misericordia dei fidit, quam in Christo pollictus est," ibid., 99.

60. "Porro bonam voluntatem meruit Christus, quem pro nobis intercessorem, quem pro nobis victimam et satisfactionem dedit," ibid., 106.

61. Philip Melanchthon, *Loci Praecipui Theologici* (1559), part 1, ed. Hans Engelland, in *Melanchthons Werke in Auswahl*, ed. Hubert Stupperich, vol. 2, part 1 (Gütersloh, C. Bertelsmann Verlag, 1952), 202.

62. Philip Melanchthon, *Loci Praecipui Theologici* (1559), part 1, ed. Hans Engelland, in *Melanchthons Werke in Auswahl*, ed. Hubert Stupperich, vol. 2, part 1 (Gütersloh, C. Bertelsmann Verlag, 1952), 198 and *passim*.

63. English translation available in Robert Kolb, Timothy J. Wengert, and Charles P. Arand, *The Book of Concord: The Confessions of the Evangelical Lutheran Church* (Minneapolis: Fortress, 2000), 107–294.

64. Melanchthon, *Apologia Confessionis Augustanae*, article III, §46–50.

65. Ibid., Article IV, §52.

66. Ibid., Article IV, §53, 57.

67. Ibid., Article IV, §79.

68. Ibid., Article IV, §103.

69. John Calvin, *Institutes of the Christian Religion*, book II, ch. 12.

70. Ibid., book II, ch. 12.

71. Ibid., book II, ch. 12. See also the *Heidelberg Catechism*, Question 40.

72. Ibid., book II, ch. 16.

73. Ibid., book II, ch. 16.

74. Ibid., book II, ch. 16. See also the *Heidelberg Catechism*, Question 34.

75. Ibid.

76. Ibid.

77. Ibid., ch. 17.

78. Ibid. II, ch. 12.

79. Ibid., ch. 17. Language has been slightly updated. See also the *Heidelberg Catechism*, Question 39.

80. Ibid. See also the *Heidelberg Catechism*, Question 44.

81. Ibid., ch. 16.

82. Ibid., book I, ch. 18.

83. "Therefore when we treat of the merit of Christ, we do not place the beginning in him, but we ascend to the ordination of God as the primary cause, because of his mere good pleasure he appointed a Mediator to purchase salvation for us. Hence the merit of Christ is inconsiderately opposed to the mercy of God. It is a well-known rule, that principal and accessory are not incompatible, and therefore there is nothing to prevent the justification of man from being the gratuitous result of the mere mercy of God, and, at the same time, to prevent the merit of Christ from intervening in subordination to this mercy. The free favour of God is as fitly opposed

to our works as is the obedience of Christ, both in their order: for Christ could not merit anything save by the good pleasure of God, but only inasmuch as he was destined to appease the wrath of God by his sacrifice, and wipe away our transgressions by his obedience: in one word, since the merit of Christ depends entirely on the grace of God, (which provided this mode of salvation for us,) the latter is no less appropriately opposed to all righteousness of men than is the former." Ibid., ch. 17.

84. Ibid.

85. Ibid., book II, ch. 16. See also the *Heidelberg Catechism*, Question 45.

86. Ibid., book III, ch. 8

87. *Der Heidelberger Katechismus. Von Gott dem Sohn.* My translation from the German text of 1563, which is available online at http://www.ubf-net.de/heidelberg/hdkat/hdkat2b.htm#34. There is also a Latin version, done at the same time as the German. An English translation of the entire text is available at www.crcna.org/pages/heidelberg_son.cfm.

88. *Formula Concordiae.* I. *Von der Erbsünde.* The German text of the Concordienformel is available at: http://www.glaubensstimme.de/bekenntnisse/concordienformel/104.html.

89. Ibid., VIII. *Von der Person Christi,* § 9.

90. Arnold Hauser, *Mannerism: The Crisis of the Renaissance and the Origin of Modern Art* (Cambridge: Harvard University Press, 1986), 79.

91. "Et patet quod ymagines tam bene quam male possunt fieri: bene ad excitandum, facilitandun et accendendum mentes fidelium, ut colant devocius Deum suum; et male ut occasione ymaginum a veritate fidei aberretur, ut ymago illa vel latria vel dulia adoretur, vel ut in pulcritudine, preciositate aut affeccione impertinentis circumstancie minus debite delectetur," John Wyclif, *Tractatus de mandatis divinis. Accedit Tractatus de statu innocencie,* ed. Johann Loserth and F. D. Matthew (Wyclif's Latin Works; London: published for the Wyclif Society by C. K. Paul, 1922), 156.

92. Ibid.

93. "In secundo errant plurimi putantes aliquid numinis esse subiective in ymagine, et sic uni ymagini plus affecti quam alteri adorant ymagines, quod indubie est ydolatria," ibid.

94. "*Si diligenter verba legis attendimus, non prohibetur facere ymagines rerum, sed facere ista ydolatrandi gracia.*" Ibid., 159.

95. Held, *Ikonoklasmus*, 89–90.

96. See especially Girolamo Savonarola, *De simplicitate Christianae vitae*, ed. Pier Giorgio Ricci (Rome: Edizione nazionale delle Opere di Girolamo Savonarola, 4, 1959); the Italian translation by Savonarola's friend Girolamo Benivieni, appeared in the same year as the original (1496): *Semplicità della vita cristiana* in Girolamo Savonarola, *Guida Spirituale*, vol. 1, *Vita Cristiana*, ed. Fra Enrico Ibertis, OP, and Fra Gundisalvo Odetto, OP (Turin: R. Berruti, 1952 [1492]).

97. Feld, *Ikonoklasmus*, 104, 110–111.

98. "Nihil erit, quod Christum expressius ac verius repraesentet quam euangelicae litterae," *Moriae Encomium id est Stultitiae Laus*, ed. Clarence H. Miller (Amsterdam: NorthHolland, 1979), 323–324.

99. Gerardus Van der Leeuw, *Sacred and Profane Beauty*, 185.

100. Feld, *Ikonoklasmus*, 118.

101. Koerner, *Reformation*, 85.

102. However, as Feld points out, it was normal for the rules of such disputations to specify that only arguments from Scripture would be permitted; hence the Reformed principle of "Scripture alone" was accepted beforehand, and any other argument ruled out of court. Frequently no representative of the Catholic position could be found who would accept disputation under such conditions. See Feld, *Ikonoklasmus*, 138–182, for a thorough summary of these disputations.

103. Andreas Karlstadt, *Von abtuhung der Bylder / und das keyn Betdler unther den Christen seyn sollen* (Wittenberg, 1522). Although the name of this early supporter of Luther was Bodenstein, he is frequently referred to as "Karlstadt," from his city of origin.

104. "Ob einer dörfft sagen, Ja ich bette die bilder nit an. Ich thün in nit eere von iren wegen / sonder von der heiligen wegen, die die bedeüten. Antwurt got kürtzlich und mit leichten worten. Du solt sie nit anbetten. Du solt sie nit eeren...Wann ichs haben wolt spricht got / dastu mich oder meine heiligen / soltest in bildnis eeren / ich wolt dir es nit verbotten haben / bildnis und gleichnis zümachen." ("If someone should say, 'Yes, but I don't pray to the images. I do not honor them for their own sake, but for the sake of the saints that they represent. God answers shortly and simply: 'You must not pray to them. You must not honor them...If I had wished,' God says, 'that you should honor me or my saints in images, I would not have forbidden you to make images and likenesses,'" ibid., quoted in Feld, *Ikonoklasmus*, 119n2.

105. Feld, *Ikonoklasmus*, 119.

106. *Von Anbetung und Ehrerbietung der Zeichen des Neuen Testaments* (Augsburg: Melchior Ramminger, 1521). Sometimes referred to in English as "The Controversy of the Chalice."

107. Ludwig Hätzer, *Ain urtayl Gottes unsers eegemahels / wie man sich mit allen Götzen und Bildnussen halten soll auß der hayligen geschrifft gezogen durch Ludwig Hätzer* (Zürich: Getruckt durch Christophorum froschower, 1523).

108. "Es sind ouch die heymichen bild verbotten," ibid., quoted in Feld, *Ikonoklasmus*, 121.

109. Ulrich Zwingli, "*De vera et falsa religione comentarius*" (1525), quoted in Feld, *Ikonoklasmus*, 125n35.

110. Feld, *Ikonoklasmus*, 127

111. "Wo sy nit vereret werdend, ist nieman wider bilder und gemäld," (Z V, 191, 15). Quoted in Feld, *Ikonoklasmus*, 148n135.

112. Ulrich Zwingli, "Notizen und Voten Zwinglis an der Berner Disputation" (Z VI/1, 318), quoted in Feld, *Ikonoklasmus*, 152n153.

113. Ibid., 129–30.

114. John Calvin, *Institutes of the Christian Religion*, trans. Ford Lewis Battles, book I, ch. 11–12, n. 109, in John T. McNeill, ed., *The Library of Christian Classics* (Philadelphia: Westminster, 1960), vol. 21.

115. "Nam quod legentibus scriptura, hoc idiotis praestat pictura cernentibus, quia in ipsa ignorantes vident quod sequi debeant, in ipsa legunt qui litteras nesciunt...," Ep. "Litterarum tuarum primordia," DS 477.

116. "Itaque qui rite Euangelii ministerio defungi volent, discant non tantum loqui et declamitare, sed etiam penetrare in conscientias, ut illis Christus crucifixus sentiatur et sanguis eius stillet," *Johannis Calvini Commentarii in quatuor Pauli Epistolas: ad Galatas, ad Ephesios, ad Philippenses, ad Colossenses* (Geneva: Per I. Girardvm, 1548), quoted in Feld, *Ikonoklasmus*, 136.

117. Feld, *Ikonoklasmus*, 137.

118. As an instance of this secularizing trend, Koerner cites the case of the knight Franz von Sickingen, a "predatory baron and outlawed destroyer of cities in France, the Palatinate, and Hesse" who in 1522 confessed the evangelical faith. (Although Koerner calls Sickingen a "baron," he did not have this title. He was a knight of the empire, and for his services was raised to the status of imperial counselor. It was his son, also called Franz, who received the title of *Reichsfreiherr* or "baron.") In addition to some unsavory qualities, Sickingen had a reputation for helping the poor. He took an interesting position on the question of images. He remarked that the common people saw in them "art, beauty and luxury." This, like Savonarola, he thought was a distraction from worship. But unlike Savonarola, he did not judge that the images should therefore be burned; rather, he said, "they might be more useful in beautiful chambers as ornaments than in the church..." As Koerner remarks, we can see in this attitude the beginning of the secularization in which "images become neutral objects of aesthetic experience," *Reformation*, 59.

119. Koerner, *Reformation*, 129.

120. Koerner, *Reformation*, 132.

121. Ibid., 131–34. Koerner supplies several period illustrations of the destruction of crucifixes. Ibid., 128–29.

122. Koerner, *Reformation*, 138. The use of the cross to ward off the devil is attested from quite early. See for example the *Catechesis* of Cyril of Jerusalem (died 386), lecture 14 (PG 33, 77).

123. Koerner, *Reformation*, 127.

124. Luther, "Von den guten Werken" (1520), WA 6: 239, 13; "Epistel am St. Stephans-Tage," Apg 6, 8–14, WA 10 I: 254, cited in Feld, *Ikonoklasmus*, 122.

125. Feld, *Ikonoklasmus*, 122, 123.

126. WA 10 III: 35.

127. WA 18: 83, quoted in Koerner, *Reformation*, 42.

128. "Eyn crucifix aber odder sonst eyns heyligen bilde ist nicht verbotten zu haben," in "Wider die himmlischen Propheten, von den Bildern und Sakrament," WA 18: 37; 214, 68; quoted in Feld, *Ikonoklasmus*, 122–23.

129. "Bilder, glocken, messegewand, kichenschmuck, aller liecht und der gleichen, halt ich frey. Wer da will, der mags lassen, Wie wol bilder aus der Schrift und von guten Historien ich fast nützlich, doch frei und wilkörig halte. Denn ichs mit den bildestürmen nicht halte," in "Vom Abendmahl Christi" (1528), WA 26, 509; quoted in Feld, *Ikonoklasmus*, 123.

130. Koerner, *Reformation*, 159.

131. Luther, *Against the Heavenly Prophets* (WA 18: 83; LW 40: 99–100), quoted in Koerner, 160.

132. Ulrich Köpf, "Passionsfrömigkeit" in *Theologische Realenzyklopädie*, ed. Gerhard Müller (Berlin: Walter de Gruyter, 1997), 27: 722–64.

133. Koerner, *Reformation*, 85.

134. Luther, *Sermones de passione Christi* (WA 1: 336–345).

135. Martin Luther, *The Sermons of Martin Luther* (Grand Rapids: Baker Book House, 1906), 2: 183–85. (Translation has been slightly modified.)

136. Ibid., 187.

137. Ibid., 189.

138. Ibid.

139. Ulrich Köpf, "Passionsfrömigkeit," 722–64.

140. Luther likewise approved of and praised the spirit of Savonarola. He contributed a preface to a publication of the latter's "prison" meditations on the Psalms in 1523. However, he interprets Savonarola after his own spirit; he writes that the reader should find in Savonarola's meditations "how necessary is a solid faith in the mercies of God, [faith] alone and without any works" ("quam necessaria sola et solida fides misericordiae dei sine omnibus operibus"), "Begleitwort zu Savonarolas *Meditatio pia*," WA 12: 248.

141. According to Althaus, Luther remained constant throughout his life in his critique of the old form of passion piety as leading to a theology of "works," *Die Theologie Martin Luthers*, 751.

142. Luther, "True and False Meditation" in *Sermons*, 192.

143. For a concise review of the state of the question and scholarship regarding Dürer's religious views, see Donald A. McColl, "Through a Glass Darkly: Dürer and the Reform of Art" in *Reformation and Renaissance Review* 5 (2003): 54–91. See Appendix 1, "The Religion of Dürer," for a brief summary of the question.

144. The "cause" for Savonarola's canonization is still pending in Rome.

145. For an overview of Dürer's life and career, see Erwin Panofsky, *The Life and Art of Albrecht Dürer*. With a new introduction by Jeffrey Chipps Smith. (Princeton: Princeton University Press, 2005 [1943]), 3–14.

146. Panofsky, *The Life and Art of Albrecht Dürer*, 34.

147. See the prefatory letter to Dürer, *Underweysung der Messung* (Nuremberg, 1538), in which he explicitly repeats this claim of the Italian humanists. A photographic reproduction of the work, along with Dürer's *De Symmetria Partium in Rectis Formis Humanorum Corporum* (Nuremberg, 1532), in a volume from the library of Emperor Rudolf II, is available on CD-ROM: commentary and narrated by David Price, trans. Silvio Levy (Oakland, Calif: Octavo, 2003).

148. Panofsky, *The Life and Art of Albrecht Dürer*, 118.

149. Price, *Albrecht Dürer's Renaissance*, 9.

150. Panofsky, *The Life and Art of Albrecht Dürer*, 30.

151. Panofsky, *The Life and Art of Albrecht Dürer*, 230. This comparison to rhetorical styles is sometimes taken as an evaluation of the worth of the artists or their

works. But should it be? Or is it more directly only an indication of their respective purposes and audiences? A high-flown rhetorical style (*genus grande*) is not always better, and indeed is not appropriate to most circumstances. Cranach's works are more accessible to a large popular audience, while Dürer's are more appealing to the connoisseur. But does this necessarily indicate a superiority of Dürer over Cranach, especially if the purpose of the art is evangelization?

152. Ibid, 42. Panofsky is referring to Dürer's famous painting of himself as a young man. Dürer had earlier done a remarkable drawing of himself as a young teenager.

153. Ibid, 43.

154. Quoted in Panofsky, *The Life and Art of Albrecht Dürer*, 243.

155. Panofsky, *The Life and Art of Albrecht Dürer*, 244.

156. "... die rechten wahrheit erkennen unnd vor augen sehen mögen damit sie nit alleyn zu künsten begirig werden sondern auch zu eynen rechten und grossern verstand komen mögen," Dürer, *Underweysung der Messung* (Nuremberg, 1538); English trans., William Mills Ivins, *On the Rationalization of Sight With an Examination of Three Renaissance Texts on Perspective* (New York: [Metropolitan Museum of Art], 1938).

157. Panofsky, *The Life and Art of Albrecht Dürer*, 82. However, there are problems with this idea. As later generations of artists would realize, a true illusionism that attempts to reproduce the momentary act of seeing, with a single point of view, does not permit the equal representation of all things within the visual field as they "are." Moreover, the ideal of naturalistic illusionism produces a problem for religious art, which deals not simply with the portrayal of events, but with their meaning.

158. Panofsky, *The Life and Art of Albrecht Dürer*, 281.

159. Albrecht Dürer, *Vier Bücher von Menschlicher Proportion*, quoted in Panofsky, *The Life and Art of Albrecht Dürer*, 280.

160. Ibid., 266.

161. Ibid, 274.

162. Ibid, 275.

163. Price, *Albrecht Dürer's Renaissance*, 280. There is not space here to document the extent of Dürer's pre-Reformation piety, including prayers for the intercession of the saints and clear expressions of a theology of "works" that "earn" grace. A couple of examples must suffice. Among prayers to saints composed by Dürer himself to accompany pictures in broadsides is this prayer to St. Catherine (ca. 1510): "O Katherina edle frucht / Erwürß mir gar götliche zucht / Bit mir Jesum das er mich kleyd / Mit rechter demüt und weyszheyt / Auch soltu mir gnad erwerben / Von christo so ich müß sterben" (roughly translated: "O Catherine, noble fruit / implant in me godly cultivation / Pray to Jesus that he should clothe me / with true humility and wisdom / thus should you obtain grace for me / from Christ, at the hour of my death"). And in a caption to a series of moralizing pictures, written about 1510, Dürer writes: "Und thu stetz noch gnaden werben / Als soltestu all stund sterben" ("And act always to earn grace / as though now you must die"), both quoted in Price, *Albrecht Dürer's Renaissance*, 121.

164. Only eleven of the drawings survive. They are housed in the Albertina Museum in Vienna. Some have speculated that they were intended for a larger work, perhaps a series of "stations of the cross."

165.

De domino Jesu ad passionem a matre discedente...
Nonne parens exule nepos, aut rapta suppelex
Te o homo lamentis afficit immodicis?
Albrecht Dürer. *Passio Christi ab Alberto Durer Nurenbergensi effigiata cu varij generis carminibus fratris Benedicti Chelidonij Musophili.* (Nuremberg, 1511). The woodcuts, along with Chelidonius's texts, are viewable at the website of the National Library of Austria: http://nla.gov.au/nla.gen-vn1539295.

166.

Christus educitur vt crucifigatur...
Deus infami cum cruce nostrum
Scelus immeritus pertulit ultro.
Homo grates cui redde perennes.

167.

Christus in cruce pendet...
Quem lugent elementa, dole, treme, pectora scinde
O homo, quin oculos fletibus obtenebra
Hunc veniam pete, quia veniam tortoribus ipsis
Optat, latroni qui dedit astra libens
Pectus ad amplexus. En praebet ad ocula frontem
Cor operit, lacrymis te vocat atque vocat.

168. For the original Latin text, consult the site of the National Library of Austria, http://nla.gov.au/nla.gen-vn1539295.

169. The "Man of Sorrows" image could have several theological meanings. It seems to portray an eternal, non-historical presence of Christ's sufferings. This could be a visual means of making the point that because of Christ's divine consciousness, we can be and really are present to all the historical sufferings he endured. Hence the image would intend to produce a present consciousness of Christ's past sufferings, as though they were still taking place; but with concomitant consciousness that they are in fact over, since Christ is resurrected and glorified. The picture would then represent the sort of useful fiction recommended by medieval authors in writing about meditating on and interiorizing Christ's sufferings. Because Christ *once* suffered for my present sins, it is *as though* he were now suffering because of them. But this nuance is only implicitly present, if at all. Hence the picture could also be taken in a "literal" sense: because of our sins, Christ still suffers in the present, or anew, or eternally. This is strictly speaking heretical, as it implies the denial of the article of the creed on the resurrection, descent into hell, and ascension.

170. Price, *Albrecht Dürer's Renaissance*, 186.

171. Although the poem refers to the beating of Christ, the picture seems to refer more directly to the mocking. The soldier does not appear to be about to strike Christ, but seems to be offering him the reed as his "scepter." However, this discrepancy is perhaps not very significant in light of the fact that the sufferings of Christ were seen to be above all mental and spiritual, and the "blows" inflicted upon him by continued sin are implicitly understood in that sense. The flagellum lies on the ground to Christ's side.

172. Panofsky, *The Life and Art of Albrecht Dürer*, 141.

173. For the original Latin text, see the reproduction in *The Complete Woodcuts of Albrecht Dürer*, edited by Willi Kurth (New York: Dover Publications, 1963), 214.

174. Reading "ru[h]" for "rw."

175. For the original German text, see Price, *Albrecht Dürer's Renaissance*, 118.

176. Price, *Albrecht Dürer's Renaissance*, 126–27. Price speculates that Dürer may have been influenced by the then-popular devotion to the "Seven Sorrows of Mary," to which he once devoted a woodcut.

177. For the original German text, see ibid., 124.

178. Panofsky, *The Life and Art of Albrecht Dürer*, 281.

179. If the autographs and dates on them are authentic, these include: 1) A 1521 *Lamentation* in pen and ink at the Fogg Art Museum, Cambridge. Christ is portrayed dead at the foot of the cross, but he seems to look at Mary, who holds his hands. The other figures clasp their hands in sign of mourning. One woman raises her hands above her head in grief. 2) A 1522 *Lamentation* in silverpoint in the Kunsthalle, Bremen. Here the dead Christ's arm is held by Mary, while his body reclines on the knee of Mary Magdalene. The head is bent back. Mary looks directly into Jesus' agonized face. 3) A study of St. John lamenting, in silverpoint and chalk, at the Albertina.

From 1523 there is also a pen drawing of a pontifical high mass, with several bishops in attendance (now in the Kupferstichkabenett, Berlin).

180. Panofsky, *The Life and Art of Albrecht Dürer*, 224–25.

181. Price, *Albrecht Dürer's Renaissance*, 237.

182. Unlike the other portraits, which have a dark background, this one has areas of light and dark, suggesting clouds in the sky.

183. Price, *Albrecht Dürer's Renaissance*, 247.

184. Koerner, *Reformation*, 77.

185. Mitchell B. Merback, *The Thief, the Cross and the Wheel: Pain and the Spectacle of Punishment in Medieval and Renaissance Europe* (Chicago: University of Chicago Press, 1998), 13.

186. Luther, "Easter Sermon for 1533," WA 37: 64, quoted in Koerner, *Reformation*, 32, and 447n21.

187. Merback, *TheThief, the Cross and the Wheel*, 287, 288

188. Koerner, *Reformation*, 226.

189. The back of the painting specifies that it was done by the studio (*Werkstatt*) of Lukas Cranach the Elder in Wittenberg, and was the gift of the Elector Johann Friedrich von Sachsen.

190. Merback, *The Thief, the Cross and the Wheel*, 289.

191. See for example Berthold Furtmayr's illumination of the *Baum des Todes und des Lebens* in the Salzburger Missale (completed 1481; online: http://ccat.sas.upenn .edu/~humm/Topics/AdamNeve/a_n_e02.html). The legend of the cross, famously illustrated in a fresco series in Arezzo by Piero della Francesca, makes the allegorical connection literal: it is wood from the tree of Eden that is hewn to make the cross of Christ.

192. The back of the painting completes the theology of salvation with a scene of the Last Judgment in the center, flanked by two Old Testament scenes of judgment: the flood on the left, the destruction of Sodom and Gomorrah on the right.

193. See Koerner, *Reformation*, for a discussion of the significance of the shift in subject matter in Lutheran painting from sacred history to the community itself in its contemporary life.

194. For a close study of this image and commentary on its meaning in the context of the entire altarpiece, the main subject of his book, see Koerner, *Reformation*, 171–211.

195. Koerner in his text correctly names Cranach the Younger as the artist, but the caption to the picture attributes it to his father, *Reformation*, 271. An extended use of images of the passion in Lutheran polemics is illustrated by Cranach the Elder's *Passional Christi und Antichristi* (1521), with texts by Melanchthon and Johann Schwertfeger (sometimes mistakenly attributed to Luther himself). In it scenes from the life of Christ are visually contrasted with caricatures of the practices of the Pope and of the Roman church. (See the entire series at http://www.pitts.emory.edu).

196. Koerner, *Reformation*, 223.

197. Steinberg, *Sexuality of Christ*, 93.

198. For relevant texts from Zwingli, see Feld, *Ikonoklasmus*, 127.

199. Merbeck, *The Thief*, 288.

200. Koerner, *Reformation*, 28.

201. Koerner, *Reformation*, 246.

202. John Calvin, "Preface" (1543) to *Les Pseaumes mis en rime francoise par Clément Marot et Théodore de Béze. Mis en musique a quatre parties par Claude Goudimel. Par les héritiers de Francois Jacqui* (1565). Facsimile edition published under the auspices of *La Société des Concerts de la Cathédrale de Lausanne* and edited in French by Pierre Pidoux and in German by Konrad Ameln (Bärenreiter-Verlag, Kassel, 1935).

203. John Calvin, *Institutes of the Christian Religion*, trans. Ford Lewis Battles, book 3, ch. 20, n. 31–32, in John T. McNeill, ed., *The Library of Christian Classics* (Philadelphia: Westsminster, 1960), 21: 894n65.

204. Calvin, "Preface."

205. Martin Luther, "To Louis Senfl," in *Luther's Works*, vol. 49, edited and trans. Gottfried G. Krodel (Philadelphia: Fortress, 1972), 428.

206. Martin Luther, "Vorrede auf die Gesänge vom Leiden Christi," in Luther, *Sämmtliche Schriften*, vol. 14, ed. Johann Georg Walch (St. Louis: Concordia, 1898), 430.

207. Martin Luther, "The Last Words of David," in *Luther's Works*, vol. 15, edited and trans. Gottfried G. Krodel (Philadelphia: Fortress, 1972), 274.

208. Luther, "Vorrede," 429–30.

209. Martin Luther, "Wär' Gott nicht mit uns diese Zeit" (1524), paraphrase of Ps. 124, *Gesangbuch*" (Wittenberg, 1537).

210. *Praefatio D. M. Lutheri in Harmonias de passione Christi* (*Vorrede auf die Gesänge vom Leiden Christi*, WA 22, Anhang, 140; *Sämmtliche Schriften*, 14: 429–30). It is unknown exactly what songs were in this collection. Luther's introduction is confined to general remarks in praise of music and singing, and in spirit is very similar to his *Vorrede auf alle guten Gesangbücher* ("Introduction to all good hymnals") writen by Luther for Johann Walter's book *"Lob und Preis der löblichen Kunst Musika"* (1538) (text available at http://www.achimkh.net/Luther_HTML/Luther.html).

211. In the next century, Lutheran passion hymns were composed that went back to the medieval tradition.

212. Luther, *Luthers Geistliche Lieder und Kirchengesänge*, ed. Markus Jenny, vol. 4, *Archiv zur Weimarer Ausgabe der Werke Martin Luthers*, ed. Gerhard Ebeling, Bernd Moeller, and Heiko A. Oberman, 178 (Cologne: Bóhlau Verlag, 1985).

213. Luther, *Luthers Geistliche Lieder und Kirchengesänge*, 240.

214. Luther, *Luthers Geistliche Lieder und Kirchengesänge*, 313–14.

215. Althaus, *Die Theologie Martin Luthers*, 185.

216. See Werner Braun, "Passion (musikalisch)" in *Theologische Realenzyklopädie*, ed. Gerhard Müller (Berlin and New York: Walter de Gruyter, 1977), 26: 44–48; Phylax, "Le Christ dans la Musique," in *Le Christ. Encyclopédie populaire des connaissances Christologiques*, ed. G. Bardy and A. Tricot (Paris: Bloud et Gay, 1946), 1049–78.

217. The quotations from the reformed liturgies are taken from *Prayers of the Eucharist: Early and Reformed*, trans. and ed. R. C. D. Jasper and G. J. Cuming, 3rd. ed. (New York: Pueblo, 1980), 184–256, emphasis added.

218. The mass was revised several times by Olivus's younger brother, Laurentius. The Swedish church order of 1571 then remained constant, except for brief intervals, until the present.

219. This part of the prayer remains essentially the same in the *Book of Common Prayer* of 1552, which in turn was followed by later Anglican rites.

220. Price, *Albrecht Dürer's Renaissance*, 232.

CHAPTER 3

1. Dürer's woodcuts of the *Apocalypse* appeared in 1498; Signorelli painted the "End of the World" in the Cathedral of Orvieto in 1499.

2. For a fascinating account of this charming family, see Michael Mallet, *The Borgias: The Rise and Fall of a Renaissance Dynasty* (London: Paladin, 1971).

3. The circumstances leading to the sack of Rome were complex. The Emperor Charles V had sent an army under the renegade Constable of France, Charles III de Bourbon, to chastise the Pope. Frundsberg joined him with an army of *Landsknechte* raised at his own expense, but he died before reaching Rome. Charles de Bourbon, lacking money to pay his troops, was able to motivate them only by promises of

plunder. After his death in the siege of Rome (Benvenuto Cellini claimed to have personally killed him), all discipline was lost and the city was sacked.

4. The extent of Savonarola's influence on Michelangelo is difficult to assess. It is known that the sculptor's brother Lionardo was a follower of the prophetic preacher, and himself became a Dominican friar. Ascanio Condivi, in his "official" biography of Michelangelo, speaks of the latter's affection for Savonarola's writings, and says that even in his old age he carried in his mind the monk's "living voice," *Life of Michelangelo Buonarroti*, trans. George Bull, in *Michelangelo: Life, Letters, and Poetry*, selected and translated by George Bull (Oxford: Oxford University Press, 1987), 68.

5. Donato Giannotti, *Dialogi*, ed. Deoclecio Redig de Campos (Florence: G.C. Sansoni, 1939), 68–69, quoted in James Hall, *Michelangelo and the Reinvention of the Human Body* (New York: Farrar, Straus and Giroux, 2005), xx.

6. Ellen Moody has made an English translation of this and other poems by Vittoria Colona available online: http://www.jimandellen.org/vcsonnets/vcsonnet234 .html.

7. Alexander Nagel remarks that this work introduces a new category of artwork: the drawing made not as a study for another work in sculpture or painting, but as finished product in itself, and one that is not commissioned by a patron but spontaneously created by the artist and offered as a gift. See Alexander Nagel, *Michelangelo and the Reform of Art* (New York: Cambridge University Press, 2000), 246–48.

8. Ascanio Condivi, *Life of Michelangelo Buonaroti*, 67–68.

9. Ibid., 185–6. In one of his late (1550–55) drawings of the crucified Christ between Mary and John the Evangelist, Michelangelo again uses the Y-shaped cross.

10. Nagel argues that Michelangelo means to take the quote out of context and refer it to blood of Christ, and that this reflects the "reformist" views of the Valdès circle. He stresses that these were close to the Lutheran interpretation of "justification through faith" in the sufficiency of Christ's sacrifice. He points out that members of the Valdès group were involved in the writing of the famous book the *Beneficio di Christo* (1542), which speaks of justification as the "non-imputation" of sins because of the merits of Christ, and which was placed on the Index of prohibited books in 1549 (Nagel, 172). All of this is true and significant. However, it should also be noted that this language could also be used in "orthodox" theology, especially in the Nominalist school. Moreover, this emphasis does not necessarily imply justification by "faith *alone*" (to the exclusion of good works) in the sense that the position was attributed to Luther. Indeed, Luther himself thought that good works were necessary, but not to what he called "justification," which he theoretically separated from "sanctification." Modern Lutheran-Catholic dialogues have concluded that the historical polemics on this matter were based in part on misinterpretations and in part on differences in vocabulary and context. As we have noted, Cardinal Pole formulated a position of "dual justification," which would also be discussed (and rejected) at the Council of Trent. Pole is said to have told Vittoria Colonna that she should believe as though all depended on God, and do good works as though all depended on herself (Nagel, *Michelangelo*, 171). This advice sounds very like the saying often attributed to Augustine: "Pray as though (or in some versions, "because") everything depends on God,

and work as though (or because) everything depends upon you." I cannot find this saying in Augustine; but it reflects his view of the relation of God's grace to human action in response to grace as expressed in his anti-Pelagian writings. Our good works truly "merit" the crown of glory; but at the same time our merits are themselves God's gifts. "In crowning our merits, God is crowning nothing else but God's gifts." ("Quod est meritum hominis ante gratiam...cum omne bonum meritum nostrum non in nobis faciat nisi gratia et cum Deus coronat merita nostra, nihil autem coronat quam munera sua?" Augustine, *Epistle CXCIV* [to Sixtus, Roman presbyter, later Pope], PL 33, 880.) Hence we are truly responsible for our salvation. At the same time, Augustine points insistently to God's initiative even in our response to grace.

This was the standard teaching of the High Scholastics as well, and is an extension of the concept of God's transcendental causality as the source of all "secondary" causes in the world. Hence strictly speaking there is no "collaboration," in the sense that God does part and humanity does part. Rather, God is (on the transcendental level of "primary" causality) the *entire* cause of existence and of salvation; and humanity (or other causes) are, on their level of secondary causality, the *entire* cause of whatever they effect. (Note that this Scholastic position allows the methodological independence of empirical science). As Rahner reexpresses the Thomist position, divine causality and human causality are directly, not inversely related. The more free and responsible we are, the more "being" we "have," the more we are caused by God and participate in the divine gift of being. The idea of "dual" justification seems to be a less philosophically sophisticated version of the idea of transcendental causality. In juxtaposing the two levels of action, it carries the danger of conceiving of "God" as a being alongside other beings in the world, forgetting what Heidegger called the "ontological difference" between Being and beings and, even more, the transcendental distinction between God and creation.

11. Michelangelo Buonarroti, *Rime,* basata sul testo critico di Girardi Basata sul testo critico di Girardi (Bari: Universale Laterza, 1967), libro IV, no. 285. The translation is mine.

12. Nagel, *Michelangelo,* 180.

13. Vittoria Colonna, *Pianto sopra la Passione di Christo,* quoted in Nagel, *Michelangelo,* 180.

14. An illustration of the scene of Christ teaching Mary about his coming passion, with a lengthy text shown coming from the mouth of each, is found in a fifteenth century Valencian manuscript in the Richelieu collection of the Bibliothèque Nationale Française (http://gallica.bnf.fr). This tradition of course conflicts with another according to which Mary even at the foot of the cross did not understand what was happening, and had to be restrained in her lamenting by Christ's dialogue with her from the cross itself.

15. Nagel, *Michelangelo,* 181.

16. Colonna, *Pianto,* quoted in Nagel, *Michelangelo,* 263n34.

17. Ibid., 184.

18. "Così la Madonna vedendo che non vi era la beata anima de Christo, qual sola era sufficiente ad honorar l'immensa grandeza de la divinità, li pareva che a lei

sola appartenesse el grand'offitio de supplire a tanto debito, onde havria voluto li-
quefarsi, consumarsi anzi farsi ultima nel fuoco del'amore et ne le lacrime de la
compassione per toglier al mondo et a se stessa l'ingratitudine, et render a Dio lo
ossequio et il colto che li convenia," *Pianto*, quoted in Nagel, *Michelangelo*, 274 n. 58.
My translation differs somewhat from Nagel's. He calls this passage a "curious con-
clusion" to be drawn by Colonna. Indeed it would be very curious if she espoused
a purely "Lutheran" position in which Christ alone is the whole and sole agent
of salvation, to the entire exclusion of others, or if, like Luther, she was suspicious of
the use of affective meditation on the passion as being connected to a theology
of "works." But it seems to me that it is quite in line with the tradition of *compassio*
referred to by Colonna herself. Affective meditation on the passion leads to a de-
sire to share in Christ's redemptive work. This is especially true of Mary, but applies
also to others as well. Mary indeed becomes the model for our response. We find
similar ideas in Savonarola, John of the Cross, Teresa of Avila, etc., and even implicitly
in the Pauline passage quoted by Cajetan against Luther: "I make up for what is
lacking to the passion of Christ in my flesh . . ." [Col. 1:24] that was an inspiration for
so much Passion mysticism.

19. Colonna, *Rime*, quoted in Nagel, *Michelangelo*, 167. The last line reads liter-
ally "with his bright light (*lume*)." I have taken "light" here to mean the eyes, as
lumen frequently did in literary Latin.

20. See for example John C. Olin, *Catholic Reform: From Cardinal Ximenes to the
Council of Trent, 1495–1563* (New York: Fordham University Press, 1990).

21. The remaining books of the Bible were printed from 1513–1517, though only
published in 1522.

22. For the text of Egidio's discourse, see "Egidio da Viterbo's Address to the
Fifth Lateran Council, 1512," in John C. Olin, *The Catholic Reformation: Savonarola to
Ignatius Loyola. Reform in the Church 1495–1540* (New York: Harper & Row, 1969), 40–53.

23. The proper name of the order was the "Congregation of Clerks Regular of the
Divine Providence." The name "Theatines" derived from the diocese of Theate
(Chieti), of which Carafa then bishop.

24. Ignatius of Loyola, *Constitutiones Societatis Iesu*, "*Prima Summa*" (1539), in
Monumenta Historica Societatis Iesu. Monumenta Ignatiana. III. (Rome: 1934–1936), I:
16–20.

25. *Canones et Decreta Sacrosancti Oecumenici Concilii Tridentini* (Turin: Marietti,
1913). See for example Session XXI: *Decretum de reformatione.*

26. Dominican Cardinal Cajetan had already enunciated this perspective on
Thomistic principles in his response to Luther at Augsburg in 1518. The merits
of the saints are not in competition with either the satisfaction worked by Christ or
his merits, which alone can be communicated to others. Christ's "satisfaction" is
completely sufficient; but God wills that we also should collaborate in our salva-
tion: ". . . appositio meritorum sanctorum cononat divine dispositioni, non quod in-
sufficiens sit christi satisfactio, sed ut plura sind in christi corpore mystico satis-
factoria. Sic enim docuit apostolus: 'Adimpleo,' inquit, 'ea quae desunt passioni
Christi in carne mea pro corpore eius, quod est ecclesia [Col. 1:24],' " Thomas de Vio

Cajetan, "De Thesauro Indulgentiarum," in *Cajetan et Luther en 1518. Édition, traduction et commentaire des opuscules d'Augsbourg de Cajetan*, ed. Charles Morerod, OP (Freiburg, Switzerland: Éditions Universitaires, 1994), tome 1, q. I, § 37 and q. I, § 67 (cf. *In Summa Theol.* IIIa, 48, a. 5, n. III).

27. *Catechismus ex Decreto Concilii Tridentini ad Parochos* (Rome, Typis S. Congregationis de Propaganda Fidei, 1858), Pars Prima, Article IV, ch. V, § 1, 30. In translating I have generally followed the English version in *The Catechism of the Council of Trent: published by Command of Pope Pius the Fifth* (Joseph F. Wagner, 1923), but I have revised the wording in a number of sections.

28. Ibid., § 4, 31.

29. Ibid.

30. Ibid., § 5, 31.

31. Ibid.

32. Ibid., § 7, 32.

33. Ibid., 33.

34. Ibid., § 11, 34–35.

35. Ibid., § 12, 35.

36. Ibid., § 13, 35–36.

37. Ibid., § 14, 36.

38. Ibid., § 15–16.

39. Ibid., Pars Secunda, ch. V, § 63–64, 183–84.

40. Ibid., Pars Prima, Article IV, ch. V, § 36–37.

41. Ibid., § 16, 37.

42. Ibid., Article V, ch. VI, § 6, 39.

43. Ibid., § 8, 40.

44. Ibid., § 12, 42–43.

45. Ibid., § 14, 43–44.

46. For an examination of the Catechism as a whole as a response to the positions of the Protestants, see Gerhard Bellinger, *Der Catechismus Romanus und die Reformation. Die Katechestische Antwort des Trienter Konzils auf die Haupt-Katechismen der Reformatoren. Konfessionskundliche und Kontroverstheologische Studien*, vol. 27 (Paderborn: Bonifacius-Durckerei, 1970).

47. *Catechismus ex Decreto Concilii Tridentini ad Parochos*, Pars Prima, ch. II, § 19, 17.

48. Some of the Reformers had taught the passivity of the human will before God's grace, which is irresistible—so, for example, the *Confessio Helvetica* II, ch. 9. The Council of Trent taught that humanity remains free before the offer of God's grace and can freely decide for or against its acceptance. See DS 814 and 815.

49. *Catechismus ex Decreto Concilii Tridentini ad Parochos*, Pars Secunda, ch. IV, § 76, 159.

50. Ibid., § 78, 159.

51. Roberto Bellarmino [Robert Bellarmine], *Dottrina Cristiana Breve Perchè Si Possa Imparare a Mente. Opera Omnia*, ed. Justinus Fèvre (Paris: Ludovicus Vivès, 1874), 12: 262.

52. Roberto Bellarmino [Robert Bellarmine], *Dichiarazione Più Copiosa della Dottrina Cristiana, Composta in Forma di Dialogo*, ch. III. *Opera Omnia*, 12: 288–89.

53. The most influential work on the nature of a courtly gentleman was of course *Il Cortegiano*, written by Baldassare Castiglione in 1528. Others that explicitly dealt with the notion of "honor" included Antonio Possevino, *Libro . . . nel qual s'insegna le cose pertinenti all'honore* (Vinegia, 1559); Andrea Alciati, *Duello* (Venetia, 1562); Fausto da Longiano, *Duello* (1551). These are cited by Milton Kirchman, *Mannerism and Imagination: A Reexamination of Sixteenth-Century Italian Aesthetic* (Salzburg: Institut für Anglistik und Amerikanistik Universität Salzburg, 1979), 52n78. *Libros de caballeria* were also common in Spain. It was of course against these that Cervantes directed his wit in *Don Quixote*.

54. Ibid., cap. XVII, 330–31.

55. I have adopted the phrase "crisis of the Renaissance" from Arnold Hauser to designate together the artistic styles sometimes referred to as "Mannerist," "anti-Mannerist," and "Counter-Reformation."

56. "*De invocatione, veneratione, et reliquiis sanctorum, et sacris imaginibus,*" *Canones et Decreta Sacrosancti Oecumenici Concilii Tridentini* (Turin: Marietti, 1913), Session XXV, 206–7.

57. Peter Canisius, *De Maria Virgine*, 712, quoted in Émile Mâle, *L'art religieux de la fin du XVI^e siècle, du XVII^e siècle et du XVIII^e siècle. Étude sur l'iconographie après le Concile de Trente. Italie—France—Espagne—Flandres*, 2nd ed. (Paris: Librairie Armand Colin, 1951), 22.

58. Further alterations of parts deemed offensive took place in 1566 under Pius V. Later, Clement VIII had to be dissuaded by the Academy of St. Luke from having the entire fresco destroyed, and El Greco reportedly offered to re-do the entire painting, and better.

59. Arnold Hauser, *Mannerism. The Crisis of the Renaissance and the Origin of Modern Art* (Cambridge: Harvard University Press, 1986), 76.

60. Maselli, S.J., *Vita della beata Vergine* (Venice, 1610), 654, quoted in Mâle, *L'art religieux*, 8.

61. Mâle mentions Molanus: *De Hist. sanct. imag et pict.*, lib. II; Cardinal Paleotti: *Discorso introno alle imagini sacre* (Bologna, 1582); Borghini: *Il Riposo* (Florence, 1584); and Gilio: *Dialogo degli errori dei pittori* (1564); ibid., 5.

62. Nagel, *Michelangelo*, 195.

63. Vasari, *Lives* (Fra Angelico), quoted in Nagel, *Michelangelo*, 191.

64. Mâle, *La peinture religieuse*, 2–3.

65. Gauvin Alexander Bailey, *Between Renaissance and Baroque. Jesuit Art in Rome, 1565–1610* (Toronto: University of Toronto Press, 2003), 51.

66. Ibid.

67. Nagel, *Michelangelo*, 136. Nagel cites Titian's *Entombment* of the 1520s as an example. He points out that Titian's "religious" paintings are essentially in the genre of historical narrative; stylistically, they could as well have secular historical subjects.

68. "Minutes of the session of the Inquisition Tribunal of Saturday, the 18th of July, 1573" in *A Documentary History of Art*, ed. Elizabeth Gilmore Holt (Princeton: Princeton University Press, 1982), 2: 69.

69. Ignatius of Loyola, *Ejercicios Espirituales. Texto Autografo*, 1ª annotación, §1.

70. Ibid., § 4.

71. The connection between penance, contrition, and the cross can be seen throughout the exercises. See for example § 87, note 1, on external acts of penitence:

... external acts of penitence are undertaken to produce three effects: first, for satisfaction for past sins; second, to conquer one's self, that is, so that the sensible passions (*sensualidad*) should be obedient to reason, and all the inferior parts [of our makeup] should be more subject to the superior ones; to seek and find some grace or gift that the person wishes and desires, for example internal contrition for one's sins, or weeping much over them, or over the pains and sorrows that Christ our Lord underwent in his passion...

72. Ibid., § 47.

73. Ibid., § 53.

74. Robert Bellarmine, S.J., *Controversarium de Ecclesia Triumphante, Liber Secundus. De Reliquiis et Imaginibus Sanctorum*. Bellarmine, *Opera Omnia*, ed. Justinus Fèvre (Paris: Ludovicus Vivès, 1870), vol. 3.

75. Ibid., 214.

76. *De Memoria et Reminiscentia*, 449b 31.

77. Ibid., ch. 7, 217.

78. Ibid., ch. 8, 218. In the context it is clear that Bellarmine is referring to Calvin's position on sacred images only. Calvin had no objection to secular art.

79. Ibid., 219.

80. Ibid., 220. Jesuit Louis Richeôme's explanation of the notion of images implies a similar argument. He gives a very wide meaning to the idea of "picture." A picture in the most basic sense is simply "the exterior form of some body." Hence the world is full of "natural" pictures or images. On another level, there are artificial pictures: " a thing made or framed to represent and signify another thing." Richeôme enumerates three forms of artificial picture: 1) The visible or imagined image, or "that to which our eyes representeth by lineaments and colours some things without words." This includes both external images and internal ones: "of this sort also are the visions framed in our Imagination." 2) "Speaking" or verbal pictures, i.e., the descriptions or fictions of poets and historians. Such descriptions may include living creatures, or ideas, or imaginary things. 3) Actions or things instituted to represent other mysteries. These are allegorical or mystical pictures, like the sacraments or the Old Testament "figures" of later events; for example, circumcision represents baptism. Lewis Richome [Louis Richeôme], *Holy Pictures of the mystical Figures* (facsimile of original 1619 English edition), English Recusant Literature 1558–1640, ed. D. M. (Ilkley, [England]: Scolar Press, 1975), 2–3.

81. "Alioqui fateor, non sine periculo exhiberi imperitis ejusmodi picturas. Hic enim tantum defendimus, non esse in universum damnandas ejusmodi imagines," ibid.

82. "Illud tamen verum est, quod sicut homo est imago Dei valde imperfecta, obscura, et dissimils: ita etiam homo pictus est imago Dei valde imperfecta, obscura, et dissimilis," ibid.

83. Ibid.

84. Ibid., 220–21.

85. "At imago Dei, et Trinitatis, ut a nobis pingitur, doctor est veritatis, quia neque habetur pro Deo a nobis, neque fit ad referendam Dei effigiem, sed ad perducendum hominem in aliquam Dei notitiam per analogicas similitudines," ibid., 222.

86. Ibid.

87. Ibid., ch. 9, 224.

88. "... etiam solitarias imagines, ut a Christianis pinguntur, semper continere quasi per compendium aliquam historiam," ibid., ch. 10, 228.

89. Ibid., ch. 12, 235.

90. Ibid., chapters 20–25, 234–54.

91. Juan de la Cruz, *Subida del Monte Carmel* [*Ascent of Mount Carmel*], Book 3, "Noche activa del Espiritu," ch. 35, § 5, in *Vida y Obras de San Juan de la Cruz*, ed. Lucino del SS. Sacramento, OCD (Madrid: Biblioteca de Autores Cristianos, 1964), 525.

92. Ibid., ch. 15, § 2, 494.

93. Ibid., ch. 35, § 3, 524.

94. Ibid.

95. Ibid., 525.

96. "... en ellas no se estima otra cosa sino lo que representan," ibid.

97. Ibid., 495.

98. See ibid., ch. 8, § 3, 486.

99. Juan de la Cruz, *Noche Oscura* (*The Dark Night [of the Soul]*), book 1, *Noche passiva del sentido*, ch. 10, § 2, 557.

100. Alex Stock, *Poetische Dogmatik. Christologie. 2 Schrift und Gesicht* (Paderborn: Schöningh, 1996), 54. On the cross in Ignatius's thought, see also See H. Wolter, "Elemente der Kreuzzugsfrömmigkeit in der Spiritualität des Heiligen Ignatius," in *Ignatius von Loyola. Seine geistlich Gestalt und sein Vermächtnis 1556–1956*, ed. F. Wulf (Würzburg 1956), 113–50.

101. Ibid., § 107.

102. Ibid. § 206.

103.

... la persona que da a otro modo y orden para meditar o comtemplar, debe narrar fielmente la historia de la tal comtemplación o meditación, discurriendo solamente por los punctos con breve o sumaria declaración; porque la persona que contempla, tomando el fundamento verdadero de la historia, discurriendo y raciocinando por sí mismo, y hallando alguna cosa que haga un poco más declarar o sentir la historia, quier por la raciocinación propia, quier sea en quanto el entendimiento es ilucidado por la virtud divina, es de más gusto y fructo spiritual, que si el que da los exercicios

hubiese mucho declarado y ampliado el sentido de la historia; porque no el mucho saber harta y satisface al ánima, mas el sentir y gusta de las cosas internamente. Ibid., § 2.

104. Ibid., 212.

105. Ibid., ch. 26, 255.

106. Ibid., 257.

107. Ibid., ch. 28, 262.

108. Ibid., ch. 30, 264.

109. Robert Bellarmine, SJ, *De Gemitu Columbae sive de Bono Lacrymarum* (The Moaning of the Dove or the Good of Tears in Bellarmine, *Opera Omnia*, ed. Justinus Fèvre (Paris: Ludovicus Vivès, 1873), 8: 398–484.

110. In light of Bellarmine's Reformation context, it is of interest at least to list the other sources of sorrow and the fruits of bemoaning them. The first font of tears is the consideration of sin; its fruit is the certain hope of forgiveness. Second is the consideration of hell; its fruit is fear of hell. (Note that in contrast to Luther, Bellarmine does not think this fear is or should be removed by the certain hope of salvation, which is not the same as certitude of salvation; rather, fear is a necessary accompaniment to hope.) Third is consideration of Christ's passion, which we will attend in more detail shortly. Fourth is consideration of the persecution of the church; its fruit is mercy toward our neighbors. Fifth is consideration of the priesthood. Far from denying the sorry condition of the clergy, Bellarmine excoriates its corrupt members, and is particularly severe on bishops. The fruit of this sorrow is reformation of the clergy. The sixth source of tears is consideration of the religious orders. Once again, Bellarmine is severe in his judgments. The fruit of this recognition of failure is reformation of the orders. Seventh is consideration of the laity; its fruit is reform of morals among the people. Eighth is consideration of the general misery of the human race. Its fruit is the undertaking of the multiple works of charity. Ninth is consideration of purgatory; its fruit is the repose of the souls of the deceased. (Again here we see an explicit response to the Protestant denial of purgatory and of the efficacy of prayers for the dead.) Tenth is consideration of the love of God, which leads us to aspire to beatitude and to groan and work toward it until it is attained; its fruit is contempt of the world, and love of God. Finally, eleventh is consideration of the uncertainty of our salvation; its fruit is ease in seeking the gifts of God. (Again we may see here an anti-Lutheran polemic.)

111. Ibid., book 2, ch. 3, 423.

112. Ibid., 424.

113. Ibid., 424–25.

114. Ibid., 426.

115. Ibid.

116. "...amator hominum Christus, ut copiosa esset redemptio, noluit paulatim suas vires, et robur ad patiendum ita diminui, ut in fine vitae nullum remaneret; sed usque ad exitum animae de corpore retinuit tantum robur, ut ipse etiam dolor integre sentiretur a principio Passionis usque ad finem," ibid., 427.

117. Ibid.

118. Ibid.

119. Ibid., 428.

120. Ibid., 429.

121. Fra Luís was imprisoned for the "rashness and imprudence" of criticizing the Vulgate translation and making his own vernacular translation of the *Song of Songs*. He was imprisoned from 1572 to 1576, when the charges against him were abandoned. He is famous for beginning his first lecture at the University of Salamanca after his release with the words, *Como decíamos ayer...*, "As we were saying yesterday...."

122. "...and to some souls it seems that they cannot think about the passion...," Teresa de Jesús, *Castillo Interior o las Moradas*, Moradas Sextas, ch. 7, § 6.

123. Ibid., § 10; also *Camino de Perfección*, ch. 19, § 1.

124. Teresa de Jesús, *Camino de Perfección*, ch. 18, § 5.

125. Teresa de Jesús, *Conceptos del Amor de Dios*, ch. 5, § 5.

126. Juan de la Cruz, *Subida del Monte Carmel*, Book 3, "Noche activa del Espiritu," ch. 35, § 5, 525.

127. Juan de la Cruz, *Dichos de Luz y Amor. Avisos y Sentencias Espirituales*, § 94, in *Vida y Obras*, 966.

128. Juan de la Cruz, *Llama de Amor Viva*, Canción 2, § 28, in *Vida y Obras*, 864.

129. Juan de la Cruz, Carta 24 (A la M. Ana de Jesús), in *Vida y Obras*, 992.

130. Letter of September 20, 1542), quoted in Michel Olphe-Galliard, "Croix (Mystère de la)" in *Dictionnaire de Spiritualité Ascétique et Mystique Doctrine et Histoire*, ed. Charles Baumgartner, S.J., tome II, deuxième partie (Paris: Beauchesne, 1953), 2623.

131. Teresa de Jesús, *Camino de Perfección*, I, ii, iii. Although Émile Mâle cites them in the context of the Catholic reaction against iconoclasm, Teresa's comments do not seem to have been occasioned specifically by this aspect of Protestantism, but rather by the entire phenomenon of "revolt" against the church and its practices. Nevertheless, given the general tenor of her piety, we may imagine that she would not be shocked by the Protestant emphasis on personal faith (she herself was accused of being close to the spirit of the *allumbrados*), nor by its Christocentrism (which she shared), but that like Ignatius of Loyola and her friend John of the Cross she would be particularly offended by iconoclasm in general and by perceived attacks on the Virgin Mary in particular.

132. Michelangelo's friend Vittoria Colonna had a special interest in these paintings, in particular the one reputed to be the original, which was housed in the basilica of Santa Maria Maggiore. Francis Borgia, the third general of the Jesuit order, had a copy of this "miracle working" Madonna distributed throughout world. See Bailey, *Between Renaissance and Baroque*, 10. Pope Paul V built a special chapel for this painting in the basilica in 1611.

133. Hans Belting, *Likeness and Presence: A History of the Image before the Era of Art*, trans. Edmund Jephcott (Chicago: University of Chicago Press, 1993).

134. Nagel, *Michelangelo*, 19.

135. Kirchman, *Mannerism*, 45.

136. Paul Thoby, *Le Crucifix des Origines au Concile de Trente. Étude Iconographique.* (Nantes: Bellanger, 1959), 215.

137. Ibid., 230.

138. Hans-Georg Thümmel, "Kreuz VIII. Ikonographisch (Reformationszeit bis zur Gegenwart)," in *Theologische Realenzyklopädie,* ed. Gerhard Müller (Berlin: Walter de Gruyter, 1990), 19: 768–74.

139. Mâle, *L'art religieux*, 278.

140. Thoby, *Le Crucifix*, 231.

141. Mâle, *L'art religieux*, 275–76. Mâle notes that the French painter and art theorist Charles Le Brun would write in the next century that the most perfect crucifixion has only three figures so as not to distract the viewer from the meaning of the scene: Christ, the Virgin, and John, ibid. 5.

142. Mâle, *L'art religieux*, 264.

143. Ibid., 268–69.

144. Ibid., 272.

145. Ibid., 270–71.

146. Ibid., 267. Mâle notes that this tradition is followed in the painting in the chapel of the Passion in the Jesuit church of the Gesù. Although the fresco is by Gaspar Celio, it is generally accepted that its design was by the Jesuit Valeriano.

147. Cellini's crucifix hangs in the Escorial. Philip II of Spain, shocked by the nude representation of Christ, had a white cloth tied around the waist, with the ends hanging in front to cover the genitals.

148. Mâle, *L'art religieux*, 274.

149. Ibid., 275.

150. Nagel, *Michelangelo*, 86.

151. Mâle, *L'art religieux*, 329.

152. Ibid., 329–31.

153. Nagel, *Michelangelo*, 2.

154. Ibid., 17.

155. Ibid., 29, 31.

156. Ibid., 31–33. Nagel notes that in depictions of the lamentation, etc., figures often represent the emotions that the viewer is supposed to share, and each engages in independent meditation on passion, rather than acting in the scene, ibid., 123. As the viewer is encouraged to enter into the event of the passion as though he or she were there, putting him or herself in the place of a witness, so those who were historically present at the event are placed in the position of the later meditator on the passion. The entire event has entered into the timelessness of its spiritual significance.

157. Augustine: *City of God,* 16:2; Jerome, *Commentary on Ps. 80,* cited in Nagel, *Michelangelo*, 97.

158. Some aspects of this painting—for example, the extreme foreshortening and the placing of the main theme in a subordinate position—anticipate some of the features that generally characterize the style of Mannerism.

159. For one example among many, see the crucifixion by Antonello da Messina (1475).

160. Condivi, *Life of Michelangelo*, 68.

161. Hall, *Michelangelo and the Reinvention of the Human Body*, 217.

162. The so-called Palestrina pietà, once widely ascribed to Michelangelo, is now generally thought not to be from his hand. However, some hold out the possibility that it may have been begun by him.

163. The history of the sculpture is given by Giorgio Vasari, *Vite de' più eccellenti architetti, pittori, et scultori Italiani* (1550–68) (Edizione Giuntina: Florence, 1568) 6: 92.

164. Hauser, *Mannerism*, 176.

165. Vasari, *Vite*, Edizione Giuntina, 6: 109.

166. Bailey, *Between Renaissance and Baroque*, 15.

167. As we pointed out in the first chapter, there were intrinsic tensions between the ideals of Renaissance art: beauty, consisting of an "objective" order and form; the expression of a symbolic message, especially in religious art; the inventiveness of the artist's genius; and the portrayal of "nature." Within the last there is also an implicit (and frequently unrecognized) tension between several different tendencies: the ideal of portraying "nature" in its intrinsic or ideal intelligibility; that of portraying "nature" or the world as it is "objectively," in empirically measurable terms; and that of re-duplicating the subjective act of vision. Any of these of course can come into conflict with the ideal of artistic creativity and expression.

168. On this see for example Bailey, *Between Renaissance and Baroque*, 23–27; Milton Kirchman, *Mannerism*, 2–6; and of course the first chapters of Arnold Hauser's provocative and classic study, *Mannerism*.

169. Arnold Hauser above all uses the term in this very wide sense.

170. Hauser, *Mannerism*, 72. At the same time, Hauser sees a connection between the spirit of mannerism (in its wide sense) and the pre-Tridentine Catholic reform movement: "... the intellectual and emotional atmosphere of the Catholic reform movement can be regarded as the closest equivalent of mannerism, which conflicted alike with the sober, rigorist, and anti-sensualist spirit of the Reformation and with the emotionalism and popular appeal of the art of the Counter-Reformation," ibid., 79.

171. Hauser, *Mannerism*, 12.

172. Ibid., 6.

173. Linda Murray, *The High Renaissance and Mannerism: Italy, the North, and Spain 1500–1600* (New York: Oxford University Press, 1977), 124–26; Walter Friedlander, *Mannerism and Anti-Mannerism in Italian Painting* (New York: Columbia University Press, 1990), 48. Friedlander divides Mannerism into two phases. The first began with the death of Raffaello (1520) and lasted until about 1550. The second phase, from 1550 to about 1580, involved the transformation of Mannerism into "mannered" painting through repetition, excessive cleverness, and exaggeration. Hauser makes a similar distinction between "Mannerism" and "mannered."

174. Hauser, *Mannerism*, 4. Before Mannerism there were certainly forms of "religious expressionism" in Christian sacred art, e.g., in Romanesque art, whose

elongated figures are recalled by certain Mannerist works. For Hauser, however, the Romanesque would not in the same sense be a deviation from the portrayal of nature, since the ideal of naturalist illusionism was not yet prevalent in art. But I wonder whether a more serious objection to Hauser's generalization might be found in the Hellenistic turn from illusionism to a more "spiritualizing" form of painting.

175. Friedlander, *Mannerism and Anti-Mannerism*, 8.

176. Ibid, 6.

177. Hauser, *Mannerism*, 29.

178. Ibid, 10.

179. Murray, *The High Renaissance and Mannerism*, 151.

180. We should recall that the Spanish Inquisition was independent of Rome, and was under direct royal authority. The Roman Inquisition was not reformed and reactivated until after Trent. We may recall that Juan de Valdès, an influence on Vittoria Colonna, had fled to Rome, probably in order to escape the unwelcome attention of the Inquisition in Spain.

181. After a failed attempt to have the archbishop's case decided in Spain by theologians appointed by the Pope, in 1566 Pius V ordered the trial transferred to the Curia in Rome. The charges of heresy were finally dropped, but not until 1576; Carranza was merely reprimanded for imprudent language. But he died within the year of his vindication. Interestingly, one piece of evidence held against Carranza was correspondence from Juan de Valdés, whose circle had influenced Vittoria Colonna and perhaps Michelangelo.

182. The *beatas* were pious women who lived together without taking religious orders, but who wore habits and took a private vow of chastity. See Richard L. Kagan, "The Toledo of El Greco," in *El Greco of Toledo* (Boston: Little, Brown, 1982), 57.

183. Ibid, 59.

184. Ibid, 56.

185. Jonathan Brown, "El Greco and Toledo," in *El Greco of Toledo* (Boston: Little, Brown, 1982), 98.

186. Ibid, 97.

187. Ibid, 111.

188. Quoted ibid, 111. It is known that El Greco wrote treatises on art and architecture, but they are lost. All that survives of his theoretical writings are his marginal notes to volumes 2 and 3 of Vasari's *Lives* (1568) and to Daniele Barbaro's edition of Vetruvius's *On Architecture* (Venice, 1556), Kagan, "Toledo," 56.

189. Brown, "El Greco and Toledo," 132–33.

190. Ibid, 134.

191. Ibid, 137.

192. Ibid, 128.

193. Ibid, 115–16.

194. Quoted in ibid, 86.

195. Ibid, 146.

196. Linda Murray writes that it is "accepted" that El Greco knew John of the Cross, who lived in Toledo, *The High Renaissance and Mannerism*, 275.

197. Hall, *Michelangelo and the Reinvention of the Human Body*, 76.

198. Bailey, *Between Renaissance and Baroque*, 15.

199. Hall, *Michelangelo and the Reinvention of the Human Body*, 78.

200. Ibid, 54.

201. Ibid, 210.

202. Ibid, 217, 221.

203. Brown, "El Greco and Toledo," 86.

204. Nagel, *Michelangelo*, 14.

205. Pietro Aretino criticized the *Last Judgment* not only for its nude figures, but also for being obscure and intellectually difficult. Giovanni Andrea Gilio wrote that Michelangelo was the leader of "modern" painters who "twist the purity of the subject to satisfy the charms of art," Nagel, *Michelangelo*, 192, 195.

206. Hall, *Michelangelo and the Reinvention of the Human Body*, 74–75.

207. Nagel, *Michelangelo*, 201.

208. Ibid, 15.

209. Quoted in ibid, 14.

210. Vittoria Colonna, stanzas 23, 188, quoted in Nagel, *Michelangelo*, 220n34. My translation differs slightly from Nagel's.

211. Ibid, 220n34.

212. Ibid, 12–13.

213. Quoted in ibid, 14.

214. Mâle, 124–126.

215. Hall, *Michelangelo and the Reinvention of the Human Body*, 78.

216. Ibid, 77.

217. "8ª regla. Alabar ornamentos y edificios de iglesias; assimismo imágines, y venerarlas según que representan." (Eighth rule [for living rightly in the church militant]. Honor church buildings and decorations; the same for images, and venerate them according to what they represent). Ignatius of Loyola, *Ejercicios espirituales* (Spiritual Exercises), § 360. The complete Spanish text of the Exercises can be found at: http://www.analitica.com/Bitblio/loyola/ejercicios.asp.

218. Hieronymus Nadal, SJ, *Evangelicae historiae imagines: ex ordine Euangeliorum quae toto anno in missae sacrificio recitantur in ordinem temporis vitae Christi digestae* (Antwerp, 1593). The second edition of this work intersperses the illustrations with the texts of Ignatius's meditations and notes: *Adnotationes et meditationes in euangelia quae in sacrosancto missae sacrificio toto anno leguntur: cum Euangeliorum concordantia historiae integritati sufficienti: Accessit & Index historiam ipsam Euangelicam in ordinem temporis vitae Christi distribuens* (Antwerp: Martinus Nutius, 1595).

219. For a description of these cycles, see Bailey, *Between Renaissance and Baroque*.

220. Ibid, 11.

221. Giovanni Andrea Gilio, *Degli errori dei pittori. Dialogo nel quale si ragiona de gli errori de pittori circa l'historie: con molte annotationi fatte sopra il giuditio di Michelangelo, et in che modo voglione esser dipinte le sacre imagini* (1564), quoted in Nagel, *Michelangelo*, 158.

222. Ibid, 16.

223. The *Enchiridion* was translated into Italian in 1530, and had a great influence on the thought of the reforming pope Paul III.

224. Quoted in Hall, *Michelangelo and the Reinvention of the Human Body*, 77.

225. Friedlander, *Mannerism and Anti-Mannerism*, 77.

226. Mâle, *La peinture religieuse*, 284.

227. Jeremias Drexelius, SJ *De Christo moriente*, pars II, cap. xii, § 5; quoted in Mâle, *La peinture religieuse*, 8. Mâle mentions a series of other authors with similar opinions: Surius, *De probatis sanctorum historiis*, t. IV, 689; Arias, SJ, *De Imitatione Dominae Nostrae*, cap. XLIII, (Antwerp, 1602); Mallonius, *Jesu Christi Stigmata* (Venice, 1606); Stengelius, *Passionis historia* (1622), 491; Confalonerio, *Vita beastissimae Virginis* (Palermo and Milan, 1664), 30.

228. Mâle, *La peinture religieuse*, 8.

229. Girolamo Savonarola, *Prediche sopra Amos e Zaccharia* (Lent 1496).

230. The word *spasmus* in classical Latin means a convulsion, like the English word that derives from it; but in "vulgar" Latin it was commonly used to mean a fit of fainting. See Thomas de Vio Caietanus, *De spasmo B. M. V.*, in *Opuscula in tres tomos divisa* (Venetiis, 1588) tom. 2, tractatus 13, 180.

231. Ibid. See also Hall, *Michelangelo and the Reinvention of the Human Body*, 16–17. The feast of Mary's sorrows was extended to the Servite Nuns in 1600 under title "Beata Virgo Maria sub pede crucis," "the Blessed Virgin Mary at the Foot of the Cross."

232. On this point Mâle cites Rebellus, *Rosario de la santiss. Virgen*, Evora, 1600, lib. II, cap. XI, act. II; Trombelli, *Mariae sanctissimae vita*, t. IV, 289; Tillemont, *Mém. Pour servir à l'hist. ecclés.*, t. I, 67. Mâle, *La peinture religieuse*, 8.

233. Mâle, *La peinture religieuse*, 284–285.

234. Francesco Corteccia, *Passione secondo Giovanni* (1527), performed by Schola Cantorum Francesco Coradini, directed by Fosco Corti. Archiv CD 453, 163–62.

235. Orlandus Lassus (Orlando di Lasso), *St. Matthew Passion* (1575), performed by Theatre of Voices, conducted by Paul Hillier. Harmonia Mundi CD HMU 907076.

236. Tomás Luís de Victoria, *Passion According to St. John*. In *Officium Hebdomadae Sanctae* (1585), performed by Ensemble Vocal Jean-Paul Gipon. Jade/BMG CD.

237. William Byrd. *Passio Secundum Johannem* (1605). In *The William Byrd Edition*, vol. 6, *Music for Holy Week and Easter*, performed by The Cardinal's Musick, conducted by Andrew Carwood. ASV Gaudeamus CD GAU214.

238. Cypriano de Rore. *St. John Passion* (1544–57), performed by the Huelgas Ensemble, conducted by Paul Van Nevel. DHM CD 7994-2-RC.

239. Among the recordings of these works are the following:

> Giovanni Perluigi da Palestrina, *Lamentations of Jeremiah the Prophet*, performed by Pro Cantione Antiqua, directed by Bruno Turner. Novello Records, NVLCD 102.
>
> Orlando di Lasso, *Music for Holy Week; Requiem*, performed by Pro Cantione Antiqua, directed by Bruno Turner. Hyperion CD CDD220212. (Includes the Lamentations for Holy Thursday, Good Friday, and Holy Saturday.)
>
> *Palestrina: Officium Tenebrarum*, performed by Ensemble Vocal Jean-Paul Gipon, conducted by Herve Lamy. Jade CD JAD C 102. (Includes the Nocturnes

and Lamentations for Holy Week, with the Gregorian lessons. Contains
music by both Palestrina and Orlando di Lasso.)

Tomás Luís de Victoria, *Officium Hebdomadae Sanctae (1585)*, Ensemble Vocal
Jean-Paul Gipon. Jade CD JAD C 322.

Tomás Luís de Victoria, *Responsories for Tenebrae. Responsories at Matins in Holy
Week*, performed Choir of Westminster Cathedral, directed by David Hill.
Hyperion CD CDA66304.

Tomás Luís de Victoria, *Lamentations; Tenebrae Responsories*, performed by
The Choir of Trinity College, Cambridge, directed by Richard Marlow.
Conifer CD CDCF 188.

240. Orlandus Lassus, "In Monte Oliveti," in *Motets et Chansons*, performed by
the Hilliard Ensemble, conducted by Paul Hillier. EMI CD.

241. Orlandus Lassus, *Lagrime di San Pietro*, performed by Ars Nova, directed by
Bo Holten. Naxos CD 8.553311.

242. Giovanni Perluigi da Palestrina, *Stabat Mater*, performed by The Cardinall's
Musick, directed by Andrew Carwood. Gaudeamus CD GAU 333.

APPENDIX

1. Albrecht Dürer, *Gedenkbuch* in Dürer: *Schriftlicher Nachlaß*, ed. Hans Rup-
precht (Berlin: Deutscher Verein für Kunstgeschichte, 1956), vol. 1: 37; quoted in
David Hotchkiss Price, *Albrecht Dürer's Renaissance: Humanism, Reformation, and the
Art of Faith* (Ann Arbor: University of Michigan Press, 2003), 287n52.

2. See discussion in Price, *Albrecht Dürer's Renaissance*, 39–65. Price concludes
that Dürer's images of the church and its life are largely positive, not revolutionary.

3. Luther's theses were circulated to the members through Kasper Nützel's
"unauthorized German translation." Donald A. McColl, "Through a Glass Darkly:
Dürer and the Reform of Art" in *Reformation and Renaissance Review* 5 (2003):
54–91, 56.

4. Price, *Albrecht Dürer's Renaissance*, 227.

5. Quoted in Erwin Panofsky, *The Life and Art of Albrecht Dürer*. With a new
introduction by Jeffrey Chipps Smith. (Princeton: Princeton University Press, 2005
[1943]), 198.

6. We might wonder why Dürer specifies precisely 140 years before, and to
whom he is referring as Luther's predecessor in "writing clearly" then about the
gospel. Wyclif was active at the time; and 1380 was the date of the birth of Thomas à
Kempis and of the death of Catherine of Siena.

7. This phrase, *du Ritter Christi*, seems to be a reference to Erasmus's early work
Enchiridion militis Christiani ("Handbook of the Christian Soldier [or Knight]"), pub-
lished in 1504.

8. Dürer, *Journal of Albrecht Dürer's Tour in the Netherlands in 1520 and 1521* in
Mary Margaret Heaton, *The History of the Life of Albrecht Dürer of Nürnberg. With
a Translation of his Letters and Journal, and Some Account of his Works* (London:
Macmillan, 1870; repr.: Elibron Classics, 2005); 303–6.

9. Melanchthon refers to *melancholia generosissima Dureri*, Panofsky, *The Life and Art of Albrecht Dürer*, 171. But see also the analysis of the idea of "melancholy" in Price, *Albrecht Dürer's Renaissance*.

10. Dürer, *Schriftlicher Nachlaß*, ed. Hans Rupprecht (Berlin: Deutscher Verein für Kunstgeschichte, 1956), vol. 1: 171, quoted in Price, *Albrecht Dürer's Renaissance*, 233.

11. Panofsky, *The Life and Art of Albrecht Dürer*, 198.

12. See Price, *Albrecht Dürer's Renaissance*, 233–35.

13. See McColl, "Through a Glass Darkly," 58.

14. Ibid, 89.

15. "In wen Christus kumt, der ist lebendig, vnd der selb lebt jn Christo. Dorum alle ding gute ding sind Christi. Nichtz gutz ist jn vns, es werd dan jn Christo gut. Dorum welcher sich gantz gerecht will machen, der ist vngerecht. Wir künnen gutz wöllen, Christus wöls dan jn vns. Kein menschlich rew ist so gros, das sy gnug sein müg, ein totsünd sw... das sie frucht pring," Dürer, *Schriftlicher Nachlaß*, ed. Hans Rupprecht, vol. 1: 216–17, quoted in Price, *Albrecht Dürer's Renaissance*, 312. Price's translation "whoever intends... to justify himself *alone*...." (282; emphasis added) may indeed reflect Dürer's thought, but it seems to me that it goes beyond what the words actually say.

16. Panofsky, *The Life and Art of Albrecht Dürer*, 198.

17. Ibid, 222.

18. Ibid.

19. Dürer, dedicatory letter to *Underweysung der Messung* (Nüremberg, 1538). As we have seen, Luther by 1522 had also rejected iconoclasm. See WA 10/3:31.

20. Price, *Albrecht Dürer's Renaissance*, 226.

21. McColl, "Through a Glass Darkly," 64.

22. Quoted in Panofsky, *The Life and Art of Albrecht Dürer*, 199.

23. See McColl, "Through a Glass Darkly," 58.

24. *Dürer: Schriftlicher Nachlaß*, 1: 36; quoted in Price, *Albrecht Dürer's Renaissance*, 22.

25. Panofsky, *The Life and Art of Albrecht Dürer*, 212.

26. Ibid, 199.

27. Price, while pointing to the same changes, admits that the connection with the Reformation is speculative, *Albrecht Dürer's Renaissance*, 236.

28. Quoted in Panofsky, *The Life and Art of Albrecht Dürer*, 230.

29. Ibid, 241.

30. Quoted in ibid, 241.

31. Panofsky, *The Life and Art of Albrecht Dürer*, 233. Probably because he could find no other use for the panels, Dürer offered them to the city of Nuremberg, which accepted the "gift" and in thanks rewarded Dürer with a sum of money.

32. Ibid, 234–5.

33. G. Pfeiffer, *Die Vorbilder zu Albrecht Dürers "Vier Aposteln"* in Jarhersber. Des Mel.-Gymnasiums in Nürnmeber 1959/60, cited in Philip Melanchthon, *Ausgewählte*

Briefe 1517–1526, in *Melanchthons Werke,* ed. Hans Volz (Gütersloh: Verlagshaus Gerd Mohn, 1971), vol. 7, part 1, 255n11.

34. Panofsky, *The Life and Art of Albrecht Dürer,* 233. Panofsky notes that like Luther, Dürer was religiously conservative; he opposed radical movements. "As is always the case with revolutionary movements, the Reformation had produced a series of phenomena which by their radicalism repelled and in some cases alienated its original supporters, and forced its very founder into a 'counter-revolutionary' position."

35. Dürer, *Schriftlicher Nachlaß,* 1: 285, quoted in Price, *Albrecht Dürer's Renaissance,* 229. As Price points out, Luther himself shared this dismay at the conduct of some of his followers.

36. Price, *Albrecht Dürer's Renaissance,* 227.

Index